ENCHANTED OBJECTS

ALLAN HEPBURN

Enchanted Objects

Visual Art in Contemporary Fiction

UNIVERSITY OF TORONTO PRESS
Toronto Buffalo London

© University of Toronto Press Incorporated 2010
Toronto Buffalo London
www.utppublishing.com
Printed in Canada

ISBN 978-1-4426-4100-6 (cloth)

Printed on acid-free, 100% post-consumer recycled paper with
vegetable-based inks.

Library and Archives Canada Cataloguing in Publication

Hepburn, Allan
 Enchanted objects : visual art in contemporary fiction / Allan Hepburn.

Includes bibliographical references and index.
ISBN 978-1-4426-4100-6

1. Art objects in literature. 2. Art in literature. 3. American fiction –
20th century – History and criticism. 4. English fiction – 20th century
– History and criticism. 5. American fiction – 21st century – History and
criticism. 6. English fiction – 21st century – History and criticism.
I. Title.

PS374.A76H46 2010 823'.91409357 C2009-907360-9

This book has been published with the help of a grant from the Canadian
Federation for the Humanities and Social Sciences, through the Aid to
Scholarly Publications Programme, using funds provided by the Social
Sciences and Humanities Research Council of Canada.

University of Toronto Press acknowledges the financial assistance to its
publishing program of the Canada Council for the Arts and the Ontario
Arts Council.

 Canada Council Conseil des Arts
for the Arts du Canada
 ONTARIO ARTS COUNCIL
CONSEIL DES ARTS DE L'ONTARIO

University of Toronto Press acknowledges the financial support for its
publishing activities of the Government of Canada through the Book
Publishing Industry Development Program (BPIDP).

Contents

Illustrations

Every reasonable effort has been made to obtain permission to reproduce the illustrations in this book.

Acknowledgments

In the summer of 1987 I worked for the marketing and education departments at the Art Gallery of Ontario in Toronto. My job was both unusual and straightforward: I surreptitiously followed people through galleries and recorded how long they spent in front of individual artworks. To my surprise, the average time that anyone spent looking at anything – painting, sculpture, or drawing – was less than a second. On Wednesday evenings, when admission was free, people loitered and studied pieces with intent. Many Wednesday evening visitors were art students. Questioning random gallery-goers as they left exhibitions, I noted what they had liked or learned about their museum experience. I correlated this information with the time that they spent reading panels of text or looking at objects. I regretfully concluded that the museum was a place of only the most superficial education and edification. My summer job set me on a path of thinking about the value of display and museums in contemporary culture.

When I visit museums, I trust my own eyes as far as possible. In scholarly matters, I have learned to trust others' keen vision. Many people contributed essential details to this book when its overall pattern remained obscure. Liisa Stephenson, working as my research assistant over several summers, found critical materials that I would otherwise have neglected. Robert Lecker provided thoughtful commentary on my argument and prose. Paula Derdiger, Justin Pfefferle, and Ian Whittington offered last-minute proofreading. Patrick Moran, Christina Oltmann, and Meredith Donaldson graciously helped with Latin and German translations. Shawn Malley invited me to give the Ogden Glass Lecture at Bishop's University in February 2004; the spirited discussion

after the lecture helped me to improve the chapter on Bruce Chatwin. Andrew John Miller kindly asked me to lecture on ornament at the Université de Montréal in January 2007.

I am grateful to the Social Sciences and Humanities Research Council of Canada which awarded me a three-year research grant in 2002 for a project on collectors and collections in modern literature. This grant allowed me to travel to research libraries and to hire assistants. Research at the Metropolitan Museum of Art in New York, the Royal Ontario Museum in Toronto, and the British Library helped me to devise answers to questions about aesthetic value and the cultural life of art objects. This book was originally designed as a short coda to the proposed book about modernist collections. As I sifted through materials about museums and collections, I realized that I was writing two books, not one. *Enchanted Objects* sheered away from the other project to become an object unto itself.

Three generous reviewers for the University of Toronto Press wrote reports on a draft of the manuscript; their suggestions, sometimes feisty, always engaging, improved the argument. Richard Ratzlaff ushered this book through the press with skill and patience.

Lastly, I wish to thank Robin Feenstra, Vicki Hogarth, Stephanie King, Lukas Lhotsky, Pauline Morel, Christina Oltmann, Jason Polley, Liisa Stephenson, and Erin Vollick for their intellectual brio. They were members of a graduate seminar called 'Material Culture and Its Representations' that I taught at McGill University in 2002. For their steadfast friendship and enthusiasm, I dedicate this book to them.

ENCHANTED OBJECTS

1 Introduction: Art and Objects in Contemporary Fiction

Aesthetic Objects

Between the 1970s and the early twenty-first century, novelists writing in English published numerous fictional narratives about visual art: paintings, statues, porcelains, vases, tapestries. These narratives collectively dwell on the meaning of artworks as representational objects. Caught up in the drama of representation, contemporary novels put objects on display in order to revive and broaden aesthetic inquiry. As a species of objects identifiable by their intentionality and technical ingenuity, artworks, as against machines or everyday objects, have complex meaning and uncertain destinies. Subject to the vicissitudes of time, artworks are hidden, smashed, looted, traded, collected, and sequestered. The persistence of art objects in contemporary narratives has less to do with the elusive quality of beauty or the encroachments of consumer culture on art than the prevalence of display and historical changes in the status of objects. Instead of emphasizing abstraction or experimentation as the ends of art, contemporary writers represent artworks to reinforce the concept of representation as enchantment. Four questions, each predicated on objects and aesthetics, motivate this study: What is a detail? Is all art ornamental? Why do fragile objects have value? What is ugliness?

Artworks in contemporary narratives display vested aesthetic properties. By virtue of their presence, objects instigate plots. In Bruce Chatwin's *Utz*, a collector who lives through the Second World War and the post-war Soviet years in Prague painstakingly assembles a museum-worthy collection of porcelain. To prevent state officials or greedy collectors from laying claim to his exquisite figurines after his death, Utz

smashes them to bits and tosses the shards into rubbish bins – or so it appears. In Barry Unsworth's *Pascali's Island*, a midnight ambush ends with irreparable damage to a Hellenic statue that had survived intact for two millennia in the ground. The damage done is unintentionally iconoclastic, but irreversible nonetheless. In *Pascali's Island*, people save artworks or damage them forever in the name of conservation and self-interest. *Stone Virgin*, a sequel of sorts to *Pascali's Island*, juxtaposes a story about sculpting a Madonna in 1453 with efforts to conserve the same statue in 1972. Pollution in Venice erodes stone. With surprising regularity, artefacts disintegrate or break in contemporary fiction. In Michael Frayn's *Headlong*, a painting alleged to be by Pieter Brueghel is burned because it is thought to be a forgery. In Peter Carey's *Theft*, a modern painting, having been declared a fake by a team of so-called experts, is destroyed by French authorities. The painting turns out to be authentic after all, which is tantamount to claiming that the French police 'incinerated a masterpiece' (87).

In contrast to thoughtless destruction, some novels document the making of an artwork, as if supplying provenance in narrative form. The urge to make art animates Tracy Chevalier's *Girl with a Pearl Earring*. Gifted with a strong visual sense, the maid Griet collaborates with her master, Johannes Vermeer, by arranging a piece of drapery that serves as an element in one of his paintings. Griet's participation, however modest, raises issues of class and gender in the production of art objects. Two other novels about Vermeer, Katharine Weber's *The Music Lesson* and Susan Vreeland's *Girl in Hyacinth Blue*, pit the destruction of art against its survival through centuries. Saving and salvaging animate both Susan Sontag's *The Volcano Lover* and Allen Kurzweil's *A Case of Curiosities*, two narratives that implicate collectors in the life of objects. The collector, not always a connoisseur, values uniqueness in objects and paradoxically demonstrates uniqueness by assembling similar objects into a collection where similarity and variation can be observed. In Thomas Wharton's *Salamander*, a printer devises *sui generis* books that offer little information but display great ingenuity in their physical form.

Other contemporary novels about artworks straddle the divide between mass-market best-sellers and literary fiction: John Updike's *Seek My Face*; A.S. Byatt's *The Matisse Stories*; James King's *Faking*; Paul Watkin's *The Forger*; Joan King's *The Impressionist*; Chaim Potock's *My Name is Asher Lev*; John Banville's *The Book of Evidence, Mefisto, Athena*, and *The Untouchable*; Jane Urquhart's *The Underpainter* and *The Stone*

Carvers; Howard Norman's *The Museum Guard*; Tracy Chevalier's *The Lady and the Unicorn*; and Susan Vreeland's *The Passion of Artemisia*, *Luncheon of the Boating Party*, and *The Forest Lover*. Many, but by no means all, of these novels invoke historical settings to suggest that aesthetics are culturally determined and far from stable. Standards of beauty and ugliness, truth and detail vary from one epoch to another. Universal truth, exalted in the eighteenth century as the end of art, does not obtain in modern or postmodern culture. Moreover, historical settings presume an abyss between past and present, an abyss in which numerous artworks have been lost, either because of negligence or because of shifting standards of taste. Artworks that survive through centuries possess a nearly magical intensity on the grounds that, being vulnerable to the depredations of time and human meddling, they too might have disappeared. Having survived against the odds of destruction, objects bear the traces of lived history, a history that happens outside museums, a history consequently aggrandized by incident.

Novels demonstrate the power of ownership in the sense that objects in a narrative sequence are neither static nor unchanging. Human agents assert their right to handle, counterfeit, or even destroy their possessions. Exerting proprietary rights, owners need not justify what they do to their property. In Michael Frayn's *Headlong*, Tony, the owner of an estate, claims: "'Everything has to be owned. That's what gives it life, that's what makes it mean something, having a human face attached to it'" (29). Tony intimates that ownership covers all parts of an estate, including hidden and unsuspected objects. If, for example, someone buys a house and finds a painting lodged behind a chimney or a drawing rolled up and stuck under the floorboards, ownership extends to that object. Tony also implies that ownership creates an identity for an object, even while the object proves the power of the owner to possess. Although Martin Clay, first-person narrator of *Headlong*, contrives to steal Tony's paintings – 'I'm going to have his property off him. He can't make good his claim to it' (44) – he ultimately feels that paintings defy ownership altogether. In a moment of self-deception, Martin Clay concludes that '*no one* owns them [the paintings]' (321). Scarce Brueghel paintings are cultural property, not personal property. They belong to a world heritage or, more precisely, the heritage of the novel, which emphasizes, throughout its long history of trickery and theft, the alienability of possessions from their owners. Intimately connected to the rights of property, narrative reveals the secret life of artworks as they change hands over time.

As property, objects incite any number of emotions: bafflement, pleasure, covetousness, consternation, even rage. Reactions to objects, however, do not explain what an object *is*. An object exists prior to perception. As a material structure with shape, density, edges, texture, and surfaces, an object demarcates and occupies space. An object, because it has spatial dimensions, necessarily has an outside and an inside, a front and a back, although the inside or the back are not always accessible to the eye or the hand. An object can be sharp, tiny, and fragile; or it can be soaring, gigantic, and unbreakable. It can be made of glass, steel, salvage material, textiles, or what have you. It can possess a nearly limitless combination of details and ornaments, which conjoin in patterns. Art objects, because they are fashioned with a specific intention, do not belong to the same categories as useful gadgets or things found in nature. Bill Brown argues that 'things' are not 'objects.' The two categories have semantic distinctness. Objects imply an order of some sort among themselves or a formal orderliness in and of themselves. By comparison, things 'lie beyond the grid of intelligibility the way mere things lie outside the grid of museal exhibition, outside the order of objects' (*Things* 5). In this paradigm, things defy classification; objects submit to conceptual order and physical arrangement.

All the same, things can transit into objects. Nor need things be cast permanently out of museums. Sliding into the category of the object, the thing ends up on display as an article of scrutiny and admiration. Indeed, the difference between a thing and an object might pivot around display. Things are de facto not displayed. To display a thing, with the implicit invitation to pause and reflect upon it, converts the thing into an object. 'Thing' designates an intractability in an object, as when it exhausts its usefulness or as when an object refuses to cooperate with human expectations for it. According to Brown, the term *things* refers to 'what is excessive in objects, [...] what exceeds their mere materialization as objects or their mere utilization as objects' (5). Those qualities challenge human cognition. The terms *object* and *thing* thus attest to different models of subject-object relations. Throughout this study, the word *object* is used in preference to the word *thing* to designate artworks, objects crafted with the express purpose of eliciting aesthetic pleasure. Nevertheless, the attributes that constitute an object, especially its aesthetic properties, cause it to take on the qualities of a thing that defies or exceeds definition. No object is ever not a thing.

Nor is any art object completely detached from the circulation of commodities within capitalism. An artwork is always potentially a

commodity, even when it is sequestered from exchange, arrested by a collector and placed in a collection, or lodged in a vitrine in a museum; at some point in the future, the object can return to circulation, its value magnified or reduced by time spent apart from the hectic world of commodity transactions. In *Le Système des objets*, Jean Baudrillard wonders whether a single classification system could account for all the objects in the world, especially when new objects appear daily and other objects face discontinuation or out-and-out obsolescence. By and large, Baudrillard analyses quotidian objects – appliances, watches, and furniture – to critique consumer society. He distinguishes between functional objects and functionless objects, which he then splices again according to unique pre-industrial objects and serial industrial objects: 'D'une part l'homogénéité est plus grande entre tous les objets dans la société pré-industrielle, parce que leur mode de production reste partout le travail à la main, parce qu'ils sont moins spécialisés dans leur fonction et que l'éventail culturel des formes est moins vaste (on se réfère peu aux cultures antérieures ou extérieures) – d'autre part la ségrégation est plus grande entre un secteur d'objets qui peut se prévaloir du "style" et la production locale qui n'a qu'une stricte valeur d'usage' (191–2).[1] Style is anathema to Baudrillard because it bears connotations of bourgeois pretence and susceptibility to consumerism. Serial production of 'stylish' commodities within industrial society alters the value allocated to handmade artefacts. As Baudrillard acknowledges, the pre-industrial object does not remain strictly defined by its uniqueness, by which he means an object that is not mechanically and serially produced. Tools once made by hand can be manufactured in identical batches in factories. When a consumer can buy an implement from any number of manufacturers, use value has little bearing on choice. Within the realm of commodities, what differentiates objects is a perception of their stylishness.

Art objects are not the same as other commodities insofar as they resist obsolescence and insofar as their value fluctuates according to principles that have nothing to do with use or labour value. In many ways, artworks demonstrate illogicalities within capitalism, such as the arbitrary designation of value. Serving no apparent purpose, the art object involves human subtlety, skill, and feeling, which, along with other qualities, unite under the rubric of aesthetics. As aesthetic artefacts, art objects seek a response of some kind, which is not necessarily true of useful commodities. It is probably easier to love a still life by Chardin than, say, a refrigerator. A sensitive appreciation of formal and

contextual aspects of an object qualifies as an aesthetic response. All too often, aesthetics has dallied over the beautiful, to the exclusion of other elements or attributes that require an equally sensitive appreciation. Yet beauty should not exclude other properties that also contribute to the identity of an object. Because art objects have no use value and because they evoke aesthetic responses, they do not fully substantiate Karl Marx's assertion in *Capital* that a commodity 'looks upon every other commodity as but the form of appearance of its own value' (97). In the realm of commodities, all objects exist in relation to other objects. But art, while bought, sold, and stolen like other commodities, is not only a commodity. Its social and aesthetic value separates it from kindred commodities and potentially magnifies 'the form of appearance' of value to the point of pricelessness.

To a certain degree, aesthetics legitimate the separation of artworks from commodities. Yet aesthetics, whatever claims are made for detachment and disinterestedness vis-à-vis judgment, are never free from other kinds of value. Pierre Bourdieu points out in *Distinction* that the value of objects derives from the social uses to which they are put: 'the ideal of "pure" perception of a work of art qua work of art is the product of the enunciation and systematization of the principles of specifically aesthetic legitimacy which accompany the constituting of a relatively autonomous artistic field' (30). Art serves the social purpose of affirming and perpetuating class divisions by creating categories of those who appreciate artworks, as opposed to those who do not. The artwork is thus never entirely free from social value. Knowing about different kinds and calibres of artworks – Bourdieu's examples include Braque, Goya, Vlaminck, Petula Clark, Ravel's *Concerto for the Left Hand*, and Bach's *The Well-Tempered Clavier* (261–7) – affirms standards of taste and validates class standing: 'Material or symbolic consumption of works of art constitutes one of the supreme manifestations of *ease*, in the sense both of objective leisure and subjective facility' (55). For Bourdieu, the artwork principally exists in a nexus of social relations. 'Cultural capital,' defined as the competence to decipher the codes embedded within artworks, a competence acquired first via social background and second via education, buttresses class position. More often than not, Bourdieu tests cultural competence through visual art: respondents to one of Bourdieu's surveys were asked to categorize photographs according to whether they could be called 'ugly,' 'meaningless,' 'interesting,' or 'beautiful' (36–7). Mastering the meaning and historical disposition of an art object determines cultural competency, and that mastery is borne

out by a knowledgeable stroll through a photographic exhibition. Although Bourdieu revises aesthetics in light of social factors, at the centre of his analysis remain the object and its display.

By reconsidering the status of objects in general and art objects in particular, without necessarily treating objects as opportunities for ekphrasis,[2] contemporary novels alter aesthetic paradigms, specifically Kantian aesthetics. In *Critique of the Power of Judgment*, Immanuel Kant writes that 'a judgment about beauty in which there is mixed the least interest is very partial and not a pure judgment of taste' (91). The beholder, according to Kant, experiences pleasure in beauty as if he or she were at a distance from desire. Whereas philosophers, obedient to Kant's formulation, argue that the disinterested apprehension of beauty informs judgment of an artwork, contemporary narratives advance the claim that aesthetics require more comprehensive and pertinent categories to define objects and judgments about them.

Indeed, contemporary novels about artworks revisit the precepts upon which aesthetics, as a discipline, was founded in the eighteenth century.[3] Aesthetics per se emerged with Alexander Gottlieb Baumgarten's *Aesthetica*, published in two parts in 1750 and 1758. Edmund Burke elaborated aesthetic principles in *A Philosophical Enquiry into the Sublime and Beautiful* in 1757. Kant responded to both Baumgarten and Burke in *Critique of the Power of Judgment* in 1790. Other philosophers and critics, such as the Earl of Shaftesbury, Sir Joshua Reynolds, Gottfried Ephraim Lessing, and Lord Kames, refined distinctions about taste and beauty over the course of the eighteenth century. For some, taste is democratically available: anyone can possess it. For others, such as Lord Kames, aesthetic acquaintance 'does not provide a means to challenge or reimagine the subject's position in social relations, but essentially restates that position' (Harkin 184). Contemporary narratives set wholly or partly in the seventeenth or eighteenth century, dealing with historical personages such as Johannes Vermeer or Sir William Hamilton, reinterpret artworks outside the framework of beauty and the hypothesis of an autonomous realm of aesthetics as laid down during the Enlightenment. Novels such as *Girl with a Pearl Earring* or *The Volcano Lover* dramatize history for the purpose of reinventing aesthetics in ways that circumvent the precepts of Baumgarten, Kant, and Burke.

In defiance of the palpable evidence that people and characters interact with objects in decidedly *interested* ways, Kant recommends that proper aesthetic judgment dismiss, even forbid, the least admixture of interest: 'Taste is the faculty for judging an object or a kind of represen-

tation through a satisfaction or dissatisfaction without any interest. The object of such a satisfaction is called beautiful' (96). In effect, Kant shifts the emphasis in aesthetics away from objects and onto the perceiver of objects. The object ceases to exist except as an extension of the subject's perception. In contrast to this Kantian remoteness from the object and its representations, contemporary novels speculate on what an artwork is and does. The object might be hidden or displayed, according to the whims and vanities of its owner. Despite Kant's intimation that objects are inert except when they arouse reactions in a perceiver, objects initiate action and propel narrative. In fiction, characters drop, steal, abrade, restore, unearth, hoard, hide, arrange, cut, smash, trade, buy, pawn, give, hang, donate, ship, insure, burn, photograph, appraise, classify, caress, and covet artworks. Characters take satisfaction from objects through interested exploitation. As objects move from hand to hand or lie hidden in a closet, they generate stories.

Novelistic description depends on details that pertain to material qualities. Certain novelists seem capable of writing *only* about objects. Lists of mundane objects, like epic catalogues, swell Georges Perec's *Un Cabinet d'amateur* and *Les Choses*. Art objects, as distinct from other kinds of objects, create an altogether different dynamic within narrative. Dorian Gray is nothing without his hidden portrait. Henry James's novels devote detailed exposition to bibelots, golden bowls, the exquisite placement of objects. The inspection of beautiful interiors is a commonplace of James's fiction, as in *The Portrait of a Lady* when Isabel Archer makes a hasty tour through the picture gallery at Gardencourt in the gathering dusk, or as in 'The Beast in the Jungle' when John Marcher and May Bartram find themselves thrown together at a country house and renew their acquaintance while looking over lovely *objets* in sunlit rooms. Contemporary fiction about artworks has important antecedents not only in Wilde's and James's novels, but also in Honoré de Balzac's *Le Chef-d'oeuvre inconnu* and *Cousin Pons*, Edith Wharton's *The Reef* and *The Custom of the Country*, Virginia Woolf's *To the Lighthouse*, and Albert Camus's *La Chute*. In most of these cases, paintings and art objects elicit controversy and conniving. Implicated in human actions, artworks acquire social value, which is never neutral.

Enchantment

Whereas modern novels about artworks and collections validate self-expression and ownership, postmodern novels historicize value and

critique museum culture. Modern narratives about art question the necessity of verisimilitude and the relation of art to experience. In Henry James's 'The Real Thing,' the commercial illustrator who narrates the story is content to acquire a modicum of wisdom from having worked with two starchy, impossible models. Too exemplary by half, the models damage the artist's ability to draw, but he claims to be glad to know that reality is an effect created by suggestion rather than unwavering fidelity to truth. Artworks in modern fiction tend to fulfil formal principles of design when they do not promote authenticity in feeling. In *To the Lighthouse*, Lily Briscoe, while thinking about Mrs Ramsay, worries about design. A break in the line of a hedge interrupts the formal pattern in Lily's painting, a difficulty finally resolved when she connects various masses with a final, masterful stroke of her brush. Modern fiction positions art as the intentional arrangement of feeling. In *The Picture of Dorian Gray*, Basil sublimates his desire for Dorian in a portrait. In *Brideshead Revisited*, Charles Ryder lets his nostalgia for the aristocracy show in subdued pictures of stately homes. Painting channels Basil's and Charles's feelings, which are otherwise inexpressible. Contemporary fiction, on the other hand, dwells on the implication of artists in systems of labour and commerce that emphasize value rather than feeling. In modern fiction, art exists beyond commerce as an autonomous realm; in contemporary fiction, characters work within the toils of commercialized art. In modern fiction, artists express emotion; in contemporary fiction, art expresses market forces at a sceptical remove.

Peter Carey's *Theft*, a novel about enraged artists and unscrupulous patrons, offers a proof of the degree to which aesthetics, enmeshed in economics, is motivated by the principle of interestedness. Authenticators and experts buzz around the estate of a painter named Jacques Leibovitz, removing canvases from the artist's studio on the day of his death only to release them later – blatantly retouched and authenticated – for sale to gullible buyers. The artist Michael Boone, whose paintings belong in collections at the 'MoMA, the Museum Ludwig, the Tate' (269), rants against the stupidities of the art world, where prices are fixed and buyers are duped:

I went, one freezing February day, to Sotheby's. They had two Légers, lots 25 and 28. The first painted in 1912 had six pages of supporting documentation which basically contained reproductions of really good Légers which Sotheby's had once sold for a lot of money. These two were shit.

They sold for $800,000. That was the real problem with New York for me. That $800,000. How can you know how much to pay if you don't know what it's worth?

There was also a de Chirico, *Il grande metafisico*, 1917, 41$^{3/4}$" × 27$^{3/8}$", ex-Albert Barnes, a deaccessioned work. Did anyone think, for a bloody nanosecond, why it might be being deaccessioned? Authentic pre-1918 de Chiricos are as rare as hen's teeth. Italian art dealers used to say the Maestro's bed was six feet off the ground, to hold all the 'early work' he kept 'discovering.' But suddenly this pile of crap was real? It was worth three million? (213)

Paintings move in and through museums. Deaccessioned, they appear on the market as exceptional finds at massively inflated prices, inflated in part because of the authenticity conferred on paintings that pass through museums. As Boone complains, museums own fakes, just as private collectors do. The museum has no special immunity to crooks or scams.

In high dudgeon, Boone lights upon a formulation for the spuriousness of value: 'How can you know how much to pay if you don't know what it's worth?' The phrase is repeated with variations throughout *Theft* (41, 269). The logic of value is circular: if you know the worth of a painting in the cultural and aesthetic sense of value, then you know how much to pay. On the other hand, paying an inflated amount establishes value in the monetary sense. The phrase also means that value in an artwork is inseparable from the forces that brought it into being. Value is capricious. It arises from provenance, from scarcity, from scholarly analysis by art historians. Such authentications, however, are only so many pleasing stories. While proving nothing factual, pages of documentation pretend to confirm value. Value further depends on the display of de Chirico or Léger paintings at museums like the Barnes in Philadelphia, or on the sale of paintings at auction houses like Sotheby's in New York. To master the codes of cultural knowledge that allow a buyer to discern the subtleties of a de Chirico or a Léger without recognizing that subtleties can be forged compromises the notion of expertise. As a corollary, should a painting perfectly exemplifying de Chirico's early style yet avowedly counterfeited give a viewer any less pleasure than an authentic de Chirico? And is a painting alleged to be by a youthful de Chirico that is, in truth, a forgery by an elderly de Chirico actually a forgery? Can an artist counterfeit his own style? Boone himself is rumoured to have gone '*out of style*' (Carey 41). If all

art is a form of deception, then surely one derives degrees of pleasure from deceptions successfully perpetrated against a viewer.

Theft is a gigantic hoax. Nothing in the novel is authentic. Both Michael Boone and his brother Hugh repeat other people's words and ideas as if they were original. Marlene, an art dealer who speaks with an American accent but is actually Australian, cons Michael Boone into selling his paintings as a cover for a more serious operation that involves forging, then authenticating, a Leibovitz canvas, *Le Golem électrique*, long thought to have been destroyed. Boone paints the lost Leibovitz as a joke, which does not prevent its being purchased by a reputable German museum. Value, therefore, depends on the willingness of museums and spectators to believe in authenticity as a criterion for value. A hoax cannot work if no gullible party can be found to be taken in. In *Theft*, a whole range of conservators, experts, and museum officials is swindled. As with the deaccessioned and doubtful de Chirico and Léger paintings, the fake Leibovitz has cultural legitimacy and provenance. Yet even inauthentic artefacts contribute to culture: authenticity alone does not define culture, just as it does not define an art object. Hoaxes and fakes, which play off the desire to see value where none exists, define culture, especially when authenticity is at play. Culture, in short, is a sequence of credible frauds.

When he sees his counterfeit Leibovitz painting hanging in the Ludwig Museum in Germany, Michael Boone bursts into laughter. Despite Boone's outburst, Marlene has the last laugh in *Theft*: the fake Leibovitz sells for 3.2 million dollars. Marlene engineers the deal and takes her percentage, the novel implies. As a forgery, the painting is really worth nothing. Unreasonable fluctuations in value reflect the hypocrisies of the art market. Authenticators work for personal gain, not accurate assessment of paintings. International corporations snatch up art as investments and tangible assets, with no regard for aesthetic merits. Whether real or fake, an artwork challenges notions of aesthetic value. Knowing that a painting is forged might mitigate the value of the painting in the long run, but it need not mitigate the pleasure derived from the painting, unless, of course, pleasure is economically determined. Nor are viewers always innocent in the face of nefarious art-world deceptions. In John Banville's *Athena*, a novel about faked paintings, a character wonders, 'How could I allow myself to be so easily taken in [by obvious forgeries]? And the answer comes of course as pat as you please: because I wanted to be' (66). The viewer of a painting, like the reader of a novel, colludes in the deceptions performed by representation.

Contemporary narratives about artworks return to the question of representation as a glorious deception. 'No work of art can be great, but as it deceives,' claims Edmund Burke (76). The artwork makes a virtue of technique that deceives. Within narrative, the deceptions of representation stand in for other kinds of deception, such as those perpetrated by hucksters and art dealers or the self-deceptions that artists and archeologists enact out of a desire to make or find a desirable artwork. In 'Art Work,' the central and most complex of the three stories in A.S. Byatt's *The Matisse Stories*, a painter named Robin fusses over the intricacies of colour theory in 'an attempt to answer the question every artist must ask him or herself, at some time, why bother, why make representations of anything at all?' (52). Nothing compels anyone to draw or paint or hack a piece of stone into a recognizable likeness of something else. The representation serves no obvious purpose. A representation can be symbolic, in that no resemblance or synecdochic relation subtends the image and the thing represented, as when people say, 'let this fork stand for a skyscraper.' Or a representation can partake of some similarity between an object and its representation, as when someone heaps rocks into a tall pile and says, 'let these rocks represent a person,' on the principle that rocks and people share height. Or a representation can be synecdochic, as when a phial of blood or a cranial X-ray stands for a person. As W.J.T. Mitchell spells out, every representation involves a triangular relationship '*of* something or someone, *by* something or someone, *to* someone' ('Representation' 12).

In 'Art Work,' Robin obsessively paints the same objects over and over to test the purity of colour. The objects are of little concern; the juxtaposition of colours counts for everything in Robin's mind. Although he adheres faithfully to his childhood vision of painting, 'which has never expanded or diminished' (Byatt 55), his neo-realist style handicaps his artistry. Meanwhile, Robin ignores his wife's efforts to keep the household running by working on a magazine and meeting deadlines. She pacifies him when he throws tantrums and cajoles him when he feels despondent about his limitations as an artist. His paintings of pure colours induce pleasure, but the pleasure is his alone. Robin cannot place his paintings in a gallery, nor can he abandon his narrow preoccupation with colour in and of itself. If Robin's paintings are addressed to anyone, they are addressed to himself. They remain solipsistic exercises without commercial viability. As Robin's paintings reveal, art provides hypothetical answers to questions that do not exist. As a mediation between people and the world, all representation attempts to solve abstract, even unspecifiable, problems.

The question that haunts 'Art Work' – 'why make representations of anything at all?' – has a particular poignancy for Robin. He keeps a small group of 'fetishes' (Byatt 62), including a sauceboat, a toy soldier, some thumbtacks, a candlestick, and a luminous green Wedgwood apple, as examples of pure colour. He flies into a rage when Mrs Brown, the woman who cleans his studio and house, moves the fetishes about. Despite Mrs Brown's ominous name, brown does not show up in Robin's palette of pure colours. Instead of evoking a colour, her name alludes to the elusive woman in Virginia Woolf's essay 'Mr. Bennett and Mrs. Brown': 'The most solemn sights she turns to ridicule; the most ordinary she invests with beauty' (Woolf 387). Anything but drab, Mrs Brown in 'Art Work' is an accomplished textile artist, unbeknownst to her employers. She has a voluptuous imagination that runs to salvage materials and clashing combinations of colours. She turns ordinary scraps of cloth into exotic sculptural pieces. For a gallery installation, she creates a 'cavern' where odds and ends of furniture commingle with a dragon made out of taffeta (Byatt 78–9). Foam and hairpins and brassieres and plastic toys and garment linings and medicine bottles filled with iridescent pills and seeds and crocheted armour in violet and saffron and knitted swags of all hues combine to create a fairyland of colour and texture in her installation. Unlike Robin, Mrs Brown revels in extremes that stretch credibility and create enchantment.

As strategies for broaching the mysterious and the infinite, artworks emit their enchanting effects. They solicit the eye or ear. While resisting the more potent connotations of the word *magic*, enchanted objects appeal to those who are capable of acts of attention. Enchantment might be another word for beauty, although it is not limited to the narrow compass of values associated with beauty. In any event, beauty is a hotly contested term in contemporary culture. '"Beauty – nobody uses the word,"' grouches an abstract painter in *Seek My Face* (Updike 139). The grouchy painter is right about beauty, but not for the reasons that he thinks. In his view, the end of art is not a universal form of beauty that aligns itself, rather spuriously, with truth. In contemporary fiction about visual art, the word *beauty* is used, but it does not exclude other aesthetic questions. Beauty is only one form of enchantment. For the purposes of this study, the term *enchantment* extends to the aesthetics of detail, ornament, fragility, and ugliness manifest in material objects. Enchantment can account for other qualities in objects as well, such as smoothness, roughness, size, and finish. Museum displays and private collections enhance, or sometimes diminish, the effects of enchantment. Enchanted objects possess history, not in the grand sense of the

term, but in the personal sense of being anecdotal. According to the crabby painter in *Seek My Face*, any artwork that smacks of a story or human feeling is passé. '"Brushwork is anecdote,"' he sneers (139). Yet Updike's novel, like any number of contemporary fictions about artworks, lingers over the enchantments cast by all kinds of figurative, abstract, and anecdotal art. Enchanted objects restore a sense of wonder to a world that has bowed down for much of the twentieth century to abstraction and theory. In contemporary fiction about art, viewers allow themselves to be beguiled by handmade objects. Representations enchant spectators by encouraging them to look again at objects that have been too long taken for granted and, consequently, have faded into plainness.

As in Mrs Brown's wondrous cavern, enchantment refers to quasi-magical properties in art objects. In the name of aesthetics, contemporary fiction isolates enchantment as a quality available in and through artworks. Various features combine to create enchantment, not least of which is the exertion of magical effects such as spells or rapture. By compelling the mind to pause for a moment of contemplation, an enchanted art object dallies with infinity; the time taken to meditate on the artwork cannot be measured by ordinary means. The object possesses a degree of mystery that can be approached by the mind, as well as the senses, but cannot easily be explained away. In its compacting of effects that unite the physical and the metaphysical, the enchanted object expresses intensity, either emotional or intellectual. In *Modern Enchantments*, Simon During argues for the persistence of magic within western culture, manifest in conjuring acts, table-turning, optical technologies, and transformations. In a discussion of E.T.A. Hoffmann's stories, During claims that magic 'suffuses the real world,' but it also 'orders a separate domain, which may be imagined as a localized enchanted kingdom' (187). Likewise, enchanted objects inhabit the real world, but they promise access to enchanted kingdoms adjacent to the real world. Enchanted objects are portals into enchantment, where intensity and infinity meet.

The preoccupation with re-enchantment in contemporary fiction follows inevitably from the preoccupation with disenchantment in modernity. In modernist thinking, science drives away possibilities for mystery. Reason affrights the spectres of the inexplicable, formerly linked to magic. Belief in magic withers before the explanations of investigative science. In 1917 Max Weber argued in 'Science as a Vocation' that rationalization and intellectualization have an intimate connection

with modern disenchantment. The devotion to science, Weber claims, 'means that principally there are no mysterious incalculable forces that come into play, but rather that one can, in principle, master all things by calculation. This means that the world is disenchanted' (139). Science, with its dogged pursuit of progress for the sake of progress and its adherence to an ideology of technological rationalization, empties the world of mystery. According to Joshua Landy and Michael Saler, who rebut Weber's hypothesis, 'there are, in the modern age, *fully secular and deliberate* strategies for re-enchantment' (2). Landy and Saler enumerate some of these strategies as proof that the world is imbued not only 'with *mystery* and *wonder* but also with order, perhaps even with *purpose*' (2). Giving themselves over to the pleasures of enchantment, individuals make themselves susceptible to miracles and personal redemption. The infinite, having taken up a place within the secularized and rationalized world, invites the re-establishment of enchantment as an alternative to scientific finitudes. In Landy and Saler's account, enchantment opens up possibilities to non-scientific, non-technical, avowedly aesthetic possibilities within the world.

Display

Enchanted objects have to be seen to be believed. As material artefacts, objects occupy space and are therefore amenable to display. In 'Art Work,' Robin's paintings are not displayed, while Mrs Brown's installation fills an entire gallery. In *Theft*, Michael Boone unfurls his canvases in front of a gallery worker instead of showing transparencies of his work. Boone brags that his paintings ultimately end up in a museum for all to see. Display has always been an implicit aspect of postmodernism. Since its initial appearance in 1972 Robert Venturi, Denise Scott Brown, and Steven Izenour's *Learning from Las Vegas*, with its photographs of casinos and its exuberant call to abandon modernism in both architecture and design, has given credence to display and the values that accrue around visual culture. Industrial signs, towers, and billboards, with their startling clash of words and images, 'show the vitality that may be achieved by an architecture of inclusion or, by contrast, the deadness that results from too great a preoccupation with tastefulness and total design' (53).

Learning from Las Vegas, widely credited as a foundational manifesto of postmodernism, argues for an eclecticism of styles. In this context, 'postmodernism' should be understood as a marker of a period,

specifically the era that follows modernism. A few definitions might clarify the relation of modernism to modernity, as well as the relation of postmodernism to postmodernity. 'Modernism,' as a period marker for culture that extends from the late nineteenth century through to the mid-twentieth century, signifies an engagement with experimentation, interruption, contemporaneity, utopianism, and futurity, whereas 'modernity' refers to the *longue durée* of industrial capitalism in its manifold economic and social forces. 'Postmodernity,' as distinct from the cultural connotations that surface in 'postmodernism,' designates the socio-economic conditions of late capitalism. Postmodernism revels in surface imitations of styles, which is to say it accepts the style as a value in and of itself. Yet styles have to have material manifestations: they have to be displayed before they can be appreciated.

As narratives such as 'Art Work' and *Theft* indicate, postmodern narratives linger over representation as a form of display, in which concealment and forgery play their parts. In these narratives, the pleasure derived from making objects sometimes trumps the museum or commodity value of objects. To display, however, is not to simulate. If postmodernism refers to a style, specifically the witty recycling of images that underscores the historical transposability of content, style itself converts into content. Simulacra replace objects. Linda Hutcheon concludes *A Poetics of Postmodernism* by denying Baudrillard's assertion that postmodernism shuffles simulacra and ignores reality: 'Postmodern art merely foregrounds the fact that we can know the real, especially the past real, only through signs, and that is not the same as wholesale substitution' (230). A further distinction needs to be made between postmodernism as an ironic mode, in which period styles can be juxtaposed, and contemporary fiction about enchanted objects that emphasize originality, uniqueness of artefacts, their textures and finishes, the pleasures of thoughtful meditation. If historiographic postmodernism is construed as the restitution of history through signs and inventions about the past, not all contemporary fiction can be called postmodern. To narrate stories about artworks in contemporary fiction is to refute the claim that the past is knowable only through its signs. Instead, the past is a nexus of events, from the making of an object through to its sale and its possible destruction. History does not happen only *in* objects; it also happens *to* objects. In novels such as *Theft* or *Girl with a Pearl Earring*, the work of art is inseparable from the labour that goes into its making, as well as the specific historical and personal contexts in which it is made. The elements that combine in an artwork

– its production, its details, its gathered energies signifying historical forces – attest to the close integration of art into social and political spheres. While contemporary fiction that represents visual art acknowledges the economic and social determinants of cultural production, it also skirts that reductive narrative about postmodernity – namely, that late capitalism governs all human enterprise – in favour of opportunities for enchantment, not in the naive sense that art has nothing to do with capitalism, but in full consciousness that aesthetics poses questions that capitalist analysis cannot answer.

Artworks re-enchant everyday life. Contemporary fiction makes a virtue of artworks that are physically present and amenable to touch. The tension in such narratives derives from the relation of artworks in ordinary, domestic surroundings and the museum that isolates artworks from lived, day-to-day reality. As a temple of display, the museum casts a long shadow over contemporary fiction. In *The Music Lesson*, a young woman working at the Frick Museum in New York helps IRA members steal a priceless Vermeer that she then carries in her luggage and looks at as if it were her own possession. In *Stone Virgin*, Simon Raikes works for the conservation department of the Victoria and Albert Museum and therefore comes into close contact with Renaissance statues. In *Seek My Face*, the house that Hope McCoy once shared with her famous husband Zack, a drip painter, is converted into a museum. In *The Museum Guard*, a young man who works at the Glace Museum in Halifax steals a Dutch painting called *Jewess on a Street in Amsterdam*. 'The average museum visitor might not realize it,' claims DeFoe Russet, who removes the painting for the sake of his girlfriend, 'but at times a guard takes a painting very personally' (Norman 76). The Dutch painting moves DeFoe so much that he breaches protocol and caresses her two-dimensional face with an adoring finger. In each of these instances, the museum justifies display culture while dramatizing breaches in protocol.

Museum decorum – gazing, no touching – remains in place in Donald Barthelme's illustrated short story 'At the Tolstoy Museum.' In the make-believe museum ostensibly devoted to Tolstoy's life and works, Vronsky and Anna Karenina clinch in a stagy swoon inside a neoclassical diorama that looks like a cut-out (figure 1). Not only are the characters framed by an architectural arch and a box drawn around the image, but they are also enclosed within a series of lines indicating architectural proportion. As the intersecting dotted lines indicate, the two characters stand at the vanishing point of the image. The image, fur-

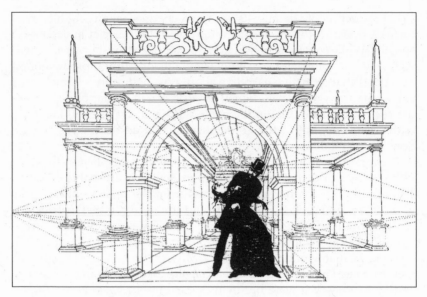

1 Donald Barthelme, the Anna-Vronsky Pavilion from 'At the Tolstoy Museum.'

thermore, implies a viewer looking in upon this emotional nineteenth-century moment. The lines in the drawing define paths along which the eye of the viewer travels. Vectors, indicating perspective, criss-cross the plane of the illustration and entrap Vronsky and Anna inside the viewer's regard. By playing with scales that vary from the miniature to the monumental, 'At the Tolstoy Museum' light-heartedly diagrams the museum visitor's intrusiveness on objects and pictures. As characters in a novel, Vronsky and Anna, fixed by the viewer's stare, subside to the status of curiosities in a display case. Barthelme plays on the cultural obsession, encouraged by museums, of looking at an image that one does not understand and, as a result of not understanding, reducing the image to a set of planes, perspectives, characters, and gestures. 'At the Tolstoy Museum' implies that something deeply unsettling underlies the cultural imperative to display anything and everything for the sake of edifying the viewing public.

Visitors to the Tolstoy Museum weep. They eat sandwiches. The narrator, as museum-goer, boldly tells the director to hang the pictures of Tolstoy six inches lower. The director complies, as if his actions could not help but be governed by visitors' demands. As a matter of policy, the museum promises enlightenment, a policy that the aggressive visi-

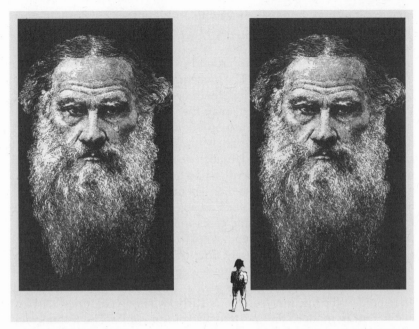

2 Donald Barthelme, Napoleon and Tolstoy from 'At the Tolstoy Museum.'

tor insists on to the point of infringing etiquette. The optimistic narrator in 'At the Tolstoy Museum' marches along to a room dedicated to 'A Landlord's Morning,' in hopes, as he says, that 'something vivifying will happen to me there' (Barthelme 128). Named for one of Tolstoy's short novels, the gallery called 'A Landlord's Morning' encourages visitors to imagine that narratives have three dimensions and are open to visitors at any time of day or night – like a book. Like books, galleries encourage guests to anticipate vivification or revivification, as the narrator specifies. Yet some displays yield conundrums instead of a vivid sense of reality. Another illustration in 'At the Tolstoy Museum' shows a miniature Napoleon, hands tucked together in a posture of inspection (figure 2). The massive, shaggy head of Tolstoy dwarfs Napoleon, who stands beyond the frame of Tolstoy's picture. As this image reminds the viewer, in *War and Peace* Tolstoy gives life to Napoleon and the Napoleonic wars as historical representations. Although Napoleon's looking at Tolstoy is anachronistic – Tolstoy lived after Napoleon – Barthelme implies that Napoleon cannot exist irrespective of Tolstoy's novelistic

imagining of him. Impassively gazing at dioramas, the museum-goer, rather like Napoleon, inserts himself into representations, whether *War and Peace* or *A Landlord's Morning*.

The cachet that accumulates around exhibited objects can be called 'display value' (Stewart 149). The museum grips the postmodern imagination in part because of its insistence on the display value of objects. Within the museum world of display, the value of an object depends on its exhibition, rather than its use or labour value. To display an object does not necessitate that it be finely crafted or beautiful or unique. It can be scaly, curious, invented, defective, mummified, or ugly and still merit a place inside a vitrine. With a nod to the ubiquity of the vitrine in natural history museums, visual artists Josef Beuys and Damien Hirst have placed unlikely objects, such as dog turds, fish in formaldehyde, rolls of felt, and bedpans inside cases to highlight display value. Display value involves the 'tendency to place all things natural at one degree of removal from the present flow of events and thereby objectify them' (Stewart 150). Display value was no doubt in play at the Great Exhibition in London in 1851, as well as at the many world fairs that were held in the late nineteenth and early twentieth centuries. Display is inherent in modern and postmodern culture alike. The technocracy implicit in modernity and postmodernity demands visibility. Culture complies. Yet display value is not the same in all situations. The difference between a modern example of display, such as Marcel Duchamp's *Fountain*, and a postmodern example, such as Josef Beuys's *Sweeping Up* or *Economic Values*, depends on changes in the conditions of display. Whereas Duchamp valorizes the found object and isolates it through display, Beuys constructs dioramas, sometimes entire rooms, in which multiple objects unite to tell a story. *Fountain* is a found object – a urinal – whose display is outrageous and intentionally offensive. *Sweeping Up*, by contrast, involves a narrative of found objects that are distanced through the act of display.

The vitrine in postmodern artworks spectacularizes objects by making them visible while placing them beyond reach. Found or purchased objects, arranged in groups, express social relations, mysterious though such relations may be. In art that calls attention to its display value, such as Damien Hirst's *Isolated Elements Swimming in the Same Direction for the Purpose of Understanding*, an artwork in which preserved fish float in formaldehyde solution inside perspex cases, a different order of time obtains (figure 3). On display, objects exist neither in the present nor in the past. Hirst's title does not clarify whether the preserved fish or the

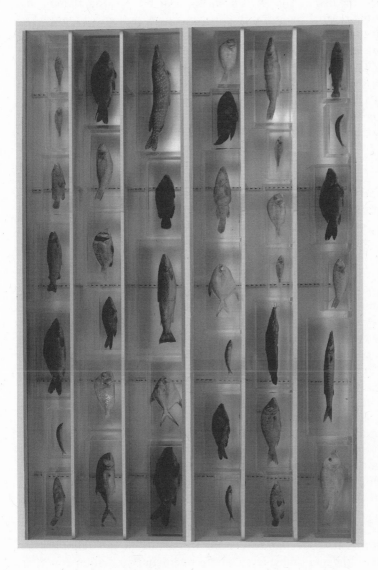

3 Damien Hirst, *Isolated Elements Swimming in the Same Direction for the Purpose of Understanding*, 1991. MDF, melamine, wood, steel, glass, perspex cases, fish, and 5 per cent formaldehyde solution. Courtesy White Cube. © Damien Hirst / SODRAC 2009.

spectators move toward understanding. Furthermore, understanding may happen in the present, the future, or the past. Suspended in time and space, the fish in *Isolated Elements* are real, but no longer alive. Display upsets normal temporality and challenges notions of reality. Despite the evidence of 'At the Tolstoy Museum' and *Anna Karenina*, Anna and Vronsky never existed at all except in the minds of Tolstoy and his readers. Their temporality is ambiguous. They belong in the private museum of recollected reading experience – a very different display case from the sort found in museums.

To display is to pause an action at a given moment or to freeze an object in a given position. The museum creates a break in temporal sequence in order to emphasize the existence of the object qua object. By interrupting temporal sequence, display creates the illusion that objects are not subject to history even though they survive through time and increase in value because they have survived. Display imposes distance between the object and the spectator. In the museum, barriers defend objects. Cordons forbid museum-goers from touching. Plexiglass further sacralizes displayed objects. 'Do Not Touch' signs reinforce the prohibition on sensory stimulation, except of course for the promiscuous eye, which can take its pleasure as it wishes. William Beckford in *The Volcano Lover* begs to be immersed in display: 'Show me more. More. More' (Sontag 86). Playing on visual insatiability, the conditions of display heighten the perception of the desirability, unusualness, or intricacy in objects while limiting access. No one is much given to studying bedpans as objects of interest until they appear inside a vitrine, as they do in Beuys's display cases. To focus on display issues a challenge to the paradigms in which objects are interpreted.

Michael Baxandall argues, 'To select and put forward any item for display, as something worth looking at, as interesting, is a statement not only about the object but about the culture it comes from. To put three objects in a vitrine involves additional implications of relation' (34). The displayed items comment on each other and assert connection through juxtaposition. Spectators of a series of items wonder about variation and detail because comparative evidence is immediately available. Arrangement of objects therefore implies narrative sequence. Augustus Pitt Rivers, who bequeathed the 15,000 ethnographical items from his private collection to Oxford University in 1883, thought his objects would benefit most from an arrangement that demonstrated, in Darwinian degrees, evolution and progress. An illustration of 'Clubs, Boomerangs, Shields and Lances' from Pitt Rivers's *The Evolution of Culture* groups weapons along axes of weapons thrown and weapons held,

as well as axes of shape and size (figure 4). Weapons that are held in the hand (shields, cudgels) are ranged against weapons that are thrown (javelins, lances) and weapons that return once thrown (boomerangs). The objects acquire significance because of their placement next to each other; they reinforce an evolutionary conception of weaponry. As Pitt Rivers intended, the spectator draws lessons about advances in technology from the arrangement itself. Display creates the conditions for inferences. Pitt Rivers thought a great deal about the challenges of properly displaying his collections with the goal of creating a story. He 'called for the establishment of a national education museum of arts organized as a "giant anthropological rotunda" – concentric circles being peculiarly adapted for "the exhibition of the expanding varieties of an evolutionary arrangement"' (Chapman 39).

Even as it enhances nuance, display defies the significance of objects. Pitt Rivers's illustration of weapons falls into a pleasing symmetry, despite the fact that weapons, as individual items, have a use value that has nothing to do with symmetry or family resemblance to other weapons. Looking at this illustration, one is tempted to forget the violent ends to which weapons are put and to concentrate instead on the variations that weapons in the abstract possess. The diagram educates the eye about variations on basic shapes. The observer, ignoring that these are instruments of injury and death, admires qualities such as the length and line of the displayed artefacts. This tendency to dissociate articles from their local contexts and relocate them to a vitrine produces a 'museum effect,' which Svetlana Alpers defines as 'turning all objects into works of art' ('Way' 26). Although they are presented as ethnographic artefacts that reveal social meanings, weapons appear aesthetic when relocated to the museum. Similarly, Renaissance altarpieces or Indonesian textiles shed their original significance when placed in museum galleries. In Alpers's opinion, objects benefit from such relocation. Shorn from their 'ritual site' and placed in a display case, objects captivate the eye: 'the invitation to look attentively remains and in certain respects may even be enhanced' (26). Nevertheless, a certain tendentiousness attends this wilful dislocation and recontextualization for the sake of display. Aesthetics subsumes religious, military, and other meanings. When hung in the Louvre or the Hermitage, a painting of the Descent from the Cross is stripped of its Christian iconography and understood in terms of colour and composition. Display, as a mediation between spectator and object, neutralizes possible meanings and reinforces disinterested spectatorship.

On the other hand, decontextualization draws attention to the traits

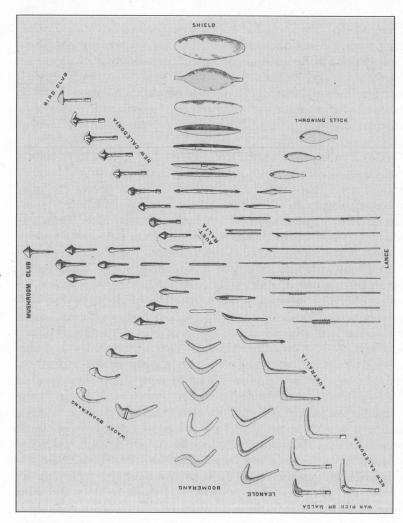

4 Pitt Rivers, 'Clubs, Boomerangs, Shields and Lances' from *The Evolution of Culture*, 1875.

of the object itself as distinct from other objects. The culture of display emphasizes order, and museums go out of their way to fulfil a self-imposed mandate to arrange artefacts in intelligible narratives. The meticulous arrangement of objects prevents discovery, for narratives have already been constructed for the objects, either implicitly through display or explicitly through catalogues and panels of texts on walls. In contrast to the curatorial fussiness practised in contemporary museums, Renaissance *Wunderkammern* promiscuously ranged together items: an elephant's head, a bloody piece of wood, a bridal garter, gems, a painting of the murder of innocents by Albrecht Dürer. Most owners of *Wunderkammern* took pleasure not just in the heterogeneity of objects, but in the disorder of objects crammed into a room. In the late sixteenth century, Sir Walter Cope had 'an appartment [*sic*] stuffed with queer foreign objects in every corner' (Weschler 76). Searching through mess leads to discovery, not to say delight. A figurative drawing of a person set against a monkey's skeleton or a precious stone opens a window onto something wondrous. The *Wunderkammer* sanctioned surprise and speculation. The objects remained within reach, touchable and textured.

In contrast to the prevailing methods of careful display in public museums, private collectors often have a predisposition to disorder. Clutter appeals to the collector's sense of discovery. History delivers numerous examples of the overwhelming disorder of private collections. For instance, the Victorian book collector Sir Thomas Phillipps lived in a state of domestic chaos; Sir Thomas, known familiarly as Sir Tippy, vowed to own 'ONE COPY OF EVERY BOOK IN THE WORLD' (Muensterberger 74). His vast and largely uncatalogued book collection infiltrated every room in his large country house. As a visitor from the Bodleian Library reported in 1854, 'Every room is filled with heaps of papers, MSS, books, charters, packages & other things, lying in heaps under your feet, piled upon tables, beds, chairs, ladders, &c.&c. and in every room, piles of huge boxes, up to the ceiling, containing the more valuable volumes!' (qtd in Muensterberger 75). To feed his passion for books, Sir Tippy bought up entire libraries. In the latter part of his career, he purchased waste paper by the ton on the off chance of finding something valuable among loose leaves. In one lot of waste, he located the main part of William Caxton's *Ovid*. At his death in 1872 Sir Tippy left what was probably the largest collection of books and manuscripts ever assembled by an individual: 50,000 books and 60,000 manuscripts.

In his disorderliness, Sir Tippy resembles many collectors. After the death of Margaret Cavendish, Duchess of Portland, her collections

were sold at auction over thirty-eight days in April and May 1786. The auction catalogue emphasizes idiosyncrasy as the guiding principle behind her collection: 'Nothing is foisted into it from the Cabinets of others; but every Subject here recorded came into her Possession, either by Inheritance, the Assistance of those who were honored with her Friendship, or by her own Purchase and Industry' (*Catalogue* vi). The catalogue further notes that some people 'may object to the Promiscuous Assemblage of the Various Subjects here exhibited' (vii), but the modality of the collector is *copia*: the more, the better. The lots, sequentially numbered into the thousands, attest to a need to master the infinite variety of the object world. The 'Concise View' of the sale demonstrates a preponderance of 'Shells, Corals, Minerals, Echini, Asteriae, Petrefactions, Insects, and other Subjects of Natural History,' interspersed with snuffboxes, birds' eggs, coins, curious seals, miniatures, drawings on vellum, prints, and pictures (x). The duchess particularly fancied conchs, although her enthusiasm for all objects caused her to purchase indiscriminately. Lot 3126 at the auction was 'A most curious and elegant specimen of crystallized arborescent native Silver, *extremely scarce*' (141). Lot 2950 was 'Queen Elizabeth's Prayer Book, which contains Six Prayers, Composed by her Majesty, and written by her own hand' (132). One item of great rarity, a Roman cameo glass that had been sold to the Duchess of Portland by Sir William Hamilton in 1784, was purchased at the auction for 1,029 pounds by the third Duke of Portland, eldest son of the duchess, who had 'largely spurned' her offspring in her will (Walker 23). While she owned it, the duchess, treating the vase according to its use value, adorned it with a spray of coral (figure 5). After it was purchased by the duchess's son, this item was exhibited in the British Museum as the Portland Vase.

When museums began, in the nineteenth century, to separate collections into natural history, ethnography, and fine arts, they also refined the techniques of display according to prevailing ideas about what was instructive and what was valuable. As against the haphazard arrangement of Sir Thomas Phillipps's library or the Duchess of Portland's collections, the twentieth-century museum conferred value through careful display. At the same time, display reinforces and perpetuates value. Inside the museum, objects, enhanced by the conditions of display, are looked at with aesthetic intention. Value resides not in the object itself, but in its staging within a gallery for the sake of being scrutinized. The museum environment presupposes distance between spectators and objects. The white walls and sanitary lighting of

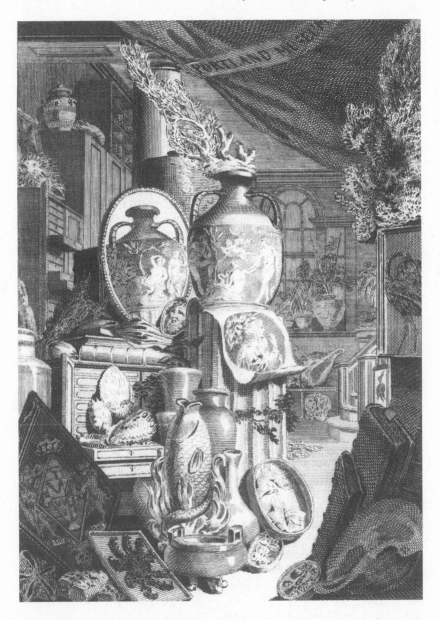

5 Frontispiece to the catalogue for the Duchess of Portland's auction, by Charles Grignion, 1786. © The British Museum.

most contemporary museum spaces around the world further alienate spectators from objects. The so-called white cube gallery, a modernist technique of display pioneered by the Museum of Modern Art in New York in the 1930s, disembodies the museum visitor: 'The art museum in general and the white cube in particular are presented in their ideal state – as a pure and absolute space seemingly conceived solely for the undisturbed presentation of art, unadulterated by the intrusion of human beings' (Grunenberg 28). The sanitary whiteness of the museum space reinforces the lessons of aesthetics by eliminating distractions. While the eye sneaks from vitrine to vitrine, subdued by evidence of visual ingenuity, the other senses crave stimulation. Museum-goers converse in hushed tones as if normal conversation would break the spell cast by the hygienic white environs.

Certain museums, perhaps not the best-known ones, question the benefits of display. In the Museum of Jurassic Technology in Culver City, California, vitrines contain fanciful assemblages. One display case boasts a dish of powder labelled 'REASON,' but the dish has been shattered by a measuring mechanism and the powder strewn about the case: '"Out of order,"advises a tiny sign taped to the face of the glass case' (Weschler 23). The out-of-order state of the exhibit migrates into the out-of-order state of reason, as well as the out-of-order obsession with putting everything, even abstract concepts, on display. The displays at the Museum of Jurassic Technology parody the museological obsession with proof. Labels, photographs, and citations from scholarly books authenticate displayed objects. Such standard museum props compound the air of truth that hovers over the objects. The Museum of Jurassic Technology, if museum it be, is a place of amusement and wonder that spring from 'improbable coincidences' (34). The museum mocks the acquisitiveness of museums and the tendency of spectators to look at anything inside a display case or diorama with credulity. Display culture in museums inoculates viewers against irony, whereas the Museum of Jurassic Technology parodies the supposed benefits of 'ironylessness' (41).

Museum display occasioned much thought in the 1980s and 1990s for a good reason: the exponential increase in the number of museums. Stephen E. Weil compares the museum boom in the United States with the boom in the United Kingdom: 'more than half of the museums in the United States were founded after 1950. During the thirty years ending in 1980, a period of some 1,566 weeks, nearly 2,500 new museums opened their doors. The rate was better than one each week' (*Rethinking*

3). By comparison, in the 1970s in the United Kingdom, a new museum opened every second week.

The increase in the number of museums suggests that the tempo of collecting and preserving artefacts has accelerated. At the same time, museums have diversified the kinds of artefacts that they collect. The Sex Museum in New York, the Spy Museum in Washington, and the Bata Shoe Museum in Toronto do not collect items traditionally found in ethnographic museums. Whereas the modernist museum is dedicated to natural history or fine arts, the postmodern museum is dedicated to esoterica and entertainment. The modern museum educated by reiterating narratives about civilization and fineness; the postmodern museum demonstrates the diversity and oddity of culture in a context of global relativism and rapidly out-of-date commodities.

Faced with the specialization of museums and the accumulation of treasures within traditional museums, Stephen Weil worries about the stewardship of material culture: 'In developing justifications for the public support of museums, we have too often forgotten that their ultimate importance must lie not in their ability to acquire and care for objects – important as that may be – but in their ability to take such objects and put them to some worthwhile use' (*Rethinking* 29). Nevertheless, that use may amount to diversion. In Weil's view, the museum provides 'visitors with an extraordinary experience' that is not only, or not strictly, educational (52). The visitor, treated as a 'collaborator' in the precincts of the museum, develops 'his own sense of heritage, causality, connectedness, and taste – his own links to both an individual and a communal past' (55). In this light, the museum-goer as collaborator prefers the specialized knowledge of the Rock-and-Roll Museum or the Barbie Museum to the heterodox collections of artworks at the Metropolitan Museum of Art or the Louvre.

Curators reluctantly concede that an artefact of lesser quality might make its way into a display case. Acknowledging that there are really not so many 'epiphanous works of art or wonders' to fill every museum, Weil wonders if museums should display works of lesser quality: 'What happens when we show less than the best works of art, for example, as if they were masterworks?' (*Rethinking* 53). Mediocre or badly executed artworks have their own merits. Masterworks have the disadvantage of being perfect of their kind. Weil admits that, 'If a museum *is* to treat visual communication as one of its primary educational goals, then the choice of what it displays in its galleries cannot be determined solely by a stringent aesthetic standard. It must in some instances be

determined instead by what can best contribute toward that education-
al goal' (*Cabinet* 119). Notwithstanding Matthew Arnold's exhortation
to seek out the best that has been thought and said, exposure to the
banal, the generic, the *chef-d'oeuvre raté*, the unfinished, and the imper-
fect object can have instructive benefits. A steady diet of masterworks
creates intolerance for lesser works. If the museum hopes to foster an
appreciation of the complexity of artworks and other artefacts, it has to
make that complexity commensurate with the competencies of muse-
um-goers. As Pierre Bourdieu argues, the '*level of reception*, defined as
the degree to which this individual masters the social code, [...] may be
more or less adequate to the code required for the work' (*Field* 224–5).
Mastery of such codes does not begin with an innate sense of what
is best or perfect. That sense, which can be called 'taste,' is acquired
through exposure to an array of objects.

By speculating on museums, contemporary fiction offers alternatives
to the culture of display and preservation. In Penelope Lively's *The
Road to Lichfield*, a forty-year-old woman named Anne teaches history
at a secondary school in England. She previously worked in the manu-
script room of a museum and retains a strong attachment to British his-
tory. She visits cathedrals, museums, and burial mounds to satisfy her
curiosity about the past. Set in the 1970s, as Thatcherite policies eroded
the ideas of common wealth and the public good, *The Road to Lichfield*
meditates on the cultural imperative to preserve. Anne joins a commit-
tee to save a fifteenth-century cottage threatened with demolition. The
committee protests the razing of the cottage with homemade banners:
'WE CARE ABOUT THE PAST. DO YOU?' (110). That past contains
much more than meets the eye: the skeletons of two abused children are
found in the rubble when the cottage is bulldozed. Public history, like
private history, turns out to contain painful secrets.

The past in *The Road to Lichfield* cannot, and should not, be sanitized.
Suzanne Keen interprets Lively's novel in light of the debates over his-
tory and heritage provoked by changes to the educational curriculum
during Thatcher's prime ministerial mandate. Whether the past 'in-
structs or not depends upon what sort of lesson is looked for' (Keen
101). Anne rejects a simple museological approach to the past, in which
one neighbour, pious about English heritage, displays farming tools –
scythes, dibbles, sickles, and flails – as souvenirs of a vanished epoch.
He does not know what the implements were actually used for. In his
home, an old bread oven, 'restored and with a glassed-in front,' has
been converted into 'a display cabinet for some choice pieces of china'

(Lively 82). Willy-nilly collecting and arranging of objects threatens to convert all objects into museum artefacts and all of England into a gigantic museum. In contradistinction to the collector of farm implements, who admires objects for their shapes and shininess, Anne articulates history as a living phenomenon: 'the point is to preserve the past and add to it – respect it but at the same time contribute something of our own' (157). Should one preserve a fifteenth-century cottage because it is old, despite its being supported by rotten timbers and despite its being an unplanned jumble of rooms added one after the other over several centuries? Anne despises an 'indiscriminate hanging onto the past' (189) for the sake of specious notions of value separated from use or exchange value. She is not prepared, however, to buy into a notion that history is instructional only if it has relevance to the present.

Anne understands that the past is articulated through objects. She tries, on occasion, 'to extract information from objects' (40), including items encased in museums. Yet she remains wary of the temptation to interpret objects taken out of context: 'Each object was wrenched from its past. It was as though by displaying what had gone before and making an ornament of it, you destroyed its potency. Less sophisticated societies propitiate their ancestors; this one makes a display of them and renders them harmless' (178). Converting the material vestiges of the past into ornaments nullifies their content as accessories to a disagreeable and often painful past. Objects are indices of historical catastrophe. *The Road to Lichfield* rejects the tendency within the heritage industry to sentimentalize and prettify the past. On vacation in Scotland with her husband, Anne visits museums to bear witness to traumatic history: 'a few pounds was little enough to pay for painless inspection of other people's catastrophic lives' (172). In *The Road to Lichfield*, display neutralizes any attempt to interpret objects in light of their original context or use. Scythes have eye-catching shapes; bread ovens house china. Yet objects are not synecdoches of the past. Exhibited, they lose their vital connection to history and drift into the categories of the souvenir and collectible.

Looking at Collections

Novels about enchanted objects often present display in terms of collections. The collection, by its very nature, requires display, even if the owner of the collection regulates who may or who may not look at his objects. In Hilary Mantel's historical novel, *The Giant, O'Brien*, the real-

life, eighteenth-century surgeon and collector, John Hunter, covets the corpse of an Irish giant. His appetite for oddities contradicts ethical appropriateness. He bargains for the giant's bones, even though the giant expressly does not want to surrender his corpse to science. Meanwhile, Hunter runs out of space for his collections: 'I must expand, he thinks, get better premises, somewhere central, and set up a gallery, where I can exhibit' (117). Exhibition is obligatory, on the grounds that no collection has merit until it is seen. (John Hunter's specimens are still exhibited in the Hunterian Museum at the Royal College of Surgeons in London.) Mantel focuses on pain as an element of collections. Sometimes objects are enchanting not because they posit an alternative world, but because they encapsulate elements of the known world that, once displayed, allow distance to intrude between spectator and object. Display accentuates stillness, which seems to exclude pain. The immobility of display resembles the immobility of death and thus the end of pain. A collection can embody pain in an effort to control it. A collection can spatialize time in such a way that death seems postponed, or, contrarily, death has always already occurred and therefore exercises no threat.

'You can look at the most appalling things in art,' Susan Sontag writes in *The Volcano Lover* (296). She includes 'deep pain' and 'deep injustice' in her inventory of appalling things (296). On the one hand, a collection of objects seems to cauterize pain. The objects communicate with each other and reveal minute differences, which have little to do with the original site or suffering of the object. The giant's physical suffering in *The Giant, O'Brien* dissipates after his death under the force of display. His displayed skeleton makes no reference to 'the pain deep in [his] bones' suffered while he was alive (Mantel 98). On the other hand, natural history collections can be interpreted as testimonials in the ongoing history of pain. In Kurzweil's *A Case of Curiosities*, Staemphli, a sadistic collector of specimens, amputates Claude Page's finger against the young boy's will. Rather than denying pain and suffering, the collection can be said to commemorate and display pain in serial form. A collection purports not to recreate pain as an affect, but to contain pain and generate metaphors of pain.

In keeping with the prerogatives of royalty, Peter the Great of Russia was something of a collector of biological specimens. He kept a room full of skeletons, including the bones of his personal footman, who stood over seven feet tall (Purcell and Gould 19–20). Skeletons were far from the only thing that Peter the Great collected; in fact, his collections

served as the foundation for the first academy of sciences in Russia. Among other specimens, he saved human teeth that he himself had pulled (figure 6). The tray of teeth, neatly displayed, evokes pain and seriality, traits that haunt collections of all sorts. Tied with a ribbon into individual compartments in a display case, the teeth occupy discrete spaces as if they have nothing to do with each other. Nevertheless, the collection of teeth, carefully numbered, serializes pain as a temporal sequence. Each tooth tells a specific story; those stories accumulate spatially inside the display case. Each story centres on Peter's royal intervention. He controls the central plot of broken, abscessed, or decayed teeth; a tooth, it appears, can enter the collection on the sole condition that Peter has pulled it. To admit teeth pulled by others would disrupt the rationale for the collection.

Pain democratizes: the teeth of serfs are indistinguishable from the teeth of courtiers or aristocrats. While each contributor of a tooth remains anonymous, merely a numerical cipher, Peter presides over the story as protagonist. The collection therefore tells an allegorical and profoundly social tale: Peter the Great heals the suffering Russians. Once the tooth is pulled and tucked into a box, the person presumably suffers no more. In this regard, the collection of teeth compartmentalizes pain by centralizing it. The collection gathers in other meanings as well. The tray filled with teeth has nearly holy powers, for each tooth stands for a crisis calmed, a malady cured. The display resembles a reliquary, with parts of the human body available for examination, although donors have no identity and therefore cannot be appealed to in the way that saints can. The display also satisfies Peter's royal prerogative to save specimens from his subjects as objects of curiosity, perhaps of some eventual use to science. Causes of pain can be analysed and prevented.

The pulling of the corrupt teeth hints at a stoppage of time, for tooth decay and cavities cease to matter or to develop once the sufferer's microbe-laden saliva stops interacting with the tooth. The tooth, no longer an organism, becomes an object. The three teeth, numbered 22, 24, and 23, violate mathematical sequence. If the numerical sequence refers to the temporal order in which the teeth were pulled, display overrules sequence: 24 precedes 23. As Susan Stewart points out, collections in general 'juxtapose personal time with social time' (154). Inside the spatial regularity of the tray, a certain irregularity in numbering points to a different order of time, namely, the sequence in which Peter pulled these teeth, a personal narrative, set against the larger context

6 Teeth pulled by Peter the Great. N.N. Miklukho-Maklay Institute of Ethnography, Russia. © Rosamond Wolff Purcell.

in which pain assumes social meaning: diseases afflict human populations. Other anomalies interfere with a straightforward sense of temporality and seriality in the box of teeth. In addition to the reversed numbers 24 and 23, tooth number 32 is missing altogether. Although these slips in the sequence may be nothing more than errors made by the curator, numerical anomalies raise the possibility that number 32 was pulled but lost, or it did not resemble the other teeth, or it was deemed not worthy of display, or Peter harvested it with some undisclosed intention, which he hoped to keep secret by keeping the tooth out of the box. That number 32 is missing is odder still, for the usual number of teeth in an adult human being's mouth is 32. Yet the collection does not display a full set of teeth from one person, or specimens of each and every type of tooth. The quirk in the sequence indicates that teeth may be pulled, but suffering continues regardless. Some teeth might have been pulled but were rejected from the collection, as if not suitable for display. Although counting creates an inventory, the jump from 31 to 33 suggests that the inventory can extend indefinitely. It is a truism of collecting that a collection is never complete. The missing tooth insinuates the impossibility of completion and the recognition of that impossibility. Whatever the reason for the missing tooth, the collection contains a mystery of the invisible. The tooth is valued not because it is displayed, but because it is hidden from view.

Displaying collected artefacts generates a counter-narrative of hiddenness. Contemporary novels about artworks make a virtue of hiddenness within collections. In *The Volcano Lover*, the Cavaliere, modelled on the eighteenth-century ambassador and collector Sir William Hamilton, keeps a semi-public collection of paintings, busts, and lava samples in the upstairs rooms of his Neapolitan villa. He keeps a second, shadow collection 'below ground in his treasure vault, his "lumber room"' (Sontag 73), which he allows only a very select few to see:

> Here were to be found rejected vases, surplus pictures, and a hodgepodge of sarcophagi, candelabra, and overrestored antique busts. And besides inferior works deemed not worthy of display, here the Cavaliere kept such pieces of antiquity as the King and his advisers would have been unhappy to learn were in foreign hands. While every distinguished visitor was shown the objects in the Cavaliere's study, few were taken on a tour of the cellar storage rooms. Every collector is potentially (if not actually) a thief. (73)

While the shadow collection in the basement includes fine artefacts that the Cavaliere has purloined from excavations at Herculaneum and Pompeii, it also contains a mishmash of less valuable objects, interesting for their inferiority. The lesser works provide a foil – a foil of imperfection and shady acquisition – to the official collection. This hidden collection, a bona fide 'hodgepodge,' defies order, except in the mind of the collector. As with Sir Thomas Phillipps's disorderly library and the Duchess of Portland's higgledy-piggledy collection, disorder among objects has the virtue of reconstituting categories of value, because the hodgepodge, far from being a sign of valuelessness in objects, blends together the priceless with the inferior. The hidden collection establishes a scale of values that reflects on the official collection upstairs.

The trope of hiddenness affects individual artefacts. In *The Museum Guard*, DeFoe Russet hides the painting called *Jewess on a Street in Amsterdam* in a carrying case to spirit it out of the Glace Museum. In *The Music Lesson*, a Vermeer painting shifts from a case to a closet to a coffin. In *Utz*, the protagonist keeps a secret cache of exquisite eighteenth-century porcelains under lock and key in bank vaults in Switzerland. The art world valorizes tales of hidden artworks as potential treasure, even if hiding a work of art can throw its provenance into doubt. Hiddenness contradicts the conventions of display. If an artwork is never seen, is it still an artwork or is it more accurately called a hidden treasure? In John Banville's *The Untouchable*, the world-renowned connoisseur of French painting, Victor Maskell, Keeper of the Queen's Pictures, finds what he believes to be an authentic Poussin buried in the storeroom of a London gallery under a layer of dust and heaps of unsuccessful canvases. Maskell, breathless with excitement, spies his Poussin masterpiece among 'some examples of English cubism that were all soft angles and pastel planes' (*Untouchable* 40). Neglect makes the painting more alluring; hiddenness adds to the aura of authenticity. The painting appeals to Maskell's connoisseurship because he sees its value, which everyone else has missed. Nevertheless, the Poussin turns out to be a fake, planted in the gallery with the intention of duping Maskell into believing that he has discovered something authentic.

Objects continue to exist, even when hidden. The act of hiding objects exerts proprietary rights, for only the person who feels charged with a sense of ownership will take it upon himself to make a painting or a figurine inaccessible to anyone else. In the case of the Cavaliere's appropriation of excavated objects through questionable deals, ownership is tenuous, even illegal. Yet the act of hiding goods, as when thieves stash

paintings in run-down buildings in *Athena* and *The Music Lesson*, exerts a form of ownership. In most contemporary narratives about artworks, ownership is temporary whereas the object itself is permanent. Because objects can be expropriated and hidden, they exist outside the realm of ownership. Artworks are set apart by their uniqueness and irreplaceability, their susceptibility to seizure and destruction. For this reason, loss, or the potential for loss, tinges all objects. The loss of objects to shipwreck, political terrorism, religious wrath, volcanic eruptions, and the slow disintegrations of time is a dominant trope in contemporary novels about artworks.

Fragile and alienable objects slip out of an owner's grasp or disappear into oblivion. In *The Volcano Lover*, a ship carrying a cargo of precious vases founders and sinks. The shipwreck causes the narrator to muse on the emotion that lost objects stir: 'The death of objects can release a grief even more bewildering than the death of a loved person. People are supposed to die, hard as that is to keep in mind [...] But objects as durable and as ancient as the Cavaliere's magnificent antique vases, especially such objects, which have survived so many centuries, offer a promise of immortality' (254). The owner might envision losing precious artworks to theft, but he finds it harder to imagine that objects can be irretrievably lost, lost beyond any hope of ever seeing them again. Because they are inorganic, objects survive indefinitely. The loss of an object occasions grief for the lost illusion of the imperishability of all objects. Nothing compensates for the loss of an object except perhaps the knowledge that objects, when viewed with detachment, are always prone to destruction.

Certain Distances

A certain distance from objects, not too close and not too far, enables aesthetic judgment, or so Edmund Burke suggests in *A Philosophical Enquiry into the Sublime and Beautiful*. The concept of distance is ubiquitous in Burke's treatise, but it is not addressed as a specific quality of either the sublime or the beautiful. He extols attributes of artworks that can be appreciated only up close, such as smallness and fineness of detail. In Burke's opinion, the appearance of '*delicacy*, and even of fragility, is almost essential to beauty' (115). He does admit that being too close to an object has disadvantages: 'When danger or pain press [*sic*] too nearly, they are incapable of giving any delight, and are simply terrible; but at certain distances and with certain modifications, they may be, and

they are delightful, as we every day experience' (40). To contemplate pain is to cease to feel it as painful and to begin to think of it in terms of grandeur or sublimity. Yet it is impossible to ascertain how near or far 'certain distances' should be.

Burke works out the issue of aesthetic distance through the senses of touch and sight. Early in his introduction to the *Enquiry*, he demonstrates the difference in the natural taste of two men through the example of 'a very smooth marble table' (22). Although the two men may agree about the smoothness of one table, they will probably disagree on, or they will at least dispute, the relative smoothness of *two* smoothly polished marble tables. Smoothness has degrees and so does taste, which depends on noticing differences in details such as smoothness. The man of taste can judge slight variations in smoothness. Even though no two men may agree on the relative smoothness of two different tables, they might agree that smoothness, in itself, is a desirable attribute of beautiful things. 'The sense of feeling is highly gratified with smooth bodies' (149), as touching smooth objects corroborates. Despite its penchant for smoothness, the finger also likes some resistance; bodies pleasant to touch, Burke claims, 'are so by the slightness of the resistance they make' (120). Roughness, causing the hand to retract, displeases the perfectly equipped judge of the beautiful. By analogy, loud sounds cause distress and cowering, yet at a distance the sound does not disturb or cause the hearer to shrink back in anguish. In this paradigm of sensory fineness, proper distance is incalculable and always variable. If one is so close to an object that it can be held or touched, one is very close indeed. But to touch 'a broken and rugged surface' (114) makes one want to separate oneself from the object, to impose distance. Not only is beauty, like ugliness, sensory, but it also depends on proximity and distance.

Burke explicitly analogizes the sensation of touch to the sensation of sight (153). Both senses revel in variations of line and texture. The movements of lines should be carefully modulated so that inequalities and sharp angles do not induce displeasure. Rather boldly, Burke defines the beautiful according to seven physical characteristics:

> On the whole, the qualities of beauty, as they are merely sensible qualities, are the following. First, to be comparatively small. Secondly, to be smooth. Thirdly, to have a variety in the direction of the parts; but fourthly, to have those parts not angular, but melted as it were into each other. Fifthly, to be of a delicate frame, without any remarkable appearance of strength.

Sixthly, to have its colours clear and bright; but not very strong and glaring. Seventhly, or if it should have any glaring colour, to have it diversified with others. (117)

Distance has a direct bearing on the ability of the eye to distinguish these seven qualities. If one is too far away, one can hardly judge the smallness of an object, for it disappears from view. Its smoothness, proportionality, variation, delicacy, and colouration cannot be appreciated at great distances, especially if the beautiful object is to uphold the criterion of smallness. All seven of Burke's characteristics of beauty pertain to visible attributes, which is to say that beauty is inseparable from display.

Distance, as a phenomenon that alters the conditions of display, has application to museum exhibitions and novels alike. As in Peter the Great's collection of extracted teeth, spatial and temporal distances intrude between the event and the appreciation of the event. When Burke mentions that certain distances and modifications moderate the feeling of pain or danger, he may not have had display in mind, but display does modify pain in such a way as to make it tolerable. At least according to Kant, aesthetic judgment requires a meditative reflectiveness in which distance works its effects. Display imposes a physical distance that acts as a psychological distance. When an object is placed in a display case, the viewer can approach only so near and no farther. Although one has to come close to the display case to study the particularities of Peter the Great's tooth collection, such as its faulty numbering and careful attaching of each tooth with a ribbon, one looks upon the display case, after surmounting an initial sense of surprise, with a gaze of meditative reflectiveness, even disinterestedness. Gazing at the tray of teeth, one understands that time has intruded between the action of pulling the diseased teeth and the present. Surprise therefore fades, as surprise always does. In the cartoon of Vronsky and Anna Karenina in 'At the Tolstoy Museum,' nineteenth-century costumes and the diorama distance the characters from the time in which the viewer, as a reader of visual evidence, peers at them. Barthelme's point is that all acts of passion and spectatorship have historical determinants; the viewer may imagine that he or she lives at a distance from the passions of Tolstoy's characters, but that distance in no way exonerates the viewer from being likewise a creature of time. Display implicates its spectators.

Narratives about objects partake of the time that objects inhabit,

which is to say that narratives function as spatial entities. Especially in novels about art objects and collections, narrative finds analogues in boxes, trunks, or vitrines. In 'At the Tolstoy Museum,' as in other narratives, characters act out their passions in fictional space, and that space can be opened and closed, visited and revisited, by spectators. In this regard, a book is a kind of box, an object with an inside and an outside, a front and a back. In Barthelme's story, the characters remain immobilized in their narrative spatialization, which is akin to the time and dimensionality of objects. Not only does the regard of the spectator objectify characters, but the characters, seen from all angles, exist only within the spatial parameters of the fictional box. Characters circulate within the narrative very much in the way that objects circulate from person to person, site to site, in social space. Characters interact with each other or with objects, but they have a limited roster of possibilities, as determined by the spatial confines of the narrative. As Susan Sontag writes in *The Volcano Lover*, 'distance distances' (288). Both a noun and a verb, distance imposes itself as indifference brought about by time and space. On the other hand, although the viewer of an object or a reader of a narrative can move away and create distance from a painting or a novel, the details, and hence the beauty of the item (if one accepts Burke's seven characteristics of beauty), can be known only by moving closer to it.

Narrative has another similarity to the display of objects: it miniaturizes. In *The Volcano Lover*, the Cavaliere keeps closing the distance between himself and Mount Vesuvius. Although the mountain erupts across the bay from his villa in Naples, at 'a safe distance' (6) or 'in the distance' (25), the Cavaliere cannot prevent himself from playing 'the game of distance' (111) by climbing to the top of the volcano and looking into its smouldering core. The game of distance involves moving between points far away and very near. In a variation on the game of distance, the Cavaliere vainly wishes to soar above the volcano in a hot air balloon and look down on the eruptions from a suitable height. Susan Stewart argues that 'the nostalgic is enamored of distance, not of the referent itself' (145). A connoisseur of catastrophe, but catastrophe at a distance in the manner advised by Burke, namely, to absent oneself from danger and pain, the Cavaliere is not nostalgic. He takes the long view of objects and catastrophes. They inspire hope and desire. They pass before one, then pass out of range. Distance vanquishes objects to the point that aesthetics no longer matter.

The Cavaliere spends several decades in Naples as British ambassa-

dor to the Kingdom of the Two Sicilies. Far from England, he feels cut off from those pursuits that impassion him: 'Distance has betrayed him' (256). Distance traduces his aspirations for a better diplomatic posting. As he learns belatedly, he has kept his distance too well. The principle of keeping one's distance applies both to time and to space. Narrative shrinks history into something smaller, less grandiose than it once was. 'The past was a small world, made smaller by our great distance from it,' claims the narrator in *The Volcano Lover* (148). The narrator, who often postures as a clairvoyant, speaks in this instance of the relation between antiquity and the eighteenth century, but the statement applies equally well to the relation between the eighteenth century and the present. Temporal distance distorts events that occurred long ago. Distance diminishes their importance and makes them less urgent or catastrophic.

In spatial as in temporal distance, scale changes. What once appeared monumental now assumes a relative smallness in the scheme of things. The Cavaliere watches the changes of the volcano with scientific and aesthetic detachment. Inhaling noxious fumes from the volcano and risking injury on its slopes, he personalizes knowledge. Were the Cavaliere only to look at Vesuvius from a safe distance, he would misunderstand the nature of the volcano as a natural phenomenon that wipes out villages and converts tracts of forest into lava-flooded waste. 'The game of distance' therefore involves a balance between interest and disinterest as well as physical proximity and distance. To play the game successfully, the person who judges the aesthetic object has to be able to adjust the scale in which the object is considered. The Cavaliere learns to look upon the objects that he collects with dispassion, which enhances his connoisseurship. Were he too interested, his passion for objects would interfere with his ability to judge their relative merits. Similarly, if he is biased about his own historical importance, he distorts the contribution that he makes to history.

Appropriate distance allows an appreciation of detail. Whereas Kantian and Burkean aesthetics universalize objects and level out their details into sameness, narratives about artworks particularize objects and their meanings. Details convey uniqueness. The enchantment cast by an artwork is commensurate with the specificity of its details and the place that the object assumes within plot. Not to notice details is not to see pattern, and not to see pattern is not to understand the relative value of an object, whether novel or vase. In *The Volcano Lover*, 'the Cavaliere's command of gratification had depended on his being able to take up

the right distance from himself and from his passions' (179). When the connoisseur of objects looks at objects from certain distances, he finds, in the end, the right distance, where physical details and metaphysical qualities come into view.

2 Details: Vermeer and Specificity

Whatever I perceive or imagine amazes me by its particularity. The quali-
ties it has in common with other things – leaves, a trunk, branches, if it is
a tree: limbs, eyes, hair, if it is a person – appear to me to be superficial.
I am deeply struck by the uniqueness of each event. From this arises my
difficulty as a writer – perhaps the magnificent impossibility of my being
a writer. How am I to convey such uniqueness? The obvious way is to
establish uniqueness through development.

Berger 136

In Particular

Contemporary novels about visual art typically isolate material at-
tributes of paintings, porcelains, or tapestries as significant details. In
many ways, an artwork is to narrative as a detail is to meaning. In itself
an artwork is an inert object; when placed in a narrative, the meaning
of the object alters. In other words, the material object catalyses events
by virtue of its presence. Similarly, a detail in narrative is a pellet of
meaning; that meaning multiplies in the presence of other details. A
narrative without details is nearly as unimaginable as a narrative with-
out objects. Certain details establish character, while others contribute
to the specificity of incidents and episodes. In *G.*, John Berger contrasts
particularity with development in narrative. If the writer tries to ex-
press the absolute uniqueness of each and every physical quality that
he perceives, narrative cannot progress. Berger therefore argues for
'uniqueness through development' (136). Contrast with other particu-
lars reveals particularity. Temporal sequence expresses particularity by

juxtaposition and contrast. In this light, 'development' means the alignment of telling details in patterns. Narrative depends on its details for progression and meaning.

By turning to visual art, contemporary novels redefine the way that details signify in narrative. Whereas detail in an object is physical and therefore visible, detail in a novel is textual and visible only if a reader knows how to isolate it as a detail. For the most part, details are liable to be dismissed as incidental or accidental, secondary to plot or character. Readers scoff at details as ornaments instead of treating them as decisive to meaning. In 'Vermeer novels' such as Katharine Weber's *The Music Lesson*, Susan Vreeland's *Girl in Hyacinth Blue*, and Tracy Chevalier's *Girl with a Pearl Earring*, where Johannes Vermeer is either a character or a historical referent, details substantiate plot and information. They provide proof. In each of these novels, Vermeer is a composite figure, a glyph for steadfast artistry and intense vision, gendered male and set over and against female competence that enables artistic creation. In Vermeer novels, details are the repositories of value, although value is not a fixed or absolute quantity. Because they condense and displace meaning, details imply hiddenness and ambiguity as much as they imply revelation and aesthetic completion. By arresting the attention of observers or readers, details disturb visual fields and narrative sequence. In the hide-and-seek relation that they bear with regard to meaning, details sometimes help and sometimes thwart cognition, which accounts for their arresting quality. As aspects of the material world and its representation, physical details exist prior to apprehension. By recognizing and organizing details, readers understand narrative order in a fashion similar to viewers' construal of details in an oil painting.

As Luc Rasson and Franc Schuerewegen claim, 'la *notion* [du détail en littérature] apparaît quand la *chose* devient problématique' (9).[1] Seventeenth-century Dutch art, which revels in the infinite variety of material goods, provides one proof for the thesis that the topic of detail arises when the status of objects becomes problematic. Rasson and Schuerewegen mean that the object as a physical entity and the detail as its representational counterpart mark epistemological quandaries. To understand the alterity of the object, the viewer segments it into component features: colour, texture, material, shape, value. Similarly, Karl Marx approaches objects through a schematization of their social functions as commodities. The more detail a commodity possesses, the more enchanted it appears. Detail puts the value of commodities on

display. According to Gérard Dessons, 'Il y a en réalité confusion entre deux acceptions de la notion de détail, celle, traditionnelle, non spécialisée, de la composante secondaire, et celle, on dira "moderne," d'un concept heuristique, faisant partie d'une réflexion sur l'oeuvre d'art et son économie sémantique' (56).[2] Vermeer novels enlist the detail as a heuristic device to investigate the problems generated by art objects. Is the art object principally a commodity that belongs to individual owners? Should such objects be treated reverentially and bequeathed to museums? Are museums fitting repositories for unique artworks? In contemporary narratives, detail provides some answers to the complex status of the art object. In its nagging littleness, its masquerade of insignificance, the detail upsets the apparent order of art and therefore liberates different approaches to the object itself.

Objects exist, but the discourses and representational procedures used to apprehend them alter according to shifts in epistemology.[3] Codes of representation establish the handling of objects within narrative. Cynthia Wall argues that eighteenth-century English narratives treat details as analogous to things: 'detail *of* thing, detail *as* thing. Description marked, rather than mimicked, the visual world' (276). Description denotes physical attributes that would not otherwise achieve singularity. According to Wall, in narratives written between 1680 and 1740 the minimal description of physical qualities – a focus on nouns rather than adjectives in the verbal stylization of objects – reinforces an ideology of the tangible permanence of things under capitalism: 'we rarely know the specifics of any details of any early narrative; the details *are* the things, and the things are associatively rather than visually connected' (264). The demotion of description to auxiliary status in relation to action or characterization demotes, by extension, objects. Objects transform into things, mute and incomprehensible. The dismissal of details as mere adjectival enhancements bespeaks an inability to deal with the contribution of objects to knowledge, as entities, as instruments, as proofs, or as obstacles. The object challenges received ways of knowing. Therefore, a shift in how details are understood will potentially allow new approaches to emerge regarding physical entities in and of themselves.

In Vermeer novels, sensory details cluster around objects. In *Girl with a Pearl Earring*, the maid Griet notices infinitesimally small alterations in Vermeer's studio and treats them as highly charged events: 'At first it seemed to remain the same, day after day, but after my eyes grew accustomed to the details of the room I began to notice small things – the

brushes rearranged on the top of the cupboard, one of the cupboard's drawers left ajar, the palette knife balanced on the easel's ledge, a chair moved a little from its place by the door' (52). Griet initially implies a distinction between details as static (the disposition of objects in the room) and changes as kinetic ('small things' that move). Yet the 'small things' that deviate from the details are themselves new configurations of details, evidence that change happens by minuscule increments. Changes in the placement of objects indicate Vermeer's intentional arrangements, or so Griet believes. On the other hand, alterations could simply indicate accidents of displacement caused by a painter's living among his props. In the intentional structure of an artwork, whether a painting or a novel, the shifting of objects, however minute, defamiliarizes them. They look different in each new arrangement and take on new meaning.

Smallness defines the detail. In Vreeland's *Girl in Hyacinth Blue*, Vermeer prepares to paint his daughter Magdalena by adjusting details for the composition: 'The open window reflected her face, and in one pane, the image of her cheek bone shone luminous as though blended with the dust of crushed pearls. He opened the window a few centimeters more, then less, settling on an angle. A whiff of breeze stirred the loose hair at her temple' (221). The breeze registers as a 'whiff,' nothing more. The small adjustments to the window, measurable in centimetres, contribute some wanted, if vague, detail to the composition – more reflection in the window perhaps, or a vector that divides the visual plane. The quest for the significant detail is allied with irreducible scale: nothing smaller lies beyond the detail. In this sense, detail refers to the smallest possible unit of intelligibility. Smallness does not disqualify the detail from meaning. On the contrary, the small detail loiters at the threshold between meaning and non-meaning in a zone where transitions and transformations happen. The detail, whose smallness heralds its provisional status, might disappear altogether from view or grow into something grand. Indeed, the provisionality of the detail may be its strongest claim to definition; like the nearly unnoticeable changes that Vermeer makes in his studio in *Girl with a Pearl Earring*, the detail concerns the ambiguous status of objects.

A narrative theory that accommodates the provisional status of details does not inevitably settle the ambiguities that interpreters discover in details. Indeed, details as physical attributes differ from interpreters' attribution of meaning to them. Readers and spectators tend either to aggrandize or to dismiss details because of their transitional nature.

In Sandór Márai's *Embers*, a character pores over the details of his personal past with a connoisseur's intensity: 'only in the details can we understand the essential, as books and life have taught me. One needs to know every detail, since one can never be sure which of them is important, and which word shines out from behind things' (167). As Márai implies, the significance attached to a specific detail may not change, in light of its being intentional or permanently encoded within the text or artefact, but the interpreter's capacity to isolate a detail and explain it does change over time. Certain details in a novel will stand out on a first reading, whereas other details occupy the mind more powerfully on subsequent readings. Noticing certain details bespeaks the observer's powers of seeing or, less neutrally, the observer's investment in particulars as relevant to a phenomenology of the detail. Some readers denigrate features of a narrative as *only* details. In this line of thinking, details are synonymous with the insignificant or the inessential. The detail detracts from meaning or structure: the integrity or the grandeur of the subject could cope nicely without any distracting details. In such an interpretive framework, details are perceived as ornamental and therefore superfluous.

Notwithstanding the supererogatory nature of detail, Vladimir Nabokov, in his lectures on *Ulysses*, advises that, 'in reading, one should notice and fondle details' (1). Nabokov intimates that different readers will be attuned to unpredictable discrepancies among the panoply of particularities. Which details ought the reader to fondle? Is the reader fondling the right details? More worrisome still, is the reader fondling the details in the right way? Nabokov fetishizes the detail as an inherent part of a text. His formulation intimates that readers – and, one might add, critics – take their pleasure from texts selfishly. They select details that answer to personal obsessions instead of asking how the detail contributes to the formal significance of the whole work. As Nabokov implies, something voyeuristic and indecent underlies the act of reading. The reader has to focus on certain details before fondling them. Fondling details is the point at which interpretation of an art object begins.

Detail in an art object, as in a narrative, usually falls within the category of description. In other words, details are expository. Often visual, descriptive details appeal to conventions of art, whether painting or sculpture. Selecting and recording details depend on ways of seeing, which are legion. One influential epoch in the history of seeing, among many, is the Dutch Golden Age, with its inclination toward showy

genre paintings. Svetlana Alpers argues that seventeenth-century Dutch painting establishes a non-narrative, descriptive syntax that utterly breaks with Italian Renaissance narrative representation: 'The Dutch present their pictures as describing the world seen rather than as imitations of significant human actions' (*Art* xxv). Visuality contradicts verbal representations of the self, the narration of action, or a symbology cunningly encoded within a painting that the viewer, equipped with the right foreknowledge, can decipher: 'In Holland the visual culture was central to the life of the society. One might say that the eye was a central means of self-representation and visual experience a central mode of self-consciousness' (xxv). Objects in themselves, as constitutive elements of visual culture, affect the disposition of objects in the making of knowledge. Furthermore, objects generate rosters of details. Alpers enumerates several consequences to the thesis that Dutch art emphasizes description rather than narrative: the absence of a fixed position for a viewer in the picture; a sliding dimensional scale between big and small, distance and proximity; absent frames that cause the visual realm to extend beyond the edges of the picture; a focus on surfaces, as if the painting were 'like a mirror or a map, but not a window'; and an insistence on craft or technique evidenced within the painting itself (xxv). Weber, Vreeland, and Chevalier adapt certain of these conventions in their respective Vermeer novels. They treat narrative as analogous to visual culture, in which diffuse points of view, stances taken in relation to objects, and the labour or craft required to produce an aesthetic artefact assume paramount importance.

Despite the emphasis on detail in contemporary fiction, narrative theory typically defines detail as an attribute of nineteenth-century realism. Accounts of detail usually stop with Gustave Flaubert and Honoré de Balzac. For instance, Naomi Schor claims that 'realism [in Balzac] is as much a discourse *on* the detail as a discourse *of* the detail' (142). Descriptive passages create an impression of reality through the accumulation of details. Conversely, 'description' refers to the choice of details as a discursive act. David Lodge, summarizing analytical approaches to realism, claims that 'the narrative text necessarily selects certain details and suppresses or deletes others. The selected details are thus foregrounded by being selected, and their recurrence and interrelation with other selected details in the text become aesthetically significant' (9). Lodge implies that conscious or unconscious intention motivates the choice of details. In this regard, no limits to accuracy or relevance constrain the number of details that can be included.

Specificity in Émile Zola's prose should, in theory, enhance the *verismo* of representation. All details that contribute to the realism of the text potentially belong to the narrative. The detail metonymically refers to other details that have been suppressed. Yet Zola, for all his comprehensiveness, could never include all possible nuances of colour, texture, dimension, duration, shape, mechanics, flow, material, timbre, and so forth. In this account, representation is always the poor cousin to reality because it fails in its details.

Yet nineteenth-century realist novels marshal details in order to create a varnish of accuracy, not perfect mimesis. Accumulated details act as indices of reality, not reality itself. In Angela Carter's *Wise Children*, the narrator Dora, trying to remember the brand of her Irish ex-lover's favourite tipple, claims, 'If you get little details like that right, people will believe anything' (196). To create the illusion of reality, the artist or illusionist sets details in a certain order. Deployed with intention, details reinforce cogency of design. Because the selection of details entails the exclusion of others, exposition is not mimetic. As particularities of representation, details summon reality without replacing it. Schor claims that 'the problematic of the detail is in large measure divorced from that of representation' (28). Concentrating on a single detail in a narrative or a painting renders representation incoherent, for the detail, even as a synecdoche, cannot substitute for an entire structure.

Although realism aims to record details as accurately as possible, accuracy is culturally determined rather than absolute. Art historian Daniel Arasse claims that details in painting dislocate meaning instead of reinforcing it (*Détail* 225). They wrench significance in unexpected directions. In realism, as in other modes of representation, details cohere according to the conventions of the representation, not the reality that lies outside of representation, which allows them to influence, even alter, the whole structure of a painting or a text. Arasse extols the necessity of in situ viewing of paintings in order to observe details properly. Whereas proximity brings details into visibility, physical distance and the reproduction of images make details disappear from view. In *Histoires de peintures*, Arasse defines a detail in terms of condensation and displacement: 'ce qui fait écart à l'ensemble, mais aussi ce que peut condenser dans ce minuscule écart la signification de l'ensemble' (268).[4] Although he generally emphasizes the intimacy of the detail and its pleasant surprises, Arasse also claims that the detail is a 'digression' and an 'ornament' to painting rather than representation itself (*Histoires* 273).

Discussion about detail should not be restricted to authenticity or lifelikeness. The detail adumbrates a feature in time or space, but, in its tininess, it does not encapsulate all history or all space. Whether one 'never forgets details' or borrows 'one detail' from another artisan in the making of a tapestry, as happens in Chevalier's novel *The Lady and the Unicorn* (69, 77), or whether one can be 'too eager with details,' as is Tanneke the cook in *Girl with a Pearl Earring* (220), the detail points to an element of historicity, rather than factual history, within narrative information. The detail metonymically gestures to undisclosed aspects of meaning that intimate the historical. The details that elaborate a sense of the past, whether true or apparently true, strengthen the rapport between particularity and history. As a corollary to this principle, Vermeer novels do not purport to give a history of seventeenth-century art and its Dutch practitioners. Instead, they offer details that allow the reader to access aesthetic problems. In effect, the emphasis on detail circumvents the postmodern preoccupation with representation as playful falsification or simulation. Gesturing to a historical epoch, Weber, Vreeland, and Chevalier do not offer biographies of Johannes Vermeer. Instead, as fictional representations, Vermeer novels invite two specific questions. First, why does Vermeer possess so much cultural cachet in historical narrative? Second, why does each of these narratives broach the problem of the detail through visual analogies?

Women, Objects, Stillness

Although he was considered a relatively minor genre painter for two centuries after his death, Vermeer's star ascended rapidly after William Thoré-Bürger's promotion of the Dutch master in the 1860s (Bailey 219–21, 226). Shortly thereafter, 'the admiring comparisons that were drawn between Vermeer's work and that of the Impressionists, and their subsequent rise to immortality, elevated him to the first rank' (Schwarz 106). In Marcel Proust's *La Prisonnière*, Bergotte's death in front of Vermeer's *View of Delft*, temporarily on loan for an exhibition in Paris, is an apotheosis of the detail – in this case, a patch of yellow wall – intervolved with aesthetic rapture. In 1995–6 a blockbuster show that travelled between Washington, DC, and the Mauritshuis in The Hague heightened public knowledge of Vermeer's works. Spin-off exhibitions abounded. A show called *Delft Masters, Vermeer's Contemporaries* was hosted by the city of Delft in 1996. *Masters of Light*, at the National Gallery in London in 1998, was devoted to Utrecht painters. *Vermeer and the*

Delft School, again at the National Gallery in London in 2001, situated Vermeer alongside Carel Fabritius and Pieter de Hooch.

While curators, connoisseurs, and the general public have access to Vermeer's works in museums, these works also bear a history as politicized commodities: Vermeer paintings have been frequently stolen and held for ransom. In 1971 a waiter hoping to raise money for refugees in Pakistan stole *Love-Letter* during a temporary exhibition in Brussels. In February 1974 thieves stole *The Guitar Player* from Kenwood House on Hampstead Heath in London; a strip of canvas was cut from the edge of the painting and posted to the *Times* with a demand that two convicted IRA criminals be moved from a British to an Irish prison. In the end, the painting was recovered without any ransom changing hands and without either prisoner being relocated (Bailey 236–8). *Lady Writing a Letter with Her Maid* has been stolen twice from Russborough House in Ireland, first in April 1974 and again in May 1986. In 1990 thieves stole *The Concert* from the Isabella Stewart Gardner Museum in Boston. That painting has not yet been recovered. Although exhibitions have bolstered Vermeer's prestige, prestige increases the vulnerability of the artworks themselves. The paintings migrate between museological pricelessness and extortionist valuation in an economy of theft. Whatever their iconic status, Vermeer's paintings retain currency as commodities. As commodities, they bear the brunt of theft and damage.

Aside from the wave of Vermeer art exhibits and thefts, the vogue for seventeenth-century Dutch art manifests itself in novels beyond those already mentioned: Sylvie Matton's *Rembrandt's Whore*, Deborah Moggach's *Tulip Fever*, and Gregory Maguire's *Confessions of an Ugly Stepsister*. Dutch history provides a template for conspicuous consumption, especially in Moggach's novel about the tulip craze in the 1630s. More specifically, by focusing on seventeenth-century culture, contemporary writers imagine historical forms of consumption that concentrate on the market for artworks. By and large, through international trade and colonization, Dutch burghers in the seventeenth century accumulated vast wealth that they subsequently funnelled into the purchase and display of art. As Simon Schama claims in *The Embarrassment of Riches*, over the course of the seventeenth century extravagance eroded the stereotype of the parsimonious Dutchman: 'By the 1660s, it was commonly said, the frugal and modest habits, which had originally created the foundations of Dutch prosperity, were now being squandered in a show of worldly vanity and luxury' (295). Extravagance had its effects on domestic interiors: 'Even in less grandiose households, there

was nothing plain or simple about taste in domestic possessions. If anything, Dutch sensibilities, from the *early* part of the seventeenth century, veered toward profuseness, elaboration and intricate detail' (304). The greater the wealth, the more generous the detail.

In Vermeer novels, emphasis falls on interiority in Vermeer's paintings, whether of houses or individuals. In their respective novels, Vreeland, Chevalier, and Weber refer to Vermeer's domestic interiors to investigate problems of gender and class. All three novelists are drawn to his portraits of women and their air of mystery. Alpers asserts, 'For all their presence, Vermeer's women are a world apart, inviolate, self-contained, but, more significantly, self-possessed' (*Art* 224). Vermeer's paintings, as enchanted objects, offer glimpses into women's private worlds. These women, with their tilted heads and contemplative expressions, exist within realms of remote privacy. As a replication of that interiority, painting interrupts and displays privacy. In this regard, Vermeer's paintings of women act as portals to another world – a world of women thinking – without necessarily disclosing the full contents of women's thoughts.[5]

From a historical perspective, as against a novelistic one, isolating Vermeer's pictures of women distorts the diversity of subjects in seventeenth-century Dutch genre painting. According to Gary Schwarz, the number of men in paintings produced between 1625 and 1675 vastly outstrips the number of women: 73.5 per cent versus 19.5 per cent, with children making up the balance of 7 per cent (106–7). Although paintings of interior spaces – kitchens, salons, corners of rooms – usually contain more women than men, these scenes typically feature children as well. Vermeer omits children almost entirely from his oeuvre, except in two outdoor scenes. A maid carries a tiny child in her arms in the left corner of *View of Delft*, and two children play on the curb in *The Little Street*. Because only approximately 1 per cent of seventeenth-century paintings survive (North 107), such statistical analysis no doubt distorts the actual contents of Dutch visual culture. Nevertheless, contemporary authors focus on Vermeer's depictions of women, in part because these self-possessed characters are unencumbered by the responsibilities of maternity. Vermeer's women concentrate on music or letters or pearls or milk. They are not preoccupied with minding babies and running households.

Vermeer novels dwell on the rapport between female narrators and female subjects in the paintings. In *The Music Lesson*, the narrator deliberately creates ambiguity about the real or representational status of

the subject identified only by third-person female pronouns: 'Her gaze catches me, pins me down, pulls me in' (Weber 1). Nameless, the female figure in the painting absorbs the identity of the narrator. Similarly, in *Girl in Hyacinth Blue*, characters peek at the young woman in the painting that gives its name to the novel. A Jewish girl in Amsterdam in 1942 sees herself as the *semblable* of the thinking girl in the picture: 'she felt this girl, sitting inside a room but looking out, was probably quiet by nature, like she was' (Vreeland 51). Even when men look at these paintings of women, they see versions of femininity that verge on the sentimental or the romantic, as when Laurens in *Girl in Hyacinth Blue* remembers his first love, whom he jilted, every time he glances at the Vermeer painting that hangs in his house.

These Vermeer novels thematize looking as an activity that ignores details. '"Look, look at her eye,"' instructs one owner of the painting in *Girl in Hyacinth Blue* (4). Yet this novel concludes with a sad reminder that many people look without seeing: 'People who would be that close to her, she thought, a matter of a few arms' lengths, looking, looking, and they would never know her' (242). The statement has several meanings. First of all, no one sees reality any more than they see representations of reality. More precisely, female subjects escape acts of looking because women are invisible except as extensions of male desire. Although representation sometimes clarifies the reality to which it refers by freezing a moment in time, reality remains largely unknown. The lessons of vision demonstrated by a painting, namely, to see in detail and to remember what one sees, do not translate into new habits of looking at the world. Painting, for all its vaunted training of the eye, does not necessarily change perception. Men co-opt and direct the female gaze in these novels as a form of apprenticeship. In *Girl with a Pearl Earring*, Vermeer constantly commands Griet to '"look at me"' (128, 129, 131, 169) as a tutelage of her powers of observation and obedience to male authority. Griet is not so easily subdued. The narrative concerns the first-person embodiment of Griet's subjective gaze. What she notices and what she narrates contradicts the paradigm, articulated by John Berger and Laura Mulvey, that identifies all gazes as male and all women as the objects of the male gaze.

Although Sylvie Matton's novel *Rembrandt's Whore* concerns Rembrandt rather than Vermeer, the narrative sheds light on gender politics in the artist's studio by concentrating on female subjectivity as a textual rather than a visual phenomenon. Superstitious and illiterate Hendrickje Stoffels enters Rembrandt's house as a maid of all work and

ends up as his model and common-law spouse. In this first-person narrative, Hendrickje provides intimate glimpses into Rembrandt's financial quandaries and artistic preoccupations: 'You still love searching, always for life, for the same answers (you say) from the transparency of flesh. And the older the flesh and skin, the more you see through them' (161). Rembrandt's keen gaze possesses the penetrating powers of artistry, but love animates Hendrickje's insights, which are recorded in words, not visual images. In a similar vein, Vermeer novels typically juxtapose art and love. In *Girl in Hyacinth Blue*, Magdalena craves her father's attention, and many of the episodes in the novel centre on misunderstandings between people in love. In *Girl with a Pearl Earring*, Griet blushes and squirms under Vermeer's gaze. She sublimates her love for Vermeer by serving him and imitating his close scrutiny of the object world. Both Magdalena and Griet have artistic sensitivity, but, for lack of training and adherence to the strictures of their class, both women end up married to tradesmen. They do not become artists.

In *Rembrandt's Whore*, the pleasure that Rembrandt takes in his art and possessions – his household chattels are inventoried and auctioned off – pairs with Hendrickje's capacity to love Rembrandt as a person irrespective of his ownership of objects. '"Dispossessed, he shall be set free"' (116), murmurs Hendrickje. Using the vocabulary of detail, she voices the difference between an artist who lives by his spiritual attainments and a man subject to the caprices of city regents: '"The men of power pretend they've agreed [about commissioned paintings for the new city hall], it's a game they play. A few words, a mere detail can remind them that this game is their war. My love, in their war of power and petty triumphs, you're a mere detail"' (169). In Hendrickje's opinion, art does not triumph over municipal politics. Whereas Chevalier and Vreeland respect art as a victory of culture over business matters, Matton implies that art has a secondary, or even tertiary, importance in the hierarchy of human attainments. Because objects possess people, and because painting is the making of objects, the making of pictures enslaves Rembrandt. In Hendrickje's eyes, art will never liberate its creator.

Matton positions Hendrickje as muse and helpmeet, as someone who exists outside the systems of exchange and commodities. Although she reclaims a linen cabinet as her personal property during the auction of Rembrandt's goods, she does not hanker to possess things. For her, possession resides in the realm of subjectivity and language, or what amounts to self-possession. On her deathbed, Hendrickje remains 'in possession of my mind, my memory and my words' (172). *Rembrandt's*

Whore therefore stakes a claim for a female subjectivity not fastened to objects, whether artistic or decorative. Instead, the physical sometimes impedes the expression of love. Whereas other novels about seventeenth-century Dutch painting dwell on specific paintings of women, *Rembrandt's Whore*, by locating narrative in Hendrickje's consciousness and avoiding her objectification as a model and muse, defies the conventions of the gaze and the problematics of framing women as objects for aesthetic contemplation. As Hendrickje makes clear, the 'detail' is male, specifically associated with Rembrandt, who is caught up in the machinations of city governors.

In contrast to Matton's fantasia on the nature of love, Vreeland, Weber, and Chevalier approach Vermeer's paintings as fables about the meditative stillness of visual art. In Weber's *The Music Lesson*, the narrator praises the everydayness of seventeenth-century interiors: 'There is a love for the real, an affection for the true, in all Dutch art. A church interior with its stillness. A hand with its gesture' (37). Immersion in this period and its art allows the narrator in *The Music Lesson* to detach from the present: 'I studied the paintings of interiors with a deep certainty that those still rooms held something for me – a marvelous sense of serenity and comfort and completion' (42). 'Stillness' and 'still rooms' authorize contemplation. Stillness contributes to 'completion,' which may be a psychological state, an intellectual abstraction, or both. The stillness that surrounds Vermeer's figures, a stillness conveyed through the smallness of human gestures that carry a weight of significance (pouring milk, sipping wine, playing a virginal), implies that those who participate in the depicted scene remain, at least to some degree, conscious of the meaning of their actions.

Vermeer figures this consciousness of gesture or action through interruption. Whether a figure turns to inspect the viewer in a narrative situation (as in *Woman Standing at a Virginal* or *A Lady Writing* or *Girl Interrupted at Her Music*), or a portrait in which the sitter's gaze confronts the viewer (as in *Girl with a Pearl Earring*), or even those paintings in which figures obstinately turn their backs to the viewer (as in *The Concert* or *The Music Lesson* or *The Art of Painting*), interruption implies access to the consciousness of the represented figure.[6] In his paintings, Vermeer often depicts interruption in conjunction with music. A woman stops playing the virginal but her fingers still trail on the keys. Sudden interruption, implied visually by a turn of the head, curtails sound. This technique of interruption emphasizes the aural dimension of the represented scene not through music, but through sudden quietness.

To confirm the intuition that Vermeer's paintings figure silence, Susan Vreeland quotes John Keats's 'Ode on a Grecian Urn' in the epigraph to *Girl in Hyacinth Blue*: 'Thou still unravished bride of quietness / [...] / Thou, silent form!' (xi). In Keats's poem, the object comes to life as an ekphrasis even as it is apostrophized as a 'silent form.' In Vermeer novels, the silence of women does not mean that women lack subjectivity. Silence magnifies their subjectivity. One character who views the eponymous painting in *Girl in Hyacinth Blue* admires the 'quietness' (51) of the girl ostensibly sewing but really looking out the window. Arranging the elements for his composition, Vermeer feels 'a respite in stillness' (223) that enables him to begin painting. Magdalena, who sits for the picture, tries not to move: 'In that mood of stillness, all the things within her line of vision touched her deeply' (232). More than just an absence of movement, stillness expands into a mood or atmosphere. Stillness enhances vision by making objects more poignant in their separateness from human consciousness.

Stillness enables a revised way of looking. One sees differently when one is not distracted by noise, interruptions, or household worries. The moment of interruption is therefore a threshold between an ordinary and a transfigured mode of seeing. Jeremy Noel-Tod, in a review of several books about Vermeer, including *Girl with a Pearl Earring*, aphorizes, 'art reminds us of the ways in which we don't see the world' (18). Stillness concentrates the act of looking by throwing details into visible relief. Ron Charles, also reviewing Chevalier's novel, finds resemblances between narrative texture and Vermeer's paintings: 'Her subject is a single woman caught in a private moment. Like the Dutch master, [Chevalier is] fascinated by the play of light, the suggestive power of small details, and the subtle thoughts beneath placid expressions' (21). Stillness complicates the entrapment of women in interiors. Chevalier herself emphasizes the captivity that stillness entails: '[Vermeer] is somehow able to *capture* a moment of stillness. The paintings are usually of women on their own doing something domestic – writing a letter, looking out of the window, talking to servants. The light is so calming, it seems to *capture* a moment' ('An Interview'; emphasis added). While Vermeer illuminates the inner lives of women, those recessive states of meditation and interruption, conveyed by stillness, contain snares, aspects of personality trapped inside the figure herself, then captured in a secondary degree by the painter. Entrapment translates into narrative event. Locked at night into Vermeer's studio, Griet in *Girl with a Pearl Earring* has little freedom. When she poses for a portrait, Vermeer

chastises her for moving. Van Leeuwenhoek warns Griet that Vermeer 'traps' (186) women in his vision. Visual stillness correlates with hidden narrative dimensions, especially narrative possibilities related to women in the act of making decisions and women entrapped by the decisions that they make.

Representation might trap women, but art also provides an opportunity, however fleeting, to escape from constraints of class and gender. In *Girl with a Pearl Earring*, Griet learns from Vermeer's example that art requires the manipulation of details. Her minute alterations to Vermeer's compositions change the overall relation of one object to another and thus alter the meaning of the painting. Griet, working by instinct rather than education, labours to perfect the painting. Her labour consists of understanding the relationship between objects and details; she thinks about the ways that minuscule variants change a total composition. When she returns to her parents' house for a visit, she notices the barrenness of their dwelling in comparison with Vermeer's: 'no marble tiles, no thick silk curtains, no tooled leather chairs. Everything was simple and clean, without ornamentation. I loved it because I knew it, but I was aware of its dullness' (48). Objects and ornaments please her. The proliferation of objects in a domestic space, with their concomitant proliferation of details and arrangements, increases visual pleasure. Vermeer teaches Griet that detail itself heightens visual pleasure. Even while it exacts infinite pains in the studio, a labour disproportionate to the diminutive paintings produced, Vermeer's painting instructs the eye in the techniques of looking.

As much as Vermeer novels reinscribe women within the history of art, with particular attention paid to female subjectivity, servitude, and the gaze, these novels also invite questions about the making and meaning of art. As Vermeer's example confirms, attention to objects and details can train the eye to see value, including aesthetic value, anew. A detail constitutes a point that can be noticed, in the sense that it detaches from narrative temporality and becomes an object in itself. Up close, the detail paralyses the reader's attention; it disturbs the entire pattern of narrative. To interpret the detail out of narrative sequence distorts meaning and exaggerates the perceived value of the object.

A Poetics of Detail

Ideally, a poetics of the detail would schematize all of its narrative functions. It is perhaps more prudent, because more limited in range, to ad-

dress only the function of details with regard to art objects in narrative. In this limited context, 'detail' designates concrete attributes, or what Alan Liu calls an 'aggregate of specific and determinate particularity' (84). Details, as physical limits or cognitive barriers in narrative, may be inconsistent with each other, but they cannot be denied or ignored for that reason. Detail has several functions that a poetics ought to take into account. First, being linked with excess, detail introduces disorganization and clutter into the intentional arrangements of artworks. Second, detail questions relevance and totality; as Dessons claims, 'le détail ne va pas avec le tout' (64).[7] Third, although critics have commandeered detail as an explanatory category for realism, detail in contemporary fiction establishes the object as diegetic. Not ancillary to narrative, objects invite aesthetic questions about breakage, completion, and beauty. Fourth, detail trails behind it questions of value and labour.

The amassing of material goods, with the resulting effect of clutter, is intrinsic to the novel from its inception. The expository details that accumulate around objects create diversity in narrative, specifically the diversity of material commodities. Like the items that Robinson Crusoe salvages and hides in a cave, objects accumulate even when they do not possess obvious utility. Crusoe retrieves muskets, powder, lengths of cable, scissors, nails, three Dutch cheeses, dried goat's flesh, money, chests, boards, broken oars, paper, ink, several dozen hatchets, and numerous other items from the shipwreck (Defoe 50–64). Not all of these items – broken oars, for example – have an immediate or obvious purpose. The impulse to hoard in *Robinson Crusoe* creates a narrative style of the inventory in which lists express the infinite variety of commodities. Heterogeneous objects obscure the interior of Crusoe's cave even while they define that space as interior and domestic.

Clutter has a close relation to domestic spaces. Entering Rembrandt's house, Hendrickje in *Rembrandt's Whore* notices a cabinet of curiosities and the conspicuous, diverse objects that Rembrandt uses as props. On her first evening in the house, Hendrickje asks only one question: '"the objects and paintings cluttering the walls in every room in the house – where were they before they were here?"' (Matton 9). Clutter obviates provenance. To know the origins of objects would subdue clutter into discrete and identifiable entities. Objects do not clutter of their own accord; they clutter when tossed together without regard to their use or origin. When Griet in *Girl with a Pearl Earring* cleans Vermeer's studio for the first time, she itemizes the furniture and objects in the room: 'It was an orderly room, empty of the clutter of everyday life. It felt differ-

ent from the rest of the house, almost as if it were in another house altogether' (Chevalier 33). With some dismay, Griet surveys the abandoned objects in the basement cubbyhole that serves as her bedroom: 'several tapestry-covered chairs piled up, a few other broken chairs, a mirror, and two more paintings, both still lifes, leaning against the wall' (31). Heaped together, objects degrade into so much clutter that interferes with clarity, not to mention household cleanliness. As Griet's inventory further indicates, clutter lies alongside breakage, as when broken chairs tumble together with unbroken ones.

Yet a different lesson arises from Robinson Crusoe's thrifty laying up of objects and the more orderly articles that Griet sees in Vermeer's studio: objects express futurity. What is not immediately useful, either as a tool or as an object that enlarges knowledge, may become useful later. Idle for the moment, a hatchet can be used to chop down a tree; a tapestry-covered chair stands dumbly in the corner before it becomes a prop. In an analysis of bric-à-brac and curios in the eighteenth century, James H. Bunn concludes that English traders' accumulation of objects without regard to their origins opened the possibility for an aesthetic of 'dispossessed clutter' (309). On Belinda's messy dressing table in *The Rape of the Lock*, Bibles, patches, and billet-doux join in an aesthetic of disarrangement. The impulse to collect objects and pile them together willy-nilly, irrespective of use, proportion, or symmetry, does not exclude the possibility that these objects will come in handy sometime later: 'The very incongruity of heterogeneously assembled objects seems to indicate their reconstruction to some *future* use. But curios that are collected for an appreciation of things in themselves, as if they were not remnants bereft of their sources, expunge usefulness. They draw attention to *potentiality* itself by denying the usefulness of the collected possibilities' (312–13). Curios may be castoffs, or they may be items of domestic utility. In either instance, they are inert. Inert, they wait. And waiting in their display cabinets, they exhibit potential. Heterodox curios 'betoken the precariousness of chance, of random collections. Unfixed by affiliation to source, the imported token conveys precarious balance' (315). Either curios never realize their potential, or they move into new orbits of exchange and value. When not revived through exchange, most objects, artistic or otherwise, disintegrate, break, or disappear. When treated as clutter or rubbish, objects are already at an advanced stage in their allotted span of material existence.

Disorder illustrates one aspect of materiality. In Chevalier's *Girl with a Pearl Earring*, Griet affirms her commitment to cleanliness and order.

She disparages the 'jumble' in the children's room of 'beds, chamber-pots, small chairs and a table, on it various earthenware, candlesticks, snuffers, and clothing' (19). She notices that Catharina's 'chemise puffed out messily' (24) and her frizzy hair escapes from the subduing tines of combs. When Griet returns to the Vermeers' house a decade later, she cannot help observing the dust, cracked tiles, and faded silk of a household in disrepair, as well as the frowziness of Cornelia's badly mended dress. Griet has an eye for tarnished and disarranged objects. She deliberately rearranges a piece of blue cloth in one of Vermeer's compositions to provoke a contrast between order and disturbance. 'Although I valued tidiness over most things,' declares Griet, 'I knew from his other paintings that there should be some disorder on the table, something to snag the eye' (132).

In Vermeer's actual paintings (as opposed to the fictitious or textualized paintings in Vermeer novels), objects intrude on the eye in their hard separateness: a table, a tapestry, a ewer, a basin, a lion's head finial on a chair, an open box, a map on the wall, a swag of fabric. All these objects appear in *Young Woman with a Water Pitcher*, yet this grouping evokes any number of Vermeer's paintings. Even when Vermeer purifies objects in the visual plane of his paintings by leaving large blocks of space unfilled, he usually amasses heterodox objects as if they were curios divorced from functionality. The eye slopes circumspectly from detail to detail, taking in a bead of light or a crinkle in a map. Heterogeneous objects have no apparent or inevitable connection to each other. Mystery resides in the unarticulated relation of one object to another. In this sense, the objects in Vermeer's paintings confirm Alpers's thesis that Dutch painting enacts a descriptive culture, not a narrative one. Objects are, so to speak, the thing.

Contemporary novels about artworks delight in jumble. Bruce Chatwin, a connoisseur of hodgepodgery, exalts in unlikely objects coexisting in space. Incongruous details of costume and accoutrements prank out his novel about West Africa, *The Viceroy of Ouidah*: 'Papa Agostinho wore coral chokers and an opera hat sequinned with butterflies and a bleeding heart. His son, Africo da Silva, had on a yellow petalled crinoline, while Yaya Felicidade, in a headscarf of purple pansies, waved about a nineteenth-century English naval cutlass' (12). Chatwin jots down everything that he sees, on the grounds that no detail and no object, in the final reckoning of narrative representation, is insignificant. Amid the profusion of details, some might stand out more than others because of their oddity. But when myriad details come together, they

all bear a touch of the bizarre or exotic. One curio, a piece of skin covered with 'coarse, red hair' in a 'glass-fronted cabinet' (1), launches his travelogue, *In Patagonia*. This bizarre collectible is said to have come from a cave in Patagonia, so the narrator sets out to find that remote place. The innocuous object, lost or misplaced among other objects, proves to have a value in excess of its curiosity value.

Fragments or curios cannot explain an entire culture. It would be a mistake to draw lessons about British culture from an artefact such as the Assyrian Winged Lion at the British Museum. A decontextualized monument from another civilization does not articulate English culture, except perhaps museologically. Some details matter less than others in their contribution to culture or meaning. In this sense, details test limits of relevance. They may possess more significance for the reader than for the author: 'This may reflect the tendency we have in our own experience to create patterns, to relate elements, to simplify, to classify' (Price 70). Details call up the will to arrange and schematize even though details challenge classification. Not all details fit into a single classificatory slot; some details belong in several slots at once. Thus, the interpreter of a novel or a painting elaborates new paradigms to explain incongruous details. Patterns of relevance expand 'to require new detail, and the irrelevant detail becomes the boundary of the limit of expansion' (75).

Details contradict systems and classification. Speaking of the encyclopaedia of details in *Bouvard et Pécuchet*, Nathaniel Wing conjectures that details defy systematization: 'The heterogeneity of detail, however, remains stubbornly resistant to systematization; each sequence is scattered with unassimilable, random items which put in question the very possibility of system. The subversion of the details as a support of meaningful difference leads to a generalized collapse of systems whose validity depends on the exclusion of an antinomous other' (50). When a detail cannot be accommodated within a classificatory system, the fault may lie with the ordering principle of the system, not with the detail. The detail subverts the system, as Wing claims, insofar as it bears valid but antithetical meaning. Alan Liu comments, 'Detail is the very instrument of the antifoundational and anti-epistemological imperative in high cultural criticism: its contention is that there is no reason [...] why contexts of discretely perceived particulars should resolve into culture as a single, grounded, and knowable order' (81). Details encode and prove cultural specificity. Resisting generalization, details confound claims to the truth value of overviews as ways of knowing. As foun-

dational units upon which interpretations or analyses are built, details retain their potential for relevance according to the paradigm in which they are construed. Hence, cultural criticism shies away from any reference to universality. Truth, when discernible at all, remains relative and local for culture critics. Yet this does not disqualify the detail from signifying in contradictory ways, even in local circumstances. Indeed, details, as so many details, signify excessively and, by doing so, make culture.

In his novel *Saturday*, Ian McEwan speaks of 'the banality of detail' (153), when excessive details crowd out the possibility of insight. When it does not consolidate meaning, the detail appears insipid. No absolute standard for the number of relevant details, however, can be applied to all objects, and certainly not all art objects. Does Hieronymus Bosch include too many details in his paintings? Does Mark Rothko include enough? Details, because atomized units of meaning, maintain independent identities. Yet when repeated, sometimes with minor variations, in a pictorial or textual representation, these small units of meaning accrete into patterns. Detail seesaws between an excess and an impoverishment of meaning. As Naomi Schor claims, 'it does not suffice that the detail *be true*, or more precisely, *appear true*, produce a "reality-effect," for the interpretation which is assigned it to be equally true' (116). Details provide a point of departure for interpretation and cultural possibility. They do not necessarily provide a platform for truth or a single dominant meaning. Details do not accumulate into a total meaning; instead, they sustain the possibility of 'the notion of a detotalized detail' (72).

If Sigmund Freud's psychoanalytic theories prove anything, they prove the benefits of applying the mind to detotalized details as signs that might be defective or overdetermined, and sometimes both at once. Although Freud does not speak directly about details in any theoretical work, his entire oeuvre demonstrates a keen regard for signification at a micro level. According to Schor, detail is 'coextensive with the vast field of insignificance which Freud undertook to reclaim' (68). In the unconscious mechanisms of displacement and condensation, detail concentrates and camouflages content. The result of diverted meaning, the telling detail in psychoanalysis disseminates fiction and purveys truth at the same time. Freud theorizes the array of possible meanings that arise from seemingly irrelevant detail. An irrational fear of white wolves sitting in a tree or fiddling with the clasp on a purse manifests unspeakable anxieties. The detail discloses hidden ele-

ments within a diegesis – a formulation that applies to psychoanalysis as much as it applies to the interpretation of narrative generally.

Freud creates an interpretive paradigm in which details function as clues, distractions, or unarticulated dimensions of diegesis. Although 'any detail referring to a familiar world makes texts, whether narrative, lyrical, or dramatic, accessible to readers' (Daemmrich 114), details can also elicit unfamiliar worlds. Details need only suggest, in their effects of authenticity or unusualness, that they belong to a possible world. Framing that world, which can be entirely made up, details 'provide an important aesthetic function when their concreteness, historical accuracy, or precision captures and sustains the reader's attention or conveys to him the illusion of immediacy' (114–15). That immediacy need not spring from the coherence of details. They can exist independent of each other, like so many curiosities in a cabinet. For this reason, details resemble material goods; the precise detail 'captures the essential qualities of an object' (116).

Perceived and interpreted, details offer counter-narratives within narratives; they supplement stories with extra-diegetical importance. In *The Pleasure of the Text*, Roland Barthes speculates on details as narrative information: 'Why this curiosity for tiny details: schedules, habits, meals, clothes, and so on. Is this the fantasmatic taste of reality (the materiality of "this once existed")? Is it not fantasy itself that summons the detail, the miniature, private scene in which I might find my place at last?' (85). Fantasy stakes its claim in the kingdom of the detail. Whereas the realist text purports to offer historical veracity through a grisaille of details, details admit speculation, fantasy, even the fantasmatic. The detail, in this sense, is not available for public scrutiny or sharing. The detail re-fetishizes ownership through particularity.

In and of itself, the detail remains incomplete. The detail exists within a narrative sequence, but it does not constitute narrative sequence per se. When Griet in Chevalier's *Girl with a Pearl Earring* attempts to describe Vermeer's paintings to her blind father, he cannot understand how the details of colour and the position of objects in various planes align into a scene, because he anticipates that details create stories. 'I wanted to tell him,' says Griet, 'that if he could only see the painting he would understand that there was nothing confusing about it. It may not have told a story, but it was still a painting you could not stop looking at' (91). Griet intimates that details exist without stories, but stories cannot exist without details. In an echo of Alpers's assertion about the non-narrative nature of Dutch painting, Griet announces that

Vermeer's '"paintings don't tell stories"' (91). By describing them to her blind father, Griet fractionalizes the pictures into separate details that themselves ought to be sufficient to convey meaning. The picture decomposes into details that need not, and do not, connect into narrative.

Ostensibly subdued within narrative, the detail is not incidental, an item that simply sustains the banality of description. Static and out-of-sequence, the detail apparently contradicts the forward direction of plot. In this perspective, the art object, as an endlessly detailed material artefact, imposes an obstacle to diegesis. Explaining the 'reality effect,' Barthes claims that notations of 'non-structural' elements seem to be 'a kind of narrative *luxury*, lavish to the point of offering many "futile" details and thereby increasing the cost of narrative information' ('Reality Effect' 141). Barthes ironically asserts that detail increases the value of narrative, just as ornament enhances the value of commodities. Allegedly 'futile' details gussy up narrative information, thus making it more costly. Barthes does not endorse a facile correlation between reality and realism in 'The Reality Effect.' He does aver that little touches create the reality effect; they cannot be omitted on the grounds that realism conveys its historic or normative world view through impartial inclusion. As Barthes clarifies, the accumulation of details, including the ugly and contingent details of the material world, *signify* reality. So-called insignificant details herald everything that has not been included in narrative. The details appear to be outside diegesis, yet they create extra dimensions within the diegesis. When Griet tells her father that the white cap in Vermeer's painting has many colours in it, she recalls her master's 'lesson' (90) to this effect, but she also reiterates that a detail cannot be taken for granted: white is never simply white.

In addition to challenging assumptions about the gender of artistic production, novels about Vermeer raise questions of aesthetics. Dutch art shifted noticeably from sacred to secular subjects in the course of the seventeenth century, which meant a corollary shift away from the iconic to the aesthetic value of painting (North 137). Despite their aesthetic merits, and perhaps because of those merits, paintings developed greater currency in the Dutch marketplace: 'Pictures were goods which had a commodity value just like a pair of trousers or any other service' (93). As a viable form of tender, paintings cancelled tavern bills or the cost of fancy embroidered garments (92–3). *Rembrandt's Whore, Girl in Hyacinth Blue, Girl with a Pearl Earring*, and *The Music Lesson* detail the financial circumstances of artists' careers, especially the declining fortunes of Rembrandt and Vermeer toward the end of their respec-

tive lives. In *Girl in Hyacinth Blue*, Vermeer asks his mother-in-law for money to defray debts. In *Girl with a Pearl Earring*, Griet's father loses his sight when a kiln blows up; unable to work, he earns no income. Griet's manual labour as a maid implicitly conflicts with Vermeer's cultural labours. The boundary between domestic service and painting blurs to some degree when Griet begins to meddle with her master's compositions.

In *Girl with a Pearl Earring*, paintings exact immense labour, a labour disproportionate to their market value. Van Ruijven, Vermeer's patron, taunts the artist for his low productivity. He allegedly spends five months on a painting of a girl with a water pitcher, even though he paints more efficiently when Griet grinds his colours and when a camera obscura clarifies compositional complexities.[8] Slowness and intensity have no impact on artistic value, despite the importunate demands of a patron. The cost of painting might be reckoned by a factor so banal as the number of figures included in the tableau. In fact, Griet surmises that *The Concert* 'was meant to be more valuable with three figures in it' (203), in comparison with paintings of people posing solo. Nor does all artistry translate into accomplishment. While Griet has an alert eye for detail, she cannot convert this talent into income. She helps Vermeer, but she does not profit from her ability. That ability is figured as the surplus value of labour, specifically the surplus value attached to cultural production. Paintings possess commodity value, but paintings, as Vreeland's, Chevalier's, and Weber's Vermeer novels make clear, construe value as cultural cachet: the value attributable to detail; the price of beauty; the aesthetic appreciation that clings to a work simply because it survives.

The Fate of Two Paintings

Both Katherine Weber's *The Music Lesson* and Susan Vreeland's *Girl in Hyacinth Blue* are named for Vermeer paintings that do not exist. Nevertheless, both fictitious paintings borrow heavily from elements in Vermeer's extant oeuvre. Weber imagines a six-by-seven inch painting called *The Music Lesson* that hangs in Buckingham Palace. A painting with that name actually does belong to the British Royal Collection, but the queen's painting shows a young woman at a virginal with her back to the viewer, her face invisible. By comparison, the imagined picture in Weber's novel shows a woman gazing out at the viewer, her face visible (1, 102). In a 'Note to the Reader,' Weber states that her Vermeer

'does not quite exist' (vii). Similarly, Susan Vreeland invents a painting called *Girl in Hyacinth Blue*, 'a most extraordinary painting in which a young girl wearing a short blue smock over a rust-coloured skirt sat in profile at a table by an open window' (4). Distracted from her sewing, the girl looks out the window, with her hand turned upward. The subject resembles Vermeer's *The Lacemaker*, as one owner of the painting remarks (7). The distortion in the tiles on the floor appears in earlier paintings, such as '*The Music Lesson*, roughly dated 1662 to '64, or *Girl with the Wineglass*, 1660' (6). Vreeland, like Weber, borrows details from known Vermeer paintings and reassembles them as the portrait of a girl whose thoughts drift away from her handwork. Both Vreeland and Weber note that Vermeer settled debts with a local baker by giving him paintings. In fact, the Delft baker Hendrick van Buyten owned three Vermeer paintings, at least two of which were acquired to settle debts upon the painter's death in December 1675 (Montias 216–18).

Insofar as the details of Vermeer's paintings can be pinpointed and recombined, those details cause cognitive equivocation. The detailing of Weber's and Vreeland's narratives extend beyond the particulars of fictitious painting to the nature of art objects themselves. In *The Music Lesson*, an art historian named Patricia Dolan works at the Frick Collection in New York. Having written her doctoral thesis on the influence of seventeenth-century Dutch paintings on cubism, she possesses expertise in Dutch art. For this reason, her Irish cousin Mickey enlists her help in stealing a Vermeer painting from the Frick. A splinter organization of the IRA called the Irish Republican Liberation Organization demands a ransom of £10 million for the painting. To help Mickey with his plan to steal *The Music Lesson* when the painting is in transit from The Hague to London, Patricia provides information about procedures for moving paintings: 'I made my best guesses about painting crates and shipping protocols and hundreds of other details. Presumably, most of my information was useful. Which makes me an accessory from the outset, I know' (111). Although the full details of the heist remain obscure, Patricia usefully supplies details known only to someone inside the museum world. A crate containing the real painting is switched with a crate containing a cheap counterfeit. Mickey does not tell her exactly where and how the switch occurs. Nor does he tell her that the cottage in the West of Ireland where she hides with the painting has been electronically bugged so that Mickey and his associates can listen to her conversations.

Detail pivots between revelation and concealment in *The Music Les-*

son. Even when visible, the detail does not give up all of its content. As a scholar of Dutch genre painting, Patricia admires 'the quality of safety, the sense of resolution, an exactness, a specificity, a devotion to order, a celebration of dailiness' in paintings of interiors (140). Specificity, the quality that distinguishes one room or one face from another, guarantees authenticity. Specificity intimates the cultural and historical accuracy of the representation – the way a woman wears her hair or the boundaries and place names inscribed on a map that hangs on the wall. Just as Mickey does not reveal all the details of his plan to Patricia, Patricia does not narrate all the details of her own actions. Patricia writes in a journal, then hides it. She claims that her private 'account is not meant for anyone's eyes' (7). Even at the end of the narrative, the journal remains a hidden document in a secret archive, buried inside a 'volume of bound duplicate publications concerning art forgeries' (176). In the Irish cottage, she locks the incriminating notebook in a cubbyhole that she discovers under the stairs. As the ransom plot untangles, Patricia carries her notebook in her handbag so that no one snooping through her few other possessions will accidentally come across it. Although Patricia initially discredits a rumour that the O'Driscolls 'were in the habit of burying gold coins in various corners of their cottage and that there is a hidden fortune buried here still' (44), she roots out a tin containing crumpled, disintegrating one-pound notes that someone hid in a secret cupboard. She has a knack for hiding things and finding hidden things. She even notes that Irish fugitives used to hide in 'settle beds' (47). Her eye is drawn to hidden objects and places of concealment, in paintings as in household spaces.

'"I don't have anything to hide"' (161), Patricia asserts, but she hides the Vermeer painting. Usually she conceals it in a 'small windowless middle room' upstairs in the cottage (67). Most of the time, the painting remains concealed inside a suitcase. The motif of hiddenness in the novel extends to the aesthetic consideration of art objects: 'Is *The Music Lesson* still beautiful when it is wrapped in bubble wrap in a Samsonite suitcase?' (120). Hiding the painting may compromise its aesthetic value by cancelling the emotive and cognitive force of its details. In retaliation for the doublecross that Mickey inflicts on her – baiting Patricia with love in order to exploit her expertise in Dutch art and museum procedures – she dupes him in turn. She replaces the real painting with a reproduction that she has brought along from the Frick. The novel offers various conjectures on the replicability of paintings through photography. With a helping quotation from Walter Benjamin, Weber concludes

that 'cult value would seem to demand that the work of art remain hidden' (120). At the same time, copies of *The Music Lesson* proliferate. Not only are these photographic reproductions accurate in terms of colour, brushstroke, and dimension, they are accessible to shoppers in museum gift stores. Instead of announcing the theft and submitting to the ransom demand, officials at Buckingham Palace hang one of the reproductions on the palace walls to replace the missing original. Patricia, too, fools Mickey and the other IRLO guerrillas by substituting one of the reproductions for the original. Thinking that they are destroying the original and capturing the event on videotape, the IRLO gang set fire to a copy. Whereas photographic reproduction disseminates images of original paintings and therefore appears to compromise their aura, photography comes to the rescue of the original painting in *The Music Lesson*.

The original painting is buried in a coffin along with Mary Carew's corpse. This burial of a priceless Vermeer may seem like a tragedy tantamount to destruction, yet Weber's novel, which has the brevity and moral quality of a parable, turns on the multiple meanings of an artwork. *The Music Lesson* is already a political object. Hanging in Buckingham Palace, the Vermeer belongs to private owners, but those private owners are the royal family, who are therefore inseparable from the state. Once stolen and ransomed, the painting sheds its aesthetic meaning and acquires a heightened political meaning. Originally a commodity traded to pay for bread at Vermeer's death, the painting circulates through other zones of value. Housed within a collection or displayed in a blockbuster show at the Mauritshuis in The Hague, the painting seems to lose its exchange value in favour of the iconic, fetishistic, and display values conferred by its museumification. Ivan Gaskell cautions that 'a museum object never entirely loses its commodity character' (172–3). In *The Music Lesson*, the IRLO have no interest in the aesthetic value of the Vermeer; they care only for the perceived market value of the painting, which they hope to convert into weapons to continue their fight for the 'liberation' of the Irish Republic.

The narrator, prone to hiding her motives along with her notebooks, performs a bait-and-switch in *The Music Lesson*. Although Patricia appears to collude with Mickey's plan to destroy the painting, either by burning it or by blasting it with bullets, she draws a lesson from Vermeer's example: 'I knew what I needed to do. *The Music Lesson* had taught me. Vermeer's is an art that chooses among things, rectifying them. It's a kind of genius that comes from never judging beforehand.

One must ask what is called for, what one's subject wants. One must let oneself be surprised' (159). The shift from Patricia's usual pronoun 'I' to the impersonal third person 'one' flags a deception. The art object assumes a moral and pedagogical dimension. It guides Patricia to a choice about how to react in this unlikely drama. After all, the subject of the painting is a *lesson*, albeit one about music. By extension of its peda-gogical content, the painting instructs its viewer. Writ large, the point of Weber's novel is the pedagogical value of art. Patricia construes the lesson of the painting as the manifest demands of the object with regard to its fate. Patricia leads Mickey, as well as the reader, to believe that she cooperates with the plan to destroy *The Music Lesson* in order to test the value that culture has bestowed on fine art. Yet the novel creates a far less clear moral about the nature of artworks. The long-surviving object, because it exists in the material world, ultimately demands its destruction. By burying the painting with Mary Carew's body, Patricia ensures the survival of the painting. That survival comes at the expense of anyone's seeing the painting again, or at least anyone's seeing it again for a very long time. The IRLO destroy a copy of the painting but the original painting is rescued only to languish in obscurity. Perhaps it will decay along with the body because of underground humidity. Plac-ing the painting in the coffin, Patricia personalizes the painting again, makes it the property of an individual, an obol to usher Mary Carew from this world to the next. Removed from the realm of politics and museums, the painting is reinvested with the magical properties as an aesthetic and personal artefact.

The Music Lesson refers explicitly to the theft of paintings from the Gardner Museum in Boston, as well as the notorious double theft of *Lady Writing a Letter with Her Maid* from Russborough House. The latter heists inspired John Banville's novels *The Book of Evidence* and *Athena*. Indeed, Patricia in *The Music Lesson* reads *The Book of Evidence* and notes similarities between her predicament and events in that novel. Mickey surmises that the paintings stolen from the Gardner in 1990, including Vermeer's *The Concert*, lie '"at the bottom of the sea"' (155). In the ground or at the bottom of the ocean, paintings are claimed by nature and, as it were, rinsed of their commodity and exchange values. In this regard, art acquires either transcendental aesthetic value or no value whatso-ever. Reading *The Music Lesson*, one does not realize that the burning of the painting is the burning of a copy of the painting that Patricia has thoughtfully brought with her from the Frick gift shop on the eyebrow-raising grounds that 'it might come in handy' (177). To imagine that the

destruction of the copy is the destruction of the painting, no matter how fleeting the thought, is to evoke the horror of premeditated attacks on irreplaceable objects. The destruction of the image arraigns the fetishistic value attributed to unique art objects. Irreplaceable objects, however, have been replaced by multiple copies, including the copy that hangs in Buckingham Palace. As if totting up pros and cons, *The Music Lesson* suggests that copies should be destroyed in order to preserve the integrity of the original painting. Yet the novel actuates an aesthetics of hiddenness, in which the original hides in plain sight among copies or literally is hidden inside suitcases, cupboards, and coffins.

Weber concludes *The Music Lesson* with the destruction of the *image*. This iconoclasm, like the conflagration that consumes the treasures of Poynton in Henry James's novel, urges a turn from idolatry toward some putative icon-free, and therefore value-free, purity. By contrast, Susan Vreeland narrates the destruction of a Vermeer painting at the beginning of *Girl in Hyacinth Blue*. Vreeland's novel then proceeds incrementally backward through time. Beginning in the present, with subsequent chapters devoted to nineteenth-century owners of the painting, then eighteenth-century owners, then the execution of the painting by Vermeer, the novel ends with the girl who inspired the painting, Vermeer's daughter Magdalena. Rather like the narrative arc of François Girard's film *The Red Violin*, the painting in *Girl in Hyacinth Blue* passes through multiple forms of objecthood: gift, token, fetish, wartime loot, pawn, and a melodramatic *croix de ma mère* device wrapped up in a blanket with a newborn baby.

In *Girl in Hyacinth Blue*, the twentieth-century owner of the Vermeer painting, Cornelius Engelbrecht, goes so far as to light a fire to burn the exquisite masterpiece. Engelbrecht inherits the painting from his father, a former Nazi lieutenant who looted it from a Jewish household in Amsterdam in 1942. Vreeland adapts details of the plot from historical events. As Lynn Nicholas documents in *The Rape of Europa*, 'When people [i.e., Dutch Jews] were detained, their possessions were confiscated, and if they were so fortunate as to escape, belongings left in storage were taken as well. Works of art from this source were collected by Mühlmann's agency and sold. A decree of August 30, 1940, also permitted them to open containers awaiting shipment abroad and remove desirable items. Museums and dealers were visited and ordered to list any private collections being held for absentee owners. Just so nothing would be missed, Seyss-Inquart authorized the removal of objects from houses abandoned during the invasion' (101–2). In Vree-

land's novel, the lieutenant's confiscation of a single painting for his own benefit hardly seems significant in light of the widespread looting conducted by the Nazi regime in Holland and other occupied European countries. In a parallel theft, one of the lieutenant's underlings steals a silver tea set from the same Jewish household. Given Nazi ransacking during the war, museums could not be considered trustworthy repositories of art and treasures. From this perspective, an officer's looting of a single painting preserves that painting from the rapacious Nazi mandate to seize all art owned by Jews. From another perspective, a single theft merely duplicates the structural logic of Nazi aggression. Vreeland complicates the meaning of the artwork by situating it as a private, stolen possession that ranks among the European, if not international, patrimony of art. Although paintings appear to be private possessions, owners are crooks. Ownership, by extension, is a legal fiction. Cultural patrimony – the painting as an object that belongs to everyone – outweighs private possession.

Engelbrecht imagines that burning the object will cancel his father's crime and the related taint that possession brings. He rules out the possibility of returning the painting or surrendering it, because he fears legal retribution. Moreover, as Lynn Nicholas writes about the retrieval of objects lost and confiscated during the war, 'The articles had generally passed through multiple jurisdictions, and the new owners were and are not always willing to relinquish them even in the face of overwhelming evidence' (415). In *Girl in Hyacinth Blue*, if the Jewish owners of the painting and their descendants all were dead, would the painting belong to the state? In fact, the picture circulates only in the Netherlands until Lieutenant Engelbrecht carries it with him to the United States. His son Cornelius expresses uncertainty about ownership: 'Willed or not, the painting didn't belong to him' (24). Destruction of the art object will supposedly release him from the shame of inheriting a stolen artwork.

In this perverse form of fetishism, the object embodies a host of political and personal meanings that supersede any or all aesthetic qualities. Englebrecht's shame arises from a particular crime, namely, that his father the lieutenant sent a Jewish boy to his death in a concentration camp; because the boy's family owned the painting, the painting comes to signify several crimes of escalating magnitude. The artwork, irrespective of its subject matter, stands as a sign of theft and the Holocaust. Engelbrecht briefly entertains the notion that he is only a custodian of the painting, not its actual owner: 'Such an act of selfish-

ness, he thought, to destroy for personal peace what rightly belonged to the world at large, a piece of the mosaic of the world's fine art. That would be an act equally cruel as any of his father's' (26). The story concludes with a relative, but not absolute, certainty that he destroys the painting. Engelbrecht's colleague, who narrates this portion of the novel, predicts that he will never see the painting again. Engelbrecht's monstrous selfishness asserts itself as the power of proprietorship, not as stewardship: he can destroy the painting because he possesses it.

Strategically placing the possible destruction of the painting at the beginning of the novel, Vreeland then gives its provenance over the preceding three centuries. Although the painting and its authenticating papers part ways in the nineteenth century, thanks to a wayward French coquette who sells the work to raise enough money to leave her philandering husband, the novel authenticates the painting. Retrograde instalments about the owners of the painting prove its durability through time. The painting survives a flood and war and theft. It goes up for auction at least twice. It passes through the hands of dealers and slave-traders, farmers and courtiers. Diegetically, Cornelius Engelbrecht's probable destruction of the painting sometime in the late twentieth century overshadows the survival of the painting over three centuries. The structural paradox of the novel creates a curious sense of belatedness or *Nachträglichkeit*. As each episode confirms the permanence of the painting as an artefact, the opening chapter intimates that the painting no longer exists. The image is destroyed; long live the image. If the painting is a Vermeer, it is priceless. Few of Vermeer's paintings exist, and those that do certainly cannot be bought in public art markets. Engelbrecht therefore reasons that the painting is worthless, nothing more than a private torment. The painting cannot be traded and it cannot be isolated from its history of shame and theft.

Engelbrecht thinks that he can break the spell of the enchanted object by doubting its authenticity. When the painting is separated from its 'certification' (107), it becomes a potential forgery. It may be a genre painting by a lesser Dutch artist. In any event, its authenticity is repeatedly questioned. One viewer in the late nineteenth century admires 'the way it mimics a Vermeer' (66). If it is not really a Vermeer, does the viewer take any less pleasure from the painting, despite the intricacy and fineness of its brushstrokes and the meditative stillness of the girl? Whether painted by Vermeer or someone else, the painting ought to be objectively beautiful, in the sense that it appeals to standards of beauty, whatever they may be. If the physical characteristics of objects alone are

worth consideration, the signature on the painting or the accreditation provided by documents should not alter its value by one iota. Nevertheless, the assertion of doubt about the painter's identity compromises the beauty of the painting and, by extension, its value.

The commercial value of the painting fluctuates wildly over three centuries. After Vermeer's death in 1675, *Girl in Hyacinth Blue* and a second painting cancel a debt of 'six hundred seventeen guilder, six stuivers' (237). In 1696 a baker sells this canvas at auction to a slave-trader and his wife for 47 guilder. In 1717 the slave-trader's wife gives it away to her nephew Adriaan Kuypers. During a flood, Kuypers bundles the painting together with a newborn baby and a note to sell the painting; in the strain of circumstance, he refuses to keep his child and he feels no sentimental attachment to a painting that only recently came into his possession. Saskia, who takes custody of the baby, sells the Vermeer in Amsterdam for 75 guilder. It goes again to auction and eventually turns up in the hands of a French tax official in the Netherlands whose wife sells it for only 24 guilder sometime during the French Empire. The price rises and falls over time without any rationale. Laurens, a Dutch water-station worker, buys the painting because it reminds him of a love affair that he had in 1874, then he gives it to his daughter as a wedding present. When it goes up for auction to raise money for German Jewish refugees in 1940, it sells for over 300 guilder. Lieutenant Engelbrecht steals it.

In *Girl in Hyacinth Blue*, art might be defined as what survives beyond looting and politics despite fluctuating value. Adriaan Kuypers observes that his slave-trading uncle and aunt acquire *objets d'art* 'by sending a soul to hell on earth in the Americas' (191). Art filters and represses a history of violence, including slavery. The French tax collector in Holland, whose wife makes off with the painting, implicitly owes his position to Napoleon and the French conquest of Europe during the imperial period. Yet visual art not only articulates cultural and political forces. As Saskia observes, the painting is resplendent with luxurious items. The luxury depicted in the painting compensates for real losses, at least in Saskia's mind. Visual representation feeds the imagination and offers solace against disaster.

Irrespective of political forces, art remains an encounter between human subject and physical object. Such encounters do not explain the reasons that an artist applies paint to canvas – the motive or inspiration for art. The purpose of art is a central philosophical conundrum in *Girl in Hyacinth Blue*. It may fulfil a social purpose; it may fulfil aesthetic

needs. It may be public or utterly private. In Vreeland's novel, Vermeer doubts that the world needs 'another painting of people quietly going about their lives' (201). Yet he also understands that 'things can live longer than people' (217). Objects exist in a different relation to time than do people. Their relation to futurity is less predictable than a human lifespan because they survive longer. Multiple definitions of the same object – as commodity, possession, decoration, and plunder – suggest that context determines meanings for the object through time as much as or more than the artist's intention does. Vreeland affirms that painting gives purpose to human events; art makes the inexplicable more comprehensible. Vermeer wonders, 'Would that have been enough – to tell a truth in art?' (238). The conditional anterior verb tense in the passive voice situates Vermeer in time. He conjectures that he will complete the painting and it will tell a truth. Only when the painting, sent into the future, meets its fate will the adequacy of that truth be revealed. Vermeer himself is in no position to know whether telling a truth in art would have been enough or not. Only the reverse chronology of *Girl in Hyacinth Blue* bears out the future of the possibility.

Everyone interprets the details of the painting, provisionally called *Girl in Hyacinth Blue*, to confirm its authenticity as a representation or, more specifically, as a representation by Vermeer. In and of themselves, the details do not vary, but characters interpret the details idiosyncratically. Lieutenant Engelbrecht observes 'blues and yellows and reddish brown, as translucent as lacquer' (17). His son Cornelius points out features such as depth of field, the basket as an obstacle, and the unfocused edge of the girl's face. His guest wonders, 'What sort of person knew that kind of detail?' (11). People who love objects notice details that confirm their love. Although the details in the painting remain the same, each viewer organizes them into patterns of colour or gesture according to cognitive distribution of information. The details atomize the composition by drawing attention to tiny features. Cornelius Engelbrecht thinks he finds a single hair still lodged in the groove of a brushstroke. He gauges the minute variations of colour between the two sides of a brushstroke as evidence of Vermeer's technique. The detail authenticates the painting even while it cannot confer the unimpugnable authority of a signature.

The detail is never one thing or another. Rasson and Schuerewegen wonder if it is possible that the detail is defined by its capacity to arrest attention in time: 'Le détail [...] ne serait donc pas une notion mais un *moment* dans un processus de perception, de compréhension? Quelque

chose est là, en train d'émerger, en train de capter notre attention. Mais nous ne savons pas ce que c'est. Et nous disons: un détail' (11).[9] The sense of the detail as *something that cannot be exactly pinpointed* complicates fiction about artworks, whether those fictional narratives assume historical or contemporary parameters. Rasson and Schuerewegen claim, 'À l'âge de la glisse et de la désertion du sens historique, le détail signifie désormais pour lui-même, en tant que signe de l'être-là de la diversité du monde, et susceptible de produire du sens en dehors de tout rapport à ce qui est Grand et Prestigieux' (13).[10] Especially when allied with artworks, the detail that summons history but that signifies meaning in and of itself is allied with questions of aesthetics and value.

Labour and Excess in *Girl with a Pearl Earring*

Girl with a Pearl Earring concerns forms of work, including manual labour and cultural enterprise. Aesthetic value registers as the labour that goes into the making of a painting: the grinding of pigments, the checking of the composition against the perspective in a camera obscura, the painstaking layering of paints, the pondering of whether to keep an object in the arrangement or to paint over it. Drama emerges from the coming-into-being of the painting detail by detail. The labour of culture is implicitly privileged over manual labour. As a proof of this implicit privileging, Griet begins to work for Vermeer on the sly instead of doing the laundry. At first she only cleans her master's studio and examines paintings in progress. Little by little, she helps him by laying out paints and mixing colours. When a model cannot pose, Griet takes her place. In a sacrifice of all semblance of maidenliness, she pierces her ears in order to wear pearls that will add lustre to the portrait that Vermeer paints of her. She loses her position for wearing Catharina's pearls at her master's insistence. Griet's work as maid and model contrasts with the largely invisible labour of Vermeer. When not painting, he spends most of his time outside the household running a tavern, dealing art, and managing the Guild of St Luke, of which he is the head. While painting, he maintains silence and near immobility. By extension of this principle, *Girl with a Pearl Earring*, a portrait of Griet the working girl, shows her not working; wearing fancy dress, she is frozen in her identity as a young woman rather than as a maid. Extricated from her role in the working classes, Griet assumes aesthetic meaning in the portrait without any reference whatsoever to her manual labour.

All of Chevalier's novels involve labour and its benefits to culture. In

Virgin Blue, midwifery and primitive farming conflict with the dictates of Christian worship. In *Falling Angels*, Edwardian workers dig graves while ladies and girls saunter aimlessly around a cemetery. In *The Lady and the Unicorn*, weavers work to make tapestries that will grace the walls of a nobleman's chambers. In *Girl with a Pearl Earring*, labour stains the hands of workers. Griet notices that Maria Thins, who negotiates the sale of her son-in-law's paintings, has 'fingers stained with ink' (18). The ink-stained fingers contrast with Maria Thins's otherwise immaculate clothes and demeanour. She stains her fingers, presumably, by holding a pen; if she works with a pen, she knows how to read figures and words. By contrast, Griet has difficulty reading, despite the prayer book that she carries with her as a talisman.

Griet identifies labour through the synecdoche of dirty hands. She notices with disgust that the 'creases between [Pieter's] nails and his fingers were filled with blood' (67), the telltale indicator of his work as a butcher. By comparison, Vermeer's 'hands were very clean' (70). Torn between her impossible attraction to Vermeer and probable marriage to Pieter, Griet makes explicit the degree of her erotic investment in each man through a comparison of their hands, starting with Pieter's: 'I looked down at his hands – they were clean, but there were still traces of blood around his nails. I thought of my master's hand over mine as he showed me how to grind bone, and shivered' (118). Rooted in the ambiguous pleasure that Griet derives from looking at men's hands, her shiver of disgust coincides with her shiver of erotic pleasure. Whereas other parts of the body remain modestly covered, naked hands attract erotic attention. Her own dirty hands decrease Griet's eligibility on the marriage market, for they render her less youthful, more seasoned. Her mother worries over 'the state of [her daughter's] hands' (81), to no avail, because housework quickly turns Griet's hands 'hard and red and cracked' (141). Working with her husband in his butcher stall after their marriage, Griet cannot keep her hands clean (225). Blood builds up under her nails and stains her fingers. No amount of scrubbing eliminates the signs of her manual labour.

Griet's observations of men's hands expand into a repertory of touches and slaps in *Girl with a Pearl Earring*. Hands and their activities indicate affiliation with class, as when Griet misguidedly slaps insolent seven-year-old Cornelia Vermeer. In return for this slap, Cornelia torments Griet whenever she can. Griet, obstinate in her moral rightness, slaps Cornelia a second time some ten years later. If Griet takes a liberty in punishing Cornelia, others take liberties by touching Griet

lasciviously. Van Ruijven touches her thigh while she serves him food; he gropes her repeatedly while she hangs up laundry or goes about her business in the house. When Vermeer tries to show her how to grind ivory, she withdraws her hand at 'the shock of his touch' (103) because it compromises her position as a hired labourer. In a more erotic, lingering touch, Vermeer traces the line of her face, brushes her neck with his fingers, blots her tears, and runs his thumb over Griet's lip (208). Vermeer's touch, unlike van Ruijven's, is not discouraged.

In solidarity with her class, and as a way of forgetting the brushing fingers of her master, Griet allows Pieter to embrace her in various alleys. 'Pieter's touch did not always repel me' (175), Griet observes, although 'always' in the sentence indicates that his touch sometimes does repel her. In the culture of looking that defines *Girl with a Pearl Earring*, touch circumvents vision and stakes immediate physical possession. Whereas the male gaze does not confer unambiguous possession of the female body, the male prerogative to touch women's bodies cannot be deflected with a downcast glance or a turn of the head, strategies that Griet commonly adopts when she senses that a man is looking at her. Griet comments about van Ruijven's unwelcome advances, 'I pushed him away as politely as a maid can a gentleman' (188). Her polite resistance cannot exceed the constraints of her class, which prevent maids from openly insulting gentlemen by rebuking them or pushing them away. For this reason, she cannot avoid but also cannot rid herself of men's unwanted touches, which are encoded as class entitlements.

Among her many tasks, Griet cleans Vermeer's studio without moving any objects. She is meant to preserve, if not partake of, the immobility of the objects that she cleans. She accomplishes the duty of cleaning by ingeniously measuring the distance between objects with her hands and sometimes other parts of her body: 'I measured each thing in relation to the objects around it and the space between them. The small things on the table were easy, the furniture harder – I used my feet, my knees, sometimes my shoulders and chin with the chairs' (34). In order to preserve the correct distances, lighting, and details in the composition that Vermeer is painting, Griet resorts to the scale of her own body. Whereas Vermeer usually (but not always) represents women in attitudes of leisure, Chevalier shows Griet at work. The novel opens with Griet cutting vegetables in her parents' kitchen. Vermeer and his wife interrupt her at this domestic chore. When she arrives at his house, he often stops her in her work. The trope of interruption, ubiquitous in Vermeer's paintings, translates into narrative event (55, 63). While she

washes windows, he orders her to stop (86). He halts her in the street to give her an order to buy items for him at the apothecary's (94). He asks her to stand in for the baker's daughter instead of going about her household chores (98). These interruptions immobilize Griet in postures of waiting or modelling. She lets Vermeer interrupt her work even though these interruptions compromise her obligations to clean the house and run errands around Delft. On all occasions, the toil of painting supersedes the toil of housework. Control over Griet's body is figured in the paradox of whether art takes precedence over domestic labour.

In exchange for mopping floors, dusting objects, soaking laundry, ironing clothes, posing for pictures, lugging water and pails of meat, Griet earns Vermeer's partial protection from the lecherous advances of van Ruijven. The exchange is unequal in terms of value. The imbalance between her labours and Vermeer's very limited help bespeaks the delicacy of negotiations between classes. As a burgher and picture-dealer, Vermeer gains nothing from condescending to help a maid, whereas Griet can lose a great deal without Vermeer's protection. As Karl Marx points out about exchange value, 'the value form of the product of labour is not only the most abstract, but is also the most universal form, taken by the product in bourgeois production, and stamps that production as a particular species of social production, and thereby gives it its special historical character' (93n). Although Griet sacrifices a great deal in order to satisfy her master, she remains almost entirely outside the bourgeois production of value. Although exchanges may appear to facilitate communication across barriers of class, they actually consolidate the class position of master over and against the maid. The portrait of the girl with the pearl earring substitutes for these complex historical relations of class and gender that cannot be expressed by other means. In this regard, the painting has to be read as an accumulation of details in which labour values are subsumed into aesthetic and display values.

Griet is an object of exchange rather than an individual who participates in the bourgeois economy of exchange. The portrait enacts control of her body and her image by people other than Griet. As an article of exchange, *Girl with a Pearl Earring* signifies value in multiple ways. Vermeer paints the picture in order to appease van Ruijven, who insists on having a picture of Griet. Vermeer seems not unwilling, however, to undertake this task, which intimates that he has some interest – perhaps aesthetic, perhaps erotic – in Griet. If not possessed in the flesh by van Ruijven or Vermeer, Griet is possessed iconically and substitutionally

through the painting. The painting also proves to Catharina that Griet is a 'thief' (214), on the grounds that the pearl earring visible in the painting can only duplicate the earrings from her jewellery box. Even as it proves her guilt in Catharina's eyes, the painting silences Griet, for no one allows her to explain how she came to wear the earrings in the first place. Griet claims that she never has a good look at the finished painting before it passes into van Ruijven's parlour. In no sense does the painting, as an exchangeable commodity, belong to her even though it represents her.

The ambiguity of Griet's status is summed up by a refrain in the novel that rings modulations on the word 'free.' Van Ruijven imagines that 'a maid came free' (141), meaning that he can prey upon her sexually without consequences. Van Ruijven has already ruined at least one other young woman without penalty. A maid may appear free to a gentleman like van Ruijven, but the maid herself knows better: she comes with a price. Pieter calculates Griet's value at 15 guilder, the accumulated amount that the Vermeers owe for meat. '"Now I know what a maid is worth"' (220), says Pieter. He means that he owns Griet because he has acquired her for a bad debt. Not free, a maid can be had for 15 guilder. These valuations compromise Griet's last statements in the novel after she repays this debt: 'Pieter would be pleased with the rest of the coins, the debt now settled. I would not have cost him anything. A maid came free' (233). Echoing van Ruijven's phrase, the sentence shifts emphasis from 'free' to 'came.' In an economy where no maid is free, she can attain freedom by buying herself out of the debt owed to Pieter. If, for Pieter and van Ruijven at least, Griet can be priced in an economy of debt and ownership, Griet pays the cost of her autonomy twice over: with money and with her body.

Griet has one recourse from the circuits of economic exchange: hiding. Small in stature, she haunts small, recessive architectural spaces. She sleeps in a hole under Vermeer's house before moving to a loft in the attic. With Maria Thins's and Vermeer's collaboration, she hides as best she can from van Ruijven, even though he ultimately seeks her out in the 'enclosed space' (188) of the courtyard. On her last day at the Vermeers', she hides again in the courtyard to await her fate. On other occasions, she hides in alleys with Pieter. While concealing her person, Griet hides her emotions as well. Although Pieter notices that unspoken feelings 'hide' in Griet's eyes (160), he decides 'not to worry about what [she] might be hiding' with regard to her helping Vermeer (174). Her hidden emotions correspond to hidden body parts. She keeps her

hair modestly concealed under a tight-fitting cap. Suddenly switching to a third-person objective self-presentation, she claims that she keeps her hair 'completely hidden' to tamp down another untamed 'Griet who would stand in an alley alone with a man, who was not so calm and quiet and clean' (122). Hiding parts of her body as if they were the correlatives of her secret identity, she keeps this passion leashed. In the same vein, after she pierces her ears, she hides the holes so that no one will know what she is up to.

Not just prone to hiding her feelings, Griet hides objects. Initially she leaves her few possessions unguarded in her basement cubbyhole. She subsequently learns the necessity of subterfuge: 'I hid the broken tile, my best lace collar, which my mother had made for me, and my finest embroidered handkerchief ' (151). Maertge retrieves these objects from their secret hiding place after Griet leaves the house. Hidden objects come to light again, just as Griet's hair tumbles from under her bonnet. So, too, Griet hides certain activities within the household, specifically her participation in Vermeer's painting, but these activities eventually surface. In this regard, the object signifies the function of the detail. Hidden and revealed content appear in the object, but only if hidden things are treated as meaningful. *Girl with a Pearl Earring* therefore questions whether value diminishes or increases when people and objects are hidden. Griet may augment the value of her things by hiding them from Cornelia. She hides her labour for Vermeer as assistant and subject, but the revelation of her hidden activities, whatever value they may grant to the painting, costs her her job. A hidden object or a hidden sentiment cannot remain hidden forever. Yet something hidden may increase in value because it is hidden.

Hiddenness has moral implications in *Girl with a Pearl Earring*. Griet hides the truth on multiple occasions. She protects her position and feelings by disguising them. She lies. While still living with her parents, she protests that she 'did not often lie' (6). As a maid, she acquires the habit of lying with surprising speed. She neglects to tell Catharina that she helps Vermeer, in order, she imagines, to protect her master. She gets tangled in a web of mendacity about wearing Catharina's pearl earrings. As Griet says, 'I began to get used to lying' (107). Sometimes she lies by omission. She lies to her father about spilling a jug of ale, a lie that 'hid a much greater lie' (93), namely, that she assists Vermeer in his studio. Her labour as an artist's assistant cannot be disclosed because of the separation of spheres between women's domestic work and men's cultural production. In contrast to her many fibs to others, Griet thinks

that Vermeer sees all of her secrets: 'I could not hide things from him. I did not want to' (184). Although this declaration exposes her yearning for Vermeer and her openness to his attention, it also intimates Griet's investment in the power of the artist's gaze as a force superior to her own to which she yields. To some eyes, nothing is ever truly hidden, or so she wishes to believe.

Hiddenness is chiefly a quality attached to objects. Objects regulate consciousness and perception in *Girl with a Pearl Earring*. Every object awaits concealment, just as every non-material event, invisible until materialized, seeks its objective correlative. Griet measures the world according to physical equivalents. In voices she hears 'polished brass' or 'a flagon' or 'rich carpets' (3), as if timbres had tangible properties. Most objects, however, function as commodities. Their semantic function not restricted to aesthetic value, they possess exchange value in commercial or erotic economies. A man poling his barge along the canal vows to retrieve Griet's pots in exchange for kisses, according to the rationale that a manly act of retrieval entitles him to some erotic return. The eroticism of objects is borne out in Griet's willingness to pierce her own ears in order to sport Catharina's earrings; not only does Griet concede to piercing her own ears, an action that Vermeer calls a 'woman's detail' (198), but she also treats the pearls as an externalization of her erotic submission to Vermeer. As if demonstrating the Freudian principle of condensation and displacement, the object reveals what would otherwise have remained secret and hidden.

In this novel, characters tussle for control over each other through objects. Hidden objects increase the stakes of dominance and subjugation. As a maid, Griet feels that anyone at any time may accuse her of theft. In Chevalier's novel *Falling Angels*, the maid Jenny Whitby steals spoons, a few at a time, from 'an old silver set in the sideboard' (184) and makes off with 'the rest of the missus's silverware' (281) when fired. Maids glean or snatch objects from time to time to supplement their wages. When Griet's brother enquires about the value of objects in the Vermeers' house, she gives evasive answers. Her chief troubles, however, arise from battles with Cornelia over objects. Cornelia tosses a pot into the canal simply to spite Griet. She breaks Griet's tile. In another act of malice, she plants a valuable comb belonging to Catharina among Griet's belongings, at the same time as she steals Griet's comb and hides it in a conch. Breaking an object compromises ownership. Owning an unbroken object, its value theoretically intact, is preferable to owning a broken one. Cornelia's malicious breaking of Griet's tile

attacks family bonds, all the more because Griet sees herself and her brother in the figures of a boy and a girl painted on the tile.

Although Griet hoards her few objects, they do not withstand breakage. As in *The Music Lesson* and *Girl in Hyacinth Blue*, the objects in *Girl with a Pearl Earring* scarcely survive the depredations of time and human interference. Even objects arranged in a still life for one of Vermeer's paintings lose their aura when separated upon the completion of a canvas: 'the letter, the cloth, the ceramic pot lay without meaning, as if someone had simply dropped them onto the table' (70). Only the painting holds together the objects and their meaning once they have been disassembled. Representation thus stands in opposition to the breakage inflicted upon groups of objects. Numerous objects in *Girl with a Pearl Earring* break. Vermeer deliberately messes up the colour scheme of Griet's cut vegetables to test her. Griet lies about breaking a mirror. Maladroit Catharina breaks objects as a matter of course. She spreads disorder wherever she goes; she pays so little attention to objects, except when she can use them for revenge or retaliation, that she does not respect their arrangement or inherent meaning. She knocks a knife off the table in Griet's parents' kitchen. Through clumsiness, she breaks van Leeuwenhoek's camera obscura. While pregnant, Catharina is still clumsy but allegedly breaks 'fewer things' (187). Unobservant, she plods into situations where she does not belong, which leads her husband to bar her from his studio. '"She never checks, she never notices"' (51), says the cook Tanneke about the mistress of the house. Whereas Vermeer paints moments of calm introspection, his wife contrives to keep everything 'in a state around her' (80), specifically a state of disorder, hurry, and mishap. The fabulistic aspect of *Girl with a Pearl Earring* emphasizes the confrontation between disruption and organization as an aesthetic inevitability. Art triumphs temporarily over forces of disintegration and desecration.

When Catharina tries to stab the painting of Griet with a knife in a gesture of Dorian Gray-ish desperation, she substitutes the painting for the person. Vermeer catches his wife's wrist 'just before the blade touched my eye' (215), as Griet describes the near miss. In her use of pronouns, Griet as narrator maintains the equivalence between representation and reality: her painted eye is still her eye. Were Catharina to damage the painting, she would administer punishment to several people. Mutilating the painting would punish Griet by substitution. Punishment would also extend to Vermeer for secretly painting a maid. Catharina complains that Vermeer has never painted her portrait. The

painting, as resonant object, seems to defy Griet's status as maid by conferring on her the status of portrait-worthy individual. By stabbing at the picture, Catharina relegates Griet to her status as a maid. She implicitly denigrates the picture as well. Although it has exchange value as it passes from Vermeer's hands to van Ruijven's, Catharina defies that value. The 'world' (214) inside Vermeer's paintings does not include Catharina. Her klutziness around objects and her habit of breaking things, seen outside the realm of exchange and aesthetic values, provide a salutary counterpoint to Vermeer's and Griet's overestimation of material objects. Breakage is one solution to the tyranny of objects.

Hiding objects provides another solution to the tyranny of objects. As a parable about the mighty labour exacted by art, *Girl with a Pearl Earring* valorizes the value of hidden things. Chiefly, the pearl earrings that Griet wears for the portrait are objects hidden in plain sight, at least when they appear in the painting. Catharina owns the earrings, but Vermeer demands that Griet wear them. Therefore Maria Thins takes them, passes them to Griet, who hands them to Vermeer to insert into her ears. From lustrous material baubles, the earrings become representations: details required to finish the painting. Although Griet typically intervenes in her master's compositions with subtle suggestions, when she sits for her own portrait she refuses to arrange his paints or suggest how the painting should look. She realizes before Vermeer does that a lustrous 'point of brightness' (191) – a detail of light – will complete the painting. The earring will harmonize the disparate parts of the face: 'Without it there were only my eyes, my mouth, the band of my chemise, the dark space behind my ear, all separate. The earring would bring them together. It would complete the painting' (195). In this regard, the painting exceeds reality, just as the lustrous point of brightness added by the pearls provides a detail that exceeds the meaning of the representation. Despite the incongruity of a maid wearing pearls, the detail gives aesthetic finish to the painting, like the glistening beads of light in Dutch *pronk* paintings.[11] The shiny detail is not justified in terms of authenticity. The painting demands the detail without justifying the demand.

Upon his death, Vermeer leaves the pearl earrings to Griet. The pearls convert from reality, to representation, then back into the reality from which the lustrous detail was derived: the effect of light on pearls. Just as the pearls are left over as material objects after they are painted, objects to be willed and distributed as part of an estate, the painting requires its

representation of excess, the glimmer of the pearls against skin. After she scoops the pearl earrings from Catharina's table, Griet holds them in her hand; the touch of the pearls returns her, by a series of substitutions, to the moment when Vermeer touched her ear to insert the earrings, then brushed his fingers along her face and neck. In a moment of pique, Griet thinks of using the gesture for revenge. Addressing Catharina in her mind, she says, "'Your husband touched me, here, in this room'" (214). More practical than sentimental, Griet sells the pearls for 20 guilder. She gives 15 guilder to her husband to pay off the Vermeers' long-standing butcher bill and hides the balance in a place where neither her husband nor her sons will look. The 5 guilder, which she holds 'tight in [her] fist' (233) – an image that brings together both her fascination with hands and her tendency to hide things – replace the pearls in a sequence of exchanges that are not fully exchanges.

In *Girl with a Pearl Earring*, objects and their images change places. In the most obvious substitution, real pearls transform into images in Vermeer's painting. Yet Vermeer's bequest of the pearls to Griet complicates the sequence of substitutions. In a manner of speaking, Vermeer acknowledges and discharges whatever emotional debt he owes Griet when he gives her the pearls. By the same token, selling the pearls discharges all of her debts. The 5 guilder that she hides stand for the unrepresentable in the narrative, the residue of the story that has no equivalent. Unlike paintings or pearls, money tells no story. Griet's stash of money is the surplus that remains after art has completed its transaction with reality. She treasures the money as the substitution for the details of the story that she will not divulge. Converted into a cash equivalent, the detail can be spent anywhere as a form of arbitrary value. Chevalier's manipulation of details creates a structural analogy: details are to artworks as money is to economies. The detail negotiates values between unlike things. The detail is an excess, a surfeit, an exuberance, an abundance. The detail as a remainder, in the sense of something left over, defies sequence yet imposes its consequences on narrative. A poetics of the detail might begin with this insight: details are not valuable in themselves, but function as the repository of value, placing emphasis here or there, while always keeping something secretly in reserve.

3 Ornament: Books in *A Case of Curiosities* and *Salamander*

Enchanted Books

In an essay published in 1890 called 'On Books and the Housing of Them,' W.E. Gladstone, the former prime minister of Britain and a life-long reader, expressed disdain for 'highly ornamental bookcases' that detract from the real objects of pleasure in a collection: books. Gladstone writes, 'books want for and in themselves no ornament at all. They are themselves the ornament' (391). Although he decries the 'flaring ornamentation' (388) of some late Victorian bindings, he does not pursue what it means to call a book an ornament. Gladstone appears to think that the contents of a book, not the cover, should be thought of as adornments. Books can be ornaments insofar as an author's labour has no value outside the putative remunerations of cultural capital. Ornament therefore invokes forms of excess. Nothing compels someone to write a book, just as nothing compels anyone to read a book. Aesthetic merit has no measurable, absolute market value. In this sense, all culture is ornamental.

Allen Kurzweil's *A Case of Curiosities* and Thomas Wharton's *Salamander* investigate the material and aesthetic value of books. Books, as physical objects, are ornamental because they resist reference to the industrial means of production. Paper, ink, typesetting, and binding combine to create the commodity known as a book. Despite being a commodity, the book represses the modes of its production in favour of its abstract qualities. The merit of a book, readers like to claim, lies not in its cover, but in its ideas or stories. Yet to make a book by hand, as happens in *Salamander*, is to invoke the materiality of the book as ornamentation. Gossamer-thin paper and tooled leather bindings appeal

to the sense of touch. Books are not just their contents, but their material form. If books are commodities, the handmade book, combining the pleasure and ingenuity of craftsmanship, challenges the idea of the commodity through ornament.

A Case of Curiosities and *Salamander*, both set in the eighteenth century, evoke the undissociated sensibility of artisans. Despite being set in the past, neither novel faithfully re-enacts history. If capitalist modes of production and the pursuit of rationalization have caused disenchantment, the turn to historical settings in these two novels aims to re-enchant production by imagining the pleasures that attend craftsmanship. In an interview, Wharton states, '*Salamander* is more concerned [than his first novel, *Icefields*] with looking for a book that I've always been looking for, that isn't there. And so that's why there's a fairy-tale quality in this book' (Wyile 179). Rather than adhering to fact, historical narrative in *Salamander* and *A Case of Curiosities* allows for the enchantment associated with improbability.

Eighteenth-century settings also allow Wharton and Kurzweil to circumvent two centuries of debate about ornament as an aesthetic category. In their diverse writings about ornament, Immanuel Kant, Karl Philipp Moritz, John Ruskin, and Owen Jones distinguish between an object and its accoutrements, as well as the moral implications of ornament. By contrast, the modernist architect Adolf Loos decries all ornament as degenerate. Siegfried Kracauer, who trained as an architect but wrote for a living, understands modernist 'mass ornament' as the manifestation of functionality within capitalism. *Salamander* and *A Case of Curiosities* do not adhere to a modernist conception of the ornament as degenerate or disenchanted. While harkening back to the wit and voluptuousness of the baroque, Kurzweil and Wharton create an ornamental style characterized by exuberance, digression, narrators' intrusions, and puzzles. In these two novels, ornamentation acknowledges the effects of capitalism while upholding the aesthetic properties of books as objects.

Ornament delivers pleasure. Without worrying about fidelity to life, ornamental narratives offer fanciful solutions to hypothetical problems. Like ornaments in the visual arts, narrative representations in *A Case of Curiosities* and *Salamander* do not purport to be mimetic. Instead of copying the world, narrative posits invented alternatives to the world. In *A Case of Curiosities*, a tinkerer named Claude Page sets himself the task of creating an automaton that can utter a few words through the cunning deployment of machinery. In *Salamander*, a printer named

Nicholas Flood accepts a commission to make an 'infinite book' (40), one that has no beginning or end. Neither an automaton nor an infinite book is, strictly speaking, useful. Why, therefore, do Page and Flood produce such ornamental artefacts?

In contemporary novels, ornament refers to the multiple meanings that objects project into the world. In everyday usage, ornament refers to the superfluous, the decorative, or the excessive. Usually a term of disparagement, ornament implies a difference between excrescence and essence, pleasing surface and formal arrangement of elements. The integrity of a wall does not improve when strips of William Morris floral wallpaper grace it. An unadorned, clay pitcher does not hold water better than a chased, art nouveau urn. The wall remains a wall; the pitcher, a pitcher. The addition of ornament does not alter the function or usefulness of either. At the same time, it is possible to imagine an object that gives itself over entirely to ornamentation and defies any utility whatsoever. An enamelled Victorian vase designed by Victor Simyan and painted by Thomas Allen is a case in point: an eagle tearing out Prometheus's liver surmounts a gaudy reproduction of Rubens's 'The Calydonian Boar Hunt.' The vase, if vase it is, draws attention to its exuberant pastiche of styles and ideas (figure 7). Similarly, painting can prove its ornamentalism by displaying non-mimetic inventiveness and emphasizing colour, line, detail, impasto, surface finish, or efflorescence. Ornamentation implies that an object has recognizable value, if only the value of labour that contributes to creating ornaments without use value. In the distinction that he draws between objects and things, Bill Brown points to what exceeds the material or useful aspects of objects, namely, 'their force as a sensuous presence or as a metaphysical presence, the magic by which objects become values, fetishes, idols, and totems' (5). Ornament literalizes excess by making it visible. According to Brown, what one intuits but cannot articulate about an object contributes to its thingness. Ornament mediates the inexplicable aspects of things by making them visible. Ornament enhances the latent thingness in every object.

Typically applied to physical objects, whether utensils, ceremonial items, or architecture, ornaments fill blank space and proclaim the cultural and social importance of the adorned object. Writing about ornament, Karl Philipp Moritz comments, 'Der Schnalle am Schuh, dem stählernen Knopf am Kleid gibt die Durchbrechung des Ansehn von Zierlichkeit und Zartheit, womit die Vorstellung des Leichtzerbrechlichen verknüpft ist, die mit der harten Masse auf eine angenehme

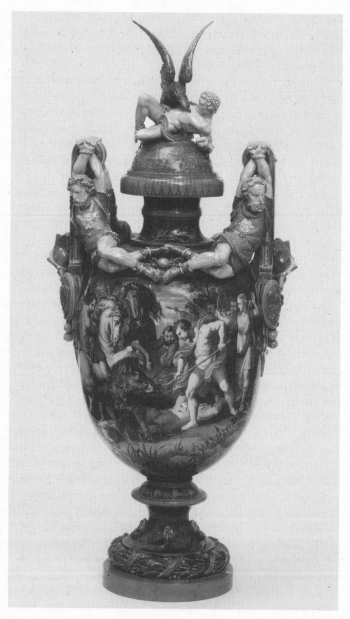

7 Enamelled earthenware Minton vase, circa 1867. Modelled by Victor Simyan.
Painted by Thomas Allen. © Victoria and Albert Museum, London.

Weise kontrastiert' (*Werke* 538–9).[1] In traditional accounts of ornament, such as Moritz gives, ornament breaks up surfaces and creates contrasts. Ornament intimates value, even when value cannot be precisely specified. An invitation to speculation, ornament suggests the complex uses to which an object can be put or, more exactly, its perceived value within a system of objects. Ornament heralds subtlety in objects, what Bill Brown calls 'metaphysical presence,' that might otherwise pass unnoticed were it not rendered as a surface appearance. Ornamentation makes abstract assumptions about objects concrete and thus intimates the inevitability of translating metaphysical meaning, however abstruse, into visible patterns.

Art historians and architects have dominated theoretical debates about ornament. In architecture, the term refers to volutes, brickwork, gargoyles, friezes, and other finishing details. In painting, the word designates colour, borders, drapery, and almost anything that does not contribute to essential form. William Dyce, a Victorian painter, unapologetically declares, 'The love of ornament is a tendency of our being ... ornamental design has had its birth long before the very conception of the fine arts' (qtd in Böe 318). In his compendium of international styles called *The Grammar of Ornament*, published in 1856 with copious illustrations, Owen Jones, the architect who designed and outfitted the interior of the Crystal Palace and who also published a book about Moresque ornament in the Alhambra, calls the impulse to ornament an instinct (figure 8).[2] Every society, Jones claims, has a tendency to ornament objects, 'and it grows and increases with all in the ratio of their progress in civilisation' (31). Fine arts arise from the primordial desire to enhance things with ornament. In Jones's view, the more civilized a society, the more ornament it applies. Visual ornamentation first appeared in the Upper Palaeolithic period between 35,000 and 12,000 years ago. Twentieth-century abstract art, in some respects, merely returns to its origins in non-mimetic decoration. In Wendy Steiner's opinion, the aesthetic imperatives of twentieth-century abstraction carry with them the possibility of 'a virtual collapse of the distinction between ornamental and pictorial art' (61).

Notwithstanding Dyce's comment that ornament precedes the fine arts, art historians suspect something tainted or seductive about ornamentation and bracket it off from painting and sculpture. In *The Sense of Order*, E.H. Gombrich warns that 'ornament is dangerous precisely because it dazzles us and tempts the mind to submit without proper reflection' (10). Gombrich resists bedazzlement in favour of intellec-

8 Hindoo ornaments, drawn by Owen Jones, *The Grammar of Ornament*, 1856.
Courtesy Rare Books and Special Collections, McGill University Library.

tual appreciation of art. Following such logic, restraint in or outright rejection of ornament breeds a proper sense of spirituality. Summarizing eighteenth-century arguments against the excesses of the rococo, Gombrich points out that notions of ornamentation often evoke literal interpretations of reality. That a stone column designed to look like a slender flower stem holds up a building is fanciful, but not rational: flimsy stalks cannot support the weight of roofs. Furthermore, the scale between flower stem and building is miscalculated. Because the ornament depicts an impossibility, the image deceives the viewer (18–25). Yet the luring of the mind into meditation, if not submission, by curvaceous lines and complex designs may also liberate the imagination. Herbert Muschamp, discussing the pleasure that he felt as an adolescent looking at the ceilings in a Broadway theatre, states that ornament 'did more than reflect the material excesses of a gilded age. Ornament established a sense of scale. It helped to relieve the sense of confinement, enabling an enclosed space to feel as expansive as the world outside, a globe seen from within. It aided acoustics, reduced tedium and showed by example that the imagination is generous' (32).

The vocabulary of ornament in architecture and painting applies to books and narratives. Books cannot be separated from advances in technology or from the tradition of ornamentation. The history of book decoration begins with incunabula. Woodcut illustrations in fifteenth-century books imitated illuminated manuscripts. Decorative borders and images supplemented the words in early printed books (Snodin and Howard 24). In the absence of tables of contents or indexes, illustrations divide blocks of text and orient readers. Such ornaments did not arise out of thin air; they belonged to well-defined traditions. Designs for the ornamentation of buildings, censers, reliquaries, *parures*, and all manner of other objects circulated widely in Europe from the earliest years of movable press printing. 'Pattern books,' as they were called, enabled artisans to share and copy designs; circulating folios standardized ornamental styles. Such volumes of engravings were unbound, as were, of course, most books, the better to extract and imitate, adapt and apply designs. As H.J. Jackson observes, until the middle of the nineteenth century, 'it was relatively easy to order a book bound with a blank leaf (or, less commonly, two blank leaves) following every printed leaf, so that for every page of text there was a blank page facing to accommodate the reader's notes' or drawings (33). The history of the book therefore has a close connection to ornament, a receptivity to annotation and active reading.

Nowhere is the sense of the book as decorative more acute than in contemporary fiction. As early as 1982 Robert Jensen and Patricia Conway proposed that 'ornamentalism' displace the less descriptive term 'postmodernism': 'Ornamentalism is characterized by a fascination with the surface of things as opposed to their essence; elaboration as opposed to simplicity; borrowing as opposed to originating; sensory stimulation as opposed to intellectual discipline. Sometimes it attempts to fool the eye, favoring humor and illusion over the honest expression of structure and function upon which Modernism has so long insisted' (2). Jensen and Conway conclude that ornamentalism, while abandoning the machine aesthetic promulgated by modernists, 'dances on the surface of technology, using it but denying its aura' (23). *A Case of Curiosities* and *Salamander* express fascination with machinery – especially watches, automata, toys, and printing presses – without fetishizing machines as indispensable to the making of things. Claude Page in Kurzweil's novel prefers handcrafted artefacts; the sight of a 'steam-operated assembly line often made him queasy' (359). Both novels advocate the pleasure occasioned by objects and their making, alongside an appreciation of the ingenious technology of machines.

Books enchant as commodities and as aesthetic objects. *A Case of Curiosities* and *Salamander* advance definitions for the polymorphous term *book*. In the first instance, books are material objects. They assert themselves in physical space, yet they also circulate. As objects of exchange, books are the personal property of individual owners, although in principle a book can benefit more people than just the owners. By the same logic, books need not have any benefit at all for their owners, either to divert or to instruct. '*Do booksellers read their books*,' wonders a character in *Salamander* (5). Irena, in the same novel, remembers that her father 'wished to own books [...] Not read them' (349). The bookshop proprietor Lucien Livre in *A Case of Curiosities* agrees: '"Books are bought less to be read than to be owned. You forget that I am an agent of their distribution. There is nothing finer than an old, perfectly preserved book. Read or unread doesn't much matter"' (99). Viewing books as chattels nullifies their intellectual or narrative content. To preserve a book in pristine condition increases its value as a collectable rarity, but minimizes its value as a temporal, readerly phenomenon. The distinction between modernity and postmodernity, figured as disenchantment and re-enchantment, plays out in miniature in the understanding of the book as a commodity and the book as an abstraction, the book made by an author and the book inhabited by a reader.

In *A Case of Curiosities*, Livre lives up to the plural meanings of his surname; *un livre* in French means a book, but *une livre*, in the feminine, means a pound, in the sense of weight and currency. Livre himself uses *livre* as a monetary term. He asks his assistant Claude to memorize '"the names of the authors and the complete titles and dimensions of their works, but also the costs of rental, and the costs, too, of the subsidiary services we provide to our customers [...] The cost [of a sodomitical text called *The Servant's Pleasure*] is two livres, six in unbound octavo"' (163). Livre emphasizes the volume of sales and the profitability of books: so many transactions equal so much money. The dimensions of the book factor into rental costs, which increase according to size not quality. Livre traffics in pornographic material; these 'philosophical' works (187), as they are euphemistically called, circulate among Parisians not for their formulaic stories about lascivious priests and nuns, but for the erotic abandonment that the stories inspire. Livre violates Kant's distinction between personal gratification that is felt vis-à-vis an object and the disinterestedness that constitutes aesthetics, the difference between viewing a nude as an extension of desire or as an example of high art.

Salamander also presents the erotic possibilities of books, but its principal narrative line concerns the making of books. Characters track down the right materials and technologies required to fulfil the commission for an infinite book: paper, ink, type, chase, and press. Because books transmit information, whether technical or narrative, they qualify as a technology. Efficient and lightweight machines, books sort, store, retrieve, and disseminate data. Indexes, for example, are retrieval devices. One of the chief virtues of books is their portability; regardless of where a reader is, he can access the information inside a book by opening its covers. In *A Case of Curiosities* and *Salamander*, books possess physical properties and metaphysical intangibility. They provide information about technology even as they transcend technology by offering content beyond the individual components that constitute them. Books thus bear meaning in excess of their materiality, and this excess constitutes their ornamentalism.

A Case of Curiosities begins with a purchase at the Salle Drouot auction house in Paris in 1983. An unnamed narrator buys an eighteenth-century *memento hominem* case filled with small objects. An Italian art historian, who covets the box, tells the narrator what the items mean: '"Each object in the case indicates a decisive moment or relationship in the personal history of the compositor. The objects chosen are often commonplace; the reasons for their selection never are"' (xi). 'Composi-

tor' refers to the person who assembled the box, but another meaning of 'compositor' – someone who assembles type for printing – shadows the term. The *memento hominem* case, with its various compartments, resembles the boxes that separate letters and punctuation marks in a compositor's type-case. The narrator, who owns the box, wonders, 'What was so potent about these protected objects? Was it that my world was kept out? Or that some imaginary world was kept *in*?' (xii). Compelled by the mystery of the compartmentalized artefacts, the narrator articulates the obsession of a collector: 'I did not take possession of the case; the case took possession of me' (xiii).

The objects form an enclosed world that incites speculation but keeps the narrator's world at bay. Underplaying his presence, the narrator withdraws from *A Case of Curiosities*, except for casual asides about etymology or historical fact. He apparently has access to Claude's personal papers; he finds Claude's copybook 'all but impossible to decipher' (309), because 'the paper was cockled, the writing illegible' (310). The narrator, more fantasist than historian, focuses on the objects in the case rather than Claude's textual remains. Inducements to contemplation, the objects, boding the secrets of an 'imaginary world,' overwhelm the narrator's subjectivity; the compartments substitute for his interior life. The interrelations of the contiguous objects in the case – a bell, a doll, a pearl, a morel, a linnet, a nautilus shell, and so forth – create a story. This story may be entirely fictitious, despite the narrator's claims to factual 'investigations' that put him into communication with 'experts at the Wellcome, at the Smithsonian, and, of course, at the French National Library' (xiii). Assembled in a different sequence, the objects might tell another story altogether.

Similarly, a unique book as an object enchants Irena in *Salamander*. Flood writes her name in glow-in-the-dark ink in the spaces between lines of a sermon. The sermon, ironically, is called *Desire*. Irena is a bookworm. Her father, Count Ostrov, rarely sees her 'without a book in hand' (24). She inventories all the books that arrive in his castle. Endowed with a freakish gift for recollection, she memorizes texts at a glance. Perusing some new acquisitions, Irena discovers inside a book called *A Conjectural Treatise on Political Economy* a cavity that contains another book, and inside that cavity 'yet another book even smaller, and within it, another, and yet another within that' (25). When she finally reaches the last, microscopically tiny book, she deciphers a single sentence that expresses the entire content of the nested volumes: '*The great do devour the little*' (25). The book, filled as it is with cavities and

volumes-within-volumes, provides a physical illustration of its thesis on political economy. The puzzling objects in *A Case of Curiosities* and the curious books in *Salamander* express recessive interiority, which is one manifestation of infinity – an approach to smallness that has no end. Both novels treat objects as inherently narratable. Objects have stories to tell, and those stories remain rooted in the mystery of physical entities: a button, a jar, a book.

Theories of Ornament

The cultural and social codes attached to ornaments create a syntax, as James Trilling implies in the title of his book *The Language of Ornament*, a title that echoes Owen Jones's *The Grammar of Ornament*. Trilling defines ornament as '*elaboration that relies primarily on the appeal of stylized or non-representational form*' (14). By stylized, Trilling means identifiable shapes – vegetation or animals – in recognizable but not mimetic copies. The syntax of ornament has grammatical features such as colour, symmetry, detail, and repetition. Geometric or organic patterns organize visual material and thereby establish the syntax of ornament. In ornamentation, details accumulate; indeed, ornamentation might be defined as the filling of space with details, one by one. Naysayers denounce excessive detail as an inherent danger in ornamentation (Snodin and Howard 63). Because ornamentation is a game of invention and elaboration, no details can be said to be the correct ones, and no number of details can be defined as the perfect number. In narrative, no reader can forecast which passages ornament the plot, in the sense that some pages or paragraphs might be skipped without injuring the overall meaning of a novel. Even if all passages are essential, not all passages are read with equal intensity. Just as the syntax of visual ornament is not reducible to a single meaning, fictional narrative, despite its ornamental details and expository elaboration, does not add up to one unequivocal interpretation.

Consequently, ornament may seem irrational or even uncivilized; it proliferates without apparent order. Medieval commentators suspected that church decoration was 'infected with moral degeneracy' (Coldstream 9). As Adolf Loos claimed in his 1908 screed, 'Ornament and Crime,' ornament proves cultural degeneration, ill health, even arrested development: 'Ornament is not merely produced by criminals, it commits a crime itself by damaging national economy and therefore its cultural development' (32). In opposition to Owen Jones's view that ornament bespeaks civilization, Loos proclaims that culture advances

through repudiation of ornament: *'The evolution of culture is synonymous with the removal of ornament from objects of daily use'* (30). Whereas Jones interprets intricacy as a sign of cultural maturity, Loos views intricacy in ornament as a form of debasement: 'The lack of ornament is a sign of intellectual power' (36). In Loos's grim version of modernism, ornateness detracts from efficiency, either in the production of objects or in their deployment. Loos objects to the uselessness of ornament as well as its obscure and undeveloped syntax, akin to the language of a child. What passes for natural expression in a child, Loos asserts, 'is a symptom of degeneration in the modern man' (30). Whereas Owen Jones considers ornament a sign of civilization, Loos associates ornament with primitivism. For many modernists, the paring away of detail to reveal geometric simplicity led to the recovery of primitive or elemental shape, as in Constantin Brancusi's or Henry Moore's sculptures. Anti-ornamentalism, as an impulse within modernism, expresses anxiety about the decorativeness of art. According to Loos, the only viable evolution in culture and national economy comes from an unshakeable commitment to functionalism: all ornament is useless.

Notwithstanding Loos's caterwauling, art historians claim that some ornaments have useful properties. Snodin and Howard point out that clothes and body ornament confer social distinction and differentiate classes (94). When aristocrats or the wealthy middle classes handed down clothes to servants, they stripped all filigree and telltale finery from the vestments, as happens when the protagonist of Samuel Richardson's *Clarissa* gives her maid a dress. The practicality of ornament depends on the medium in which it appears. Jensen and Conway observe that ornaments on buildings 'orient people' (3) by telling them where to enter and how to move through built spaces. Ornaments provide scale by 'breaking down the mass of a building into smaller pieces that relate comfortably to the human observer' (Jensen and Conway 4), a function inevitable in skyscrapers or other buildings that vastly exceed human scale. Function might have nothing to do with use per se, but might concern the perception of necessity. Interlace patterns, which feature rope-like lines and knots of daedal complexity (the sort found in Gordian knots and Celtic designs), once staved off spells or consolidated curses: 'magical protection could be built into a knot, which the aggressor must untie for the attack to work' (Trilling, *Language* 135). As a design invested superstitiously with magical powers, interlace may not be ultimately effective (figure 9). Ornament expresses the logic of the need, not the need itself.

9 Celtic ornaments, drawn by Owen Jones, *The Grammar of Ornament*, 1856. Courtesy Rare Books and Special Collections, McGill University Library.

Practicality aside, ornament conveys tensions between grace and strength, movement and stasis, stylization and literalism, virtuosity and fidelity to materials, comprehensibility and complexity, hierarchy and usurpation (Trilling, *Language* 11). Ornamentation generates more ornamentation, which demonstrates the imagination of the artist, not the truth of an object. Ornament, proceeding from the imagination, exhibits virtuosity of design through symmetry, asymmetry, fluidity, grace, and cleverness. Because it issues from the imagination, ornament is suspect, for it might bespeak the diabolism of a human creator. Non-mimetic design cannot be checked against reality, which makes it more suspect. Aristotle, resorting to pictorial analogies in *Poetics*, wonders how a spectator can judge the quality of an imitation if he has not seen the thing copied: 'if you happen not to have seen the original, the pleasure [of the art object] will be due not to the imitation as such, but to the execution, the colouring, or some such other cause' (51–2). Several meanings issue from Aristotle's observation. First, aesthetic appreciation need not derive, or need not only derive, from invidious comparisons with reality. Colouring and execution in their own right inspire appreciative pleasure as virtuosic elements in representation. Art itself need not be imitative; a spectator may not have happened to see the original, because that original may not exist and might never have existed. Many Renaissance painters never set eyes on a mermaid, a Greek god, or even a lion for that matter, but they did not hesitate to paint or sculpt such marvels. Ornament thus captures what is unknown but strongly suspected. Aristotle, while sketching a poetics of drama and epic, inadvertently allows that ornamentation in itself – colour, execution, 'or some such other cause' – has intrinsic merit.

The medieval, Renaissance, and baroque acceptance of ornament as intrinsic to objects should not be dismissed lightly. The labour-intensive production of ornament, whether mosaic tiles or curlicues painted on panels, is as ideologically determined as the relegation of ornament to the status of craft. Aesthetic discourses justify an appreciation of objects but dismiss the ornamental properties of those objects. Martin Jay documents the fraught discourse that evolved around the problematic status of beauty, as the chief locus of aesthetic contention in the late eighteenth century. The focus on beauty attests to a structural shift in the understanding of what constituted art objects:

The recontextualization of such objects [i.e., representations of sacred events or personages] in the heterotopic, atemporal space of the public

museum – the classical example being the transformation of the palace of the Louvre during the French Revolution into a repository of the nation's cultural patrimony – accompanied and abetted the new discourse, which also emerged in the wake of an accelerated market for objects of beauty by private collectors outside of the aristocracy or the church. Concomitant with the change was the new distinction between fine artist and merely skilled artisan, neatly symbolized by the decision to exclude engravers from the newly created Royal Academy of the Arts in London in 1768. (5)

The professional distinction between artists and artisans, or more specifically painters and engravers, reinforces a corollary distinction between the products of each. Engravers and other artisans produce decorative art, whereas artists produce fine arts. A hieratic aura lingers around desacralized objects that museums house and preserve. Artists appropriate this aura as a quality discernible in fine art. By contrast, artisans, enabled by the factories and machines of the Industrial Revolution, make objects for mass markets. As the story goes, artisans design replicable commodities, whereas artists painstakingly produce unique artworks. This formulation, however, is culturally and ideologically determined to disfavour ornament as a praxis.

Immanuel Kant can be blamed for this perception of the second-class status of ornament. In *Critique of the Power of Judgment*, Kant codifies the difference between artwork and ornament. He sternly insists that the genuine apprehension of beauty, and the consequent pure judgment of taste, must be free of what he labels 'charms and emotions' (108), which derive from personal interestedness in the artwork. Kant subsequently allows 'charms' to buttress a comment about ornaments:

> Even what one calls ornaments (*parerga*), i.e., that which is not internal to the entire representation of the object as a constituent, but only belongs to it externally as an addendum and augments the satisfaction of taste, still does this only through its form: like the borders of paintings, draperies on statues, or colonnades around magnificent buildings. But if the ornament itself does not consist in beautiful form, if it is, like a gilt frame, attached merely in order to recommend approval for the painting through its charm – then it is called decoration, and detracts from genuine beauty. (111)

Kant distinguishes between art objects as form and attachments as decoration. In order properly to be called beautiful, the elements of an

artwork must have an internally coherent form. Anything that does not contribute to the form is superfluous. Using the analogy of a frame to a painting, Kant takes this aesthetic discernment further by claiming that decoration detracts from beauty.

Yet Kant's emphasis on ornament implies a perceptive spectator who can discern essential form from its decorations, whether a building and its colonnade or the human body and drapery combined in statuary. Kantian aesthetics tacitly acknowledges the 'uncoupling of aesthetic experience from the art object' (Jay 14), with increasing sophistication attributed to the spectator who appreciates, in his detached fashion, the formal beauty of the object. Once aesthetics shifts to the subjective experience felt by a spectator, a concomitant bracketing of 'the real-world referent of the artwork [...] in the service of pure fictionality' and the suppression of 'the materiality of the representation itself' occur (14). Experience itself turns aesthetic, as happens in *À Rebours* or *The Picture of Dorian Gray*. Art, once personalized, requires no technical knowledge for appreciation. As a result, the artwork need not represent real-world objects with any accuracy. This proposition causes consternation only if one believes that artworks are supposed to be mimetic.

The trouble with ornament emerges forcefully in Joshua Reynolds's *Discourses on Art*, which he delivered viva voce to students at the Royal Academy between 1770 and 1790. Whereas Kant approaches aesthetics rationally, Reynolds broaches the subject expertly as a professional painter. 'Ornament' bears an uncertain meaning in Reynolds's fifteen discourses, an uncertainty that contrasts with Kant's categorical separation of object and ornament. Because Reynolds wrote the discourses over twenty years for the annual distribution of prizes in his capacity as president of the Royal Academy, they do not demonstrate consistency of thinking on the matters of ornament, detail, and beauty. In the end, he hardly knows whether artists should abandon ornament or embrace it. The polysemic meanings of ornament in *Discourses on Art* arise from Reynolds's uncertain adherence to both particularity and universality as the ends of art. He contrasts the 'merely ornamental' (67) style of Veronese and Tintoretto with the 'great stile [*sic*]' (64) of Michelangelo and Raphael, to the detriment of the former. Reynolds returns to this theme in a later discourse, when he compares heroic passions in painting with 'meretricious ornaments' (129) applied to enhance visual effects. Ornament detracts from the nobility of the great style when it ought to remain subordinate to form. Reynolds disparages 'little ornamental helps' (70), by which he means effects of lighting in Dutch paint-

ing or a superabundance of colourful drapery that makes for the 'mere elegance' (63) of the Venetian school. Without flinching, Reynolds condemns the 'mere matter of ornament' (57) that springs from technical facility, in addition to the 'false, though specious ornaments' (82) that distract the mind from the contemplation of a universal and abstract truth. English national style favours restraint, but not to the point that all pomp and elegance disappear. Reynolds, in fact, wonders why the British empire 'should so long have wanted an ornament so suitable to its greatness' (13). A nation cannot live by trade alone; it requires 'refinement of taste' (171) through fealty to proper ornamental principles.

A noticeable alteration in the meaning of ornament occurs as the *Discourses on Art* proceed. When Reynolds calls ornaments 'false, though specious,' he evokes the Latin *speciosus*, meaning 'fair,' 'plausible,' or 'beautiful.' Ornaments offer beautiful and plausible completion to painting, a finish otherwise impossible to attain. In sculpture, he admires the 'ornament of grace, dignity of character, and appropriate expression, as in the [Belvedere] Apollo, the Venus [de Milo], the Laocoön, the Moses of Michael Angelo' (178). In portrait painting, Franz Hals expresses character nicely, but he lacks 'a patience in finishing what he had so correctly planned' (109), and this lack of finish makes his portraits less convincing or perfect than Van Dyck's. Ornament therefore signifies abstract qualities that bring sculpture or painting to a pitch of 'finishedness.'

The idea of finish emerges from a disquisition on the natural deformity of things, which good art checks and corrects. Reynolds claims that 'the object and intention of all the Arts is to supply the natural imperfection of things, and often to gratify the mind by realising and embodying what never existed but in the imagination' (244). The formulation recalls Aristotle's concession that one can admire virtuosity in lieu of truth. Yet Reynolds grants that the quest for abstract, ideal beauty originates in the imagination. Art makes up for the deficiencies of things by improving them, and thereby finishing them. He believes in the moral and ethical obligations of art, which can be achieved through the pursuit of beauty. In Reynolds's opinion, a painter improves mankind 'by the grandeur of his ideas' (42), and this edifying grandeur stems from the painter's ability to distinguish between the 'deficiencies, excrescences and deformities of things' and their essential form (44). Reynolds phrases this concept in another way: 'the whole beauty and grandeur of the art consists, in my opinion, in being able to get above all singular forms, local customs, particularities, and details of every kind' (44).

Transcending detail in order to render universal truth is all well and good, except that painting, like fictional prose and poetry, relies on the building up of details for its total effect: a gesture, a coiffure, a facial expression, a glove, an atlas, a gown. In the third discourse, Reynolds summarily dismisses details. The painter of genius will not 'waste a moment upon those smaller objects, which only serve to catch the sense, to divide the attention, and to counteract his great design of speaking to the heart' (50). Details distract from the truly important aspects of painting, namely, the larger design and the emotional valence of the work. Details also deceive the eye by persuading it toward inessential planes and meanings. Only details that contribute to the elaboration of the 'great design' matter. In the fourth discourse, Reynolds admits that 'minuteness and particularity frequently tend to give an air of truth to a piece,' yet he insists that 'smaller things, however perfect in their way, are to be sacrificed without mercy to the greater' (58). Portrait painters tend to go in for petty effects, what Reynolds calls 'the little style' (69), constituted of the 'little ornamental helps' that he despises (70). Littleness, insofar as it functions as a synonym for detail, accentuates 'blemishes' or 'deformities' (102). Despite this quibbling over the contribution of visual detail to taste and overall structure, Reynolds acknowledges that a painting without detail is not a portrait, a history painting, or even, by his generic classification, a work of art at all. In the eleventh discourse, he states that 'a Painter must have the power of contracting as well as dilating his sight; because, he that does not at all express particulars, expresses nothing' (192). In the end he cannot recommend 'a neglect of the detail' (197). If, in the early discourses, one hears echoes of Samuel Johnson's dictum about not numbering the streaks of the tulip, in the later discourses Reynolds accepts that particularity and detail augment the artwork.

In the dedicatory letter written on Reynolds's behalf to preface the *Discourses on Art*, Samuel Johnson remarks, 'The regular progress of cultivated life is from necessaries to accommodations, from accommodations to ornaments' (3). Ornament completes cultivation. William Blake, whose Bible was rarely out of his sight and never out of his mind, flew into a rage over this statement. He scribbled a note in the margin next to Johnson's sentence: 'The Bible says That Cultivated Life Existed First. Uncultivated Life comes afterwards from Satan's Hirelings. Necessaries, Accomodations [*sic*] & Ornaments are the whole of Life. Satan took away Ornament First. Next he took away Accomodations, & Then he became Lord & Master of Necessaries' (qtd in Reynolds 285).

Bombast aside, Blake presumes that cultivated life exists in absolute terms, not in any sequence. Ornament, an attribute of divinity, cannot be distinguished from perfection, especially not from the graces conferred by art. Blake, in spite of his hatred for Reynolds, does not differ from his opinions so much as he thinks. In the seventh discourse, Reynolds strenuously argues that 'he who neglects the cultivation of those ornaments, acts contrary to nature and reason. As life would be imperfect without its highest ornaments, the Arts, so these arts themselves would be imperfect without *their* ornaments' (135). For idealistic Blake, a perfect world already bears ornaments, and these are lost through the machinations of Satan's hirelings; for Reynolds, the cultivation of ornaments perfects the imperfect world. Blake strives to return to what has been lost; Reynolds strives to create what never was and has not yet been.

Blake's objection to Reynolds's ideas touches on the problem of the religious motivation and content of ornament. If Gombrich expresses a Kantian unease about the bedazzlement of ornament, he does so out of a will to neglect its specific moral and religious content. John Ruskin, in two chapters devoted to ornament in *The Stones of Venice*, emphasizes that ornament emerges from the natural world and therefore substantiates moral order. Because God authors nature, nature manifests divine rightness. Any ornament modelled on man's labour 'is utterly base' (1:219) because it embellishes human, not divine, virtue. According to Ruskin, the supple curve of a leaf or the line of a mountain range, no matter how extensive its scale, supplies the artist with material for his compositions (figure 10). Nature prevails. Machine-made ornaments and ornaments that defy the intention or scale of architecture offend Ruskin's sensibility. He admires chiselled lizards that cling to a column because they occur in nature and they possess the right scale to enhance the structural element; the stone lizards might plausibly flick their tails and flash away behind the column. By comparison, decorative grilles or miniature elephants affixed to columns distort scale. Elephants are too large for columns; the distortion strains credibility.

Nature should guide ornamentation. In an elaboration of his principles of nature, Ruskin maintains that birds' wings give us 'almost the only means of representation of spiritual motion which we possess, and with an ornamental form of which the eye is never weary, however meaninglessly or endlessly repeated' (1:233). In the Christian schema that motivates Ruskin's art criticism, the natural world completes divine intention: 'all noble ornamentation [is] the expression of

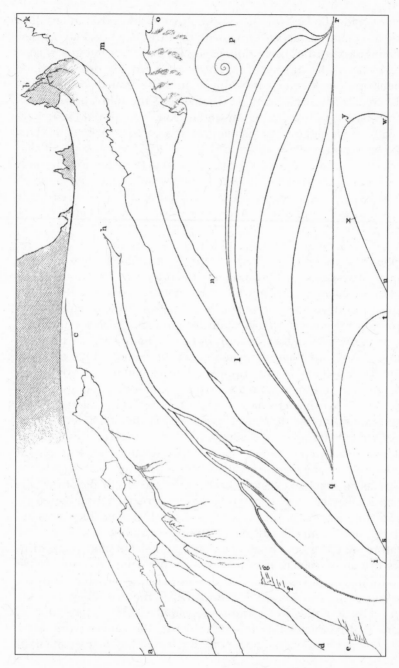

10 Drawing of lines found in nature, by John Ruskin, *The Stones of Venice*, 1851.

man's delight in God's work' (1:211). Any ornamentation drawn from
nature, without necessarily imitating nature exactly, could be justified,
providing it fits the object that it adorns. This premise allows the divi-
sion of ornament into hierarchies, each magnifying divine work. Al-
though Ruskin alleges of ornament that 'you cannot have too much if it
be good,' he hastens to add that ornament should be 'governed' (1:257)
by proportion and taste.[3]

Blake's and Ruskin's understanding of ornament as an attribute of
divinity enables a reinterpretation of the modernist dismissal of orna-
ment. God in Christian theology possesses unity, but unity cannot be
grasped unless it is subdivided into component parts. Each separate
part magnifies divinity. Hence ornamentation in parts – decoration
through details that cause the eye to linger over the object – enhances
divine perfection. Secular modernists prefer to see an object as in itself
it really is, that is, free of adornment of whatever kind. The unorna-
mented object expresses fearless godlessness. Blake, on the other hand,
asserts that divinity begins with its ornaments and accommodations,
and that the secular world loses those attributes. If Ruskin adheres to a
moral order that springs from nature, that moral order is no less com-
mitted to a theological plan and the ornamentation that divine majesty
arrogates to itself. Traditional ornament serves a purpose beyond itself.
When Reynolds voices doubt about the need for ornament in relation to
central design in painting, his doubt arises from his quest for simplicity
and repose in the represented object, features that might lose ground to
detail. With greater conviction, Ruskin claims that ornament is subser-
vient to the buildings or paintings that it adorns. If, in Ruskin's opinion,
the Arab artist 'made his architecture a glittering vacillation of undis-
ciplined enchantment' (1:235), the proper application of ornament in
Christian architecture produces 'glory' (1:247). Ornamentalism in con-
temporary fiction does not in the least mark a turn to religious beliefs.
Instead, the ornamental style as practised by Kurzweil and Wharton,
with its multiplication of detail and beautiful effects, elicits enchant-
ment through wondrous objects.

In an essay called 'Ornament,' Ananda Coomaraswamy recapitulates
to some degree Ruskin's claims that ornament promotes divine glory.
Rather than fulfilling aesthetic requirements alone, adornment makes
the qualities of divinity 'manifold in their relations and intelligible'
(252). To adorn something 'enhances its effect, empowering it' by mag-
nifying its innate properties (244). As Trilling claims, ornament fulfils
an 'anagogic' purpose ('"Meaning"' 59), not a literal, analogical, or alle-

gorical one. The separation of ornament from beauty in an object entails
the failure to apprehend this anagogic purpose, which is to say that the
ideological determinants that made ornament integral to the artwork
prior to modernism have changed utterly. If twentieth-century artists
followed Kant's precepts in their pursuit of beauty, they did so by treat-
ing artworks as independent objects, whether commodities or museum
pieces. By relating ornament to necessity and completion, Coomaras-
wamy recuperates an older understanding of aesthetics, one that by-
passes Kant's segmentation of frame and artwork.

To confirm his argument, Coomaraswamy focuses on the etymologi-
cal origins of 'ornament' in Sanskrit, Greek, and Latin. The Latin verb
ornare means, first, to fit out, furnish, or provide with necessaries, and
only secondarily to embellish (250). The fitting out of an object with
ornament is a necessary completion of the object, not an add-on or ap-
pliqué. Ornament supplements the latent potential of the object: 'What-
ever is in this sense "ornamented" is thereby made more in act, and
more in being' (244). When Cicero claims in *Pro Archia* that 'books are
an ornament in good times and a consolation in bad' (*Defence* 296), he
means ornament as a necessity, not an embellishment: 'haec studia ado-
lescentiam alunt, senectutem oblectant, secundas res ornant, adversis
perfugium ac solatium praebent' (296).[4] Cicero's use of *ornant* conveys
the sense of completion. Reading only for diversion does not contribute
to virtue and therefore does nothing to assist the public good. Else-
where in *Pro Archia*, Cicero claims that the praise bestowed on wise and
brave Romans belongs to all Romans: 'sed etiam populi Rom. nomen
ornatur' (*Defence* 300). 'All Romans share the praise,' or more literally,
'the name of the Roman people is thus ornamented.'

If ornament completes the artwork, either divinely or aesthetically,
an artwork may never be justifiably finished. In *Modern Painters*, Ruskin
weighs in on the matter of finish with stern advice: 'it ought to be a
rule with every painter never to let a picture leave his easel while it is
yet capable of improvement or of having more thought put into it. The
general effect is often perfect and pleasing, and not to be improved
upon, when the details and facts are altogether imperfect and unsatis-
factory. It may be difficult – perhaps the most difficult task of art – to
complete these details, and not to hurt the general effect; but until the
artist can do this, his art is imperfect and his picture unfinished' (1:413).
A finished picture provides more pleasure to its possessor than half a
dozen unfinished ones, according to Ruskin. Those artists who offer
incomplete pictures for sale ruin general taste and cheapen the 'market

for more careful works' (1:413). The conundrum of completion involves an interplay between general design and detail, as well as the dialectic between market demand and public taste. To supply incomplete pictures to a public willing to buy them undermines the aesthetic of completion. Artists should not cater to the taste for brilliance and fluency of execution if that execution defies finish.

Walter Pater rejoins that unfinishedness is inevitable in artworks. Oriented toward the organicism of the art object as it penetrates the sensibility of the viewer, Pater luxuriates in Michelangelo's unfinished sculptures as exemplars of human spirit breaking through material confinement: 'this effect Michelangelo gains by leaving all his sculpture in a puzzling sort of incompleteness, which suggests rather than realises actual form' (53). Because incompleteness emits the 'breath, pulsation, the effect of life,' it is 'in reality perfect finish' (53). The omission of detail preserves fidelity to the material form of art. Whereas Ruskin dismisses incompleteness as a lack of serious purpose, Pater endorses incompleteness as an opportunity for meditation. Completion occurs in the mind of the spectator.

Even though ornament intimates what lies beyond itself, it cannot communicate the extent or nature of infinity. In both *A Case of Curiosities* and *Salamander*, the image of the infinite is the spiral. The Abbé in Kurzweil's novel adopts the nautilus as his personal symbol because of its recessive chambers. In Wharton's novel, Nicholas Flood finds mathematical proof of infinity in nature: 'In the spiral of a seashell, for instance, which is itself only a fragment of a greater spiral of increase. An infinite one' (94). The whorls of the nautilus draw the eye inward to microscopic infinity and outward toward macroscopic infinity. Ornament in contemporary literature returns to the materiality of things – a nautilus shell – and relishes that materiality as an intimation of what is not itself. While ornament might tease the mind toward grandeur, its details in themselves sustain endless pleasure. *A Case of Curiosities* and *Salamander* dwell on materiality in relation to infinity and completion in relation to unfinishedness as ornamental aspects of narrative.

A Case of Curiosities: Collection and Display

Some objects have neither use value nor aesthetic value. In *A Case of Curiosities*, Claude Page creates a diorama in his apartment that showcases his ingenuity: 'a globe pivoted, a fountain sprayed, a waterwheel turned' (229). He introduces animals into the exhibit, including a fake

linnet that chirps and a stuffed owl that flies on a rack-and-pinion. The magical effects that Claude creates have no apparent usefulness. Madame Hugon ridicules the contrivances in the garret, which she calls 'a drunkard's doll house' (233). Whatever exuberance of imagination the diorama displays, it is exuberance for its own sake. Claude cannot prevent himself from making toys and gadgets. He invents devices that express his inventiveness. Imbued with artistry, his toys and watches overcome technical problems, such as how to create motion in a machine. Although he makes objects, the objects that he makes are neither commodities nor artworks. They are purely ornamental.

Jean Baudrillard hypothesizes that objects have only two possible functions: to be utilized or to be owned. Beginning with this schematization of objects, Baudrillard deduces that objects have social and subjective functions: 'Ces deux fonctions sont en raison inverse l'une de l'autre. À la limite, l'objet strictement pratique prend un statut social: c'est la machine. À l'inverse, l'objet pur, dénué de fonction, ou abstrait de son usage, prend un statut strictement subjectif: il devient objet de collection' (121).[5] Notwithstanding Baudrillard's hard-and-fast categorization, the books and automata in A Case of Curiosities have no practical purpose and little value as collectibles. If anything, they are curiosities. Skilful creations, Claude's inventions incite pleasure and wonder, but they are not, strictly speaking, aesthetic objects. The narrative aims to explicate things that have no discernible meaning. They exist exclusively for their display value. In this sense, the narrative decontextualizes objects, especially the items in the *memento hominem* case.

Narrowly avoiding being guillotined during the Terror, Claude moves to England and founds a watch and clock factory. Watches are both an analogue and a structuring device for A Case of Curiosities. Over the course of the novel, Kurzweil works out the similarity between watch and book with mathematical precision. Excluding the prefatory section about the purchase of the *memento hominem* at auction, the paperback edition of A Case of Curiosities has 60 chapters distributed across 360 pages, equivalent to the full 360-degree sweep of the minute and hour hands on a watch. (To the author's dismay, the first hardcover edition rounded off at 358 pages.)[6] Addicted to oddities of language, Kurzweil revels in the coincidence that 'the numbers on a watch face are called *chapters*' (340) as if a book and a watch are, by virtue of their segmentation into units, one and the same thing. Watches and books have numbered increments: pages and seconds. The book measures time; the watch ticks off events. And vice versa. In both watch

and book, temporality reigns. By the principle of similitude, the book is a technology – a clever device that establishes and resolves several complications at once.

When Claude creates an automaton called the Talking Turk, the hack Plumeaux advertises the wondrous machine by writing a book about it. Fixated on the dual meaning of 'chapters,' Plumeaux tells Claude, 'The language of your work and my work converge on the face of the time-piece. Which is why I have constructed the story of the Talking Turk in *twelve* chapters, naming each after moments in its inventor's life. The whole work will run to 360 pages and will come full circle' (340). Plumeaux has already published works 'based on contrived structures. He had told tales through the progression of a card game, a round of chess, and other forced conceits' (138). Forced or not, the conceit of the watch-as-book regulates *A Case of Curiosities*. The novel has only ten chapters, a number justified horologically by an appeal to changes in timekeeping during the French Revolution: 'French time ran ten hours to the day, one hundred minutes to the hour. Hence, ten chapters for the ten compartments' in the *memento hominem* (359). Not coinciden-tally, Kurzweil's second novel, *The Grand Complication*, about a mag-nificent timepiece commissioned by Marie Antoinette from the master watchmaker Abraham-Louis Breguet, has 60 chapters and 360 pages in the hardcover edition. Watch time advances by counting off the same round of minutes and hours. The 60-second cycle of a minute and the 60-minute cycle of an hour end only to start over again. A 'grand com-plication' watch has to perform at least three separate tasks simulta-neously beyond the mere movement of hands around the dial. These tasks are usually associated with timing, striking, and astronomy. The 'grand complication' that gives its title to Kurzweil's novel also refers to the various mechanisms required to keep a story rolling. Like a grand complication watch, a novel performs multiple tasks – advancing plot, measuring time, describing objects – simultaneously. Once set in mo-tion, watches and novels are machines that keep moving of their own accord, the very definition of *automata*.

Automata fascinate spectators because they imitate, however im-perfectly, human beings. In an attempt to provoke wonder, the Abbé collaborates on building a mechanical Christ that simulates bleeding. When that project fails, he tries to perfect a spinnet-playing automaton named Madame Dubois. He fails again: Madame Dubois never masters a single ditty. Encouraged by the Abbé to pursue his studies, Claude fabricates the Talking Turk because it brings together research into the

production of sound and the mechanics of motion. The Talking Turk participates in the eighteenth-century mania for building automata. Enlightenment automata were 'amusements and feats of technological virtuosity [... as well as] philosophical experiments,' in that they dramatized 'the problem of whether human and animal functions were essentially mechanical' (Riskin 102). In *A Case of Curiosities*, one craftsman admires the inventor Vaucanson's youthful inventions for their 'true ingenuity' (286). Vaucanson famously created a gear-driven duck, 'a triumph of mechanical whimsy' (318), which replicated the actions of paddling, eating, quacking, and defecating. Claude praises this clever contraption over Vaucanson's agricultural machines, because of their whimsy. Madame Hugon wonders what all the fuss over automata is about: 'Why would you wish to reproduce sounds that are already found in nature? Isn't the call of the linnet *itself* enough?' (216). Claude has no reply to this stumper. The Talking Turk can blink, roll its head, move its limbs, and utter 'Vive le roi!' but it hardly improves on nature. Claude might have answered Madame Hugon's question by observing that what he fabricates does not, in fact, exist in nature: a talking machine.

Like other toys and automata built in the eighteenth century, the Talking Turk and Madame Dubois astonish because of their ingenious resemblance to life without being life. A hallmark of ornamental style is virtuosity. The automaton exists first of all as an imaginative challenge, then as a set of mechanical problems. The automaton does not imitate nature so much as exemplify the bravura of the creator as an engineer. In a similar manner, the novel as a constructed phenomenon creates a universe and stocks it with characters that appear to move and talk, but whose magnetism arises from their resemblance to dolls or toys, not human beings. Plumeaux makes this connection explicit: 'What is an automat? It is something that remakes itself. Doesn't that also describe the efforts of the writer? Why shouldn't our intentions overlap? We are both, after all, searching for a voice' (341). Lacking any obvious usefulness, fictional narrative, with its talking characters and Talking Turks, is purely ornamental: it displays ingenuity and provides gratuitous pleasure.

A Case of Curiosities represents amateur scientific experiments as expressions of cleverness, which need not justify itself. Inventing is a pastime, a phenomenon to which Kurzweil has given some attention. *Ein Kurzweil* in German means 'a pastime,' as *A Case of Curiosities* onomastically clarifies (260).[7] In *The Grand Complication*, Henry James

Jesson III reads a book called *Hocus-Pocus, oder Kurtzweilige Taschen-Spieler,* roughly translated as 'Hocus-Pocus, or the Entertaining Conjuror' (253). Curiosity offers its own rewards for the amateur, the hobbyist, and the inventor, who experience satisfaction from problem solving, regardless of the practicality of the solution. Creating a machine or writing a book is a way of passing time ingeniously.

When *A Case of Curiosities* appeared in 1992, reviewers singled out Kurzweil's cleverness, but sniffed at that cleverness as excessive. Jonathan Keates objects to Kurzweil's 'enchantments' on the grounds that the intrusive narrator requires readers to admire the 'ingenuity' of such self-reflexive devices (21). Robert Towers likes the 'ingenious device' of the Talking Turk (35). Malcolm Bradbury begins his review with faint praise for 'Kurzweil's very mannerist and delicate novel' (1), but proceeds to an appreciation of its 'wit,' which highlights 'ingenuity' as a 'key word' (25). Indeed, the word 'ingenuity' figures regularly in the novel in relation to invention and information (243, 274, 276). As the novel makes clear, 'ingenuity' shares etymological roots with 'engineers' (154) and 'ingenues' (245). In his review, Patrick Parrinder notices the fixation on 'miniaturism' and 'curiosa' in *A Case of Curiosities* then complains that Kurzweil 'combines immense imaginative exuberance with an irritating archness of style' (22).

For the most part, these reviewers reject ingenuity and exuberance as improper pursuits. Yet these qualities, typical of Kurzweil's baroque ornamentalism, are vaunted by the narrative itself. The novel abounds with verbal curiosities: 'dossils' (24), 'rabbeting' (32), 'masicot' (47), 'orpiment' (47), 'scutches' (132), 'bilobated' (146), 'swiving' (170), 'galuchat' (202), 'caracoling' (274). This recherché lexicon is both archaic and ingenious, in the sense that such words are working parts of the English language, even if they are not made to work much or often. Many of these rare words have a scientific cast, an acknowledgment that invention enhances language with technical terms. Plumeaux, who confesses his taste for contrived structures, exaggerates rarified verbal qualities with chiastic rhetorical flourishes: 'Citizen Page has no interest in playing with the mechanisms of the state [...]. It is the state of mechanisms that concerns him' (351). Curiosity does not pertain only to human beings. Curiosity, as the title of the novel conveys and as cognate terms such as 'curio' and 'curiosa' reiterate, resides in objects themselves.

A Case of Curiosities displays objects as narrative curiosities. Claude entertains his neighbours by using 'found objects to try his hand at storytelling,' on the grounds that 'all discoveries hide a tale' (175). The

central premise of the book – the *memento hominem* represents Page's life through nine different objects – assumes that collections substitute for human presence. Souvenirs, toys, talismans, and mementoes evoke missing persons. When Claude decorates the window of Livre's bookshop, he fancifully represents himself and his friends with spoons, enema pumps, a flyswatter, pamphlets, and treatises. He identifies his daughter in an orphanage because her mother, Madame Hugon, left a bell with the baby, a bell that Claude had previously given to Madame Hugon. As in the case of the baby and her bell, objects have a proximate relation to the body, which justifies in some fashion their replacement of individuals. The Abbé cannot lose his glasses because they are 'tied to their owner with a leather thong' (38). Later he attaches Claude's watch to his waistcoat. The Abbé, growing deaf over time, holds a nautilus-shaped ear trumpet to his ear, an extension of the body when viewed charitably, but an excrescence emerging out of the body when viewed ornamentally. Assorted objects dangle from Paul Dome's body, which make him look like 'Linnaeus returning from Lapland wearing a leather band that held clothes, inkstand, pens, microscope, and spyglass' (283). In *The Grand Complication*, the protagonist Alexander Short attaches a notebook to his person, which he calls a 'girdle book' (15), and jots notes in it in shorthand. Objects attached to the body provide a sense of scale and demonstrate mastery over technology and knowledge. Regardless of their practicality, objects ornament the body.

Ornaments in *A Case of Curiosities* compensate for lack, especially bodily lack. A Calvinist collector named Adolphe Staemphli amputates Claude's middle finger because it bears a mole that, in certain lights, under the right conditions, resembles the profile of Louis XVI. Staemphli preserves the finger in a jar and subsequently inserts an illustrated plate of the so-called anomaly into his published book, *The Art of Cystonomy*. Claude's finger thus moves from curiosity to collectible to representation. In each incarnation, display value of the finger increases. Although the mole has passing scientific interest, no real investigative purpose is served by cutting it off. The mole proves nothing; its vague resemblance to Louis XVI has no scientific value. If anything, the amputation provides evidence that reason or reasonableness does not always guide scientific inquiry. Later in life, Claude retrieves his severed finger from Staemphli's collection. He also rescues other preserved body parts from Staemphli's cupboards and posts them back to the people from whom they were severed as if such a gesture could undo the terrible sacrifices that Staemphli's science demands. Owning

his own finger once more, Claude never mentions it again. No longer attached to a body and no longer displayed as an anomaly, the finger loses narrative value.

The amputated digit sits in a jar of embalming fluid. Denaturalized by being removed from circulation, the heterogeneous objects in a collection have an ornamental status. As in Hilary Mantel's *The Giant, O'Brien*, collections elicit wonder. Meditating on the oddities of nature or the products of human labour, the eighteenth-century collector treats empirical evidence as the point of departure for scientific inquiry or aesthetic appreciation. Arranged in a cabinet, objects substitute for the universe insofar as one item evokes whole classes of items. Hence, a fossil betokens other epochs and extinct life forms. Grouped together by category, fossils stand over and against taxidermied animals or coins, among any number of other objects. In any systematic collection, the seriality of objects suggests the possibility of infinity, for no collection is ever finished, even while curiosities in a cabinet are boxed up. Containment exaggerates the potential limitlessness of the collection; inside the cabinet or container, the object is valued as an example of the other objects that remain outside. Cut off from exchange or use value, collected objects acquire display value.

While assembling objects for his *memento hominem,* Claude leaves one compartment empty on the grounds that he cannot represent with an object what is not yet finished. The box remains unfinished, even when it passes into the hands of the collector at the Drouot auction house 200 years later. Viewed from one perspective, the empty compartment represents the intangible parts of Claude's character: his curiosity, his bonhomie. It also signifies Claude's absent father, who travelled far and wide, died abroad, and left nothing behind for his son except a watch. From another perspective, leaving the compartment empty is a gesture of refusal. Time, like curiosity, cannot by quantified. Emptiness, as an emblem of infinity, has no dimensions and therefore does not submit to measurement. Claude, it is alleged, owns the famous Breguet 'grand complication' watch for a while (359). That watch might have filled the empty compartment in the *memento hominem* case. The missing watch suggests that time, in its multiple forms, cannot be articulated by any single object. The future and past have no correlatives that sum them up. In this regard, emptiness is more puzzling than the nine objects in the case. Vacancy draws attention to the obduracy of the objects from which the narrative is extracted. Unfinishedness is thematized in the novel as an inherent characteristic in artworks. As a boy, Claude draws

a picture that moves past the border of the page. He likes an 'incomplete image better [than a complete one]. It would force the viewer to imagine what existed beyond the frame' (29). As a historical and invented character, Claude Page is only a sensible emptiness, a historical fiction that addresses a conception of the eighteenth century as an epoch of wonder and enchantment.

The *memento hominem*, with its serial compartments, is the most conspicuous and orderly collection in this novel about collections. Everyone collects something. Staemphli collects cysts, gallstones, 'a bottled bubo' (294), and other human deformities, which he ranges alongside stuffed animals and rocks. Claude's mother gathers herbs and other plants, then hangs them from the rafters of her cottage. Claude collects 'unique time-pieces and dioramas' (359), almost, it appears, as recollections of time past. Collected objects sometimes refer to secret, even unmentionable stories. Livre keeps his collection of pornographic literature sectioned off behind a curtain. He also collects aphorisms, which he writes on slips of paper and strings together in sequences. In the Abbé's library, piles of books are interspersed with laboratory equipment. Paraphernalia stands among 'large shells, pestles, and chunks of fossilized stone' (45), as if no classificatory distinctions separate diverse fields of inquiry. Collections instruct. Claude plans to visit Amsterdam to see Frederik Ruysch's famous anatomical specimens in order to build his automaton. Anatomical specimens incite scientific inquiry, however rudimentary or wrong-headed. The impulse to collect has no single etiology or goal. The Count de Corbreuil owns 'recreational machines, scientific apparatuses, and a collection of antique playing cards. He had over thirty rare illuminated decks' (323). Collecting playing cards may spring from an aptitude for games or a passion for gambling, but such a rationale does not justify the heterodox collections in *A Case of Curiosities*. Taken together, they demonstrate the pervasive will to collect, for whatever conscious or unconscious reasons.

Collections often have strictly regulated visibility, as when the Duke of Ferrara in Browning's 'My Last Duchess' twitches aside a curtain to display a portrait. Staemphli in *A Case of Curiosities* arranges his collections in three enfiladed rooms. The Abbé has odd alcoves built into his library and forbids Claude to pass behind a reredos that hides his most secret invention, Madame Dubois. The collector's desire to gaze upon his assorted objects transforms into his desire to regulate others' looking at the collection. Controlling access to a collection fetishizes objects, while also fetishizing the act of looking. Clothes represent a portable

and highly visible collection. Paris couturiers confect furs and fabrics from all over the world into an outfit for Madame Hugon: 'The hat of white miniver was taken from the belly of the Siberian squirrel; the tasseled polonaise was produced by a colony of Italian silkworms; the corset was made, in part, from the baleen plates of a Greenland right whale harpooned amid the ice floes of the Arctic; the handbag was covered in skin stripped from an ostrich that had once plodded over the arid scrub of Angola; the buttons were sawed from a roebuck's antlers; the common bits of leather were taken off a cow; the cosmetic grease came from a pig' (190). Lavishness of descriptive detail cannot obscure the fact that Madame Hugon's wardrobe combines imperialist dominion over the world and the animal kingdom. Imperial conquest in the name of capitalist expansion enables the fashionable ensemble. According to David Cannadine, clothes amplify the pomp and pageantry of imperialism, specifically British imperialism: 'the most successful British proconsuls and imperial soldiers were knights and peers several times over, veritable walking Christmas trees of stars and collars, medals and sashes, ermine robes and coronets, who personified the honorific imperial hierarchy at its most elaborate' (95). Vestimentary and honorific ornaments proclaim the power to own and rule. Madame Hugon, a member of the fashionable Parisian middle classes, exudes imperial entitlement as a personal prerogative. Unlikeliness of origin and material links the epic catalogue of her articles of clothing to the curiosities assembled in Staemphli's and the Abbé's heterogeneous collections. In this regard, capitalism is indissociable from the will to collect and display. The conspicuous mounting of pictures in a private gallery or the wearing of fashionable clothes substantiates ownership.

Ornament demands display. Claude displays the Talking Turk to wonderstruck Parisians. Gifted with an animistic sense of objects, Claude arranges books into narrative dioramas in Livre's shop. Piero, a taxidermist, tries to impart a sense of 'movement to his specimens' (174), despite their immobility. Art meant for consumption and collection, including folk handicrafts and souvenirs, has no prior use value or hieratic function. In *The Connoisseur*, Evan S. Connell's novel about the gullibility of an amateur collector of Mayan objects, the neophyte collector puts great faith in the 'magical properties' of originals (168), but he cannot tell the difference between pre-Columbian objects and recently made artefacts buried in the ground or splattered with chemicals to create patina. Items created for display value, such as souvenirs, are purchased as proof of an experience regardless of whether the experi-

ence happened or not. The displayed item may be an object of curiosity, like a narwal horn in a cabinet of oddities, but the exhibited souvenir does not provoke scientific curiosity; it betokens mild anthropological reflection and a degree of cultural irony. The souvenir has display value alone.

As souvenirs prove, no inevitable connection joins objects to events. The *memento hominem* case consciously displays the phases of Claude's life, although the assembled objects can just as easily call attention to events that have no object equivalent. The collection of objects therefore displays hopes and possibilities as much as it displays significant events in the trajectory of a life. Just as ornament magnifies the social and cultural significance of the adorned object through elaborate patterns or inventions, the displayed object acquires value by virtue of its being on display. The displayed object is an experience in itself. To see the Talking Turk or to own a stuffed animal is to feel touched by the magic of display. Culture seeks its showcases. Even though Staemphli builds his collection of specimens at considerable pain to others, the citizens of Geneva talk of 'providing municipal support for the display of his collection' (49). From private collections mighty municipal and national collections are born. Peter the Great purchased Ruysch's extensive collections of anatomical wonders – some 2,000 embalmed specimens – and had them transported to Russia to form the foundation of his own collections (Purcell and Gould 20). Museums confer display value by putting objects in vitrines and forbidding any contact between hand and object.

Even though they benefit from the dialectics of order and disorder that govern private collectors's passions, museum collections tame disorder altogether. Walter Benjamin claims that 'there is in the life of a collector a dialectical tension between the poles of disorder and order' (60). In contrast to museal tidiness, extreme disorder complicates display value in *A Case of Curiosities*. For the most part, objects in the novel fill private spaces. Characters touch and hold their possessions. Kurzweil's characters delight in their objects as discoveries. The narrator picks out the overlooked *memento hominem* case 'in a corner of the room, behind a rack of furs' (x) at the auction house. The display value of the box is increased, not diminished, by its unobtrusiveness, for the narrator sees, in the quintessential moment of a collector about to make a conquest, the worth of the object that others have neglected. Stickers on the back of the case suggest that it has been deaccessioned from several provincial museums. Once sent to auction, it still emanates the

faint gleam of display value, but only for the cognoscenti. Maximized by exhibition in a museum, display value has an intimate connection to the degradation of objects. Rejected as valueless rubbish and deaccessioned, the object is subsequently resuscitated through refurbishment and redisplay. Thus the private collector, the self-proclaimed saviour of discarded things, retrieves objects when museums have ceased to display or care for them. Re-privatized, the object ceases to belong to national heritage and becomes, again, a private artefact.

In *A Case of Curiosities*, books occupy a contested field of order and disorder. At least some of Livre's villainy derives from his fastidiousness; he cannot abide disorder or dust in his shop. He teaches Claude the proper technique for removing and replacing books on shelves. His precautions against injuring books prohibit the enjoyment of them. His nemesis, the Abbé, dribbles pea soup on one book and regularly cuts stencils from leather covers. He breaks the spines on books and dog-ears corners as a matter of policy, for these injuries indicate that the book has been entered and mastered. Books tumble off tables in the Abbé's library as the visual sign of his restive curiosity. He habitually cross-references information: 'the Abbé clearly demanded a great deal from his books. Endpapers revealed scrawls of criticism. Little slips stuck out between pages, white flags making reference to correlative tomes' (46). As in Renaissance *Wunderkammern*, where heterogeneity of objects permitted the mind to roam and discover, the library achieves usefulness when the contents of books commingle. Differences, forcefully apparent among unlike things jumbled together, challenge modes of classification and habits of thinking. Juxtaposing fields of inquiry allows the Abbé to recognize patterns that others have missed. For this reason, he discerns a certain 'order' (46) in his disorderly heaps of books.

Disorder also obtains in Kurzweil's *The Grand Complication*. The librarian Alexander Short lives amid mountains of scrap paper and annotated call slips. *The Grand Complication* offers itself as a twin to Kurzweil's first novel, on the conceit that Henry James Jesson III narrates *A Case of Curiosities*. Similarities between the novels multiply. With a nod to Claude Page's *memento hominem*, the narrator of *The Grand Complication* calls life an 'empty compartment' (98). The automaton loses its head to the guillotine in *A Case of Curiosities* and, in a parallel event, Alexander stages a guillotining of the grand complication watch in *The Grand Complication*. Machines destroy other machines. Characters reincarnate between the two books; Staemphli the collector turns in a brief appear-

ance as Stümpf the émigré Jungian psychoanalyst. Both novels indulge in word play, and both fondly represent machines as materializations of the knotty puzzles inherent in language. Both novels dwell on the meaning and nature of books. Jesson reads voraciously and creates a family crest featuring a book inside a book. Alexander steals an unusual book from the library in order to help Jesson's research. The recessive location of that book increases the difficulty of extracting it from the shelves of the lab where it has been sent for repairs: 'The book was in a box that was in a cage that was in a lab that was in the library' (140).

The Grand Complication pits negative spaces against the material presence of books. In the dialectic of box and book, books take up measurable space, but they resemble pockets or cabinets in that their contents remain intangible. In The Grand Complication, Alexander Short mentions his 'fascination with objects of enclosure' (11). The novel has many tight architectural spaces: the 'cage' (31) in Alexander's apartment, a janitor's hideaway (293), the off-limits stacks in the library, and a 'cubby' at the automat (44). Smaller but no less secret spaces – a grocery bag doubling as a 'briefcase' (45), Jesson's 'fob pocket' (49), incubators and caskets (89) – catch Alexander's attention because they are places to stow objects. On two different occasions, Alexander slides a coaster and some call slips into his jacket pockets. He observes that the jeweller Ornstein keeps cards and keys hidden under his yarmulke. Quite unlike Alexander, Jesson claims, 'I never went near the pockets of my jackets' (103) as a boy, but he converts avoidance into a mania for pockets and hidden compartments later in life. Jesson hides a tape recorder inside the armrest of his chair (57). Inside a globe, he hides a scroll containing sketches for his novel called A Case of Curiosities, about an eighteenth-century tinkerer named Claude Page (282–7).

The correspondence between cavity and book suggests that all books are pockets of interiority filled with words. The relation between book and globe in The Grand Complication and the name of Livre's bookshop in A Case of Curiosities – he jokingly calls it 'Bibliopolis' (161) – argue for the global expansiveness of textuality, even if books remain hidden away from view. Each book is a miniature world in a nearly literal way. Alexander's wife makes him a miniature snow globe containing swirling 'miniature books' (22). The miniature books recall that all books reduce characters and events to a scale that can be manageably possessed. Susan Stewart observes that miniature books have a history that coincides with the invention of the printing press: 'In the fifteenth century, small books of hours (measuring two square inches, set in gold,

and worn suspended from the belt by a charm or rings) were made for the merchant princes of Florence and Venice' (39). The book as an ornament announces the prestige and, presumably, the literacy of the wearer. Rather than reading the book, its owner displays it; in a similar manner, ornamentation on an object has display value rather than use value. The scale of the miniature permits the owner mastery over a tiny but infinite domain. The labour required to make a miniature book exceeds the labour required to make a book of regular size. The miniature draws attention to the intricacies of its details: its gold leaf, its teensy type, its binding. The person who examines the miniature can gauge the fineness of his mind by the exactness with which he notices details. No fineness, of course, is ever sufficient, which makes the miniature a simulacrum of infinity.

Books and Infinity in *Salamander*

Like Arcimboldo's caricature of a librarian whose features are made up of books, characters in Wharton's *Salamander* are regularly compared to books. Books and images imprint themselves on characters' bodies. The metallurgist Kirschner, who creates a set of magical type, has Hebrew letters impressed into his fingertips (110, 169). As Flood works at his press, ink seeps into and discolours his skin (87). Likewise, the twelve-fingered compositor named Djinn has stories tattooed into his skin (184). The daughter of Nicholas Flood and Irena Ostrov is named 'Pica,' after the type size. Time passes in relation to Gutenberg's invention of the movable press (16, 67), as if history were an offshoot of printing. Instead of casting the book as a transcendental object, *Salamander* draws attention to the materiality of books. As an object made from paper and ink, *Salamander* itself is a miniature display case for curiosities, a box of wonders. Following the logic that narrative is spatial rather than temporal, Wharton insets tales in this narrative case like bijoux inside a frame. Although preoccupied with time and infinity, the novel reinforces the materiality of the book by spatializing form. The immeasurability of infinity may best be figured through space and its ornaments.

Salamander offers conflicting definitions of the objects called 'books.' A book is '*a fragile vessel of cloth and paper*' (221). It holds something – a story, a world – but the exact nature of that something eludes description. Sometimes books look or sound like animals. A book splayed open resembles a moth (2). A book closing looks like a beetle folding

its wings into its wingcase (8). The rustle of paper sounds like the 'nocturnal stirring of owls' (253) or the 'scratching of insects' (310). The book hums with a life of its own, irrespective of the animating force of a reader's attention. In Wharton's subsequent novel, *The Logogryph*, the eponymous 'elusive creature that lives inside books' (22) is said to be extinct, although its deserted nest still perches on a high ledge in a mythic library (212). If not perhaps an animal, either real or mythic, a book may possess regenerative life, like the salamander that gives its name to the novel. In *Salamander*, a gardener finds a tome buried among the roots of plants, its cover, like a codex, 'made of wood' (252). As the gardener reads the book, pages wither and peel away like leaves falling from a tree. Instead of lamenting the destruction of the book, the gardener forecasts the sprouting of new books from the ground in the spring.

Despite the independent and organic life that books metaphorically possess, *Salamander* cautions that they do not, in the end, spring from nature. The crooked edges, the variations in ink, the squishing of insects against paper when the platen comes down – all these features of the book attest to its artificial status, a '*thing not found in nature, yet still subject to its changes*' (153). Nicholas Flood, commissioned to make an infinite book, assembles the necessary elements that suggest endlessness. He tracks down the finest, thinnest paper imaginable, a unique Chinese product allegedly fashioned from 'crushed hummingbird-egg shell, dragonfly wings, and the inner lining of wasp nests' (238). He finds the perfect ink, called 'fallen-angel ink' (182), blended from squid ink, herbs, gum, oils, and human blood. He puts together a printer's chase containing 'gooseflesh' type that ripples when touched, 'as if within the depths of the metal pages were being turned' (169). For the endpapers and binding, he finds exotic monkey parchment and green sealskins. The components of the book – squid ink, gooseflesh type, monkey parchment – recall the natural origins of the material object, in addition to the intensity of labour required to combine these elements, as if by alchemy, into a magical object. Broken into constitutive elements, the book expresses infinity through the details of its production. Exceeding the sum of its parts, the novel qualifies as both a technology and an ornament.

In its recuperation of ornamentalism as an aesthetic, *Salamander* recovers the political content of ornament as well. Ornament has always served power of one sort or another: state, church, market capitalism. Count Ostrov hires Nicholas Flood to make an infinite book, not be-

cause he needs such a book, but because he wants such a book. Pirates and slaves reinforce the political content of *Salamander*, which manifests itself in the pursuit of a book that has no end just as capitalism has no end. If it offers any lesson at all, ornament teaches that surface content reveals hidden structures. No one understood this principle better than Siegfried Kracauer, who studied surface effects in modern culture for evidence of underlying structures. 'Mass ornament,' as Kracauer calls the manifestations of capitalist production, expresses the efforts of individuals working in coordination with each other. The mass ornament requires individuals to perform specialized tasks, but the totality of the ornament does not pause to acknowledge each individual. In a similar fashion, the infinite book in *Salamander* requires contributions from every character; the commodity exceeds the sum of those individual contributions. Kracauer perceives a direct line between groups and their ornaments: 'A current of organic life surges from these communal groups – which share a common destiny – to their ornaments, endowing these ornaments with a magic force and burdening them with meaning to such an extent that they cannot be reduced to a pure assemblage of lines' (76). Kracauer takes as his examples dance routines performed by the Tiller Girls and stadium rallies in which individuals 'become fractions of a figure' (76). Although these mass ornaments appear to be rational, they actually replace reason with 'the *rational and empty form* of the cult, devoid of any explicit meaning' (84).

Ornament in contemporary fiction is not about the emptiness of existence, but about the political service that the state exacts from printers and artists. According to Brent Brolin, the return of ornament in architecture, as advocated by architects Robert Venturi and Michael Graves, sounds the death knell of modernism: 'Venturi proposed that the simple, universal solutions of modernism be replaced by ones that are complex, ambiguous, and individualized' (223). The return of ornament does not repudiate modernism so much as acknowledge that the anti-ornamentalism of modernists – Alfred Loos, Le Corbusier, Walter Gropius, Albert Speer – had a political function. Streamlined design and the geometric angularity of modernist architecture served fascist and totalitarian politics just as easily as the highly ornamental Romanesque style magnified the political glory of the Church. In Kracauer's account, all ornament, regardless of its intricacy or plainness, perpetuates myths. In *Salamander*, the pursuit of an infinite book does not pretend to be free of the politics of ornament, at the same time as it pursues the implications of mythologizing printing and book culture.

Salamander equivocates on the meaning of infinity, in part because the concept has personal connotations for each character and in part because physical traits betray the essence of infinitude. Count Ostrov views the universe as an infinity of language: 'The planets, the starry firmament, the unfathomable abysses of darkness and time through which we plummet without knowing how or why, the entire universe, I have come to realize, is a vast, unbounded book of riddles. A book written in the elusive and unutterable language of God' (42). Time and space, immeasurable in themselves, puzzling because abstract, require physical equivalents. For the Count, that equivalent is an infinite, unbounded book. The books nested within books in Flood's *A Conjectural Treatise on Political Economy* exemplify an approach to infinity through miniaturization; infinity haunts even the tiniest atom of the material world. Detail particularizes infinity not because *every* detail bears in itself a point of access to timelessness, but because one detail and one alone amid ornamental accumulation in narrative might finally provide access to something beyond itself. Blake sums up this paradox in his aphorism about eternity existing in a grain of sand. Not every grain of sand bears eternity: one single grain, which must be perpetually sought and labouriously sifted from all others, might yield a privileged glimpse of the infinite. In *Salamander*, Pica carries one blank slug from the quivering gooseflesh type – 'infinity in her pocket,' as it is called (368) – because any single particle of infinity might serve as a synecdoche for the whole collection of type and for the unending book.

Flood wonders if 'infinitely thin sheets of paper' (55) will fulfil the Count's commission for an infinite book. Yet infinity might reside in the contents of books rather than their physical properties. By compiling a dictionary, Samuel Johnson creates an 'endless book' (322) that synopsizes language and encapsulates other books through citation. Out of the entries in a dictionary, all other books can be created. A dictionary potentially generates a whole library of books by combining and recombining words in infinitely variable patterns. Alternatively, an infinite book may be an as-yet-unprinted set of leaves. Evil Abbé Ezequiel de Saint-Foix spends his childhood in a library scanning empty pages in blank books; as a result of this activity, he comes to believe that all reading is an interpolation into blankness. He conceives of infinity as an existential void where time, his enemy, does not hold sway. 'Within every book,' he concludes, 'there lies concealed a book of nothing' (75), a formulation that, years later, as he faces imminent death, Nicholas Flood remembers (331). The Abbé means that representations deceive

the reader, for books give 'a semblance of life to things and people who are really nothing. Nothing at all' (76). The truly infinite book represents all or nothing, which, in their extremes, may amount to the same thing. Whereas Kracauer interprets mass ornamentalism as devoid of meaning and individualism, *Salamander* proposes that books are ornamental because they allow readers to retain subjectivity and, with subjectivity, the opportunity for enchantment.

The Abbé's debunking of representation as a figment conjured up on paper leaves the primary encounter between book and reader intact. A book remains inert until a reader assays it. Infinity, therefore, stems not from the contents of the book, but from the imaginative engagement between text and reader. In this regard, *Salamander* takes cues from Jorge Luis Borges's 'The Garden of Forking Paths' and 'The Library of Babel,' as well as Italo Calvino's *If on a Winter's Night a Traveller*, as instances of endlessly fracturing narratives. *Salamander* obliquely refers to James Joyce's *Finnegans Wake*, another infinite book, but infinite in the sense of skirting definite meaning and mobilizing any number of languages to create a gigantic word puzzle. The differences between *Salamander* and *Finnegans Wake* pertain to infinity as a spatial concept versus infinity as a linguistic concept. Whereas *Finnegans Wake* is circular, elusive, dense, Irish, multilingual, intellectual, daunting, *Salamander* is recessive, narrative, Canadian, global, accessible, touching. Although Joyce's infinite book may be a remote intertext for *Salamander*, Wharton overtly aligns himself with Calvino and Borges. In his acknowledgments, Wharton thanks Borges for 'the novel that he never wrote' (372) and mentions that one of the inset tales of *Salamander* is adapted from Calvino's *Italian Folktales*. Active reading brings into being the book and its fictional universe. The materiality of the book does not disintegrate just because its representations deceive. A book, even without words printed on its pages, is still a book, albeit one with forking paths and endless possibilities.

The assignment to make an infinite book inspires Nicholas Flood with solutions and questions. If the infinite book exists in the imagination of a reader, perhaps that book should be '*sealed shut, with the word* infinity *burned on its wooden front cover. The reader cannot read the book and thus is free to entertain an infinite number of conjectures about the contents*' (53). Perhaps an infinite book should move or give the illusion of movement because infinity implies repetition with minor variation. Trusting this hunch, Flood designs a whirligig from a scroll of paper, its ends joined in a loop, 'but with a twist, so that the paper seemed to have (or perhaps

did have) only one side' (65). The story printed on the whirligig, about a girl's pursuit of a boy and a boy's pursuit of a girl, depends on circularity and movement to convey infinitude. A circle, for all it might symbolize perfection and endlessness, excludes by enclosing. Only those who belong in the circle – the girl, the boy – participate in their personal version of infinity, namely, the eternal return of desire.

Flood's breakthrough in the design of the infinite book happens when he hypothesizes the relation of a frame to the story. Imprisoned and therefore unencumbered by the 'limitations of real paper and ink,' he imagines that the 'book would climb into being on the infinite spiral of the Fibonacci sequence. The frame, the container of the words, was the key' (105–6). Although Kant dismisses the frame of an aesthetic object as unnecessary or purely ornamental, Karl Philipp Moritz praises the frame for controlling the art work and directing spectators' attention to the interior of the image: 'Das Bild stellt etwas in sich Vollendetes dar; der Rahmen umgrenzt wieder das in sich Vollendete. Er erweitert sich nach außen zu, so daß wir gleichsam stufenweise in das innere Heiligthum blicken, welches durch diese Umgrenzung schimmert' (*Schriften* 210).[8] Transposing the frame into narrative terms calls attention to Kant's limitations and Moritz's prescience, for narrative frames, as in Boccaccio's *Decameron*, Chaucer's *Canterbury Tales*, the *Arabian Nights*, Mary Shelley's *Frankenstein*, Charles Maturin's *Melmoth the Wanderer*, not to mention *Salamander* and *A Case of Curiosities*, interact with, comment upon, and supplement the tales that they enclose.

Flood views the frame not as a restriction, but as a liberation of an infinite number of inset stories. The frame establishes the boundaries for enchantment. *Salamander* heralds each frame tale with titles worthy of Chaucer or Defoe: 'THE ABBÉ'S NARRATIVE' (68–74); 'THE METALLURGIST'S TALE' (165–71); 'THE LEGEND OF SESHAT' (195–8); 'THE TRUE HISTORY OF THE NOTORIOUS FEMALE BUCCANEER, AMPHITRITE SNOW, AND HER BLOODTHIRSTY CREW OF ADVENTURESSES, HARLOTS, AND JEZEBELS' (205–12); 'THE TALE OF THE TANNER'S FATHER-IN-LAW' (278–80); 'THE CURIOUS CONFESSION OF THE WIDOW JANSSENS' (282–5); 'THE ADVENTURE OF DJINN' (244–64), which encloses within it, like boxes-within-a-box, the ferryman's lament (245–50) and the gardener's tale (252–5). Wharton ranges across genres: legend, adventure, tall tale, true history, confession. These stories concern characters incidental to the core narrative about bookmaking. Stories about Nicholas, Irena, and Pica also number among the roster of inset tales, notably Irena's account of what

happened to her during and after the birth of Pica (342–8). These inset stories, all orally delivered, encyclopaedize characters and their narrative self-representations. The characters tell non-consecutive, digressive tales that the reader can approach 'in any order' (109). Setting tales within a frame deregulates the serial organization of chapters and sections and spatializes narrative.

The frame is the key to the infinite book, because stories proliferate within the frame. The frame story of *Salamander*, set in Quebec City in 1759 on the eve of the Battle of the Plains of Abraham, enables an ornamental filling of space with stories. Pica tells the story of her family, or invents the story, to entertain Colonel de Bougainville, much as Scheherazade fabricates incomplete tales to stop the murderous sultan Schahriar from killing her in *Arabian Nights*, a text cited several times in *Salamander* (45, 181, 218).[9] The character Djinn earns his name by resemblance to the djinns in *Arabian Nights*. Like Schahriar's longing for the continuation of each tale, Colonel de Bougainville asks, '"*And then?*"' (363), when Pica pauses in her storytelling. Individual stories captivate through excess of detail, implausible meetings and events, arabesques of invention. The frame narrative ultimately limits the number of stories told, but it does not limit the desire for stories, which extends into the plausible future beyond the historical framework of 1759. *Salamander* contains any number of oracular glimpses into the future, which might be called the obscure side of infinity. The historical setting of the novel anticipates future stories without either limiting or realizing those eventualities.

Enchantment issues from these inset narratives much as objects within a collector's case induce wonder. Indeed, narrative is spatial in *Salamander*. When Pica begins to read the infinite book created by her father, Nicholas, she glimpses the endless tantalization that stories offer: 'On the shelf or just opened, a book was all possibility, a wondrous box of paper that could contain anything' (309). The book as box is wondrous because of its limitless possibilities. The book as box exists in relation to the other spatial puzzles, cabinets of curiosities, and objects in the novel. Count Ostrov designs his castle as a labyrinth, a clock, 'a giant puzzle' (19). Irena's shop in London, filled with automata and clocks, duplicates her father's gadget-crammed household-as-puzzle. 'Book' is the answer to one of the Count's many riddles (33). While providing the solution to the riddle, the book remains puzzling as a material object.

Wharton treats language as a cabinet inside which miniature particles assert their own mysteries and puzzles. The automaton

Ludwig echoes human speech imperfectly. When he hears the word *sala-mander*, he omits a few syllables and pronounces it 'alam.' The secret word within the word means several things, including 'everything' or 'all world' (89). *Alam* is a letter in the Hebrew alphabet. The two-syllable word also refers to a Singhalese father-in-law (278). Same word, different language: the Sanskrit *alam* means 'sufficient' or 'enough,' and its affiliation with aesthetics emerges in the word *alamkāra*, which means 'ornament' (Coomaraswamy 243). *Salamander* revels in such word puzzles, in which lost or suppressed meanings lie coiled within a few letters. *Ostrov*, for example, means 'island' in Czech, and *Sala-mander* can easily be read as a catalogue of islands flung around the globe. Although the narrative trajectory of *Salamander*, dedicated as it is to the making of an infinite book, purports to demystify cultural pro-duction, the generous detail and ornate structure of the novel maintain the mystery of language and its textual manifestation in books.

Like language, books emerge from 'things hidden and lost' (308), in that they contain and expose secrets. Narrative exists in a tempo-ral dimension, yet books exist in a physical dimension. In *Salamander*, characters think about infinity as a shape in space. As a child, the Abbé imagines the cycles of universal time as 'a dark sphere' or 'an iron prison' (71). Both spaces entrap him. Although Nicholas and the Abbé are antagonists, Nicholas also thinks of time dimensionally: 'Time [in the prison cell] became spherical. Past events gathered around him like words in a book' (109). The treatment of time and infinity as spatial en-tities allows for the reshuffling of contents within the infinite book that is always coming into formation or that exists in the imagination. Infin-ity, then, extends from the physical object of the book to the reader's progress through 'a broken labyrinth of unfinished stories' (190).

While purporting to reveal secrets, *Salamander* persistently represents recessive and secret spaces. Objects drop from trapdoors and panels suddenly gape open or slam shut in Ostrov's castle. Ostrov locks Flood in a dungeon beneath the castle, and the Abbé imprisons Irena in a chamber onboard a ship. Many recessive spaces contain paper. Djinn tucks a letter and a ream of Finest Tortoise paper inside the hollow legs of an automaton. Ludwig Ostrov dies while carrying military orders in a pouch. Nicholas Flood keeps a letter from Irena in his pocket at all times. These cavities, pockets, and pouches mimic the recessive struc-ture of the novel, with its frame narrative and inset digressions. These papered spaces are often, but not always, malignant. The Abbé, with patents issued by the pasha in Alexandria, sinks into an airless pit lined

with papyrus scrolls. Pica, who, like an amphibian, can breathe under-water, dives into the molten type designed by Kirschner, a pocket in time and space. Like Alice, when she tumbles down the rabbit hole in *Alice in Wonderland*, Pica enters an irregular zone where time stands still – a different concept of infinity linked to the proliferating textual possibilities of the printer's chase. The chase, which opens onto infinity, creates a recessive space within which nothing moves except Pica. Four of the five section titles in *Salamander* concern spaces as enclosures: 'The Cage of Mirrors'; 'The Well of Stories'; 'The Paper-Thin Garden'; 'The Cabinet of Wonders.' The fifth section takes its name from an object: 'The Broken Violin.' Inside the spaces of each section, characters come together and separate, disappear and resurface. These frames set limits on the permutations that can be wrought on plot within the narrative. The reader, posited throughout *Salamander* as the presiding genius of infinity, can start and stop reading at any point in the narrative without regard to chronology.

Inside compartments, objects accumulate. Like *A Case of Curiosities*, *Salamander* delights in lists. The narrative gives a list of the ways that books might be bound (52); a list of technical books required to create the infinite book (58); a list of Irena's lingerie (97–8); a list of toiletries (103); and so on. As miniature collections, lists jumble things together by cat-egory. Minute variations appear between a 'laced modesty piece' and a 'damask stomacher stitched with silk rosettes' (97). Such variations bespeak the endless fertility of nature and the boundless inventions of the human imagination. Although it would be possible to understand hoarded and collected objects in *Salamander* as evidence of the sham-bles that capitalism leaves in its wake, the novel treats ownership as a vehicle to other ends. Specifically, having and hoarding things enable meditations on otherworldliness. Collectors approach infinity through the amassing of material objects. The pasha in Alexandria abides by this logic, for he collects 'things that would assist his meditation on the inevitable [i.e., his death]. Lugubrious poetry, dismal music, the bones of suicides, and courtesans dead of the plague' (181). The shadow of mortality haunts the pasha, yet his collections, macabre though they may be, survive him. Things endure; people die.

The amassing of objects occurs at the level of syntax in *Salamander*. Long lists of items prevail as equivalents to the collector's assembling of objects. Linked paratactically, lists have no logical stopping point. Once a list begins, it ends only when ellipses gesture to what goes with-out saying. Books accumulate in lists. A publisher's catalogue, for in-

stance, enumerates Nicholas Flood's novelty books (25). Nicholas lists the books that he reads to his sister Meg (45). Pica mentions a list of her favourite books, namely, Ovid's *Metamorphoses, Gulliver's Travels,* and the seventh volume of the *Libraria Technicum* (132), to which she later adds *Robinson Crusoe* and *Arabian Nights* (218). Kirschner lists 'fabulous, impossible, imaginary books' (167), a list that resonates with a list of the so-called Four Noble Books (271). Syntactically, the list relies on the comma to punctuate and itemize, but the comma does not regulate the content or number of items. Books beget books. Pica, peeking into the infinite book created by her father, reads an extraordinary, haphazard table of contents, which lists 'numbered chapters, but in no apparent order' (308). The list, as a narrative tabling of unlikelihoods, detaches from the objects it supposedly controls. The authority of syntax in the table of contents in the infinite book yields to whimsical topics – a description of a right ear, hieroglyphics, numbers, cut-outs, 'the contents of an iron chest buried in a sandbank beside the Orinoco River' (310), earthquakes, beheadings, rain, and so on – that surge from the pages of the infinite book. The only ordering principle, in the end, is the book itself, as container of heterogeneous items.

The last word of the novel, the word on which it pauses as if written beneath a fermata, is 'collection.' In context, the word refers to a collection of type, which can fall into any number of patterns to create words, sentences, books, and ultimately libraries. A meditation on libraries as sites where information gathers and disperses, the novel literalizes the meaning of a 'circulating library' to describe Count Ostrov's collection of books. Moving bookshelves trundle through his castle on a timetable: 'The entire castle in effect became the library' (21). Libraries are places of secret knowledge. The Abbé hides in his father's library and later appears in the pasha's underground library. The Chinese mandarin's library contains 'great treasures, it was rumoured. An encyclopaedia in eleven thousand volumes. A book made of jade that could predict the future. The world's lengthiest erotic novel, banned by imperial decree for its power to turn readers, men and women both, into shamelessly rutting beasts' (239). Even though these libraries serve as repositories of safeguarded objects, they drift inevitably toward destruction. Water threatens to engulf the pasha's library, which comprises the vestiges of the burnt library of Alexandria. Servants topple bookcases and plunder the Count's collections after his death.

Salamander opens amid the ruins of a bombed bookshop in Quebec City. In many ways, the history of the book is inseparable from

the destruction of books and libraries. Under Henry VIII's anti-Catholic regime, spoliation of monastic libraries in England sent communal property into private hands. Henry VIII's successor, the boy-king Edward VI, further stripped libraries of manuscripts and books. For all they are cultural artefacts, books assume heightened political significance in military campaigns. In 1914 the German army wilfully razed the university library and collections in Louvain, Belgium, and razed it again after it had been rebuilt, during the Second World War. In 1992 Serbian soldiers methodically shelled the National and University Library of Bosnia and Herzogovina, setting it ablaze: 'Fueled by fifteen thousand meters of wooden shelving and a collection of books estimated to have numbered 1.5 million volumes, the fire smoldered for three days, filling the hot summer sky with clouds of searing fragments that one witness described as a blizzard of sooty black snow' (Basbanes 134). Wherever and whenever books have been collected in one place, they become targets for vandalism or burning. *Salamander* alludes to this historical pattern in its representation of plundered and threatened libraries, particularly the library at Alexandria.

Defaced books in Wharton's novel have analogues in other contemporary Canadian novels. In Michael Ondaatje's *The English Patient*, Hana writes notes in books taken at random from the library, then places them here and there on the shelves, much as Flood, in *Salamander*, writes Irena's name in the book called *Desire* then hides it among volumes of an encyclopaedia.[10] Ross King's *Ex-Libris* dwells on biblioclasm during the English civil war. However vociferously readers quote John Milton's *Areopagitica* as an appeal to cherish books – 'he who destroys a good book kills reason itself, kills the image of God, as it were, in the eye' (720) – historically informed readers will not forget that Cromwell's Puritan government despised books and appropriated and desecrated private libraries in the name of Christian truth. In *Ex-Libris*, the bookseller Isaac Pickvance leafs through the mildewed spoils of a private collection:

> I picked one of the books at random from its collapsing rank and opened the battered cover. The engraved title-page was barely legible. I turned another crackling page. No better. The rag-paper had cockled so badly because of water damage that, viewed side-on, the pages resembled the gills on the underside of a mushroom. The volume disgraced its owner. I flipped through the stiffened leaves, most of which had been bored through by worms; entire paragraphs were now unintelligible, turned to fluff and powder. I replaced the book in disgust and took up another, then

another, both of which were likewise of use to no one but the rag-and-bone man. The next looked as though it had been burned, while a fifth had been faded and jaundiced by the rays of some long-ago sun. (King 21)

Salamander, beginning with the image of books tossed pell-mell about a ruined shop, lists the manifold ways that books sustain injury: *'Books without covers. Covers without books. Books still smouldering, books reduced to mounds of cold, wet ash. Shredded, riddled, and bisected books. Books with spines bent and snapped, one transfixed by a jagged black arrow of shrapnel. In one dark corner lies the multi-volume set of an outdated atlas, fused into a single charred mass'* (2). In both novels, books shunt between being purveyors of truth and stories and being objects of cultural and religious plunder. Whereas *Ex-Libris* displays the many ways that books disintegrate into waste, Wharton's novel hopes for the restitution of books from destruction. Flood's motto is *'Vitam mortua reddo ... I restore life from death'* (64). Although the Abbé vanishes with the infinite book, Pica reconstitutes it in her imagination. The enchanting effects of a book do not end with its destruction.

Salamander thus traces the cyclical making and unmaking of artefacts. Although Nicholas seduces Irena by showing her how a book is made, he informs Pica: 'Only when you unbind books, piece by piece, do you truly learn to love them' (132). The book withstands dismantling and outright destruction as a fragment of culture, which this novel portrays as a contested terrain among labourer, patron, reader, and thief. If ornament completes the object that it adorns, the book completes a process of labour by bringing together, however temporarily, the physical elements that gesture toward the metaphysical meaning of the book. Pica wonders when her father will know that the infinite book is finished. He cannot say, but implies that organic form will let him know the answer. Obviating the book as an end in itself, Flood quotes his father on beauty and finishedness: *'Make a beautiful thing, but remember, it is not only the material object we strive for. The work is not finished until the book passes into the hands of a reader'* (306). The appeal to the reader as the one who completes meaning highlights the inevitability of circulation among cultural commodities. In and of themselves, objects may have form or other aesthetic attributes, but as Kant and others observe, those aesthetic attributes demand appreciation for their completion. Furthermore, Flood argues, 'nothing in this world lasts forever. Metal rusts. Gears wear down. Wooden beams warp, rot, get gnawed by insects. And people never leave anything alone. They will always pry, and

interfere, and try to improve, correct, or tear down what is supposedly finished and perfect' (93). Disintegration of the material artefact may be inevitable. Wilful breakage of an object raises the possibility that atomization of the object fulfils its destiny. As Pater asserts, unfinishedness ornaments the otherwise perfect object by allowing the viewer to interject life into it. Emphasizing style and fragmentation over beginning-middle-and-end wholeness, Wharton's novel advances ornamentalism as the will to finishedness, and the ironic acceptance that finishedness, at least in narrative, is an illusion.

Like the sooty fragments of paper that float out of the sky, writing circulates throughout *Salamander*. The infinite book passes from Flood's hands, to Pica's, then to the Abbé's. Similarly, stories pass from teller to auditor in each of the inset stories as well as in the frame narrative in Quebec City. Circulation transforms objects and characters. Virtually nothing or no one stands still. Floors, beds, and shelves move through Ostrov's castle like the gears and cogs in clockwork on which the castle is modelled. The quoin key that Flood gives to Irena passes to her daughter Pica, back to Irena, then back to Pica. Djinn, who as a child travels with a circus, roves as an adult through China in the guise of an automaton. Circulation assumes global proportions through the voyages of *The Bee*, the ship that frisks from port to port with Pica, Nicholas, Djinn and others aboard. When Pica enters the stopped world inside the gooseflesh chase, immobility terrifies her; she breaks the spell of non-circulation by slapping a globe to set it spinning again. Pica, at least, cannot live outside the principle of circulation.

The rotation of the planet and the circulation of all things on it suggest that *Salamander* allegorizes the creation and movement of goods. The novel encodes fringe activities of capitalism as forms of enchantment: piracy, boycotts, theft, the transmogrification and destruction of commodities. The Chinese evict westerners from their country and set bans on the use of certain writing materials. A bounty hunter tracks Amphitrite Snow and her crew of female pirates. These aspects of capitalism find analogues in storytelling. Who owns a story? Who pirates stories? Who destroys novels? Why print books? Labour in the novel is a vocation, not a form of drudgery. The carpenter Turini repairs furniture and boats throughout the novel, but Flood creates unique books for the sake of doing so. The foundational fantasy in *Salamander* is not about the human or monetary cost of commodities – money is never mentioned – but rather about the status of objects as objects.

Fredric Jameson points out that postmodernism brings about an 'in-

tensification of the forces of reification' (148). Whereas Marx's analysis of capital isolates the commodity as an object with a fetishistic aura emanating from it, Jameson claims in 'Capitalism and Finance Capital' that 'with the emergence of exchange value a new interest in the physical properties of objects comes into being' (146). Those physical properties, such as green sealskin leather or Finest Tortoise paper, augment the exchange value of commodities through the elaboration of detail. The extensive lists of goods in *Salamander* make concrete the workings of capital, in that capital demands the conversion of abstraction into commodities. Jameson hypothesizes that modernist defamiliarization techniques lavish value on objects as an equivalent of the perceptual richness provoked by objects, a defamiliarization technique voiced in discontinuous, fragmented syntax. In contradistinction to this modernist wresting of breakage into narrative, the representational practices of postmodernism valorize the fragment as complete unto itself: 'each former fragment of a narrative, that was once incomprehensible without the narrative context as a whole, has now become capable of emitting a complete narrative message in its own right' (160). Although the frame story holds the multiple fragments in *Salamander*, each inset story does emit 'a complete narrative message.' Even as these fragments go into circulation through the inevitable demands of exchange, they retain something of their baroque value: they display virtuosity, which is its own reward, and they fulfil an aesthetic end, which is the essence of ornament.

4 Fragility: The Case of *Utz*

Broken Idols

Why do we value fragile things? Fragile objects occupy a distinct cultural and aesthetic category, but one that has scarcely been examined. Fragility is a physical trait in an object, yet fragility cannot be proven until tested. If one tests fragility, one risks breaking the allegedly fragile object. If one does not want to run that risk, one can attribute fragility to the object. In aesthetics as in the material examples of sculpture and porcelain, the attribution of fragility, in addition to physical vulnerability, confers value. At the same time, fragility imprints destiny into artworks: an object that is not broken has not yet acquired completion in the sense that its fragility remains a disposition, not a *fait accompli*, something that might happen but that has not yet happened. Chipped or smashed, objects prove their disposition toward fragility. In a certain way, all truly fragile things will come to grief. Breaking or damaging an artwork, especially a delicately wrought one, such as an ornate glass sculpture by Dale Chihully or the Portland Vase, fulfils expectations about fragile objects. In this regard, fragile objects invoke the future or come into being as metaphysical entities at some indefinite moment in the future.

Fragility regulates Bruce Chatwin's novel *Utz*. In this novel about a porcelain collector living in Prague during the Soviet regime in the 1960s and 1970s, a priceless collection of Meissen porcelain disappears without explanation. The nameless narrator, who had only the slenderest acquaintance with Kaspar Utz before his death, conjectures that the collection of irreplaceable porcelains has been smashed and dumped into rubbish bins. In part a meditation on the nature of objects and the

preservation of art, *Utz* dramatizes the viability of a private museum in which objects are held hostage to political vagaries. Tagged by curators for future museum procuration but displayed meanwhile in Utz's apartment, the collection of porcelains heralds the power of the state while extolling the circulation of objects through private hands. Objects locked up in museums appear fragile, but their fragility may be tendentiously induced for the purposes of confirming their cultural and symbolic value. Breaking precious artefacts frees the collector from the tyranny of ownership, even while it augments the perceived value of the work of art by enhancing its rarity. Chatwin's appreciation of fragility, as both a physical and a cultural attribute, is inseparable from his intimacy with rare and fragile artworks. Hence, fragility in *Utz* can be understood only in terms of Chatwin's wider view of objects and museums.

Objects of all kinds enthralled Chatwin. As a young man, he worked as a porter at Sotheby's auction house in London, where he dusted 'European and Oriental ceramics, glass, majolica, and tribal antiquities' (Shakespeare 87). During auctions, he stood behind vitrines to prevent people from touching sale lots with sticky fingers. Chatwin ascended through the ranks at Sotheby's by becoming first a cataloguer, then head of the Antiquities and Impressionists departments. In 1965, at the age of twenty-five, Chatwin was appointed a director of the auction house. Some insiders touted him to be the next chairman. 'There's nothing about the commercialisation of art that I don't know,' he bragged to an editor (Clapp 104). He was probably right. His knowledge of objects extended beyond their commercial viability to their provenance and metaphysical properties.

Chatwin was said to have the 'eye,' meaning he possessed an infallible instinct for the authenticity and uniqueness of an object (*What* 359). With an insouciance that recalled Joseph Joel Duveen, the early twentieth-century art dealer, or Bernard Berenson, the art historian and connoisseur, Chatwin made a habit of flamboyantly exposing fakes. At a glance he would declare objects authentic or forged. His quick-study expertise spanned epochs and diverse artefacts. Emboldened by his intimate and often tactile knowledge of rare items, he would as easily pronounce a purple faience Ushabti figure a fake as he would decry a Jackson Pollock drip painting a forgery (Shakespeare 101). Chatwin could even discern which parts of an object were authentic and which parts were not. He inventories such combinations of the authentic and the fake in the collection of an art dealer named Alouf: 'A Roman gold

pectoral set with blue glass pastes. A forgery. // A neolithic marble idol with an erect phallus, on an accompanying perch. The perch was genuine, the idol not' (*What* 288). Having the 'eye' means atomizing an object into its component parts to see where the genuine and the factitious join together, sometimes without success. The declaration of fakes is a strategy, as Utz proves in his negotiations with a dealer over a rare spaghetti-eating Pulchinella. Questioning the genuineness of the piece is a ruse: 'He was simply playing for time' (*Utz* 92). He knows in advance that he will buy the ceramic at any cost. Calling an artwork inauthentic unsettles fixed definitions of what an object is and loosens the fierce grasp of ownership that people feel in the presence of material things.

On the pretext that he suffered from a sudden onset of blindness caused by looking at too many objects, Chatwin quit Sotheby's in June 1966. He narrates this episode of psychosomatic blindness in *The Songlines* and 'I Always Wanted to Go to Patagonia.' Through repetition, the episode of non-organic blindness takes on a mythic quality. To cure Chatwin's object-induced illness, a doctor advised him to look at 'long horizons' instead of studying pictures (*Anatomy* 11; *Songlines* 17). After leaving Sotheby's and before settling into a rhythm of travelling and writing, Chatwin, who was attracted to buried and prehistoric things, studied archeology at Edinburgh University without taking a degree. Archeology is a way of thinking about the social meaning of objects without having to own them. Chatwin's archeological inquiries mostly pertained to the detritus left by nomads. The great theme of all Chatwin's books, a theme that sometimes falls flat for being frequently reiterated but never decisively proven, is that human beings are by nature and inclination nomadic. According to Chatwin, the true nature of humankind is to own as few possessions as possible. Evolved to walk, as suggested by a long striding gait, *Homo erectus* has succumbed to the burden of possession and the 'malaise of settlement' (*Songlines* 161). All of Chatwin's works revolve around the twin poles of ownership and freedom from objects.

By turns, Chatwin adopts idolatrous and iconoclastic attitudes toward objects. Despite the yearning to break free of artefacts as if they exercise a spell, he also maintains that human creatures cannot live completely free of their tangible possessions: 'Some people attract more things than others, but no people, however mobile, is *thingless*' (*Anatomy* 171). Although Chatwin himself longs to 'escape from the "mania of owning things,"' he admits to sneaking into Christie's or Sotheby's

during sales even after he quit his job (*Anatomy* 18). He resigns himself to the fact that there is no escape from the hypnotic economy of ownership. Utz similarly wonders if he has the courage to 'leave the collection' (58) that he has assembled in Prague, and concludes, after a woeful trip to Vichy, that 'the collection held him prisoner' (90). He exclaims, in a *cri de coeur*, that porcelain has 'ruined [his] life!' (90). Objects themselves are responsible for Utz's enslavement; possession roots him to Prague, a city he claims to hate. A complete evacuation of objects from one's life, let alone a depletion of curiosity about the nature of objects, proves impossible for Utz and for Chatwin.

If one cannot be free of objects entirely, one can think about the relation between possessor and possession in all its forms. In his most searching investigation into the nature of physical objects, a 1973 essay called 'The Morality of Things,' Chatwin writes, 'Things appear to be vital to us; to be without them is to be lost or deranged' (*Anatomy* 181). He means, citing the psychoanalytic theories of Freud, Winnicott, and Bowlby, that objects integrally contribute to identity. For infants, toys substitute for human contact and teach adverting minds how to negotiate social relations. Like a baby's grabbing a rattle or a child's hoarding toys, clutching and collecting are human impulses. Because they can be held and touched, objects create a habitat and, in the long run, a culture. Picked up and handed around or hidden and cherished, certain objects acquire totemic status. Indeed, culture materializes in goods that are exchanged or hoarded. Such goods absorb meaning because they function as possessions. When he says that 'things appear to be vital to us,' Chatwin also means, with reference to anthropological evidence tendered by Marcel Maus and Claude Lévi-Strauss, that people share with animals the tendency to mark territories through objects: 'An African ancestor statue, not less than a Gainsborough, announces the legitimacy of a man, family or tribe in their own particular place. Now we have all heard the notion that art collecting is territory formation. The collector patterns his spot as a dog marks a round of lamp-posts' (*Anatomy* 181). The principle of establishing legitimacy and territory applies to *Utz* with a political twist. The collection of eighteenth-century porcelains divides the private fantasy realm of wit and transformation that is Utz's dream world from day-to-day pressures and dissatisfactions in the Soviet state. In all of his essays and novels, Chatwin interprets objects semiotically, as a meaningful language with peculiarities and nuances known only to those who have mastered it. The rarity of certain objects complicates the language of visual culture even further. Regardless of

their preciousness or scarcity, objects confer identity and meaning in cultural contexts. People lose their bearings without them.

As Karl Marx and Friedrich Engels argue in *The German Ideology*, human consciousness is mediated by material goods. A material dialectic, as against a Hegelian dialectic of spirit, forms from the repeated transactions between human consciousness and things, especially property: 'The production of ideas, of conceptions, of consciousness, is first directly interwoven with the material activity and the material intercourse of men' (42). Acquiring and dispersing material goods knits people into society. Chatwin wonders what human consciousness and culture would look like in a world *without* objects. In *The Songlines*, a book about Aboriginal mythology and land rights in Australia, a priest makes a bid for material poverty on the grounds that psychological health may be possible only through being possessionless: 'men had to learn to live without things. Things filled men with fear: the more things they had, the more they had to fear. Things had a way of riveting themselves on to the soul and then telling the soul what to do' (64). Ownership exacts its obligations and thereby forms and deforms personality. In *The Songlines*, Chatwin claims that 'possessions exhaust us' (163), which derives in part from his theory that nomadism defines the human species. Nomads cannot carry too many possessions without feeling physically exhausted. But the care and upkeep of objects drain psychological energy as well. Transferring ownership into the category of fetishistic worship, Chatwin frets under a 'fierce iconoclasm' (*Anatomy* 12). He periodically abandoned everything that he owned by selling or giving away his possessions. Very ill with AIDS in the last year of his life, Chatwin went on delirious shopping sprees in London. At the same time, he dispersed to close friends a small hoard of treasured fetish objects that he kept in a little jumble box (Shakespeare 511–12).

For Chatwin, iconoclasm does not inevitably have a religious connotation – a smashing of idols that attempt to depict the ineffable in a physical object – so much as a connotation of lashing out against the tyranny of objects over the spirit. In Constantinople and Byzantium, iconoclasts objected to the worship of a material idol, rather than the divine itself. Attuned to this historical iconoclasm, Chatwin updates it for twentieth-century commodity culture. In particular, his iconoclastic zeal is directed toward aesthetically crafted objects that enchant the eye and entrap the mind. The human tendency to treat material goods as sacred tinges all ownership. In *The Viceroy of Ouidah*, Chatwin's novella about a cruel, scapegrace slave-trader named Francisco Manoel da

Silva, the slaver leaves relics – a cane, a silver elephant, a gilt crucifix, a 'pink opaline chamber pot' (23), a rosary made of nuts, an open bottle of gin, some scraps of paper – to his numerous offspring, who cherish them reverentially. Holy auras envelope all possessions even when those objects derive from a human, not a divine, source, as happens with Francisco's relics. Such totemic or sacred auras are hard to dispel because human beings tend to accumulate things and magnify the symbolic meaning of their accumulated possessions.

Such auras are even harder to dispel when valued objects are aesthetic. In an essay on George Costakis, who collected avant-garde Russian art when such art was no longer fashionable, Chatwin explicitly invokes idolatry and iconoclasm in relation to paintings, not holy relics. Anatoly Lunarcharsky, Lenin's first commissioner of education, lamented the 'monstrous destruction of beauty and tradition' wrought on the Kremlin and St Basil's Cathedral in Moscow during the Russian Revolution, whereas 'a mood of iconoclastic fervour swept the Leftists' who were committed to advancing revolution through art (*What* 161–2). The artist Malevich hoped that 'all towns and villages would be destroyed every fifty years' (*What* 162); the sentiment anticipates Utz's wish that 'museums should be looted every fifty years, and their collections returned to circulation' (*Utz* 20). Not all artists in the 1920s and 1930s shared Malevich's destructive ruthlessness, just as most collectors do not share Utz's anti-museal wrath. Kandinsky believed 'in painting as a healing ritual to cure mental anguish and wean men from materialism' (*What* 162), which is to say that painting is a material object that points to an ineffable immateriality beyond itself. By contrast, 'Tatlin and Rodchencko insisted that materialism was the only value that counted. All the artists, however, agreed to hate the image [...]. For beneath the Russians' obvious devotion to human images lurks an impulse to smash them to bits' (*What* 162–3).

Iconoclasm among the modernist avant-garde signals a commitment to the new, a conscious and crushing repudiation of the past. Hatred of images, however, entails a concomitant declaration of allegiance to abstraction. Within this aesthetic program, the image interferes with understanding the new. The iconoclasts presume to speak from a position of greater insight and social awareness than idolaters do. Guided by a belief in righteous progress, iconoclasts denounce the past in order to move forward aesthetically and culturally. The purification of art comes at the cost of repudiating and then losing touch with tradition. Eventually, no reminders of tradition remain; all have

been smashed, discarded, burned, or otherwise destroyed. Chatwin conjectures that the Leftists' relentless smashing of icons in Russia ultimately led to 'fatigue' (*What* 169). Nothing remained to attack and demolish. Their fury spent, the avant-garde iconoclasts could dispense with painting and art altogether. If objects are anathema to painting, then paintings, irrespective of subject matter, impede social advancement because they are material possessions. Any and all paintings should be obliterated for impeding the transformation of human consciousness. The totemic or sacred aura that lingers around artworks is attributable to this paradox: objects are obstacles, but the possession of objects is inevitable.

Chatwin illustrates this paradox through the anecdote of a British salesman. Prone to telling the same story many times over as a means of perfecting it, he recounts the salesman anecdote in both 'The Morality of Things' and *The Songlines*.[1] The salesman, whose market was in Africa, lived out of a suitcase; 'he appeared to possess nothing, but when I pressed him, he admitted to owning a box which he didn't want to discuss' (*Anatomy* 182). He kept the box locked inside a safe at corporate headquarters. Back in London, after long voyages abroad, the salesman locked himself in a bunk-room and spread the contents of his secret box on a bed:

> In the bottom of the box he kept the bric-à-brac salvaged from an earlier existence: his parents' wedding photo; his father's medals; the letter from the King; a teddy bear; a Dresden kingfisher that had been his mother's favourite; her garnet brooch; his swimming trophy (by 1928, he no longer had attacks of bronchial asthma); his silver ashtray 'for twenty-five years' loyal service' to the firm.
>
> In the top half of the box, separated by a layer of tissue paper, he kept his 'African' things – worthless things, each the record of a memorable encounter: a Zulu carving bought off a sad old man in the Drakensbergs; an iron snake from Dahomey; a print of the Prophet's Horse, or a letter from a boy in Burundi thanking him for the present of a football. Each time he brought back one new thing, and chucked out one old thing that had lost its significance. (*Songlines* 232)

In the rendition of this story in *The Songlines*, Chatwin concludes that the salesman 'had only one fear: that soon they would make him retire' (232). Were he forced to retire, the salesman would be permanently stuck in London with his box of fetishes. If the salesman travelled no

more, he could not substitute new objects for those already gathered. Their significance would be more or less permanent.

Although the version of the anecdote in 'The Morality of Things' is nearly identical in organization and phrasing to the version in *The Songlines*, with slightly less emphasis on the inventory of mementoes, Chatwin annotates the story differently. He concludes that the salesman had 'solved the tricky equation between things and freedom. The box was the hub of his migration orbit, the territorial fixed point at which he could renew his identity' (*Anatomy* 183). The two parts of the salesman's box, devoted to family mementoes on the bottom and African objects above, express the psychological and social aspects of his personality in spatial layers. Although the anecdote does not state that he throws out family heirlooms – would he chuck his mother's brooch for an item brought back from Benin? – the salesman does separate personal souvenirs from impersonal commodities. The souvenirs are indispensable to the formation of identity, whereas the African mementoes can be swapped for new ones. Never permanent, one token of a 'memorable encounter' replaces another. Memory is not invested in objects only. Freedom from objects is, at least in part, a freedom from sentiment expressed for objects.

The story, as a parable about fetishes, treats material objects as obstacles. In his definition of the fetish, Freud emphasizes the obstruction to vision and, consequently, the barriers to desire that fetishes impose: 'when the fetish is instituted some process occurs which reminds one of the stopping of memory in traumatic amnesia. As in this latter case, the subject's interest comes to a halt half-way, as it were; it is as though the last impression before the uncanny and traumatic one is retained as a fetish' (155). When sight is arrested at a moment of traumatic revelation, the last visual impression converts the perceived object into a fetish. Adam Phillips glosses Freud's idea of the fetish as a stoppage or obstacle: 'obstacles without desire are literally unthinkable' (83). Confusion underscores the fetish: is it a barrier to some other desired object or is it the object of desire itself? Phillips concludes that 'it is a sign of a good fetish that it keeps incompatible ideas alive' (88). The fetish objects that the travelling salesman keeps locked in a box in a safe in London, objects constellated around contact with family and strangers, freeze his memory at specific moments, although the full meaning of those moments may not be available to him, just as no one is ever in full possession of the meaning of an exchange or an encounter. Indeed, fetishes sum up the mysteries of contact without explicating them.

Because they combine substituted and condensed meanings, fetishes are never fully decipherable. One thing, however, is certain: a fetish is never, as Kant would have it, *ein Ding an sich*. Although the objects root the salesman to an identity, they do not inhibit his nomadic wandering. Stoppage is vested in the objects themselves, not in the possessor of the objects, who remains free to travel. Chatwin concludes that the salesman successfully integrates the object as obstacle into his identity by periodically discarding his assortment of fetishes, one at a time, while replacing each with a new one. By careful psychological parsimony, the salesman never allows himself too many secrets – or fetishes – at once.

The anecdote of the salesman anticipates Utz's unhappy and unsuccessful attempts to flee his porcelains. Utz positions his porcelain collection, politically and psychologically, as the necessary obstacle to his satisfaction. He cannot realize his desire to travel because his porcelain collection holds him to Prague. The objects excuse him from fleeing permanently to the West, even while Utz recognizes that his being tied down by porcelains is absurd. Porcelains are only so much 'expensive junk!' (*Utz* 94). Yet the relation between things and freedom has other consequences as well. The salesman keeps his trinkets hidden; he feels ashamed to acknowledge any attachment to the object world. Similarly, Utz keeps a cache of porcelains in a bank vault in Switzerland; he sneaks away to visit them on occasion. As Freud points out in his definition of the fetish, visual apprehension and remembrance are arrested just prior to the traumatic moment. Hiding objects in a vault or a box exaggerates the prohibition against looking, even while such hidden objects, occasionally laid out on a table under anglepoise lamps in the inspection rooms of a Swiss bank, as happens in *Utz*, or spread out on a mattress in a locked room, as happens in the story of the salesman, teases the fetishist into ecstasies of looking and fondling. The hidden objects acquire more significance for their owner because no one else knows that they exist, at the same time as the owner represses their secret significance as a denial of the power that the objects exert. To hide an object is to hide it from oneself and from others at the same time. Utz hides his porcelains in a bank vault in order to mislead the Czech government about the extent of his collection, although his activities abroad seem to be monitored by officials. Utz fools himself, not the state police.

The salesman hides his objects in an office safe in order to mislead himself about meaning and mobility in his own life. The salesman's willingness to toss out an object and replace it with another preserves

an equilibrium between veneration for the past, as embodied in things, and indifference to the past. A nonchalant disposing of objects breaks the enchantment of the object. Chucking out a memento is not iconoclastic if the memento – a purely personal totem – does not possess sacred significance. Nevertheless, jettisoning objects calls into question the value allocated to material goods. Locking objects in a box inside a safe confers the appearance of value upon them, but only until such time as the salesman deems them devoid of value in his personal inventory. To break the perceived value of an object is to prevent ownership from becoming fetishistic or disproportionately obstructive in the making and renewing of identity. W.G. Sebald, detecting the contradictory impulses in Chatwin's writings to smash idols and to cherish them, implies a connection between compulsive note-taking and the desire to render concrete what can never be precisely known: 'Something of this fetishistic greed went into [Chatwin's] mania for gathering and collecting, and then into turning the fragments he found into significant mementoes endowed with a wealth of meaning, reminding us of what we, as living beings, cannot reach' (184). Objects are obstacles to desire, even when they inflame and heighten desire. As the anecdote of the salesman proves and as *Utz* dramatizes, objects inhibit rather than liberate people by circumscribing desires and freedom.

The story of the salesman epitomizes Chatwin's voyeuristic narrative style. Objects exist to be looked at. That looking can be vicarious, as the anecdote of the salesman intimates. As a narrator, Chatwin takes pleasure secondarily, through the intermediation of the salesman. Chatwin's customary narrative stance is a combination of anthropological detachment and titillation. When he describes a boat trip down the Volga (*What* 171–91) or when he witnesses the ritual passage of adolescent boys to manhood in the Bororo tribe in Nigeria (*Songlines* 264–7), he invariably adopts the attitude of a dispassionate anthropologist: aloof, yet pruriently given over to details of ritual, clothing, and movement. When he dines with Utz and Orlík at a restaurant in Prague, the narrator in *Utz* observes the 'well-rehearsed duet' (36) of the two Czechs and records their banter. The narrator pretends to be detached, but he is a voyeur. Visiting Utz's apartment, he conjectures that Marta is Utz's maid. Snooping in Utz's bathroom, the narrator spies a peach silk peignoir, with 'appliqué roses on the shoulders and a collar of matching pink ostrich plumes' (100), hanging from a hook on the door. The narrator suspects that Utz, whose *raffinement* as a connoisseur of porcelain might translate into refinements of a sexual sort, likes to wear wom-

en's clothes. The narrator muses that the 'atmosphere of musty, rather coarse femininity' (101) in Utz's apartment, which is decked out with flounces and pink satin, is a clue to Utz's well-guarded homosexuality. This conjecture, based on optical evidence, turns out to be misguided. In fact, Utz is married to Marta and has, according to noisy rumours, serial affairs with female opera singers. The disengaged anthropologist-voyeur does not always draw accurate conclusions. Then again, he is obliged to report only what he hears and sees, rather than the truth.

Chatwin typically narrates obliquely, with asides on historical personages and events and casual speculations based on visual clues. Curiosities attract his attention. In an essay about the photographer Robert Mapplethorpe and the bodybuilder Lisa Lyon, who defined an aesthetic of muscular femininity for the 1980s and who billed herself as a performance artist, Chatwin insinuates himself into the giggling camaraderie of the two friends during photo shoots:

> Robert does not talk much, but he is very watchful and he listens to all that is said. Listening to Lisa, he would suddenly pounce on some detail of her astonishing trajectory, see the possibility of turning it into an image, and so extend the range of the 'intimate portrait.'
>
> In session after session, Lisa posed as bride, broad, doll, moll, playgirl, beach-girl, bike-girl, gym-girl, and boy-girl; as frog-person, mud-person, flamenco dancer, spiritist medium, archetypal huntress, circus artiste, snake-woman, society woman, young Christian, and kink. She posed in Jamaica. She posed, naked on an arctic day, in Joshua Tree National Monument. One afternoon in New York, she posed flat out on a masseur's bench. 'I think there's something of the slab in this one, don't you? The anatomy table? I don't find it morbid, though. I find it calm.'
>
> She and Robert laughed, juggled with ideas, agreed on some, and squabbled over others. They squabbled, for example, over whether she should wear a set of fake scarlet fingernails which, Robert insisted, were essential for a fashion shot. ('An Eye' 14)

Although Chatwin narrates the scene as if he were not present, he clearly witnessed several exchanges between Mapplethorpe and Lyon.[2] In an interview with Michael Ignatieff in 1987, Chatwin likens his narrative stance to photography: 'All one hopes to be is the first-person narrator who is like a camera shutter, taking flashes on the story as it develops in front of his eyes' (24). Mapplethorpe's 'cold and sharp' ('An Eye' 9) take on people and objects appeals to Chatwin's detached

narrative sensibility. He admires the way the photographer cajoles his models into private dream worlds, where they assume the status of objects: 'His eye for a face is the eye of a novelist in search of a character; his eye for a body that of a classical sculptor in search of an "ideal" [...]. His portraits of flowers are somehow interchangeable with his portraits of society women – a cloud of white-spotted gypsophila, a black-spotted veil' ('An Eye' 9–10). The photographer's eye begins with an ideal and fits models into that mould. Like a tangible object, the human body has its textures and accoutrements and therefore can be photographically recorded as if it were an object, arranged and displayed.

Chatwin's own photographs level the distinction between human subjects and inanimate objects. In *Far Journeys*, a collection of posthumously published photographs, people appeal to his visual sense because of the colour and drape of their clothes, not for any interest in their countenances. He does not take portrait shots that reveal sitters' personalities. Instead, his eye seeks out decorative detail as an incidental effect (figure 11). Almost all of his photographs feature flat panels of colour, some of which play with, but resist, depth in the visual field. Broad bars of colour look like abstract paintings by Richard Diebenkorn. Colour is surface; surface, it seems, is all that matters. In these photographs, walls or sides of boats beseech the eye, but they do not admit any speculation on the functionality of walls or boats as objects. The blue of the sea is simply a plane of colour detached from its referent. Blues and yellows are startling in their purity as colours, made pearlescent by sunlight. In many of Chatwin's photographs, colour obstructs the eye and defies horizon lines. Prone to photographing doors and walls as solid colours, Chatwin views buildings not as dwellings, but as inviolable spaces (figure 12). He peeks into the semi-private spaces of other people without entering those spaces. As the position of the photographer implies, he haunts thresholds and loiters in yards, spaces beyond which he dare not intrude. The photographer in all of Chatwin's pictures is marginal: a nomad, a traveller. In many of his photographs of yards and doorways, some activity, whether play or work, has only just been abandoned. In his photographs of houses, people are seldom visible; if visible, they remain incidental to the composition. The images of walls, doors, and houses imply that the photographer does not care to be invited inside. Although he takes pictures of doors, doors do not always open to Chatwin. When he cannot see around doors, he photographs them as apertures opening onto impenetrable spaces.

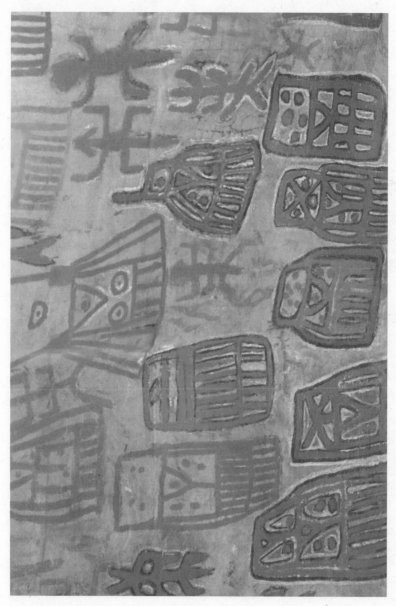

11 Bruce Chatwin, symbolic decorations in Dogon Village, Mali. © The Estate of Bruce Chatwin.

12 Bruce Chatwin, Pisé house, Mali. © The Estate of Bruce Chatwin.

Photography has further implications for Chatwin's technique. By textually documenting the interactions between Lisa Lyon and Robert Mapplethorpe, Chatwin participates in the making of art by recording the event, nothing more. By putting himself in the position of Mapplethorpe the photographer, Chatwin tutors his eye to see differently. The camera distances, or estranges, the narrative glance from the polymorphous Lisa Lyon and redirects it to Mapplethorpe's way of seeing. Two gay men, one with a camera and the other with a photographic command of visual detail, inspect the overly muscular body-builder for traces of masculinity or desire, exacerbated by the implicit voyeurism of the triangulated encounter. Consequently, Lyon's body, a force field of muscle and sinew, is described as a metamorphic object. Chatwin pretends that his position vis-à-vis the photographer and model does not interfere with the photo shoot. Yet Lyon and Mapplethorpe behave like puppets acting out their respective roles for Chatwin's voyeuristic pleasure.[3] Chatwin's incarnation as the slightly absent, slightly disguised narrator of all his books and essays – he only wrote fictionalized accounts of real events that he witnessed[4] – derives from his silent communication with the world of objects. He is a peeping tom in all of his tales, a habitual observer, even when he does not name himself outright. He watches human interactions with the same detachment that he applies to things. Writing is a way of possessing people and objects without taking ownership of them.

The object world dictates Chatwin's style. At Sotheby's, he wrote descriptions for sale catalogues in precise, economical phrases (Clapp 88). The cataloguer's task of summarizing pertinent details sets the template for his bare-bones prose. Minor variations distinguish one object from another, so the cataloguer makes minute distinctions in order to draw connoisseurs' eyes to nuances. David Plante remembers that Chatwin typically kept a few objects on a table in his sparely decorated London apartment: 'he had a small collection of objects, which often changed: a fragment from Persepolis, an Eskimo toggle, a pre-Columbian bit of polished black stone' (185). The ceremonial display of heterogeneous objects from around the world and from diverse eras, all within reach, enhances the peculiarities of each. Changing them regularly, Chatwin familiarizes his eyes and fingers with the endless textures and singularities of the object world. V.S. Pritchett praises Chatwin's 'ability to catch the evanescent detail' (46). Noticing elements of colour, shape, and texture requires an eye for exact detail, as well as a precision in the recording of visual information. Chatwin's style could be summed up

in a motto: *I travelled to see many things*. Plante singles out Chatwin's 'attention to detail, and the abruptness, the almost non-sequitur-like abruptness, of his sentences' (186). Objects, not dramatic coincidences or abrupt reversals of fortune, determine his quicksilver shifts in focus.

John Lanchester comments that, in his writing, 'Chatwin is committed to the anomalous and the improbable' (10). In the travelogue *In Patagonia*, Chatwin records collages of details: 'The hotel in Río Pico was painted a pale turquoise and run by a Jewish family who lacked even the most elementary notions of profit' (73). No inevitability underlies the string of coincidences – that the hotel is turquoise, the family Jewish, and the business unprofitable. If the hotel were painted crimson or yellow, it would not be more profitable, nor does the Jewishness of the family have any inevitable link to the failure to turn a profit, which might be attributable to the out-of-the-wayness of the hotel, the benevolence of the family, or any number of other factors. Chatwin's expository style, characterized by such spareness and speed, registers the idiosyncrasies of people, objects, and places as a series of curiosities. The coalition of details – turquoise, Jewish, hotel, unprofitability – creates the uniqueness of the place and the possibility of a narrative. Nothing happens event-wise in the sentence.

Chatwin notices unlikely objects in strange configurations. In Russia, he sees on a barge that 'some babies' nappies were hanging out to dry on the same clothes-line as half a dozen carp' (*What* 181). Such incongruous items slung together invite a question about the relation of food and diapers, but the question goes unasked. The juxtaposed objects reinforce their contingency and unknowability as so many material objects blowing in the breeze. Objects do not yield their interiority to the questing eye. The eye rests on material facets only. The detail exists as detail, calls attention to itself as detail, without contributing to the linearity of causal narrative. Because these details surface and subside without commentary, they intimate the discontinuity between people and possessions. In Chatwin's prose, objects do not convert into property, nor can objects be so exactingly classified that diapers and carp would never be thought of in combination. What Plante defines as the non-sequitur rapidity of Chatwin's prose springs from unexpected contiguities. In *In Patagonia*, Chatwin admires a 'genius' (33) pianist who plays Beethoven sonatas and Chopin mazurkas in the remote village of Gaimán, not because classical piano music in itself is all that startling, but because classical piano music played with virtuosic perfection in a bleak backwater provides such an unusual combination of effects.

When Chatwin visits a museum of artefacts housed inside a church in the Patagonian village of Río Grande, he comments that the natives in Tierra del Fuego were hunters who 'owned no more than they could carry. Their bones and equipment decayed on glass shelves – bows, quivers, harpoons, baskets, guanaco capes – set alongside the material advances brought by a God who taught them to disbelieve the spirits of moss and stones and set them to petit-point, crochet and copybook exercises (examples of which were on display)' (*In Patagonia* 148). Chatwin implies that hunting instruments were abandoned for crochet hooks in a conflict between native and European cultures. The museum, with its random assortment of petit-point and harpoons, tells a story about conquest through objects. Objects propel narrative, albeit a non-verbal narrative that is both material and spatially organized inside glass cases. The aligned elements contain an incipient story, but the story has to be looked at, as well as looked for, in order to come into being. In this regard, Chatwin is a habitual translator of objects into the medium of prose narrative. In his narratives, he curates objects. He selects and arranges them; he sets them in a certain light. As a narrator, Chatwin moves objects around for the reader to admire. He does not pretend to possess all information about objects. In *Utz*, the narrator cannot definitively say what Utz does in Switzerland or what happens to Utz's collections. The narrator as curator simply exhibits the objects that create a story.

The disposition of things in space, as well as in sentences, creates display. In a glass case at Sotheby's or in a museum in Patagonia, displayed objects acquire the mystique of inaccessibility. They can be looked at but not handled. In the most intelligent review of *Utz* that appeared upon publication of the novel in 1988, Adam Mars-Jones calls Chatwin's visual emphasis a defect: 'If he has a weakness it is that the insistent detail can seem in some way self-advertising, drawing attention not to the things seen but to the quality of the eye seeing them. If there is a spiritual side to Utz's connoisseurship, after all, there is a materialist side to Chatwin's, and his sentences can seem like shelves for items of beauty, for fragments of history and culture that have developed beyond mere footnotes but seem somewhat inert as the ingredients of fiction' (1041). Sentences like shelves support the textualized artefacts that Chatwin rescues from obscurity or ephemerality. Whereas Mars-Jones sees a hodgepodge in Chatwin's prose, Chatwin himself self-consciously questions the relation of objects to order and the social reproduction of value through display. Shelved objects resist assimila-

tion into seriality or narrative. They have a fleeting, even flirtatious, relation to the eye. They enchant vision, but only for a while. As Chatwin's prose suggests, objects are never conquered by, or subdued within, the field of vision.

Raising the possibility that narrative does not inhere only in language, Mieke Bal asks the question, 'Can things be, or tell, stories?' (99). Chatwin understands the indispensability of objects in human interactions, yet he distrusts this reliance on objects for social exchanges. Although objects in themselves may not be stories, objects either animate or conclude stories. In *Utz*, objects coalesce into collections. By arranging objects on shelves, Utz configures a flawless, miniature world. In his flat in Prague, the objects occupy 'a narrow room, made narrower by the double bank of plate-glass shelves, all of them crammed with porcelain, that reached from floor to ceiling. The shelves were backed with mirror, so that you had the illusion of entering an enfilade of glittering chambers, a "dream palace" multiplied to infinity, through which human forms flitted like insubstantial shadows' (*Utz* 48–9). Telling a tale of salvage and heroism, Utz maintains that he has 'rescued' these objects from the jaws of destruction (19, 48). Yet the fragility of objects, rather than objects themselves, instigates narrative. Narrative sequence depends on the fate of Utz's collection, whether it is lost, destroyed, or hidden. Narratives occur because of the human desire to possess and manipulate objects as property – in this case, the aestheticized property of porcelain figurines.

The End of Museums

In Chatwin's books, exposition follows the serial arrangement of objects or their movement into and out of a visual field. In this sense, a narrative is a box, not a duration; a space, not a temporality. Objects pass into and out of the frame of the container. In *Utz*, objects hide inside boxes. Utz's grandmother sends him a coveted figurine in a 'specially made leather box' (19). As a child, Utz first saw the figurine inside a 'vitrine of antique porcelain' (18). The dealer, Dr Frankfurter, removes the prized spaghetti-eating Pulchinella from 'multiple layers of tissue-paper' in a box (91). The narrator in *Utz* eyes garbage bins on a hunch that the collection of precious porcelains has been sent out with the trash. Like the salesman who hides his trinkets in a box in London, the boxes in *Utz* contain items of assorted value. The box often magnifies the value of the items inside. Like a magician pulling objects from his

hat, Dr Frankfurter can whet Utz's appetite for porcelain by slowly unwrapping the tissue paper from Pulchinella. The box has many forms: china cabinet, bin, shrine, drawer, valise, penny arcade, console, cage, glove compartment, basket, trunk, coffer, kit, coffin, stage, shop window. As Joseph Cornell's constructions do, the box protects, but it also renders precious items invisible. A boxed object can be unboxed in a gesture of revelation. The novel begins with Utz's corpse boxed up in an oak coffin, but through an act of narrative resuscitation, Utz returns to talk about his collection. Through the abracadabra of achronological sequencing, a narrator produces objects and bodies at will. The box is, in the end, only a fictional barrier between inside and outside, between what is visible and what is temporarily invisible.

The principle of spatiality is taken to museological lengths in postmodern fiction. In short stories such as Donald Barthelme's 'At the Tolstoy Museum' and 'The Flight-Path of Pigeons from the Palace,' as well as Diane Schoemperlen's 'Five Small Rooms' and 'Innocent Objects,' graphics supplement and spatialize text. Meaning in these stories is deciphered through the passage of the eye from word to image and back again. In 'Innocent Objects,' engravings of a camera, a tea set, a typewriter, a pistol, a pocketknife, and other objects are relegated to explanatory notes at the foot of the page. The objects are stolen during a crime (a theft that is either real or imagined by the victim of the crime). In effect, the stolen goods are hocked in the margins of the story or presented as testimonials, like evidence at a trial. Schoemperlen's story exemplifies the postmodern valorization of space over time, just as Chatwin's narratives do. Although Chatwin does not usually scatter pictures among his novels and travel books (some editions of *In Patagonia* include photographs), his narratives do advance through material accessories. The narrator in *Utz* sadly states that things 'are tougher than people. Things are the changeless mirror in which we watch ourselves disintegrate. Nothing is more age-ing [*sic*] than a collection of works of art' (113). *Utz* displays that ageless collection the way a vitrine contains physical artefacts.

For Chatwin, narrative is a museum within which objects glitter. *In Patagonia*, for instance, jumbles together things and people. On Patagonian farms, a traveller 'can find, nestling behind windbreaks: herbaceous borders, lawnsprayers, fruit-cages, conservatories, cucumber sandwiches, bound sets of *Country Life* and, perhaps, the visiting Archdeacon' (120). Cucumber sandwiches and lawnsprayers – syntax alone holds dissimilar things together and equalizes them. In *The Viceroy of*

Ouidah, the narrator describes a plantation in Dahomey through bizarre juxtapositions: 'Humming-birds sucked from scarlet honeysuckle. Morpho butterflies fluttered over the morning-glories and, after dark, in a Chinese loggia, black choirboys in snuff-velvet breeches and lace jabots would sing Pergolesi's *Stabat Mater*' (43).[5] The clash of colours, music, lace, animals, flowers, and textures disorder the senses. Sentences strain to accommodate diversity. Can a loggia, as an Italian architectural feature, be Chinese? And who in the twentieth century wears a jabot? Narrative does not triage objects according to significance. Like a visitor to a museum, the reader deciphers value within a panoply of exhibited things.

A book resembles a museum in that both are replete with artefacts and curiosities. In *Utz*, inset tales, jokes, digressions, historical notes about porcelain-making, folktales about golem, and assorted other genres create the equivalent of a cabinet of curiosities, in which rag-ends of stories are thrown together. The 'I' narrator sifts this information; his eye threads among diverse objects and random occurrences. The book itself, as a physical object, frames divagations. Inside the physical confines of the book, asides on etymology and the fifteenth-century Hussite Rebellion fall into a pattern of unpredictability and digression. The novel, in fact, begins with a detour; the narrator intends to write an article about Rudolf II and his collections, but he gets sidetracked with a trip to Prague, where a mutual acquaintance recommends that he meet Utz. The narrator never completes his research on Rudolf II and remembers the whole escapade as 'an enjoyable holiday, at others' expense' (12). When the narrator returns to Prague, he does so haphazardly on his way back from the Soviet Union. Like the physical displacements and detours of the narrator, *Utz* is an arabesque that leads nowhere, an immense joke about things that change without ever improving. Just as Utz fools everyone by causing his collection to disappear, the narrator hopes to have the last laugh 'at others' expense,' namely, those who expect narratives to deliver a satisfactory pay-off. Instead of plot, *Utz* offers fragments and dwells on the afterlife of objects and their arrangement within narrative.

Utz critiques collectors and collections. Unlike Chatwin's other books, in which a know-it-all narrator observes others' actions with voyeuristic intensity while minimizing his own presence, *Utz* suggests that the unidentified 'I' narrator who visits the porcelain collector at home and receives postcards from Utz's biologist friend Orlík is collected by the Czechs, both of whom have museological careers or interests. Orlík is

a palaeontologist who specializes in woolly mammoths and makes a hobby of catching houseflies. Utz has a 'poorly paid job, as a cataloguer in the National Library' (25). Both like their little jokes. In the end, the narrator does not control events. Egged on by the prankster Utz, the narrator misdiagnoses the collector's 'Porzellenkrankheit' (90), or porcelain sickness, as a standard case of collector's mania. Chatwin knew the psychoanalyst Herbert Muensterberger and may have exploited his ideas about collectors in the representation of Utz and his porcelain sickness.[6] Muensterberger theorizes that 'repeated acquisitions serve as a vehicle to cope with inner uncertainty, a way of dealing with the dread of renewed anxiety, with confusing problems of need and longing' (11). But such psychological insights, while accounting for the impulses of the collector, do not fully address the covetousness of the state and the political nature of objects in Chatwin's novel. The communist government, having laid claim to the collection, sends a photographer to document every single piece and a cataloguer assigns a number to each porcelain. Not just private objects, the porcelains already have a political function.

The display of Utz's porcelains against a wall of mirrors visually exaggerates the perceived value of the objects much as a museum display does: as infinite, as incalculable. Chatwin thought long and hard about museums as sites of mediated display. For a six-part series called 'One Million Years of Art' that ran in the *Sunday Times Magazine* during the summer of 1973, he selected a comprehensive roster of artefacts and collectibles. Among predictable relics, statues, and objects – the Victory of Samothrace and the Bayeux Tapestry – Chatwin included a photograph of an Afghan lorry and a picture of a door in Mauritania that he had taken during his travels. The neatly presented objects, miniaturized to a uniform scale for the purposes of magazine publication and shorn from any context that would provide clues about use value or religious value, are treated as aesthetic. Aside from chronology, no progress is implied in the arrangement of objects in Chatwin's series of a million years of art. The writer serves as a curator, for whom objects are self-expressive. The Ardagh Chalice from eighth-century Ireland and a ninth-century vellum page from a Kutic Koran coexist without commentary. No explanation links these disparate objects. Religious value lingers around these objects, but that iconic value is not explicated. Without explanation, objects are inert; they lose their capacity for enchantment. In 'One Million Years of Art,' the objects are museumized: dated, inventoried, and mute.

Chatwin's language exerts a form of enchantment that objects themselves may not possess. Objects occupy a fixed space, but narrative occupies an indefinite length of time. Lists can prolong narrative indefinitely. In 'The Estate of Maximilian Tod,' a story about an unstable glaciologist who murders his collaborator and violates rare books by razoring out pages, inventories swell the narrative: 'Inventories make tiresome reading, so I shall confine the list [of Mr Tod's possessions] to a Shang bronze fang-i with the "melon-skin" patina; a Nuremberg sorcerer's mirror; an Aztec plate with a purple bloom; the crystal reliquary of a Ghandharan stupa; a gold mounted bezoar; a jade flute; a wampum belt; a pink granite Horus falcon of Dynasty I and some Eskimo morse ivory animals which, for all the stylised attenuation of their features, seemed positively to breathe' (*Anatomy* 63). As in 'One Million Years of Art,' the list unites dissimilar periods and artefacts. Materials – ivory, bronze, crystal, granite, jade – have no discernible commonality. Inventories may be dull, but the narrator cannot resist enumerating objects as pieces of exotica. Elsewhere in 'The Estate of Maximilian Tod,' he shows a tendency to admire style above substance. The ornateness of vocabulary ('fang-i,' 'stupa,' 'bezoar,' 'wampum') dazzles because of its extravagance and internationalism. Chatwin knows that readers sometimes find his 'baroque prose unstomachable' (*What* 138), but he remains unwilling to give up showy descriptive language that defamiliarizes objects. Drawing attention to itself, vocabulary detaches from the objects it signifies, which demonstrates the arbitrariness of the linguistic sign and implies that objects exist prior to and after language. The object world comprises an order unto itself, even if these objects are the products of human skill. Objects snub the meretricious language that describes them.

As in 'One Million Years of Art,' the display of objects in 'The Estate of Maximilian Tod' could continue indefinitely. Lists, like museum exhibitions, never reveal the full extent of holdings. Something is always left out. Although this story ostensibly concerns the transmission of a legacy, the narrator, Maxmilian Tod himself, eventually leaves all of his possessions 'for others to pillage' (*Anatomy* 69). He claims to have done 'everything to protect [his] retina from the visual affronts of the twentieth-century' (*Anatomy* 69). He seeks death in a desert as an antidote to visual surfeit. Yet narrative in 'The Estate of Maximilian Tod' piles objects into heaps as a capitulation to visual affronts inflicted on the reader. Narrative, like a museum, contains objects to be caressed with the eye as with the mind. The story displays objects almost as

glass cases in a museum do. Chatwin's narratives typically advance the claim that gathering and inventorying objects are two of the central stories of aesthetics in the twentieth century. As he writes in *In Patagonia*, 'the concepts of "good" or "beautiful," so essential to Western thought, are meaningless unless they are rooted to things' (175). The rage to possess drives narrative as much as it underlies the mission of museums. Narrative is, therefore, analogous to museology and the will to display.

The institutional museum, a sanctuary for the eye, stages the gaze. In 1971 Chatwin contributed a section titled 'Museums' to a guidebook called *The London Spy: A Discreet Guide to the City's Pleasures*. Chatwin prefers the haphazardness and mess of small museums to large ones. He especially likes those penniless museums that cannot increase their cachet with '"hard-sell" exhibitions of the American type, in which selected objects are superficially highlighted' (95). Dickens House in London, as Chatwin describes it, 'is a sombre little building, containing quantities of Dickensiana and an expanse of lino' (99). The syntax implies that linoleum contributes to the sombreness in Dickens's former living quarters. The personality or accomplishments of Dickens apparently have less significance than the museum that houses him and the linoleum on the floor. In this material rendering of Victorian culture, Dickens leaves behind not novels, but floor coverings. Visitors should pay attention to linoleum because decor enhances the experience of looking at objects *in situ*. The conditions of display contribute to the value of objects on display.

Chatwin invariably documents incongruities in the museums that he describes. At the London Museum, he notices 'a very fine Anglo-Saxon brooch seething with Serpents, a model of the Great Fire of London which looks like a simulated coal electric fire, Pavlova's costume from the *Dying Swan* and the cradle in which most of Queen Victoria's children were nursed, a claustrophobic affair draped with green satin' ('Museums' 103–4). Unlikely things crowd together without rhyme or reason but with comic or macabre effect. Rather than being a liability, eclecticism in the display of objects frees the roaming eye to revel in discoveries, the visual equivalent of zeugma. Fenton House displays the late Lady Binney's bequest to the National Trust of 'her collections of Chinese and European porcelain. The Trust then had the happy idea of bringing into these mellow panelled rooms a collection of harpsichords formed by a Major Benton-Fletcher, an old soldier, who insisted in the terms of his will that the instruments should be kept in working condition for musicians and students to play' (100). The domesticity

evoked by porcelains and harpsichords, even though they belong to two different collectors and two orders of objects, appeals to Chatwin's pleasure in strange conjunctions, whether those conjunctions are curatorial decisions or narrative arrangements: 'Lady Binney's porcelain figures, Columbine and Pantaloon, Harlequin and Arcadian shepherds and shepherdesses pirouette in their vitrines and are far happier here than in arid museum cases. Highly recommended' (100). Chatwin ascribes happiness to porcelains, as if human emotions enliven objects. Porcelain happiness depends on the conditions of display: intimate vitrines rather than arid museum cases. Chatwin's description of Fenton House implies that *the* Lady Binney and *a* Major Benton-Fletcher consort together through the intercession of their objects. Classes collide in the vitrines; the aristocracy and the military find themselves on equal footing within this particular museum, just as Utz, a minor nobleman, marries his housemaid, Marta, in order to ensure the survival of his collections.

Chatwin advocates a museum experience of diversity and freedom rather than conformity and constraint. As he argues in 'The Morality of Things,' objects inhibit movement, yet a life devoid of things is unimaginable. By the same reasoning, objects that are displayed exact more obligations than things kept hidden in a box of fetishes. Display implies curatorial responsibility; displayed objects automatically have value, and that value is part of a cultural heritage, whether personal, national, or international. Chatwin notices the restraints imposed by display for objects and visitors alike. In his summary of London museums, Chatwin praises the Bethnal Green Museum because of its 'refreshing absence of slick display' ('Museums' 96). He comments that, at the Imperial War Museum, 'the visitors are as interesting as the exhibits. We saw a father instructing his six-year-old son in the use of trench knives. A gallant but unsuccessful attempt to destroy the Museum by arson in 1968 caused the copper sheathed dome to collapse, but the damage continues to be reconstructed' (102). The irony of the adjectives – 'gallant but unsuccessful' – implies that the museum should not be restored, because it commemorates war. The ironic tone registers Chatwin's resistance to the museum as an institution that separates objects from environments where they are useful, exchangeable, or damageable. Learning to fight in the Imperial War Museum extends knowledge beyond displays and into the world again. The displays inspire different narratives from those that curators may have foreseen, such as learning to wield trench knives.

As a young man, Utz published an essay called 'The Private Collector,' in which he championed freeing objects from imprisonment in museums: '"An object in a museum case," he wrote, "must suffer the de-natured existence of an animal in the zoo. In any museum the object dies – of suffocation and the public gaze – whereas private ownership confers on the owner the right and the need to touch. As a young child will reach out to handle the thing it names, so the passionate collector, his eye in harmony with his hand, restores to the object the life-giving touch of its maker. The collector's enemy is the museum curator"' (*Utz* 20). Favouring the eye, museums inhibit other senses. The material world exists as an address to the hand – the feel of glass or clay, the appeal of ivory or fabric – an address foiled by the distance imposed by the display case. Utz's anti-museum plea chimes with Chatwin's own dismay about the false aestheticization of objects and the burden that possession of one sort or another imposes. Hence, Chatwin calls for a world of fewer possessions: 'man is the sum of his things, even if a few fortunate men are the sum of an absence of things' (*Anatomy* 65). The museum, as an institution, replaces the individual's need to hoard by putatively collecting on behalf of the nation. Utz's disdain for the museum curator stems from the devitalizing effect that museums have on objects.

As Chatwin clarifies in 'The Morality of Things,' objects that circulate, especially gifts, mark territorial boundaries, whether personal or political. Museums embody political authority. Hiding precious objects in depositories 'proves symbolically the power of the Tribe, City or State. For power is always manifested by the capacity of authority to hold wealth. The American Museum [i.e., all American museums taken together as an institution] became a paraphrase of the State itself, with its ceremonial unveilings, presentations of wealth heavily guarded, its technical experts and providers of cash, its court of privileged visitors and the not-so-privileged public for whose education the Museum ostensibly exists' (*Anatomy* 173). The lending back and forth of artefacts from one museum to another, across international boundaries, promotes goodwill and parity. By the same token, were Britain to sell the Crown jewels to the United States, 'America would have absorbed Britain and destroyed [...] territorial integrity' (184). As Chatwin implies, museums are, at heart, national institutions that vaunt symbolic capital through the sequestering and display of objects. More specifically, the museum, as a temple devoted to material culture, consecrates certain artefacts by increasing the distance of those works from the marketplace and

from individual owners. Ransacking a museum would return objects to circulation and prove that objects have more fragility – value and meaning encoded as a physical attribute – than their material existence alone guarantees.

Chatwin's general critique of museums owes something to André Malraux's *Le Musée imaginaire*, a book that Chatwin admired almost as much as he admired its author. Malraux may have been one of the few people more gifted as a conversationalist than Chatwin. In a laudatory profile of Malraux published in 1974, Chatwin praises him as a 'compulsive' talker whose 'breathless career' defies summary (*What* 114, 119). During the interview, Chatwin dares not interrupt the master as he pronounces on topic after topic: 'His presence mesmerizes his listeners. They feel physically charged by his voice as it alternates from staccato outbursts to slushy whispers' (118). In his thinking about museums, Chatwin appeals to Malraux's *Le Musée imaginaire* for its critique of the meaning of museums as depositories of national and international heritages. In Malraux's definition, a historical transformation befalls visual culture in the 'imaginary museum,' in that artworks from all epochs and all cultures are accessible to viewers through engravings, photographs, or other reproductions. The hypothetical 'imaginary museum' causes an alteration in the way that spectators view and appreciate art, as well as an alteration in the way that curators display and explain art. Spectators, not seeing art in its original location, do not appreciate it properly; colours, medium, and scale are distorted in reproductions. Local cultures become universal culture in the museum without walls.

According to Malraux, the museum, for all it purports to embody history, actually dehistoricizes and rehistoricizes artefacts: 'Le vaste département du Musée Imaginaire qui rassemble les tableaux et les statues, oriente la transformation des vrais musées par une intellectualisation sans précédent de l'art, et par sa destruction des appartenances' (240).[7] The modern museum decontextualizes objects and thus strips them of history and specificity. A Roman crucifix was not, at the moment of its creation, a sculpture, nor was Cimabue's *Madonna* a painting prized for its brushwork and other painterly qualities (11). Both objects were religious icons. Museums transform religious and domestic objects into works of art by transplanting them to institutional settings. In the modern museum, portraits do not represent specific individuals so much as styles or expressions of individual talent; paintings such as *Man in a Helmet* or *Man with a Glove*, having ceased to be thought of as depictions of individual figures in the later Renaissance, merge with their

creators' identities to become 'a Rembrandt' or 'a Titian' (12). Tragedy haunts the decontextualized object, in Malraux's view. Instead of being a repository and refuge for objects, the modern museum removes artefacts from any vital connection to their social uses. Chatwin adapts Malraux's conception that objects metamorphose through time and according to institutional setting. As a critique of museums, *Utz* exemplifies the possibilities of a personal museum, rather than an impersonal institution that putatively collects for the public good.

In many respects, Chatwin, through his appreciation for decontextalized and heterogeneous objects, substantiates George Dickie's institutional theory of art. Dickie resists philosophical accounts of art that dwell on specific qualities in objects that might make them qualify as aesthetic. Instead of elaborating an aesthetic theory, Dickie argues that art 'must exist in a cultural matrix, as the product of someone fulfilling a cultural role' (*Art Circle* 55). In *Art Circle*, he claims that some objects acquire 'conferred artefactuality' (61). In short, some objects are regarded as art and others are not, according to the context in which they are understood. Andy Warhol's *Brillo Box* is not distinguishable from an ordinary Brillo box by any 'visible characteristics' in the two seemingly identical objects (62). Thus Dickie rejects mimesis or intention, among other traditional considerations, as constitutive elements of an artwork. He focuses instead on interpretive discourses that confer artefactuality. In *Art and Value*, he defends the idea of the systemic functioning, even the interdependence, of cultural and institutional discourses: 'An artworld system is a framework for the presentation of a work of art by an artist to an artworld public' (61). A Brillo box has artefactual integrity partly, but not wholly, because of its presentation. In this regard, display value is a subset of the institutional theory of art.

Parallel to Dickie's institutional theory of art, and intersecting with it at some points, Arthur Danto's arguments about art emphasize that the 'primary ambitions' of contemporary art 'are not aesthetic' (183). The contemplation of objects in an institutional setting does not convert objects into aesthetic artefacts. 'It would be a mistake to suppose that contemplation belongs to their essence as artworks,' Danto asserts, and he concludes that the 'posture of contemplation, which stills the mind, has no special rapport with the aesthetic' (95). Malraux's observation that modern museums remove contexts and appurtenances from objects resonates with Danto's claim that an object is art because it is displayed, irrespective of any qualities in the object itself: 'the basic perception of the contemporary spirit was formed on the principle of a

museum in which all art has a rightful place, where there is no a priori criterion as to what that art must look like, and where there is no narrative into which the museum's contents must all fit' (5). According to Danto's definition of museal art, beauty does not make an object artistic, nor does intentional structure, nor does artistic technique. Art need not communicate to viewers. It need not be accessible, either emotionally or intellectually or socially. Danto does not exclude beauty, form, technique, or emotional communicativeness from art; objects may include such elements, but they are not sure-fire guarantees that an object will be viewed as an artwork. The only thing that makes an artwork art is that it resides within the precincts of the institutionalized art world.

Museums are mausoleums for acquisitive cultures. Housing artefacts preserves them, often as examples of imperilled or extinct civilizations. Mieke Bal argues that the impulse to collect objects, among adults at least, derives from 'subordination, appropriation, de-personification' (105). By treating objects as radically other, the collector liberates fantasies of domination and subordination. The object has no life of its own, but only the life granted by the collector who sees its inner meaning. An object becomes collectable when severed from its context, a process made easier when that original culture is characterized as defunct or irresponsibly reckless about preserving its own artefacts and traditions. In a private transaction, Lord Elgin bought fragments of friezes from the Parthenon and shipped them to England because the Greeks in the early nineteenth century deemed them not worth keeping. Bequeathed to the British Museum, they are preserved as an international, monumental treasure. Collecting, in the end, is not the same as buying. Collectors are thought to be superior to purchasers because of the preservationism that motivates collecting. Buyers invest; collectors cherish. The collector assembles objects as a means of remembering and ordering the past. The same principle extends to institutions. Preservation staves off the depredations of time; the museum, in principle, lasts forever and its treasures do not tarnish or disappear. Yet subduing artefacts to museum collections inflicts a certain violence on them: 'violence is done to the objects in each episode of collecting, each event of insertion that is also an act of deprivation' (Bal 111). Wrested from its original context, the artefact squeezes into a sequence where it has no prior claim or inevitability. Both the Elgin Marbles and Duchamp's *Fountain* support this idea.

In the museological milieu, insertion into a sequence through display is done with the intention of explaining the artefact, of making sense

of it for a viewing public. Yet museum visitors do not necessarily learn anything from sterile dioramas and displays. Many contemporary critics are sceptical of the edification that museums provide. For example, a mummy from pharaonic Egypt illustrates funeral rites and burial practices, or whatever narrative is curatorially applied to the desiccated human remains arranged inside a display case. The mummy signifies a reality that is metonymically intimated, but not fully present. Although museum-goers may be curious about the Egyptian way of dealing with death, they understand ancient Egyptian cultural practices of burial through partial visual information. They might not be particularly adept at interpreting such visual clues. They might be even less adept at interpreting the meaning of human corpses in comparison with other sorts of visual information because they recoil from cadavers, no matter how mummified the body. The eye is not more reliable than other senses when it comes to deciphering the meaning of objects, including their remote historical meaning. Moreover, the curious museum visitor may have a particular interest in slavery or castes or classes or race or gender or clothes or profession in relation to mummies. As Bal claims, the museum setting and the narrative created to explain the artefact determine its meaning. David Carrier, following Dickie and Danto, calls this nagging doubt about the efficacy of museums in educating viewers 'museum skepticism,' which he defines as 'a legitimate worry that we are losing touch with the past' (217), notwithstanding the efforts of curators to preserve history.[8]

Even as an adolescent, Chatwin foresaw the problems of museum display and the scepticism that museums elicit. In a letter thanking his parents for a French book about furniture, he writes, 'Like many French books it is eminently sensible in that it does not deal exclusively with those fabulous rarities that are locked behind glass cases in museums, and on that account are apt to be dull' (qtd in Clapp 63). Chatwin's books suggest that the museum can remake itself through less orderly displays. To have a genuine sense of discovery, people loitering among objects need to have their senses discombobulated. The Renaissance *Wunderkammer* provides one model for such disorder or deregulation, for it houses artworks, fossils, natural history specimens, jewels, and other curiosities of the natural and man-made world. It defies disciplinary classification of objects. *Wunderkammern* and cabinets of curiosities, characterized by disorganization, create the conditions for 'continuous, compounding amazement' (Weschler 82–3). Similarly, Chatwin disorders readerly expectations through the accumulation of amazing ob-

jects. The book, as box or diorama, tutors readers to look anew at the object world – especially at the subdued objects in museums.

Although Danto refers to art museums and Bal refers to collecting as a generalized phenomenon, Chatwin does not customarily distinguish between art museums and other kinds of museums. He seems more attracted to display and curiosities than to museums per se. In the 'Museums' guide written for *London Spy*, he comments with glee on the Bethnal Green Museum, the National Postal Museum, Dr Johnson's House, the Pharmaceutical Society's Museum, and many other out-of-the-way locales. With the stamina that only the truly inquisitive have, he gazes upon the musty and disorganized utensils and embroidery in the museum housed in a church in Río Grande. Chatwin looks up George Costakis in his private museum in Moscow. In a fictional guise, he murmurs appreciatively over Utz's porcelain collection. He does not especially like Meissen porcelain, but his 'years of traipsing round art museums' have taught him to appreciate it (*Utz* 50). Amid public and private collections, Chatwin admires the unusual and the wondrous. He expresses delight that the Horniman Museum, founded by a philanthropist in London in 1901 'to demonstrate the indivisibility of human culture, and the relationship of man to his environment,' contains 'excellent collections of comparative ethnographical and musical instruments' ('Museums' 101). Unlike the British Museum, 'which sends the bulk of its collections into storage in the interests of space,' the Horniman is 'intellectually alive' (102).

Whereas Danto subscribes to a postmodern view of the museum that entrenches it in its role of acquiring and expanding while remaining indifferent to aesthetic criteria per se, Chatwin takes a longer view of the rise and demise of museums. In *Utz*, objects circulate through museums and private hands. Rather than being permanently frozen, collections have a life of their own. Provisional, they expand and contract. To collect one genre of object does not prohibit appreciation of other objects. As a confirmation of his generalized taste, Utz, in addition to his porcelains, possesses a couple of original Mies van der Rohe Barcelona chairs. The narrator sardonically notes that a temporary exhibition in the Rudolfine Museum in Prague is devoted to '"The Modern Chair" – with student copies after Rietveld and Mondrian, and a display of stacking chairs in fibreglass' (123). The narrator, exercising his taste, admires Utz for owning original Mies chairs and scorns the museum for exhibiting copies. All things considered, the public museum, usually closed in order to '"keep the People out!"' (124), as one haughty curator

puts it, may not be the best repository for decorative arts of any kind. Maintenance is shoddy; burdocks sprout 'through cracks in the steps' (123). The museum curators are maladroit Communist Party members who have no idea what Meissen is. They covet Utz's porcelains for the sake of owning them, not for their eighteenth-century craftsmanship or even as examples of corrupt bourgeois excess.

Utz thus critiques public museums by comparing them with Utz's private collection. When the clumsy official photographer visits Utz's two-room flat to record the collection, she knocks over a figurine of Watteau's Gilles, breaking off its head. Like those signs in shops that warn customers that they must pay for things they break, Utz thrusts the broken porcelain at the photographer: '"Take it!" he snapped. "Take it for your horrible museum! I never want to see it again!"' (58). A perverse law of ownership dictates that an unbroken commodity might belong to anyone, but a broken one belongs to the person who breaks it. The klutzy photographer deserves marred goods. The monetary value of the clownish Gilles plunges from exorbitant to worthless. Breakage personalizes the commodity and removes it from circulation. Breakage violates symbolic and cultural values invested in the art objects. This observation forces Utz to champion private over state ownership. Utz's pronunciamento that '"museums should be looted every fifty years, and their collections returned to circulation"' (20), if put into effect, would liberate objects of all kinds from the storage vaults of public institutions. The artefact that never undergoes jeopardy and never changes hands stiffens with lifelessness. The mystery of Chatwin's novel depends on the value attributed to fragility and the challenges that must necessarily be inflicted on objects to prove their fragility.

Chatwin found a precedent for Utz's besieged porcelains in the Leftist artworks assembled by George Costakis in Moscow. After being offered three brightly coloured avant-gardist paintings, Costakis took up his vocation as a collector with zeal: 'he hunted for "lost" pictures "thrown around all the corners of Moscow and Leningrad." The hunt led to old people who imagined time had passed them by. Some were broken by events and delighted to have even a token of recognition. He rescued canvases that were rolled up or covered with dust' (*What* 155). Like Utz, Costakis 'rescues' forgotten artworks. Chatwin, visiting Costakis's apartment, where canvases are pinned on all available doors and walls, compliments him on avoiding the sterility of the art museum: 'Too often a visit to a famous art collection entails a display of sterile exhibitionism on the part of the owner' (157). Utz uses his

eighteenth-century dinner service for ordinary evening meals. The private collector, motivated by passion for his subject, develops expertise, which no scholar can rival and no amateur can understand. The private museum, presided over by its impassioned curator, celebrates a forgotten movement of art, which is no less valuable or historically significant for being forgotten. The collector is a lonely hunter, whereas the state is merely a receptacle for symbolic treasure already gathered.[9] Private collections, Chatwin implies, rescue works that have fallen into oblivion and present them in a lively fashion, in a way that staid museums never do.

Costakis's collection survives and flourishes under the Soviet regime, which is nothing short of remarkable. The collection of privately held property contravenes Soviet laws. Art, in the end, has a purely private, not social, function, even when, in the first instance, that art was created to serve the social cause of revolution, as was the Leftist movement in Russia. As personal property, art is Costakis's barrier against political conformism. Like Utz's collection, amassed against the forces of devastation, which are evoked in the guise of 'revolution and the tramp of armies' (Utz 51), Costakis's collection poses this conundrum: if art is inherently political, what politics does it serve? What use does the state have for artworks, whether that state is Soviet Russia, Soviet Czechoslovakia, or Nazi Germany? The many treasures stashed in Swiss safety deposit boxes may guarantee ownership, however secretive, but they do not guarantee political stability. Owners have only a shadowy, fleeting contact with these hidden objects. Artworks have a political valence – porcelain figurines mimic eighteenth-century public figures; abstract art declares the primacy of the Russian people – but those artworks have subsequent lives as objects politicized in other ways. Sometimes 'national renewal [happens] through catastrophe,' as Chatwin acknowledges (What 117). Political tumult produces art, but artworks thereafter embark on a strange voyage of ownership, appropriation, museumification, and liberation, although not necessarily in that order. As Chatwin's essay on Costakis insinuates, no artwork is ever free of political appropriations.

In conversation with a friend, Chatwin described Utz as an allegory about the political antagonisms against which Utz keeps his collection intact: 'This was a man who'd ruined his life by clinging onto his enormously wonderful collection of Meissen figurines through the horrors of the Second World War and the early years of Stalinism. The whole thing had trapped him because he could never leave the collection and

it ruined his life. On the other hand, as compensation he managed to shrink his horizons down to the world of *commedia dell'arte* figures, so he lived the life of Harlequin and Pulcinella, and they were his real friends and *blocked* out the horrors of the Novotný and Gottwald regimes' (qtd in Shakespeare 478). In *Utz*, the collection of porcelains mediates Utz's psychological and political identities. The porcelains barricade the individual from political horror. The collection, as a private dominion where Utz exercises his fantasy, allows a regressive fixation on objects akin to a child's fantasies that concentrate on the inner life of toys. Yet whatever they mean to Utz personally, the porcelains already belong to the communist state. Utz formulates this paradox in a *bon mot*: 'luxury is only luxurious under adverse conditions' (80). Private property having been abolished, Utz never fully owns the figurines. They elude the grasp of absolute possession because they occupy the 'tenuous borderline between property (which was harmful to society) and household goods (which were not) ... Porcelain could also be classed as crockery' (*Utz* 26–7). As fragile objects, the objects remain vulnerable to Utz's indifference. He could break them and emigrate to the West. Attached to the objects as aesthetic artefacts and putative private property, Utz knows only a circumscribed freedom. In addition to blocking out the horrors of communist oppression, the porcelains are an obstacle to freedom. An obstacle keeps things in at the same time as it keeps things out. The state manipulates Utz's freedom by holding the porcelains hostage. Utz, as the custodian of the collection, is less free than the inanimate objects in the collection.

In *Utz*, things are the changing mirror in which political decisions register. Objects signify the rise and fall of regimes. Porcelain figurines, for all their prettiness, are useless in the instrumental sense. Although porcelain bestows pleasure, the state cannot regulate aesthetic pleasure taken from uselessness. In communist Czechoslovakia, porcelain dishes and figures are classified as useful domestic goods: 'So, providing it wasn't smuggled from the country, it was, in theory, valueless' (27). The state, uncertain about aesthetic differences between crockery and Meissen porcelain, cannot confiscate everyone's tableware. Therefore, by a technicality, Utz's collection remains in his hands during his lifetime: 'the State, in its efforts to wipe out "traces of individualism," offered limitless time for the intelligent individual to dream his private and heretical thoughts' (15). Utz seconds the political nature of collections and objects; he chooses his figurines as incarnations of 'wit, charm, gallantry' (50) and other eighteenth-century traits. He rescues vestiges of

the past, even though he knows that political change has swept away the culture of wit and gallantry. By fetishizing artworks, he preserves a fictive sense of order and forestalls the arrival of clodhopping political regimes. Paradoxically, the freedom that Utz finds among his porcelains – the freedom to own, touch, admire, catalogue, and display art objects – recapitulates the repressiveness of the state, in that the objects will not release him. He can neither leave the collection nor disband it. The fragility of the porcelains assumes symbolic value, as a quality of Utz's dependence on the political regime to determine his individualism. Things are political not in the sense advocated by Marx, in which commodities consolidate the identity of the bourgeois individual, but as loot acquired during political antagonisms and turbulence.

Kaspar Utz may be the plaything of the state, but his actions confound its authority. He is a fool, satirist, and trickster. The narrator, poking around in *Grimm's Etymological Wordbook*, discovers that 'utz' has connotations of dim-wittedness, and '"Heinzen, Kunzen, Utzen oder Butzen," in the dialect of Lower Swabia, is the equivalent of "Any old Tom, Dick or Harry"' (*Utz* 16–17). Not just a fool, Utz occupies a social role as an ordinary chap with many facets: titled baron, museum cataloguer, Jew, Czech, collector, and gourmand. Patrick Meanor points out that the name Kaspar means 'treasurer' in Persian, and Kaspar was one of the magi who brought gifts to the infant Jesus (135). In Czech, 'Kaspar' means 'fool' or 'harlequin.' Most, if not all, editions of the novel feature the fool card from the Tarot deck on the cover. Chatwin complained that the jacket blurb for the original edition of *Utz* made no reference to the fact that 'Utz identifies himself as Harlequin, the Trickster, and runs his own private *commedia* – outwitting everyone, until, finally he finds his Columbine' (qtd in Shakespeare 478). Utz's grandmother stirs his first passion for Meissen by giving him a Harlequin created by the master craftsman J.J. Kaendler. As a sign of his solidarity with the sneaky *commedia* character, Utz arrays seven Harlequins on his shelves. As his collection widens in scope, it encompasses all the *commedia* characters, as well as 'ladies of the Court' and 'the lower orders' of tradesmen (*Utz* 53).

The porcelains represent a political order unto themselves. Utz gives a little lecture on Kaendler's satirical wit, with reference to the way he laughs at members of the Saxon court by transforming them into 'amusing' animals (*Utz* 54) to show their inner nature, rather as La Fontaine does to courtiers at Versailles in his *Fables*.[10] The porcelains, at their origin, already have a political function as satirical jests.

In his 'slur' against porcelain, the eighteenth-century art theorist and historian, Winckelmann, wrote, '"Porcelain is almost always made into idiotic puppets"' (*Utz* 19). Puppets are not neutral. In post-war Czechoslovakia, an iconic marionette named 'Kasparek,' a diminutive form of Kaspar, attained immense popularity in the marionette theatre. Kasparek's strings being pulled by a puppeteer served as an analogy for the Soviet communists' manipulation of the Czech people. The puppet-like porcelains fulfil the same function in *Utz*: the tricky and cunning collector can resist the manipulations of state officials by buying and trading porcelains. The objects, never just material or aesthetic goods, represent eighteenth-century political figures while enacting twentieth-century political insubordination.

Political turbulence offers '"wonderful opportunities for the collector,"' Utz remarks (21). Utz maintains a breezy political neutrality, but this does not prevent rumours from circulating about his having helped 'Goering's art squad' (24) during the war. Goering, as a notorious confiscator of art, seized paintings from museums for his own collections, including two Cranachs taken from the Alte Pinakothek as well as 'two Palma Vecchios, a Jan Brueghel *St. Hubert*, and five very nice other pieces "lent" by Berlin's Gemäldegalerie' (Nicholas 35–6). At Goering's country house, Carinhall, vast treasures were displayed, many of them looted and many others given by corporations currying favour with the Nazis. Goering, official successor to Hitler, loved luxury, yet promised, as a justification for his indulgences, to leave his collections to the German nation. Given Utz's rumoured past, his idea of liberating artefacts from museums has a fascistic taint to it. Although he augments his private collection as an act of political rebellion against the Soviets, liberation of artefacts from museums, however enlightened it might be from the perspective of shaking up the art market, looks like an act of political sympathy with Goering's art squads.

Utz understands that the dislocation of artworks reconfigures their value. Art pillaging during the Second World War was a free-for-all. The Nazis seized and sold the contents of many museums. A Russian curator travelling in Estonia in September 1944 glimpsed a familiar table in a shop. Looking underneath the table, he 'found an inscribed museum inventory number' (Nicholas 361). Similarly, when Utz turns over a Harlequin, the narrator of the novel notices 'an inventory label with a number and letters in code. // This was the label that earmarked the piece for the Museum' (56). Utz condones looting in order to preserve his collector's rights, whatever the political ramifications of his position.

Modern museums purport to save cultures and artefacts that might otherwise disappear, just as, in Aldous Huxley's *Brave New World*, eugenic Londoners travel to a living museum in New Mexico to see barbaric people procreating inside dioramas. The museum, by preserving bygone ways of life, dehumanizes those societies. Museum value differs from use or exchange or labour or aesthetic values in that it denies the social function of objects. In Prague, Utz explains, the Nazis spare the Jewish cemetery, the synagogues, and the Old Town Hall of the original ghetto in order 'to form a proposed Museum of Jewry, where Aryan tourists of the future would inspect the relics of a people as lost as the Aztecs or Hottentots' (41). The will to convert cultures into museum studies, whether in Huxley's fiction or under the Nazis, is a particularly modern impulse. Modernist politics and modernist aesthetics collude with the notion that museums, designed to preserve the vestiges of extinct cultures, actually drain cultures of their vitality and push them to extinction.

In *Utz*, the Museum of Jewry implicitly commemorates genocide rather than civilization. For these reasons, Utz may resent the appropriation of his objects for a museum. His porcelains seem doomed to disappear into the sarcophagi of glass exhibition cases. Consequently, their disappearance altogether at the end of the novel might be interpreted as a coup for individualism and thriving culture. Objects establish and perpetuate society. The fate of the collection, however, bothers the narrator. He conjectures that the objects were 'smuggled abroad' (151), destroyed, secretly dispersed, or confiscated.

Representation in *Utz* departs from reality with regard to the fate of the porcelain collection. Chatwin based his novel on a real collector, Dr Rudolph Just, whom he met in Prague in 1967. Contrary to Chatwin's intimation that the collection is destroyed, the Just collection resurfaced in 2000 in Bratislava. It had stayed in Just's second wife's apartment until her death in 1992. Just's grandson also lived there until thieves, who had purloined the key to the apartment, murdered him. Just's daughter-in-law and her surviving son secretly moved the collection to Bratislava. They sold some pieces at a Prague antiques fair and others, at one-twentieth of their market value, to unscrupulous dealers. Just's daughter-in-law and grandson notified Sotheby's officials that they still owned certain pieces; 300 were located in a Zurich bank, and 300 more were pulled 'from under a sofa, from washing baskets, from boxes' (Riding E1) in the Bratislava apartment. At the time, Just's grandson offered the opinion that 'it would be better to destroy the collection

because it was bringing us such bad times' (Riding E1). Just's collection, which included very few Meissen pieces, unlike Utz's fictional collection, was sold at Sotheby's in London on 11 December 2001 for 1,567,927 pounds. Included in the sale, a pair of 1740 vases depicting birds among flowering plants sold for 108,250 pounds. Just's grandson had never heard of Chatwin's novel, which had done so much to make the collection famous.

Before his death, Rudolph Just wrote that he was 'interested in objects which pose not easily resolved problems' (Riding E1). When objects pose problems, they tend to turn around complexities in aesthetics and value. As Chatwin confirms, objects are implicated in problems of display and value. Objects 'disconcert' (Clifford 104). Because of their obscure provenance and uncertain future, they pose riddles of interpretation. Rather than demonstrating the pathology of a single individual, Utz's collection, like Just's, implies that collections invariably have a political meaning and viability. Public and private collections alike embody ideologies of property, ownership, freedom, and individualism, just as they demonstrate the violation of those principles. Disinterestedness, which Kant heralds as the signature of aesthetic contemplation, gives way to covetousness and keen interest in Just's and Utz's collections. As Chatwin writes in 'The Morality of Things,' the institutional sequestering of objects heightens their political value by converting them into national treasures hoarded away from prying eyes or locked up behind glass. Although the mission of museums is to enlighten, Chatwin, in *Utz*, doubts that the staging of the gaze that happens in museums in any way obviates the battles over material objects as possessions. The history of museums, notwithstanding their commitment to keeping museum-goers in touch with the past, is inseparable from a long history of looting and breakage.

Fragility

In contemporary fiction, damaged and destroyed artworks pose puzzles for aesthetics. If an artwork is vandalized but not completely destroyed, does its value increase? Does value have a relation to the jeopardy that a work has undergone? Do blemishes or cracks compromise value? In Barry Unsworth's *Pascali's Island* and *Stone Virgin*, sculpture withstands the onslaught of time, but not indefinitely. Human intervention, whether through archeology or pollution, harms artworks. The representation of art as imperilled or befouled defies the

modernist advocacy of pure, integral artworks. The number of broken idols in postmodern narratives suggests an anti-modernist desire to unmake the museum, along with museological assumptions about display, fragility, scale, distance, preciosity, and accumulation for the sake of preservation.

Like *Pascali's Island* and *Stone Virgin*, *Utz* adds fragility to the aesthetics of enchantment that lie outside the formulations of conventional categories of beauty and taste. These narratives ask why art objects have a status different from other objects and whether that difference derives from an unacknowledged relation between art and rubbish: yesterday's refuse is tomorrow's treasure. The fragility of Roman glass, Greek amphorae, or Tanagra figurines renders them unlikely to survive the vicissitudes of time. Objects have a life span that depends on the material from which they are made. Stone lasts longer than glass. The survival of certain objects over centuries or millennia does not guarantee their perpetual survival. Fragility may compromise their integrity or permanence at any moment. In this sense, fragility is a disposition in objects: 'If an object were to break when illuminated, or under certain temperatures, or for no reason at all, we would count this relevant to its fragility. At any rate, this certainly seems right for the simple disposition [known as] *being disposed to break*' (Manley and Wasserman 75). Some objects are more fragile than others in that they are more prone to break – crystal goblets versus origami birds or Donald Judd steel cubes – which argues for degrees of fragility. As a corollary, some objects, once broken, might be considered '*more broken*' than others because of their prior disposition to breakage (73). In all events, an as yet unbroken object is disposed to breakage and therefore points to the dimension of futurity in the object.

In *Speaking of Beauty*, Denis Donoghue concludes that the '"tense" of beauty is the future, and that its apprehension is propelled by a politics of hope and anticipation, a surge of feeling beyond the merely given present moment' (86). Donoghue investigates the 'political status' (86) of the beautiful without mentioning specific political contexts or without addressing materiality as factors that contribute to political status. Nevertheless, he means that beauty incites expectation; those who experience beauty once wait for its recurrence. Having held an unblemished porcelain in his hands and experienced a *frisson* that he associates with the beautiful, Kaspar Utz continues to caress and accumulate figurines in hopes of feeling that *frisson* again, or at least some similar sensation. Beyond such personal feeling, *Utz* represents beautiful objects

as both barriers to political antagonism and loot that revolution throws up in its wake. Against the horrors of the Novotný and Gottwald governments, beauty appears indestructible because it is allied with an expectation of recurrence. Beauty, as a complicated pleasure located in the sensibility of the perceiver, has no fixed date of return. Expectation outlives all adversity.

In material terms, the fragile object has beauty because that fragility is imperilled sometime in the future and because art can be used for specific political ends, irrespective of the original intention of the art object. Fragility exaggerates the likelihood that the object will not survive intact. As a quality that inheres in objects, fragility is proven by negation – breakage or vandalism. As Burke suggests, one attribute of the beautiful may be fragility. Yet causality may operate in the opposite direction: material things are called beautiful because they are fragile. Value accrues to an object that may not exist forever simply because it is perceived to be endangered.

Like Keats's 'still unravished bride of quietness' (209), Grecian urns represent the futurity of violation, an anticipated trauma or rupture that time may deflect but may not, perhaps, stave off forever. Writing about an antiquity, Keats predicts both the pastness of the future and the futurity of the past; the figure on the vase, and the vase itself, are 'still unravished.' Ravishment will occur, but, for the time being, that traumatic breakage is deferred. In a collection of objects, whether urns or glasses, fragility magnifies the relation between materiality and time. According to most theorists of material culture, collections embody a version of suspended time (Stewart 151). In Jean Baudrillard's estimation, the collection aims to reconcile lived time with the systematic time of the collection: '[La collection] est d'abord au sens fort un "passe-temps." Elle l'abolit tout simplement' (135).[11] In Utz's collection, the miniaturized boundaries of the self, shrunk down to the size of *commedia dell'arte* figurines, live among temporal layers suspended between the courtly eighteenth century and a childhood that predates the Second World War in Czechoslovakia. Utz happily discusses the provenance of his figurines as a way of controlling the past and fetishizing what has been lost to the ravages of time. Utz defers the inevitable present by living among the porcelain past. Yet he cannot defer the future interminably.

Porcelain, by virtue of its fragility, does not survive forever, as proven when the photographer accidentally snaps off the head of the Gilles figurine. The figurine has survived for two centuries, but survives no longer. The collector prevents damage as best he can, but the span of his

own life limits his control over fragile objects in the future. Utz's death, announced in the opening sentence of the novel, inevitably means either the transmission of his worldly possessions to another owner or their outright destruction. The collector might not be able to bear the thought of leaving his objects and so destroys them all as an assertion of ownership. If he leaves them to heirs, the objects risk dispersal. At no time are possessions more jeopardized than when they are alienated from their owner because of death. They are suddenly subject to transport and covetousness, damage and loss. Destruction – or ravishment, to use Keats's term – lies somewhere in the future of all objects simply because owners cannot live forever.

Art might be defined by the perceived, provisional value of objects within culture, rather than the didactic purpose of an artwork or the pleasure that objects induce in beholders. T.S. Eliot in 'The Function of Criticism' remarks that 'art may be affirmed to serve ends beyond itself; but art is not required to be aware of these ends, and indeed performs its function, whatever that may be, according to various theories of value, much better by indifference to them' (13). Eliot distinguishes between criticism, which relies on works of art, and art itself, which has no inevitable need for criticism. He makes a pitch for the indifference of the artwork to its afterlife, how it is used and by whom. By emphasizing indifference, Eliot makes the artwork valid across time. More crucially, Eliot observes that the value of art does not abide by intentionality. The artwork enters into 'various theories of value' irrespective of the conditions under which it was created. Eliot implies that the success of the artwork, otherwise called the *fate* of the object, increases according to the non-answerability of the artwork to specific cultural values in operation at the time of its making. The artwork survives through time because of its pliability; the artwork adapts to multiple functions, not use-values, but ends beyond itself. Aesthetic value changes according to contexts within which the art object appears.

Indeed, the artwork may ensure value, as a constant factor, in the absence of other assurances. This assurance has political resonance. To assert authority, political regimes loot or destroy art works. Napoleon removed the group of four horses known as the 'quadriga' from the façade of St Mark's in Venice, transported the ensemble to Paris, and had it reassembled atop a little triumphal arch he built for himself beside the Louvre to commemorate his victories in 1805 (Flanner xiv–xv). After the Battle of Waterloo, the quadriga was disassembled, crated, and returned to Venice. Just as the toppling of public monuments af-

ter the fall of Stalin or of Saddam Hussein symbolically enacts the end of their regimes, the return of the quadriga allegorizes the end of Napoleon's empire. The perilous back-and-forth voyage of the quadriga satisfies the need to display political power in purely arbitrary terms, which is to say in terms of artworks.

In *Men and Monuments*, Janet Flanner states that 'Art must be the most precious portable property man has ever invented because it is always the first thing civilized man steals and sends home during a war' (xiv). Flanner has the authority of history on her side, yet the definition of art in her formulation may be backward. Being stolen and sent home by marauding armies, whether Napoleon's or Hitler's, defines the object as art. Objects prove the validity and might of antagonistic regimes. The display of looted artefacts neutralizes the meaning of those objects by relocating them within the imperialist, capitalist, and museological will to view. The value of objects depends on putting them on display atop a triumphal arch or within a case in a museum, where mass, shape, scale, technique, colour, material, and other formal indices declare the triumph of the political power that ceremonially exhibits artworks. Displayed objects tacitly acknowledge political polarization. Chatwin phrases this problematic in terms of hierarchical authority applicable to Utz's quandaries under communist power: 'Authoritarian societies love images because they reinforce the chain of command at all levels of the hierarchy' (*What* 163). Political authority manipulates icons in order to consolidate and preserve its authority. That the state technically owns Utz's collection confirms its power to invade personal life at the level of the iconic object. This power remains valid, of course, only as long as the figurines remain unbroken. Were Utz to snap the heads off all his courtly figurines, he would defy the power of the state to control his collection.

Spectators and connoisseurs of art, who freely invest in the value of fragile objects, fetishize intactness as an aesthetic attribute. An intact object has limitless value, but a smashed or shredded object has no value. In May 2002 in Gerstheim, France, frogmen dredged about 100 art objects out of a canal. Over a period of seven years a felon named Stéphane Breitwieser had looted various unique objects from small European museums; he confessed to having sliced sixty paintings by François Boucher, Pieter Brueghel the Younger, and Antoine Watteau from their frames. He then reframed and hung them for his own pleasure in a private chamber at his mother's house in Eschentzwiller. When her son was caught stealing a bugle from a museum, Mireille

Breitwieser, 'in anger or hoping to avoid the possible revocation of her permit to work as a nurse in Switzerland [...] either chopped up and burned or threw out the paintings, which investigators said might be worth $1.4 billion' (McNeil E1). She did, however, leave some religious artefacts, including 'a wooden Virgin Mary, at a local chapel' (E1). In this exemplum of destroyed art, implacable mother love holds sway over aesthetic value. But aesthetic value precariously hinges on market valuation. The valuation of the works destroyed by Mireille Breitwieser depends entirely on their being intact. The irreplaceability of artworks makes them more valuable, and that value escalates as soon as the object qua object is categorized as art. The wilful destruction of so many paintings – metal objects, ivory carvings, and a Gobelins tapestry survived unharmed – recalls the frequency with which art, especially museum art, is mutilated, and sometimes utterly demolished. Stéphane Breitwieser was sentenced to thirty-six months in prison in 2005, with ten months of the sentence suspended. His mother likewise received a three-year sentence, with eighteen months suspended.

A short list of artworks that have been hammered, sliced, assaulted with bricks, or otherwise damaged includes many iconic works. Their iconic status is inseparable from their having been damaged. A Canadian suffragette named Mary Richardson slashed Velasquez's Rokeby Venus with an axe in March 1914. Da Vinci's Mona Lisa was stolen from the Louvre in 1911 by an Italian who repatriated the painting to Italy, where it was recovered in 1913. La Giaconda's tribulations did not end there. A brick-wielding Bolivian attacked the woman with the enigmatic smile in 1956; the left arm of the Mona Lisa was damaged and the painting has been protected by a glass case since then. In May 1972 Lazlo Toth struck fifteen quick, fierce hammer blows to Michelangelo's Pietà, severing the left arm of Mary and injuring her cheek. While assaulting the statue, Toth yelled, 'I am Jesus Christ.' The Pietà now huddles behind a protective case inside the main entrance of St Peter's. In 1991 a vandal with a hammer badly marred the marble toes of Michelangelo's David at the Accademia in Florence.

Although assaulting art might be a pathology unto itself, it confirms the cultural and fetishistic value of art. What Walter Benjamin calls the 'aura' (221) of an individual artwork unites its singularity with its fragility. The so-called aura of the fragile object might be attributable to radical fluctuations in value according to the state of the object. The intact object is priceless; the broken object is worthless. As in the instances when people attack iconic artworks, fragility moves from being an aes-

thetic quality in objects to being a fetish value, an over-investment in the power of that object as a regulator of psychic life. Incompatibilities within the fragile object accumulate around the inherent material value of an object, combined with its future form and preservation, as well as its aesthetic devaluation when damaged.

In *The Volcano Lover*, Susan Sontag poses similar questions about the Portland Vase, permanently loaned to the British Museum in 1810 by the Duke of Portland, who had acquired this exceptional example of Roman cameo glass in 1786. Neither the rarity of the vase nor its preservation against the hazards of time determines the full extent of its fame. In 1790 Josiah Wedgwood, master potter, started to manufacture reproductions of the vase to demonstrate the sophistication of industrial techniques (Forty 16). The vase therefore bears a relation of original to copy, as in a Platonic allegory. The enshrinement of the vase at the British Museum conferred further status through display. In 1845 an '"intemperate" vandal' ('Conservation History') smashed the Portland Vase to smithereens with a hammer. The tiniest bits of the vase were collected and glued back together. The craftsman could not replace all the fragments; some were left over (figures 13, 14). These were preserved like splinters from the True Cross. Another 100 fragments were lost until 1945, when the British Museum purchased the vase outright; the various dukes of Portland, who retained technical ownership of the vase, had held back these fragments for a century. In 1948 conservationists stripped away the nineteenth-century adhesive, reconstructed the vase, and found room for another three fragments (figure 15). In 1987, because the adhesive had deteriorated and the vase rattled when lightly tapped, conservationists disassembled it, then epoxied the pieces back together again in one renewed whole, with no visible flaws or fault-lines. The cracks do show up, however, under X-ray (figure 16). In the latest reconstruction of the vase, restorers incorporated all fragments except for a few small splinters. Sontag asks about this recreated artefact, 'Can something shattered, then expertly repaired, be the same, the same as it was? Yes, to the eye, yes, if one doesn't look too closely. No, to the mind' (347). The eye may perceive no irregularities or injuries, but the aesthetic conception of the vase alters because of its fracturing and reconstruction.

If the mind confers value on objects, that value alters according to the knowledge that the form of the object alters. The smashed and restored vase invites another set of questions about the dialectical interchange between fragment and whole. If the vase does not require all of its frag-

13 Fragments of the Portland Vase, watercolour by T. Hosner Shepherd, 1845.
© The Trustees of the British Museum.

14 Portland Vase, dismantled. © The Trustees of the British Museum.

ments in order to appear whole, is it, in fact, whole? Are the leftover fragments in excess of, or integral to, the meaning and structure of the vase? Why did the successive dukes of Portland hold on to fragments until the British Museum purchased the glass object outright? Does possession of some fragments of a structure guarantee ownership of the whole structure? Is the form of the vase invested in the idea of the vase or the material substance of the vase? Such aesthetic questions should not lead us away from the recognition that damage is integral to the life-cycle of an art object. The apprehension of fragility informs aesthetic appreciation.

Speaking of William Blake in *Iconology*, W.J.T. Mitchell observes that much post-Reformation art tends toward iconoclasm; distrust of false gods animates the making of art. Instead of worshipping idols, artists extol the living power of the imagination. According to this thinking, images that recreate conventional reality must be smashed to allow a new visual language to emerge. The semantic difference between an

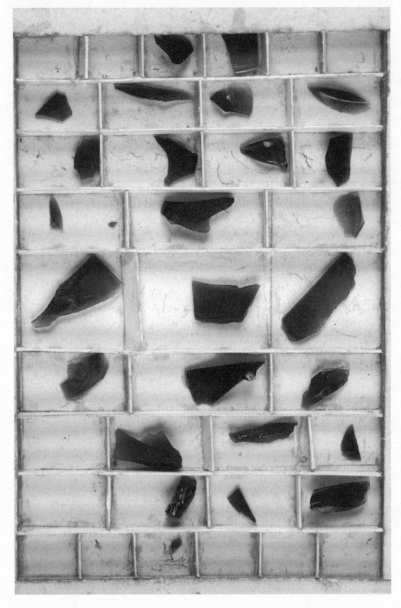

15 Portland Vase, leftover pieces. © The Trustees of the British Museum.

16 Portland Vase, under X-ray. © The Trustees of the British Museum.

idol and an aesthetic image is tenuous. An idol can become an aesthetic object. An aesthetic object can become a cultural icon. Symbolic codes attached to certain artefacts command attention when those artefacts are threatened with destruction. When the Taliban in Afghanistan announced in February 2001 that they would blow up two gigantic rock carvings of a male and a female Buddha because they represented idols not acceptable to Moslem fundamentalists, UNESCO formally requested that the Taliban respect the archeological and world heritage of the statues, created most likely in the third and fifth centuries of the Common Era. Dismayed by the iconoclasm of the Taliban, the Metropolitan Museum in New York offered to purchase any statues that were not incised in rock faces in Afghanistan. Whereas the Taliban presumably viewed statues as idols, the Metropolitan Museum and westerners looked upon them as invaluable aesthetic artefacts. Notwithstanding all appeals, the Taliban blew up the two Buddha statues in March 2001 and reportedly destroyed any number of portable artefacts as well. Pleas from Kofi Annan, secretary-general of the United Nations, fell on deaf ears. The fragility of the paired Buddhas had nothing to do with their medium – solid rock – and everything to do with their vulnerability in a religious and cultural antagonism. Fragility, then, is not always intrinsic to the material of an object. Rather, fragility is the aesthetic signifier of the entry of political meaning into the work of art.

Damage is in the eye of the beholder. Chatwin often notices bruised and damaged goods. Broken things mark an injury to ownership. Fragments of smashed china and mechanisms that no longer work lose their appeal as possessions and hence find their way to the trash. In *The Viceroy of Ouidah*, 'when Dom Francisco bought for himself a silver swan that gobbled up fishes to the airs of Bellini, it vanished overnight [stolen by the king's spies], only to be sent back from Abomey with the neck off, the mechanism overwound and a warning never again to send anything broken' (82). Utz trades away Meissen pieces that are 'inferior, or cracked' (*Utz* 19). They compromise the perfection of his other acquisitions. In Chatwin's essays, damage extends to buildings and from buildings to entire cities. Visiting the architect Konstantin Melnikov in Moscow, he notices flaking stucco on the exterior walls and water stains inside the 'somewhat dilapidated' house (*What* 107). Cruising down the Volga with a stop at Volgograd, formerly Stalingrad, Chatwin comments that the Russians left a pile of rubble – 'a shell-shattered mill-building' (187) – as a memorial to the defeat of fascism during the Second World War. Other Russian monuments and dams, made

of ferro-concrete, have little chance of lasting for a long time, as one German concrete expert remarks (182, 188). Despite their appearance of durability, man-made edifices and monuments are never permanent. Large and small objects amass into undifferentiated heaps. The pile of rubble left over from the Battle of Stalingrad paradoxically represents Russian victory. The 'memorial' demands that the viewer see worth in destruction. Such destruction is not always safely in the past. As a child in the years immediately after the war, Chatwin heard lectures that predicted where 'the zones of total and partial destruction' would be found in Europe should a third world war occur (*In Patagonia* 3). Fragility expands from the individual object to entire cities. Chatwin, whose eye habitually alights on broken or damaged things, suggests that all objects decay or break. Disintegration is a general phenomenon in the material world.

Some objects might be structurally unsound because they have faults or because they are made of corrupt materials, but the fragility of objects is confirmed by the human tendency to harm and destroy. Utz loses all love for England when he hears a BBC radio announcer say, after the flattening of Dresden, '"There is no china in Dresden today"' (*Utz* 24). War destroys artworks, even as it releases objects into circulation through pillaging and looting. The fragility of Utz's porcelains may be proven once and for all when (and if) Marta and Utz surreptitiously throw them into the trash. Recalling an earlier query that he put to Utz, the unnamed narrator wonders at the end of *Utz* if images 'demand their own destruction' (151). 'Images' refers broadly to representations: porcelains, statuary, paintings. Every age generates a set of images that may or may not survive the culture of their making. Although the forces of iconoclasm threaten images and objects at all times, no one can predict when the moment will arrive, late or soon, that delivers an annihilating blast to a material representation. Furthermore, an impulse to demolish the objects that grip, and create, fetishistic consciousness counters the impulse to collect objects. It may have appealed to Utz's 'sense of the ridiculous that these brittle Rococo objects should end up on a twentieth-century trash-heap' (151). Collections disperse, as do the treasures that once made up Rudolf II's Ambras Collection, some of which 'had long ago vanished from Prague' (13). In its speculation on material culture, *Utz* thus sketches a narrative continuum between collected objects, museum holdings, and garbage.

Utz touches on the relation of objects to trash. Porcelain is crockery; painting is skilful decoration. Curiously, critics and reviewers charge

that Chatwin's writing is 'decorative,' because it is filled with detail (Pritchett 46). In his introduction to Chatwin's *Far Journeys*, Francis Wyndham states that he always 'retained a fastidious delight in the exquisite, the intricate and the perfectly wrought' (12). Nicholas Shakespeare in his biography of Chatwin calls *Utz* a 'decorative' novel (475), yet praises Chatwin for knowing 'the magic of a name and of the specific detail that gives authenticity and conviction' (278). As ornaments, objects waver in value. To call something decorative diminishes its aesthetic quality. Fine art diverges from decorative art. Decorative and pointlessly detailed objects, including novels, are vulnerable to worthlessness, and worthless objects get tossed in the garbage. Toward the end of *Utz*, the narrator ponders the meaning of garbage. Lurking in doorways, he watches the 'vivid orange' (145) garbage trucks that circulate through Prague emptying bins. Destroyed images end up in the 'grey, galvanised dustbins, of standard size, and with identical articulated lids' (145) found in every apartment block. Decorative adjectival detail, applied even to the description of garbage bins – grey, galvanized, identical, articulated – serves no structural necessity. Decoration does not increase the apparent value of a commodity, although it may increase the value of an art work. In *Capital*, Marx claims that a commodity 'has use-value for others; but for [the owner] its only direct use-value is that of being a depository of exchange value, and consequently, a means of exchange' (97). Marx does not allow for the possibility that commodities can be stripped of value altogether, nor does he account for the accrual of decorative detail as an attribute of value in a commodity. Lumping things into narrative, Chatwin intimates that material goods have no ultimate relevance, or that their value must be discerned in conjunction with cognate categories of junk and art.

Chatwin's linking of art and trash derives from the Czech writer Ivan Klíma, whom he met in Prague in 1987. Not only a novelist, Klíma worked as a messenger and window cleaner. Under duress many Czech writers did manual labour during the long years of communist government. In Klíma's novel *Love and Garbage*, published in Czech in 1986, a scholar writing an essay on Kafka abandons that project to sweep streets. Chatwin recalls this scenario in *Utz* when the narrator's friend, who is well informed about Czechs and their attitudes, wonders, 'Where else [but in Prague] would one find, as he had, a tram-ticket salesman who was a scholar of the Elizabethan stage? Or a street-sweeper who had written a philosophical commentary on the Anaximander Fragment?' (15). In *Utz*, the orange overalls of the sweep-

ers and the bright orange trucks with their twirling lights catch the attention of the narrator (145–6). In *Love and Garbage*, the street-sweeper wears an orange vest. Klíma's novel speculates on the endurance of material things, even when they have been thrown out or incinerated. Attracted to garbage while still a child, the narrator realizes that 'rubbish is indestructible' (9). As an adult who burns hospital waste, he watches the tatters and ashes waft into the air, then settle over the ground and buildings: 'Rubbish is immortal, it pervades the air, swells up in water, dissolves, rots, disintegrates, changes into gas, into smoke, into soot, it travels across the world and gradually engulfs it' (6). The narrator, on a sojourn in Detroit, wonders what happens to defunct automobiles. At the invitation of the president of Ford Motors, he visits the plant where cars are compacted. The metaphor of garbage in *Love and Garbage* moves from material things to human relations; abandoned elders, abandoned lovers are tossed into 'the dumps of discarded people' (84). In an interview that he gave not long before his death, Chatwin recalled that archeology, with its fixation on middens, had made him come to resent trash. 'I have started liking people who have no garbage to leave,' he said (Clapp 124). For Klíma, living with trash is a human inevitability; for Chatwin, leaving no trash means that one has successfully broken free from the tyranny of objects.

Trash has an intimate connection to earth. People dispose of their waste by seaming it into the earth. Unsightly trash is concealed from view. Chatwin, alert to the human impulse to hide objects, implies that art, like trash, attains its symbolic power by concealment. Howard Hodgkin, an artist and collector of Indian paintings, has a 'strong impulse to hide [a purchased painting], to lend it, or at least to get it out of his sight' (*What* 75). The narrator in *Utz* relates that 'there were families in Prague who kept their Picassos and Matisses rolled up between the floor joists' so they would not be confiscated (27). Some people hide art just as they hide garbage. Trash, of course, sometimes converts into treasure in the fullness of time. What other cultures leave behind disappears into the earth as valueless waste. Retrieved centuries later, abandoned objects acquire cachet that exceeds their initial utility. What goes into and comes out of the ground is always in the long run a potential art object.

In one of his flights of fancy, Utz meditates on the relation of humankind to dirt. Adam, the first man, was made of clay; therefore, he was the 'first ceramic sculpture' (*Utz* 42). If Utz does consign his smashed porcelains to the garbage, as the narrator imagines, he merely hastens

their destiny as fragile objects. He also unfastens himself from the tether of ownership and the obligation to display his collection. The disposition of objects to be fragile is a metaphor for the tenuousness of ownership in *Utz*, for nothing is less secure than the possession of a material object. Breaking a collection of objects could be an act of terrible revenge or a negative proof of ownership. Utz confirms his absolute right to ownership by preventing anyone else, whether individual or museum, from taking possession of his collection. The fragility of Pulchinella and Harlequin expresses the resistance of material things to any absolute ownership.

Utz speculates on transformation in art.[12] Objects remain the same even while they are bought and sold in a sequence of exchanges. Some objects go out with the garbage. Some objects survive and end up in museums. Yet, as Utz intimates, owners are only ever custodians of art, not out-and-out possessors. Objects transform those who collect. Rescuing things from obscurity and placing them in a collection – as both George Costakis and Utz do – constitute only one transformation that fragile objects withstand. Garbage or rejected items have the opportunity to become scarce examples of lost traditions. The collector appreciates objects that others see as worthless. By seeing rejected objects as art, the collector rescues them from oblivion or outright annihilation. Utz transforms the collected porcelains into an image of a comic world, comic because it has survived the onslaughts of time the destroyer. In Utz's mind, the collection tells jokes about people in the Saxon court. The collection itself, as an ensemble, is a wonderful joke about the political status of objects, subject to the whims of emperors and soviets. The collection ought not to exist in private hands, but it does. It ought not to have survived against the covetousness of the state, but it has.

In Irving Stone's novelized biography of Vincent Van Gogh, *Lust for Life*, a prospective buyer admires a painting of four apples by Paul Cézanne but does not want to pay the asking price of 100 francs. To satisfy the buyer, Madame Tanguy, wife of the art dealer who represents Cézanne, takes a pair of scissors and cuts a strip bearing one apple off the canvas, spoiling the integrity of the artwork per se. The client pays 25 francs for the single apple and walks away happy. Laying the 'mutilated canvas on the counter,' Madame Tanguy offers some advice to her husband: '"Next time someone wants a Cezanne, and hasn't much money, sell him an apple. Take anything you can get for it. They're worthless anyway, he paints so many of them"' (346). Madame Tanguy perpetrates a cruel joke by making a painter subservient to a buyer. She

implies that a painting is like an apple; both can be bought and sold. The painting is only a commodity and the painter nothing more than a manufacturer. Cézanne can always paint another still life with apples. In this anecdote, Stone makes a point about the integrity and destructibility of an artwork. The apples are perhaps just as valuable without the context in which they appear. They could be tacked to the wall as representative fruits by Cézanne – metonyms for the object status of painting, freed from reference to any other objects.

When a creator desecrates his own work of art, the spoliation falls under a different category of damage than when a twentieth-century collector smashes irreplaceable eighteenth-century porcelains. In *Lust for Life*, Van Gogh exclaims in a fit of rage over his unsaleable paintings, '"Look at this junk!"' To confirm his disgust, he kicks 'his foot through a large, dead canvas' (295). Violation of the artwork enacts its fragility. In *Utz*, the impulse to hoard and love objects is counterbalanced by the impulse to be rid of objects once and for all.[13] The best proof of ownership of things is breakage. To shatter something may be the logical end to the principle of property ownership, regardless of whether the object disposed of is built with obsolescence in mind or is painted, as a work of fine art, to last for centuries. Fragility fulfils itself at the moment that it no longer matters.

5 Looking at Ugliness: *Pascali's Island* and *Stone Virgin*

Après tout, pourquoi n'y aurait-il pas autant d'art possible dans la laideur que dans la beauté? C'est un genre à cultiver, voilà tout.

<div align="right">Céline 78[1]</div>

Representation

Ugliness has never had its due. In aesthetics, beauty dominates inquiry to the exclusion of ugliness. Even an adequate definition of ugliness is lacking in aesthetic discourse. Ugliness may appear in objects as a formal quality, as deviations or excrescences, or ugliness may refer to moral qualities, such as wickedness or evil. When applied at all, the term *ugliness* usually refers to visual art, without consideration of its effects in textual representation. Rooted in material culture, ugliness addresses the senses as does beauty. Instead of being the opposite of beauty, ugliness designates a wide range of unspecified and unspecifiable attributes. The ugly refers to what cannot be named or known.

Ugliness knows no restraint; it exceeds bounds. The difficulty of defining 'ugliness' arises from its complexity and diversity. The term is applied broadly to objects and phenomena, but no two people agree on the exact characteristics of the ugly. While ugliness shares borders with the grotesque, monstrous, hideous, deformed, and disgusting, it possesses a realm of its own: the *terra incognita* of the despised. Once noticed, the ugly offends the senses; because it offends the senses, the ugly is shunned. Whereas Immanuel Kant advises that disinterest should govern an appreciation of beauty, no one looks upon ugliness with equanimity, let alone disinterest. The ugly addresses the eye or ear with

a plethora of disagreeable detail or ornament. Whereas beauty requires a displacement of thinking to ideals beyond the physical – 'les anciens disaient que l'artiste inspiré est comme un voyant de l'au-delà, un prêtre ou un prophète' (Lalo 45)[2] – the ugly never transcends the physical. As a corollary to that statement, ugliness stems from the human instinct to consecrate objects and images with value that exceeds their materiality. For this reason, ugliness, uncompromisingly material, asserts itself through fragmentation, breakage, or corruption of artworks, events or effects that underscore the materiality of objects and prevent their overvaluation. Although the survival of objects through time intimates value, in the event of breakage, that value converts to valuelessness, or, at the very least, the artwork slides down the scale of value. Breakage in and of itself does not render an object ugly. Rather, breakage reveals the ugly truth about the fragility of representation.

Barry Unsworth's novels *Pascali's Island* and *Stone Virgin* approach ugliness as a visual and narrative phenomenon by representing damage to statues. In *Pascali's Island*, a Hellenic statue of a youth falls to the ground during a midnight raid. As it falls, the statue crushes a man to death, and the right arm of the statue shears off. In *Stone Virgin*, pollution in Venice corrodes a statue of the Virgin Mary. Both *Pascali's Island* and *Stone Virgin* pose aesthetic questions that touch on representation and ugliness: Who has the right to excavate antiquities, and who owns them when they come out of the ground? Who has the right to smash artworks: private owners, archeologists, government officials? If a statue is finely polished and sealed in wax for the sake of preservation, as happens in *Stone Virgin*, is the statue improved or further damaged? The repair of a statue implies a dialectic between ideal beauty and the depredations inflicted by time and human intervention, which are two forms that ugliness takes within narrative. In *Pascali's Island* and *Stone Virgin*, statues register aspects of ugliness that cannot be expressed through narrative alone.[3] As disfigured statues prove, things of beauty, never permanent, devolve into ugliness.

In *Stone Virgin*, Harold Slingsby, who works in Venice for the American Committee to Rescue Italian Art, gives voice to the ugliness behind both images and the human impulse to make images. According to Slingsby, image-making is ugly because of its implicit narcissism and tendency to idolatry:

'I do not like the human image,' he said. 'Not really. Not deep down. If you ever want a trip on a downward slope go from these beautiful mar-

ble panels to the sculptures at the Giovanni and Paolo Church, severe,
yes, restrained, yes, but our ugly passion for self-replication is evident al-
ready; from there to the grotesqueries of the Ospedaletto; finish up with
that hideous, degenerate face on the campanile of Santa Maria Formosa
– the gratuitous ugliness of which inspired your John Ruskin's wrath and
disgust.' (278)

Ugliness arises from the will to make idols after the human image: mas-
carons, Madonnas, Hellenic youths, murals. In Slingsby's estimation,
a trip around Venice exposes the symptoms of idolatry. Tourists wor-
ship at the altar of false gods, namely, the gods fashioned from human
images. Image-making, as a sickness, worsens over centuries. In fact,
artworks record the symptoms of sickness as historical narrative. The
tourist's progress around Venice to look at each object corresponds to
the historical plot of uglification; each artwork on Slingsby's itinerary
is uglier than the last. The will to make images after the human form
ensconces human beings at the centre of the universe and pre-empts
questions that contradict that centrality. An alternative to such idoliza-
tion would be ornamental representation without reference to human
figures. Intentionally or not, Slingsby aligns ugliness with the 'hideous'
and 'degenerate,' as well as 'self-replication' and 'disgust.'

In his disgust over the tendency to represent human images, Slingsby
specifically recalls John Ruskin's description of a grotesque head, the
mascaron attached to the base of the bell tower of Santa Maria For-
mosa. In *The Stones of Venice*, Ruskin calls this 'head – huge, inhuman,
and monstrous, – leering in bestial degradation, too foul to be either
pictured or described, or to be beheld for more than an instant: yet let it
be endured for that instant; for in that head is embodied the type of the
evil spirit to which Venice was abandoned in the fourth period of her
decline' (3:120). Ruskin groups the mascaron with other disgraceful ex-
amples of 'sneering mockery' and 'low sarcasm' (3:121). Its tongue loll-
ing from its gap-toothed mouth, its face a series of lumps and bulges, its
lips like a misshapen roll of plasticine, the mascaron distresses Ruskin
(figure 17). It has no proportion, no balance of features; it has neither el-
egance nor restraint. Although Ruskin describes it in detail, it allegedly
defies description. Its violation of mimesis renders it 'evil' in Ruskin's
eyes. In this moral scheme, the ugly is a species of evil and evil a species
of ugliness. What Ruskin cannot pity or admire he deems an affront to
morality and good Victorian taste. Ugliness implies qualities in objects
that cannot be seen or fully understood.

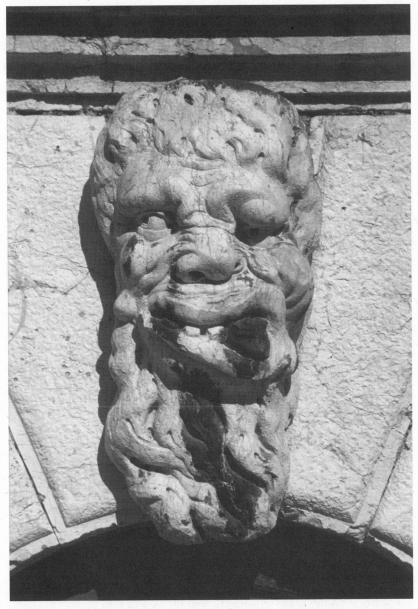

17 Gargoyle on the Campanile, Italian School, stone, sixteenth century, Santa Maria Formosa, Venice, Italy. © Sarah Quill / The Bridgeman Art Library.

Simon Raikes, the museum worker and conservator assigned to repair the corroded Madonna Annunciata, tells Slingsby that art historians now believe the ugly head to be a faithful mimesis of someone with a disfiguring disease, an argument that diminishes the 'gratuitous ugliness' of the mascaron in favour of realistic portraiture. Ignoring this argument, Slingsby, a specialist in the decay of stone, seeks proof that all things erode and disintegrate. By rejecting the mimetic interpretation of the ugly head with its lolling tongue and wall eyes, Slingsby seconds Ruskin's verdict of ugliness. The head sums up the Renaissance grotesque and Venetian decline. Not mimetic at all, it is intended to be ugly.

By focusing on artworks, *Pascali's Island* and *Stone Virgin* explore the aesthetics of ugliness and the museumification of culture. Several of Unsworth's other novels, especially *The Partnership*, *The Hide*, and *Losing Nelson*, investigate objects in terms of fabrication and display. Outside museums, the value of objects depends on degrees of hiddenness and exposure. Display can even convert an object deemed hideous into a valued one. Excavated objects, like the bronze statue in *Pascali's Island*, enact a drama of exposure that has historical dimensions. Brought out of the earth, the object appears miraculous for having survived without its ever having been seen by contemporary eyes. To see it is to admire it. In *Stone Virgin*, the restoration of the Madonna statue taps into the language of miracles. Whether delivered from the earth or from layers of grime, the discovered or restored statue, like a herald of another age, possesses qualities that contradict contemporary aesthetics. It is ugly insofar as ugliness designates aesthetic ideas that challenge prevailing convictions.

In his fiction, Barry Unsworth lingers over the details of objects: their shape, gestures, material, and probable origins. Artworks housed in museums particularly captivate his attention. In general, he interprets objects in terms of recovery and loss through history with the understanding that materiality embodies history. Despite the fact that half of his novels have contemporary settings, Unsworth is best known as a historical novelist whose narratives cover various epochs. For example, *Sacred Hunger*, which won the Booker Prize in 1992, concerns the eighteenth-century slave trade along the west coast of Africa and in the Caribbean colonies that Liverpool merchants controlled. *Sacred Hunger* focuses on the idea of property and the corruption that stems from the human tendency to objectify everything. Slavery demonstrates the worst degradations of commodification. Erasmus Kemp thinks about

'the complex chain of transactions between the capture of a negro and the purchase of a new cravat' (*Sacred* 266). The two events are related by the substitutability of commodities under capitalism. Even in a utopian village established in the Florida marshes, where white and black races intermingle, 'most disputes concerned property or trade' (533). The craving to secure objects as personal property quickly settles into 'ugly complacency' (80) or 'ugliness of spirit' (559). If *Sacred Hunger* represents history as an economy of things in circulation, that economy itself fosters a species of ugliness, which is the ugliness of possession. Owners of objects see themselves reflected in their possessions as a form of representation.

The mystery of representation – one thing or person credibly substitutes for another – lies at the centre of Unsworth's historical fiction. In *Morality Play*, a troupe of fourteenth-century actors roam through Yorkshire presenting mystery plays and, startlingly, an improvisation based on a local murder. 'These things had happened. Now with our words we made them happen again, as later we would with our bodies,' claims Nicholas Barber about the pleasures of recreating the past through words and gestures (*Morality* 86). Equally schooled in the enchantments of representation, a group of five gypsy dancers and musicians travel around the southern kingdoms of twelfth-century Italy in *The Ruby in Her Navel*. Even when Unsworth's imagination extends from the historical to the mythic, he continues to speculate on the complexities of representation. *The Songs of the Kings* concerns the sacrifice of Iphigenia to appease Zeus and to help the Greek campaign during the Trojan War. Prior representations limit Iphigenia's story, for, among other versions and adaptations, Euripides dramatizes the story in *Iphigeneia in Aulis*, and Racine reinvents it in *Iphigénie*. Multiple representations of the same story interlock as history.

Unsworth delves into history to clarify the present, as he acknowledges in *Crete*, a lively travelogue about myths and excavations on that Mediterranean island: 'I often use the past, sometimes the remote past, as a setting for my fiction. It's a matter of temperament, I suppose, but I find this distant focus liberating, clearing away contemporary clutter and accidental associations that might undermine my story, and allowing me to make comparisons with what I see as the realities of the present. So it's a sort of fusion, an interaction of past and present' (5). Historical narratives self-consciously inscribe history to demonstrate that the past communicates with the present. Such postmodern representations do not purport to tell incontrovertible truths about the past

in the present; instead, 'historiographic metafiction,' as Linda Hutcheon argues in *The Politics of Postmodernism*, 'de-naturalize[s] that temporal relationship' (71). In Unsworth's fiction, remote civilizations influence contemporary society or stand as counter-examples to the present. The past intensifies the present in productive, if sometimes irruptive, ways.

In order to be comprehensible, the remote past requires translation.[4] History is understood as a sequence of representations that translate the remote past into the language of the present. As Suzanne Keen points out, Unsworth 'shows how absorption in a deeper, more remote past rewards the attention of those who wish to avoid the unsavoury aspects of the more recent, documented past' (110). The historical is invariably political in Unsworth's fiction. He looks upon history as a sequence of 'plunder,' 'atrocities,' 'destruction,' 'massacre,' and 'vindictiveness' (*Crete* 18, 39, 44, 64, 65). Although he uses these nouns to describe the history of Crete, they apply just as well to his novels. Against the forces of destruction and violence, societies fortify themselves with laws. He refers to justice as 'that striving for order, for shelter from violence and chaos common to every human society' (*Crete* 133). The commander of a British garrison in *Sacred Hunger* phrases the matter more colloquially: '"Justice is a mighty fine thing"' (464). More often than not, Unsworth's historical novels pivot around emissaries who do the bidding of a reclusive king or sultan. The emissaries try to fulfil the wishes of the political figurehead while obeying their own conscience. Emissaries, whether governors, secretaries, diplomats, or spies, perform acts of justice as they see fit. Thurstan Beauchamp acts for King Roger in *The Ruby in Her Navel*. The sultan controls legions of spies in *The Rage of the Vulture*. Pascali spies on behalf of Ottoman authorities in *Pascali's Island*. They are representatives.

To some degree, representation of any sort occludes truth. Although history can be known only by its representations, those representations do not tell the whole story. Unsworth sums up this contradiction in *Losing Nelson* with the analogy of visual art: 'If one could peel the layers away, find the truth below the image, before the original painter found it, before the first, deceiving brushstrokes ... ' (320). The thought trails off in an ellipsis because nothing exists 'below the image.' The conditional 'if' stands guard over the suspected truth; if layers could be peeled away from images, one would hypothetically have access to truth beyond representation. Yet peeling away images alters or destroys the truth if the truth is composed of images. No truth exists before the 'original painter' starts laying oil on canvas. In this regard, an abiding

suspicion of representation appears throughout Unsworth's novels. In *Sugar and Rum*, Benson, a novelist with writer's block, cannot give up 'his invincible passion for image' (54), even though he knows that his image-making habits falsify truth.

Making representations creates distance from truth. As a corollary, destroying representations seems to create proximity to truth. Iconoclasm expresses a desire to close the gap between the self and reality or the present and past. While inspecting religious frescoes and images in Crete, Unsworth marvels at the permanence of icons: 'the head of the Virgin is still inclined in the icon posture of submission' after many centuries (*Crete* 18). Nevertheless, he specifies that images are incomplete tokens of reality: 'A visual image is never purely visual; it depends on the feelings and sensations of the moment, elements beyond our power of recall' (19). Even if the layers of deceiving brushstrokes – or any kind of representational camouflage – could be peeled away, the visual image would not be complete, for it relies on sensations or perceptions that exist in the mind of the perceiver. Representation is iconic because it summons up an absent object without completing it.

For Unsworth, objects are visual analogues to textual representation. In many of his novels, he provides details about objects and their routes of circulation. Hidden, stolen, exchanged, caressed, abandoned, and broken, objects bear a history of their own, quite apart from human history. Within narrative, objects establish aesthetic principles and register value. The history of objects, especially the history of art objects, is inseparable from their classification as beautiful or ugly. Such classifications depend in part on the perceived deceptiveness of all representation. In Unsworth's first novel, *The Partnership*, Michael Moss and Ronald Foley sell plaster pixies as piggy banks and souvenir ashtrays to holidaymakers along the Cornish coast. Popped out of their rubber moulds, the pixies are mutants, deformed by 'monstrous accretions, little ridges and humps, swellings, goitres, phalluses' caused by irregularities in the moulds (*Partnership* 8). Imperfect representations, the pixies exaggerate deformity and coarseness latent in the human form. On the other hand, as Plato argues in *Ion* and *Republic*, representation itself falsifies the human image and therefore cannot be truthful. Physical deformities in the pixies exaggerate the deformations of truth perpetrated by representation. Unsworth, working within the constraints imposed by novelistic representation, worries over the distinction between an image as an idol that substitutes for an absent object and the object as a material form in and of itself, with its own history and meanings.

The Partnership works out the implications of representational false-ness in objects. In addition to making the malevolent pixies, Ronald Foley fashions cherubs into lamps and wall brackets, which he hopes to sell to fashionable London shops. Both pixies and cherubs represent something beyond themselves: Cornwall and London; souvenir and decor; malevolence and benevolence. As a totem or fetish, the idol con-centrates the mind 'in the way that the Orthodox devout use ikons, as a focus for simultaneous discharge and replenishment' (23). If the icon focuses the mind for spiritual purposes, it risks becoming the object of veneration in and of itself – a false idol. Ronald Foley, enamoured of his own plaster cherubs intended for a commercial market, feels 'the stirrings of idolatry' (193). Because he fashions the cherubs with his own hands, then admires them in secret sessions of gazing, he creates a complicated circuit, albeit a closed one, of self-adulation. On the mantel in his bedroom, Foley keeps a photograph of himself from his days as a model in London. Michael Moss, trespassing in Foley's room, stud-ies the photograph 'intently' (15), as if in veneration. Adulation takes numerous forms in *The Partnership*. Selling the cherubs as household ornaments, for instance, multiplies the effects of idolatry insofar as oth-ers mistake the cherubs for sacred images. In Foley's opinion, 'there was a demand for the ornate these days' (18), the implication being that baroque volutes and intricacies fulfil spiritual needs.

Idolatry generates iconoclasm. The idol, intolerable in its various distortions, whether pixie or cherub, can be smashed to stop the dis-semination of false images. The urge 'to take the nearest pixie, set it down in some convenient position, and use his fist like a hammer on it' (*Partnership* 109) overcomes Moss from time to time. He longs to smash the pixies to end the drudgery of work. In the end, he yields to his iconoclastic impulse but not to the detriment of the pixies. Instead, he pulverizes Foley's cherubs. Finding the broken idols, Foley regards them as he would a massacre: 'Here a body had been struck off at the neck and sent flying to shatter into fragments against wall or floor, leav-ing a trunkless golden head, its curls intact, its blind ecstatic gaze un-wavering. Here nether limbs still writhed beneath a bent lamp shade, the torso gone, stark white dust spilling out like powdered intestines' (212). Moss routes his violence toward Foley into violence against Fo-ley's cherished objects. While retaining some semblance of the human form, the shattered objects return to the elements of their composition: plaster and paint.

Although the partnership between Foley and Moss dissolves at the

end of *The Partnership*, the narrative does not resolve the contradictions that group around representation and idolatry. The golden cherubs have been smashed, but the evil pixies leer from knick-knack cabinets in countless British households. The pixies and cherubs, as tangible representations, necessarily evoke objects other than themselves: invisible fairy folk or celestial denizens. The idols convert belief into material form. Unsworth does not gainsay belief as such; attuned to the human tendency to create images, he is more concerned with the material forms in which beliefs are cast. Ugliness creeps into the suggestive power of the idol, as a passage loosely narrated in free indirect discourse from within Foley's mind indicates: 'Things ugly in themselves can none the less suggest beauty and perhaps for many this pixie leer would evoke the flight of gulls, the envied life of fishermen, a golden hitchless passage of adultery or a dazing win at Bingo' (*Partnership* 11). The sentence attributes ugliness, as a formal quality, to objects; they are 'ugly in themselves.' At the same time, the sentence links ugliness with suggestiveness. As a souvenir of a holiday in Cornwall, the ugly pixie intimates various forms of freedom, such as the flight of gulls or an adulterous encounter. Although the sentence lists such events as forms of beauty, the ugly object evokes them. Ugliness, therefore, may be not an attribute of the object, but the excess of meaning that issues from the object, including the sentimentalization of the life of fishermen or the dazing win at bingo. These meanings arise by association with the ugly object. They are not aspects of the object itself. Whereas the sentence literally promotes the possibility that ugliness dialectically generates intimations of beauty, the syntax implies that ugliness flares up when there is too much suggestiveness. In *The Partnership*, ugly objects are common property: anyone can own a malevolent pixie. The cherubs do not survive, but the pixies – crude and kitschy souvenirs – do.

Moss smashes the cherubs because they belong to Foley, who has taken advantage of him as a partner and rebuffed him as a lover. Moss's iconoclasm strikes a blow at Foley's narcissism, for the cherubs are expressions of his secret artistic inclinations and his private scheme to become wealthy. Foley keeps his cherubs hidden in a private room at the top of the house. Concealing them exaggerates their iconic and fetishistic value. W.J.T. Mitchell argues that the idolater and the iconoclast are not opposites: 'The iconoclast sees himself at a historical distance from the idolater, working from a more "advanced" or "developed" state in human evolution, therefore in a position to provide a euhemeristic, historicizing interpretation of the myths taken literally by the

idolater' (*Iconology* 197). The iconoclast and idolater stand in a historical, or putatively historical, relation to each other in terms of perceived evolution. The iconoclast constructs a narrative of superiority vis-à-vis the idolater. Primitive societies worship false gods. The smashing of idols, in theory, releases the idolater from his false worship, or, in the case of Foley, from his self-deception and self-flattery. Nevertheless, the iconoclast harbours other idols that he hopes to substitute for those that have been smashed. 'The iconoclast,' Mitchell argues, 'prefers to think that he worships no images of any sort, but when pressed, he is generally content with the rather different claim that his images are purer or truer than those of mere idolaters' (*Iconology* 198). Moss gazes lovingly upon Foley's toiletries as if cologne, toothbrush, and aftershave lotion constitute an altar. Moss even fingers over these toiletries in a familiar, 'almost ritual' way (*Partnership* 14). Having idolized Foley, Moss leaves him to take up with a frivolous hanger-on named Max. In short, Moss is an idolater who mistakes the worship of thankless men for love. By smashing the cherubs, he frees himself from the commercial partnership with Foley. He does not, however, free himself from idolatry.

Although it would be possible to interpret the smashed pixies in *The Partnership* as an act of iconoclasm directed toward the commodity fetish, iconoclasm in this instance expresses ambivalence about representation as a necessity and a deception. Art is a way of presenting answers to hypothetical questions through a displacement into representation, whether objects, paintings, statues, drama, or novels. Representation enables abstract thinking. Abstract thinking, because it relies on the details and context of the narrative in which it occurs, cannot be translated back into reality. 'We live in a world where language is used to cloak the most appalling realities,' claims a novice writer in *Sugar and Rum* (48). To break the artwork is to break through the deceptions of representation. In *The Partnership*, the act of iconoclasm resolves, if only provisionally, an aesthetic problem. Once representations acquire spiritual or metaphysical value, the way to wrest control from the representation is to break the material object that functions as an idol. The spell that an object possesses can also be broken by burying it.

Digging

The history of art is unimaginable without excavation. Digs at Knossos, Troy, Nineveh, Pompeii, Herculaneum, Tanagra, Rome, and elsewhere have brought to light buried antiquities that have changed the

interpretation of art history. Archeologists delving in the earth enter into a relation with history. Civilizations disappear underground; excavation retrieves material vestiges of the past. Those material vestiges raise key problems about the nature of objects. Who owns excavated objects? Should excavated objects circulate as antiquities or curiosities, or should they be housed in museums for purposes of study and analysis? Frequently, but not invariably, objects brought out of the earth end up in museums, where they yield historical information about culture and the everyday practices of defunct civilizations. Scarce if not always unique, amphorae, funeral totems, or other objects that come out of the ground appear to speak of the past without mediation.

In *Unearthing the Past*, Leonard Barkan claims that the unprecedented excavation of statues in the fifteenth and sixteenth centuries in Italy, prompted by Renaissance humanists' fixation on antiquity, produced shocking face-to-face encounters with the past: 'Underlying all the possible relations in front of art objects, whether characterized by medieval notions of idolatry or by Renaissance notions of ancient glory, historical recuperation, and aesthetic pleasure, is a sense that, in the act of looking at ancient statues, modern individuals are encountering their own mirror images from the classical past, not in bronze or marble but in the flesh' (55). The facticity of the objects – their solidity in space – challenges the viewer's tastes, expectations, and judgments. Despite its hermeneutic ambiguity, an object is a tangible proof; it allows deductions to be made about culture and its functioning. Because of its materiality, the excavated statue or object establishes an irrefutable link with the past.

Items retrieved from the earth often ended up there because of negligence. Debris accumulates over a dropped coin or a vase. A box is buried in the garden, then forgotten. Other objects are deliberately interred: tombs or stolen treasures. These objects, too, run the risk of being forgotten in the long run. Being underground alters the meaning of objects. They shed contextual information, such as the crimes that led to the buried treasure in *Treasure Island* (pirates hide booty) or the covering up of the statue in *Pascali's Island* (a slope subsides). Once excavated, objects acquire new meanings as if, by virtue of having disappeared from view, they revivify. Certain artistic or human intentions vanish with the buried object. The way that an object was originally sited cannot be recovered through excavation. Objects that might once have been public, such as a heroic bust, become private; objects that might once have been private, such as a reclining nymph, become pub-

lic. In this sense, being underground permanently alters the paradigms in which objects are interpreted. Objects abandoned because of their ugliness or uselessness return in changed circumstances. In fifteenth-century Italy, when the mania for unearthing statues crested, Christian monotheism had vanquished Latin gods. The Roman empire had yielded to local configurations of power in Europe: principalities, city states, kingdoms. In such changed circumstances, a Roman statue intended as a public monument or a religious idol sheds its antique use value and acquires value as a historical vestige.

If time and burial transform the meanings of objects, meaning is an alienable aspect of objects. Barkan notes, 'Objects are capable of more than one exegesis without the necessity of a unique orthodox reading' (46). At the same time, exhumed objects attest to histories that can never be recovered, or never recovered fully. Cultural codes and conventions that made the objects interpretable have shifted or vanished. The Metropolitan Museum of Art in New York owns case upon case of silver objects, including filigreed, finely wrought shoe buckles, often in the shape of discs, dating from colonial America. Like eighteenth-century Europeans, Americans expended inordinate craft and money on ornamental shoe buckles. Portraiture of the period 'reveals that modish footgear was rarely without such decorative accessories. The fashion thrived for over a century but never regained its popularity after 1789, when George III appeared in St Paul's in shoes without buckles' (Davidson 146). The buckles at the Metropolitan Museum might not have been dug out of the earth, but the cultural signification of the ornate buckle no longer obtains. That they are housed in an art museum, as opposed to an ethnographical museum, indicates their recontextualization from functional to artistic signification. Because history cannot be recovered, objects resituated in museums are free to signify in multiple new ways.

Barkan hints that the emergence of aesthetics in the eighteenth century, in theories expounded by Baumgarten, Lessing, and Kant, grew out of the Renaissance encounter with excavated statues, in which viewers experience 'the aesthetic pleasure of contemplating objects independently of what they mean or represent' (49). One can appreciate the formal properties of an object, such as shape, design, massing, gesture, line, finish, and surface, irrespective of its prior function or significance. In the absence of knowing precisely whether a statue represents Cleopatra dying or Ariadne sleeping, this emperor or that, Domitian, perhaps, or Caligula, the object provokes a consideration of its execution:

it succeeds or fails on aesthetic criteria. Excavated antiquities license aesthetic contemplation unencumbered by contextual information.

This predisposition to react aesthetically – with sensitivity and dispassion, as it were – is complicated by the fact that many excavated objects are fragments: 'There is nothing more obvious or more important about rediscovered sculpture than the fact that it is nearly always broken' (Barkan 120). Virtually no antique sculpture survives intact. Headless torsos, noseless heads, limbless bodies are the norm for antique sculptures, just as shards and fragments are the norm for excavated pitchers, combs, urns, and other objects. The ability to look at a fragment and see its excellence qua fragment required a retraining of the eye in the Renaissance and after. An aesthetic disposition toward the fragment involves an ability to extrapolate an entire work from the part, and to imagine the perfection, in all senses of that term, of the whole. An aesthetic attitude toward the fragmented and broken object is in part an act of imaginative invention; the object 'becomes a whole through the acts of beholding and contemplation' (122).

After the Renaissance, excavation acquires other tropes and meanings. Nineteenth-century excavations at Nineveh and Troy, for instance, synchronize with the history of imperialism. The British Museum sponsored numerous digs in Egypt, Mesopotamia, and Asia Minor. At Nineveh, the British laid claim to objects that archeologists unearthed. Among other treasures, an Assyrian Winged Bull dug up at Nineveh was transported to the British Museum as an antiquity to be displayed for the British public. In 'The Burden of Nineveh,' a poem inspired by the Assyrian statue, Dante Gabriel Rossetti adapts the lessons of ancient empire to nineteenth-century Britain. Rossetti interprets the excavated monument as the omen of a fallen empire: the 'Bull-god' is 'a relic now / Of London, not of Nineveh' (37). Although excavation permits a face-to-face encounter with the past, the lessons that a spectator extracts from that encounter vary according to knowledge and context. Not surprisingly, Rossetti interprets an ancient monument in light of his own era. Excavated objects, whether statues or bas-reliefs, clarify the aesthetic values of the present as much as they speak to monumental history in ancient Mesopotamia or elsewhere. The value of excavated artefacts depends upon aesthetic predispositions (during the height of nineteenth-century imperialism, the British endorse monumentality), as well as the perceived relations between the present and the past (the British empire will last no longer than Nineveh or Troy did). Excavated objects are assigned aesthetic value despite their religious or imperial

connotations. Aesthetics, understood as a cultural practice, suppress history in favour of form.

In *Pascali's Island*, the statue of a young male, dating from approximately the fourth century BC in Greece, comes out of the ground. The statue assumes pride of place among many other objects that circulate in a complex economy within the novel. As an antiquity, the statue throws into relief the commercial and aesthetic properties of other objects represented in the narrative. Rifling through Anthony Bowles's luggage, Pascali, an inveterate snoop and a professional spy, finds three items: a revolver, a notebook filled with cryptic 'figures and dates in red ink' (35), and, most surprising of all, 'a smallish marble head of a woman' (34). Pascali identifies the head as Paros marble of ancient design. The three objects constitute a puzzle, and Pascali's narrative, set down as a spy report to a distant and heedless sultan in Constantinople, attempts to solve the puzzle. Bowles, an 'amateur archeologist' (35), has no apparent reason to carry firearms, which rouses Pascali's suspicions about his true identity. The marble head looks like an antiquity but could be a fake. In any event, Pascali has no immediate explanation for it. Mute and mysterious, objects participate reluctantly in human economies of possession. Pascali understands that subjectivity arises only in relation to objects: 'Nothing I see pleads for me, upholds me as a person, makes me feel more than a temporary vehicle for someone else' (47). He means that his few chattels – he calls them his 'familiar possessions' (125), his 'accustomed things' (134) – hardly anchor him to the world. He knows that objects have no inevitable relation to him, or to any human being, no matter how much he desires to possess them. Objects remain defiantly other.

Although Pascali plans to 'study the indifference of things' (189), by which he means the neglect that government officials and casual acquaintances inflict on him, as well as the indifference of objects to the ideology of ownership, he insinuates himself into situations that cause him to purloin and sell wares. He steals the few books that line his shelf. He appropriates a fez; not exactly confessing to theft, he confides that he obeyed a 'certain compulsion' (37) when he saw the fez lying near a wall. In another act of light-fingeredness, Pascali pockets Bowles's notebook. Having already sold his watch, Pascali worries that he will be pressed to commit further sacrifices: 'If this goes on I shall have to sell my telescope – which an Italian gentleman left behind' (16). Knowing that Pascali has stolen a fez and books, the reader surmises that the telescope was also stolen. A thief by temperament and habit, Pascali understands objects as

communicative signs, rather than individuals' possessions. Like the information in which he traffics, objects acquire value and meaning when they circulate. Theft and trade preserve the appearance of meaning in a world given over to 'the indifference of things.'

Pascali feels 'ill at ease' around 'disparate objects' (64) and wonders if Bowles experiences similar discomfort. In fact, Bowles demonstrates an intimate acquaintance with the contextual details of objects, especially their origin and material. For all intents and purposes, he comes to the island to gather 'material for a book about classical antiquities in Asia Minor' (33). His excavations on the island can be interpreted in relation to the history of British archeological expeditions in Asia Minor throughout the nineteenth century and into the first decades of the twentieth century. Just as the British appropriated what they excavated and shipped back to England, Bowles conjectures that anything he digs out of the earth belongs to him as plunder. His motives do not rise above the tawdry: greed and vainglory. For six months and more, he travels around Asia Minor looking for sites that might yield a trove of antiquities. As it turns out, the neat, red notations in his journal 'are the records of his transactions' (158). Convinced of his vocation as an archeologist, Bowles confides, '"Schliemann was my great hero"' (161). The appeal of ancient history couples in his mind with the possibility of excavation: '"Sumerians, Babylonians … And then the idea that you could dig, find out things about them"' (160–1). For Bowles, as for other archeologists, the earth opens up to the past. Unlike other archeologists, however, Bowles operates independently; he has no professional connection to any institution, and his negotiations around Asia Minor satisfy his amateur desire to excavate in the roughshod manner of Schliemann at the mounds of Troy.

Excavation shows up in many of Unsworth's novels. In *Land of Marvels*, Somerville, a British archeologist, excavates an ancient Assyrian palace. He feels a sense of violation as he looks upon the 'ancient heap of earth and rock and rubble, gashed and trenched for no purpose immediately apparent' (2). Sometimes Unsworth's characters dig in the earth to create shelter or to conceal themselves. In *The Hide*, Simon digs a tunnel across his sister's property and plans a network of trenches that will allow him to lurk unobserved within sight of the house. His reasons for digging are obscure. As Simon states, '"I am no longer sure what led me to excavation"' (30). Fearing that his sister tampers with his belongings, he excavates 'a subterranean room' (31) and hides the objects that he values in it. He spirits birdwatching books, a 'collec-

tion of advertisements for ladies' silk stockings,' and a copy of a Monet nude into the shrine-like room (32). The Monet nude presides over the grot like a minor deity, revered by Simon for her hint of impropriety. In the dim light of a paraffin lamp, the objects assert 'almost with violence their familiarity, their quality of being objects that, however common in themselves, have a uniqueness of placing, of consideration in my mind,' as Simon claims (123). Freed from prying eyes and Simon's bedroom, the poster and books acquire heightened fetishistic value in the subterranean room.

The Hide is manifestly about voyeurism. Using binoculars, Simon watches a woman dress and undress in a nearby house. Despite this emphasis on looking, the narrative plays on the trope of hiddenness. The title of the novel refers to a blind: trees screen the entrance to Simon's trench and the secret underground room where he hides his fetish objects. Certain other objects acquire fetishistic significance. Throughout The Hide, a wooden horse with a bloodstain along its back moves in and out of pockets and dresser drawers; mystery surrounds its several appearances. Although visible, the wooden horse is never adequately seen before it goes back into hiding. Many events and objects are inadequately seen. Simon fetishizes women's undergarments because there are hidden. A coward by nature, he averts his eyes from traumatic events. When his sister Audrey tries to commit suicide with a breadknife, she makes an 'attempt to hide' the flow of blood from her neck with bedsheets (191). When sixteen-year-old Marion is raped, Simon turns deliberately away from the violent assault and does nothing to help Marion fight off her attackers. Voyeurism, regardless of curiosity, remains a weak-willed activity. Simon's avoidance of violence marks the ultimate imposition of hiddenness as an aspect of seeing itself. The underground room where Simon hides his fetishes, a grotto and a shrine at the same time, attests to the quasi-sacred value of hidden objects. A hidden object, because it is hidden, increases in value. To put an object in the earth can augment its value.

Archeology happens in caves as often as it happens in earthworks. In Pascali's Island, Bowles claims that he finds pottery shards, a circlet set with blue stones, a marble head, and other objects in 'a cavity in the hillside' below a Roman villa (111). The cavity – not, in this case, a cave or trench – may open into the foundations of ruined houses, or perhaps shrines built one atop the other. To hoodwink Ottoman officials, Bowles plants these items, then argues for their authenticity. After hearing about the possibility of archeological finds, Pascali, rummaging in the

cavity to see what is there, lays his hand on 'an object cold, smooth, *shaped'* (185). The archeological treasure turns out to be a doll planted by Bowles as a joke about his faked discoveries. Bowles's joke works because he understands the archeological significance of caves: they are places of discovery and wonder. Searchers expect to find valuable objects in caves.

'Caves are always a mystery,' Unsworth concludes in *Crete* (158), a book deeply engaged with the history of Mediterranean archeology. In many of his novels, Unsworth examines the mysteries of caves in terms of sacrifice and exhumation. In *The Rage of the Vulture*, Robert Markham hides in a cave dug out from the sepulchres in a vast cemetery in Constantinople. In *After Hannibal*, a German named Ritter finds a cave on his property; he discovers that the cave provided refuge for an Italian soldier hiding from the Nazis in the latter stages of the war. In *The Songs of the Kings*, a priest visits a cave where votive offerings lie on a blood-stained table: 'bronze knife blades, the simulacrum of a double-headed ax, a wide-mouthed jar. Beyond this, in the center of the cave, rose the shrouded figure of the goddess, in the shape of a column, streaked with eternal dew' (78). Cave shrines are associated with 'unclean earth cults' (52) devoted to Artemis or other female goddesses. According to Greek mythology, the three malevolent Graeae live in a cave and share a single eye. Equally monstrous and fabulous, Echidna, half nymph and half snake, gathers herself 'into a coil in the darkness of her cave' (147) before lunging at victims.

The cave exudes a quasi-magical, quasi-divine power. In *Crete*, Unsworth visits two caves, said to be the birthplace and the tomb of Zeus, respectively. Christians appropriate another cave, sacred to Artemis, and reconsecrate it as a shrine to Mary. Bandits and revolutionaries hole up in caves at various junctures in the history of Crete. To occupy a cave does not diminish its mystery. On the contrary, each successive inhabitant leaves his mark by lighting a fire, painting walls, or discarding waste. Archeologists dig in caves because of their rich deposits of artefacts. In the spring of 1900 an archeological party led by D.G. Hogarth discovered a bronze Mycenean knife wedged in a crevice in one of the Cretan caves sacred to Zeus. Further investigations revealed 'many hundreds of objects: knives, belt clasps, pins, rings, miniature double-headed axes, wedged in slits in the stalactites, brought down by devotees into these awesome depths some four thousand years before' (*Crete* 7). *Crete* recounts successive waves of conquest by Byzantines, Turks, pirates, and other marauders on the island. Objects

left untouched in a cave for several millennia seem almost miraculous because no one stole them. The cave, as shrine and hiding place, is a pocket of inert time. History compacts inside the cave.

Crete focuses on excavation everywhere on the island, not only in caves. Visiting the ruins of Aptera, Unsworth broods on the disappearance of a once vital city: 'the evidence of violent events is half buried, grassed over, softened out of recognition, whether it is the violence of natural forces or the savagery of human beings' (88). What once possessed value no longer signifies. At some time in the past, the city slumped into earth. Arthur Evans's excavations of Minoan civilization inspire rhapsodies from Unsworth because of the implied will to reconstruct lost history: '[Evans] and others worked on sites throughout the island in the early years of the last century, uncovering an entire civilization that had lain unsuspected below the earth and rubble for thousands of years. Together with Schliemann's work on the site of ancient Troy a little earlier, it was one of the greatest enterprises in the history of archeology' (43). Despite the impulse to destroy that characterizes human civilizations, people rebuild their cities on the sites of devastation; buildings rise out of ruins. The example of half-buried Aptera proves that not all cities come back to life in the long run. For any number of reasons, inhabitants abandon their houses and the city dwindles into inactivity, then total dilapidation. Covered by earth, the ruined city awaits the archeologist.

As a guide to ruins and caves, *Crete* advances two propositions about objects. First, objects left underground have value; they please the gods. Second, objects and buildings, such as the palace at Knossos and the vases unearthed around Crete, sink into the ground because they have no value; they please no one. Whether valued or forgotten, excavated objects take on a different life in museums. On display, they tell a parable about the rise and fall of dynasties. Fearing that cities and civilizations can be 'traduced by history' (105), Unsworth nevertheless believes that objects bear the spirit of the past. The objects in the archeological museum in Iraklion 'give physical expression to the spirit of that remote [Minoan] society, and trace the way that spirit developed and changed' (134). Crude terracotta goddesses resemble 'creatures in mourning for their own ruin and for their ruined world, raising their arms in terrible mute grief' (138). Unsworth interprets the gesture much as Ruskin interprets the ugly mascaron on Santa Maria Formosa: as an illustration of degeneration. More than an example of Minoan craft, the terracotta sculptures attest to the inevitability of ruin.

In the museum, the sacredness of objects and the valuelessness of objects yield to the display value of the object. On display, the object assumes different kinds of value, namely, the value of survival and historical communication. In a disconsolate passage about the destructive tendencies of humankind, Unsworth appeals to the archeologist of the future: 'The desire to communicate is the desire to save, to preserve from destruction. This is a paradox that has always accompanied our story and it finds a vivid example here, in these obscure remains. Our own age is just as barbarous, or more – more, certainly, if the criterion lies in the capacity for destruction. One hopes the archaeologist of the future will find evidence, in the ruins of our society, of this same saving desire to understand our fellows' (*Crete* 46). Hoping that future archeologists heed twenty-first-century attempts at communication is not the same as realizing that hope. The archeologist possesses not all information about a civilization, but only what remains, what obscurely remains, in fragments and buried objects. Vestigial traces are not necessarily intelligible. Nor, tucked into museum vitrines, do surviving objects contribute to systems of exchange or utility.

Excavation and display are twinned activities in *Pascali's Island*. Having signed a lease for some land with the local pasha, Bowles discovers a bronze statue in the bauxite-rich soil. While digging the statue from earth, Bowles resembles not a 'sculptor but [a] midwife, freeing the form from its *impedimenta*, its gross obscuring matter, *delivering* it' (142). In effect, he re-enacts the efforts of the sculptor to create a work of art from formless dirt. The life-sized bronze, 'bemonstered' with 'gouts of clay' (144), emerges day by day from its chthonic crypt. Bowles estimates that the bronze has lain underground for two millennia. Pascali, as a witness to the delivery of the statue from the earth, describes it as kinetic and beautiful. He begins with physical attributes before turning to aesthetic qualities that, in his estimation, constitute beauty:

> the appearance of the statue drove everything else from my mind. He stood there, a young man of possibly twenty or so, taking a slight step towards something. His head, chest and arms gleamed in the sun, dark olive colour, with glints of gold. The tarnish of ages still lay on the bronze, but the oil [rubbed on by Bowles] had glossed and darkened it. There was no visible flaw in any of the surface we had cleaned. The gleaming torso contrasted with the dull earth colour below, giving him the look of someone struggling out into sunlight – an accidental effect, but deeply impressive. Above all it was the tension within the movement of the body itself,

something unresolved, disturbingly ambivalent, that gave the work its life and distinction. The form expressed a subtle conflict between advance and recoil. It was there in the raised, slightly smiling face, in the squared shoulders, the tentative gesture of the arm; in the slight forward step and the withheld trunk, which could now be seen to be slightly turned from the direction of the walk, a further torsion of reluctance. With some marvellous instinct the remote creator of this youth had found a form for awkwardness and grace together. (168)

Pascali isolates gesture, contraposto, torsion, awkwardness, and grace as aesthetic attributes. Beauty conveys itself in nuance, as the repetition of the adverb 'slightly,' interspersed with the adjectives 'slight' and 'subtle,' makes clear. Drawing upon formal categories, Pascali distinguishes between intrinsic and extrinsic features. The contrast between the dull colour of the earth and the gleaming bronze is an accident of momentary context; it has no inevitable relation to the work of art. Nonetheless, the effect contributes to Pascali's appreciation of beauty. Whereas 'dull earth' remains impassive, the statue gives the impression of 'struggling out into sunlight,' of 'taking a slight step towards something.' The figure possesses, or seems to possess, kinesis, even though it is immobile. Pascali attributes intrinsic qualities to the statue, such as its seeming tensions between awkwardness and grace, advance and retreat, upraised arm and withheld trunk.

Beauty unites contradictions while driving other thoughts from Pascali's mind. Whatever detachment he affects, his lingering description of the young man's body has an erotic cast. Bisexual Pascali pauses on details of physique and posture as aspects of beauty, but not disinterestedly. The beauty of the sculpture derives from longevity and survival, in the sense that this artwork has outlived mudslides and political controversies. Beauty also exists in the seeming contrast between formless earth and cast metal. A human hand shaped bronze into a thing of beauty. Pascali directs attention to the archeological aspects of the discovery, as against the categories of texture, material, and shape. Beauty emerges from the ground. At the same time, narrative arises not from visual reconstruction of the object – a relation between object and beholder – but from the actions that the object instigates.

The art object creates action, while remaining entirely indifferent to causality and outcome. Pascali and Bowles appreciate the statue because it frustrates explication. It refuses to return, cooperate with, or refute desire. Motivated by cupidity, Bowles scrabbles in the clay to free

the statue.[5] A complication arises between his actions and the nature of desire. In *Pascali's Island*, action is motivated by curiosity about the body and its urges. Pascali sneaks up on Bowles and Lydia while they bathe in the sea. Aroused by their dalliance on the beach, Pascali hurries off to his masseur, who masturbates him. The statue, in Pascali's opinion, expresses '*desire*' (173). This interpretation is tendentious: Pascali interprets his desire in and through the figure of the youth. Pascali's lusts aside, the statue functions allegorically as the coming-into-being of the body as an object and subject of desire. Insistently, the statue, although 'blind' (163), looks 'over Mister Bowles's head with a sort of ecstatic aloofness, beyond, to where his step was taking him' (173). Whether the statue steps toward 'life and joy, or into some degrading rite, could not have been told from the face or posture of the body' (174). The description of the statue, as rhetorical ekphrasis, promotes the possibility of drama through the ephebe's look of expectancy and hesitant stride toward the future.

Ekphrasis calls into question the origins and nature of desire within aesthetics. The beautiful incites desire, which brings the object into the circuit of human control. Needless to say, the object does not reciprocate desire. In *Pascali's Island*, the statue itself desires nothing, yet serves as the object of Pascali's desire. The statue torments Pascali as it torments Bowles, because it inhabits a zone that is almost unthinkable: a zone of human experience untouched, and therefore uncompromised, by desire. Action arises in the novel in order to pull the aesthetic object into a narrative where desire is promulgated. Objects themselves do not express desire, whether the desire of the artist, the model, or the spectator. Narrative fills the void where desire is not. Desirelessness in objects incenses Bowles, Pascali, and the pasha. Their will to possess the statue signifies a need to deny, and even destroy, the absence of desire in the statue. In Pascali's description, the gaze implies direction, yet the immobile statue moves only through the muscle-power of Bowles, who eventually uses a block and tackle to hoist it into the air.

Tipped off by Pascali, the pasha and his henchmen ambush Bowles while the bronze dangles above the ground. It tumbles and crushes Bowles to death. Pinned to the ground by the statue, he is literally disfigured: 'he had no eyes, no nose, no mouth: only a glistening mask of blood' (184). Instead of mourning Bowles, Pascali concentrates on damage to the statue brought on during the ambuscade. Speaking of the statue as a person, he reports that 'the fall had broken off his right arm at the elbow, so that he was prostrate against the earth, his face

pressed into it. I could not see the arm anywhere, and I did not look for it' (184). The statue presses back into the earth from which it has only recently risen. The perfection of the object ends with its entry into narrative and time through breakage. The cost of that entry is human life and aesthetic wholeness. Pascali implies that the right arm has been lost altogether, either because someone carried it off as a trophy or because, being broken off, it compromises the integrity of the statue. Damaged, the statue acquires a story, if only a story of covetousness and greed, two run-of-the-mill forms of desire. Exiting the ground, the statue heralds the rough entry of the aesthetic into human activity. The object, in order to signify historically, cannot but be damaged. In a manner of speaking, aesthetics triumph. Bowles is dead; the statue, though damaged, endures.

The bronze statue in *Pascali's Island* invokes the complex relation of representation to death, as well as futurity and masculinity. As a catalogue of ekphrastic oppositions, Pascali's exposition of the sculpture recalls Gotthold Ephraim Lessing's description of the Laocoön statue, unearthed in Italy on 14 January 1506. The Laocoön grouping depicts a father and his sons wrestling with serpents (figure 18). Lessing's unfinished treatise on the Laocoön emphasizes that drama in sculpture should occur at the moment prior to culmination. Frozen prior to completion, representation relays temporality. A dramatic climax ensues, yet representation only implies that culmination without showing it. The spectator understands that the agony of the father and sons doing battle with the serpents will end in death. As John Dryden claims in *An Essay of Dramatic Poesy*, the direct representation of death is indecorous, at least according to neo-classical convention; death may be mentioned but should occur, as an event, offstage, outside the frame of representation. Lessing, abiding by similar strictures of decorum, concludes that the father's parted lips do not emit a scream, because screaming would connote fear and fear would undermine the heroic decorum of the masculine figure. Since Greek ideals of restraint prohibit indecorousness, the artist of the Laocoön group represents a moment before the father knows whether he will live or die. The body remains kinetic, capable of gesture, posed in agony. Causality still has an influence on the living body in a way that cannot apply to a dead body. Pascali notes that 'something unresolved' animates the youthful body represented by the statue. The youth moves toward the future while recoiling from it.

Because the statue emerges from the ground, its meanings are tied to the chthonic and the archeological. Like the Tiber River god, the Apollo

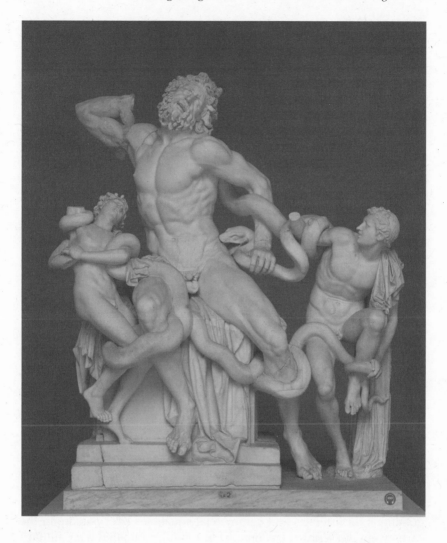

18 Laocoön and his Sons. Museo Pio Clementino, Vatican Museums, Vatican State. © Vanni / Art Resource, New York.

Belvedere, the Laocoön, and other ancient statues discovered during the Renaissance, 'the material object that emerges from the ground becomes the nexus point for the discourse of ancient narrative or history' (Barkan 4). That nexus includes the value of the buried object, which might be augmented by its long underground sleep. The unearthed statue attests to what and how history means. Removed from context, blasted out of history, as Walter Benjamin says about the dialectical image, the unearthed artwork demonstrates the devolution of history into the visual. Benjamin posits that an object leaves 'an after-history, the conditions of its decay and the manner of its cultural transmission' (Buck-Morss 219). By contrast, the excavated statue bespeaks a synchronic point in time until it leaves the ground and enters the narrative of political intrigue. The diachronic life of the statue is neither consecutive nor causal. Its after-history takes no predictable course. The statue in *Pascali's Island* enters into a value system that has nothing in common with the conditions and values of its making. Whereas it may have been fashioned for decorative ends, or (were it a depiction of a youthful god) as an idol for religious veneration, the statue, as Bowles and the pasha perceive it, exists as loot destined for the commercial art market.

Pascali's Island condenses conflicting interests in trade, archeology, and aesthetics into a narrative about the dying days of the empire and the inevitability of decline. As Bowles explains, Greek sculpture provides a paradigm for 'all human affairs' (170), including the expression of political ideals and the falling away from those ideals. All human affairs descend from 'a collective idea of man, to a very brief period of perfect balance, then to increasing anguish and disunity, finally to breakdown and fragmentation' (172). This arc very nearly coincides with Slingsby's and Ruskin's diagnosis of decline in Venetian art in *Stone Virgin*. In *Pascali's Island*, the digging up of the Hellenic statue – assigned by Bowles to the period between perfect balance and breakdown – forces the political analysis into the framework of imperial negotiations for artefacts and commercial squabbles over bauxite in the early twentieth century. Hellenic art is nothing compared with military armament and conflict among nations.

Less given to overarching theories and more prone to ekphrastic interpretation, Pascali describes the statue in terms of transformation: 'there was a sense of affliction and stillness in the form, as of some creature arrested by the gods, punished with partial metamorphosis, flesh into earth' (144). Stillness is taken as a sign not of tranquillity but of paralysis in an in-between state. Pascali thinks this incomplete meta-

morphosis has to do with the disintegration of flesh into earth. As an art object cast in bronze, the statue promotes the possibility of an opposite transformation, of metal into flesh. Pascali, who prefers movement to immobility, understands stillness as a sign of decay, even if stillness preserves unity (49). As both a political and aesthetic observation, he notes, 'Human beings prefer destruction to perfect balance' (58). Betwixt and between, the hesitant youth represented in the sculpture is neither fully born nor fully dead. Emerging from the ground, the statue draws attention to the corruptibility of human flesh. Its aesthetic value resides in its unchangeable nature as an object, even if that value cannot remain uncontaminated by other systems of value superimposed on the object.

Through its representation of excavation, *Pascali's Island* posits that objects become art through contact or proximity with dirt. The linking of art with earth is not unusual among contemporary writers. Unsworth himself reprises this theme in *Stone Virgin*; Simon Raikes polishes the 'diseased stone' and 'leprous deposits' (259) off the begrimed Madonna. As in *Stone Virgin*, fictions about enchanted artworks tend to focus on preservation rather than destruction of objects. In Susan Sontag's *The Volcano Lover*, the Cavaliere imagines the 'ground [in Sicily] loaded with rifts of treasure' (22). He inspects Herculaneum and Pompeii, where 'everything the ignorant diggers unearthed was supposed to go straight to the royal palace at Portici' (24). Unsworth himself examines carbonized papyri recovered at Herculaneum and deposited in the National Library ('Naples is Closed' 253). Contemporary narratives suggest that valuelessness haunts art objects; whether made of stone or oil paints, artworks are only so much ingeniously arranged dirt. By the same token, artworks acquire value because of their durability. In *The Volcano Lover*, workers send excavated treasure off to Portici for preservation among the royal collections. Despite being buried or hidden, most of these objects endure, and their durability confers value.

More accurately, the value of artworks fluctuates according to the perception of durability. *Pascali's Island* speculates on whether the excavated statue is valuable as a consequence of its having endured. Arguing for the fluidity of value in the assessment of artefacts and the migration of durable items from trash to treasure, Michael Thomson claims that preservation and circulation affect the perception of durability: 'The complete transfer of a class of items to museums and public collections is consonant with a general belief that, if only those items were in circulation, they would be increasing in value. In other words,

they are so durable they are priceless' (104). The occasional breaking of a durable item threatens value because it proves that treasures are not so hardy as they appear. If artworks can be broken, the concept of the durable artwork is bogus. An iconoclast cuts a painting into strips; a pasha orders an attack on an archeological dig that irreparably damages a Hellenic statue. No artwork qualifies as priceless because no artwork survives forever.

As Thomson explains, there is a way out of this conundrum of pricelessness based on durability: 'Objects in the durable category do not have to last for ever, just long enough. As long as the majority of the items in the durable category survive the lifetime of the individual culture-bearers, and, more important, as long as during this time people act towards those objects *as if* they were going to last for ever, then the category boundary is unthreatened' (104). Rarity, especially rarity based on survival through time, establishes a different order of value. The value of an artwork can be ensured by destroying all similar artworks and, through such perversity, proving that the artwork that survives is unique. Only a unique object, the one that has no duplicate, is truly irreplaceable. To destroy an object draws attention to the fiction of its durability and the unique work is no less resistant to damage or destruction than any other.

Material culture cannot outlive materiality. The possibility of obliteration haunts artefacts, whether archeologically recuperated or housed in museums. To perceive an artefact as inferior is to consign it to the possibility of its immediate obliteration. Should a broken bit of pottery not be understood as a unique Etruscan relic, it can end up in the garbage as easily as any other shard. Rubbish is the alter ego of art, in the sense that any artwork can be destroyed and discarded. Figured as archeological rescue, aesthetics happen at the moment of damage or disintegration, when the object breaks out of the realm of independent, underground existence into the narrative realm of possession and value.

Theories of Ugliness

In the past ten years, beauty, long a term of disparagement among literary critics, has staged a comeback. Numerous books have been devoted to beauty: Eddy Zemach's *Real Beauty*; James Kirwan's *Beauty*; Elaine Scarry's *On Beauty and Being Just*; Wendy Steiner's *Venus in Exile: The Rejection of Beauty in Twentieth-Century Art*; Denis Donoghue's *Speaking*

of Beauty; Alan Hollinghurst's *The Line of Beauty* and Zadie Smith's *On Beauty*, both novels; Alexander Nehamas's *Only a Promise of Happiness: The Place of Beauty in a World of Art*; and others. Those who write about beauty marry it with diverse topics, ranging from cosmetic surgery and theology to race, futurity, history, crafts, fashion, and architecture. In a review of several books about beauty, Nehamas wonders whether the return to beauty should be resisted on the grounds that beauty has no exact value: 'If beauty is not a determinate feature of things (as the dismal failure of all attempts to define it implies), it turns out to be important – I would even say, valuable – precisely because its value is always in question' (402). Were the word 'beauty' replaced by 'ugliness,' the sentence would still make sense. Ugliness is not a determinate feature of things; it lacks a foolproof definition; its value remains undecided.

Yet ugliness has few champions. Convincing theories of the ugly are few and far between. Edmund Burke, Karl Rosenkranz, Vernon Lee, Theodor Adorno, Lydie Krestovsky, Murielle Gagnebin, Mark Cousins, Umberto Eco, and Slavoj Žižek have pondered ugliness, but almost always they subordinate ugliness to beauty. Burke does not hesitate to claim that ugliness is 'in all respects the opposite to those qualities which we have laid down for the constituents of beauty' (119). Burke's authority notwithstanding, ugliness may not be the diametric opposite of beauty; their relations are at best asymmetrical. Whereas theories of beauty dwell on form, goodness, distance, Eros, and the abstract, ugliness deals with form, fear, evil, proximity, and the physical. The lopsidedness between beauty and ugliness derives from the non-aesthetic properties of the ugly. Aesthetics, being principally concerned with beauty, cannot conceive an adequate definition of the ugly. The philosophical alignment of beauty with truth excludes ugliness from any purchase on the truth. Keats's axioms that sum up the beautiful – 'Beauty is truth, truth beauty' or 'A thing of beauty is a joy forever' (210, 55) – forbid the ugly from any definite association with truth and permanence.

Those critics who address ugliness often turn to painting, which casts the ugly primarily as a visual problem rather than a widespread phenomenon. Others treat ugliness under the rubric of aesthetics. Karl Rosenkranz, whose *Aesthetik des Häßlichen* places the ugly in relation to deformation, illness, caricature, and similar categories, argues, 'Das Häßliche ist keine bloße Unwesenheit des Schönen, sondern eine positive Negation desselben. Was seinem Begriff nach nicht unter die Kategorie des Schönen fällt, das kann auch nicht unter die des Häßliche

subsumirt werden. Ein Rechenexempel ist nicht schön, aber auch nicht häßlich' (164).[6] As a Hegelian, Rosenkranz disqualifies anything that is ugly if it cannot also be beautiful. He views the ugly as a formal and philosophical concept detached from human perception. An empiricist rather than a Hegelian, Vernon Lee describes various reactions to the agreeable and disagreeable in terms of 'elementary impressions furnished by the senses of sight and hearing' (161). Lee concentrates on elements of the beautiful, such as pattern, movement of lines, and colour, sensitively appreciated; by implication, the ugly evokes no appreciative response. If one has no appreciative response, the fault may lie with the spectator rather than with the ugly object.

Murielle Gagnebin's magisterial *Fascination de la laideur* advances the paradox that beauty eludes human grasp, but ugliness strikes too close to the human subject: 'la laideur s'offre à l'homme dans une proximité aussi angoissante qu'irréductible' (13).[7] Ugliness offends the senses yet cannot be conjured away. Whereas the beautiful is evanescent and remote, the ugly, never far from fleshliness, is irreducible in its closeness, as close as our own bodies. Because the ugly is so familiar, we fail to recognize it. Tracing the relation of modern art to primitive religion, Lydie Krestovsky provides an exacting definition of ugliness: 'La Laideur – c'est la vie cachée de l'homme avec ses passions, ses instincts et ses vices pris à l'état latent, dépourvue de masque et de tout travestissement, dégagée par l'artiste dans sa vérité hideuse, sans souci aucun de sublimation' (35).[8] This definition equates ugliness with hiddenness. Passions and vices, which disguise ugliness, issue from a common source. Like Gagnebin, Krestovsky understands that the stripping bare of affect reveals ugliness; what is hidden by and within human beings comes to light through representation, for the artist detaches ugliness from its disguises through artworks. Krestovsky's definition contains a paradox: either ugliness exists prior to its representation or the laying bare of hideousness in representation is the form that ugliness takes. Although both Gagnebin and Krestovsky relate ugliness to artistic production, Krestovsky imagines an end to representation in ugliness, a terminus where no masks or sublimation remain.

The ugly has a precarious lineage in aesthetics because of its hiddenness: the ugly designates 'something we can't even imagine' (Gigante 578). The ugly, ulterior and perhaps anterior to beauty, does not enter representation except fugitively; when present, it skittishly escapes detection. Too often and too readily, the ugly masquerades as the obscene, the diabolical, the grotesque, the curious, or the kitschy. Umberto Eco's

On Ugliness scrambles these categories to demonstrate the persistence of the ugly in art history. Yet the ugly operates according to categorical imperatives of the occulted, the unfunny, and the inexpressive. It is not the same as the grotesque or the obscene. The grotesque is sometimes comical, but in general 'the ugly lacks comic effect' (Gigante 565). The obscene has erotic content, whereas the ugly need not have it. The ugly has unsuspected complexity. E.F. Carritt, in *The Theory of Beauty*, asserts, 'there must be degrees of expression, that is, of beauty, or at least, what is the same for our present purposes, there must be degrees of that inexpressiveness which is ugliness' (217). Ugly, uglier, ugliest: loathsomeness can be quantified in its comparative and superlative degrees, but it rarely is. In *Atonement*, Ian McEwan echoes this sentiment about the multiplicity of ugliness: 'beauty […] occupied a narrow band. Ugliness, on the other hand, had infinite variation' (7). McEwan intimates that ugliness varies itself in a sequence of actions that produce consequences. Rather than being an essence or an absolute, ugliness is detailed and unwhole.

Ugliness eludes recognition because representation is premised on the pursuit of beauty. According to received wisdom, all artworks aim to express the beautiful. Plato claims in *Republic* that the soul is naturally drawn to grace and beauty. In Book X of *Republic*, Socrates, discussing music and style in his usual provocative fashion, declares that youth inevitably make 'graces and harmonies' their goal (30). From this assertion, Socrates extrapolates that painters and other artists invariably strive for grace and harmony. In all arts, he concludes, 'there is grace or the absence of grace. And ugliness and discord and inharmonious motion are nearly allied to ill words and ill nature, as grace and harmony are the twin sisters of goodness and self-restraint and bear their likeness' (30). Plato implies that ugliness and discord spring from ugly and discordant temperaments; art, seeking the good and harmonious, avoids 'ill words and ill nature.' Thus, the impetus for creating art precedes conscious intention. A yearning toward beauty and goodness motivates artworks to the exclusion of the ugly.

Yet the pursuit of beauty, manifest as an intention to create something graceful, coherent, or harmonious, does not prohibit artists from setting out to create something ugly. As Céline notices in *Voyage au bout de la nuit*, ugliness offers as many opportunities for the artist as does beauty. Recognizing the limitations of grace and harmony, the artist can aspire to deform or break the restrictions of a given medium. Charles Lalo claims that ugliness is not simply art without harmony, but a negative

attitude toward the idea of harmony; he cites as examples 'un mobilier de bon goût mais pauvre en valeur marchande et un riche bric-à-brac pauvre de goût, entre un vêtement sans mode qui date de deux siècles et un vêtement démodé qui date de deux ans' (69).[9] Instead of flattening all ugliness to one uniform category, Lalo, to his credit, perceives degrees of ugliness, rather like the infinite variations of ugliness that McEwan mentions. A 200-year-old piece of clothing that never had style is less ugly than a piece of clothing that becomes outmoded after two years because of the original intention, such as it can be discerned, to make something fashionable rather than something wearable. Trying to have style and missing the mark offends more than not trying at all. Ugliness therefore arises as an effect of intention, if a negative one. A formalist and idealist, Lalo concludes, 'La laideur est le refus de poser les problèmes insolubles de l'harmonie, ou de résoudre des autres, ou de vivre en elle, tout conflit résolu' (69).[10] A refusal to address harmony, by which Lalo means proportion and reconciliation of opposition, is tantamount to submitting to ugliness. Even living in a perpetual state of harmony without striving to create something perfect can be called ugly, according to Lalo.

Modern art is often characterized by the intentional incorporation of ugliness into expressive content and form. Henry James, always 'alert to the little dramas of beauty' (Donoghue 89), condones the intentional intermingling of the beautiful and ugly. In *Roderick Hudson*, the sculptor Gloriani, a character who returns in *The Ambassadors*, does not extol the beautiful above the ugly: 'It was the artist's opinion that there is no essential difference between beauty and ugliness; that they overlap and intermingle in a quite inextricable manner; that there is no saying where one begins and the other ends; that hideousness grimaces at you suddenly from out of the very bosom of loveliness, and beauty blooms before your eyes in the lap of vileness' (James 107). The artist cultivates ugliness as assiduously as he cultivates beauty. Varying from medium to medium, modern ugliness manifests itself in dissonance, jaggedness, gashes, death, rottenness, and similar effects. As in Unsworth's *The Hide*, when the newly moulded pixies are covered with bumps and goitres that have to be filed away, modernism instantiates itself in broken surfaces and the intrusion of extraneous fragments as a disruption of harmony. James Applewhite goes so far as to suggest that ugliness, as a displacement of the pursuit of beauty, is an 'aesthetic cliché' (418) in twentieth-century art and literature. In Dada and Futurism, artists snub audience expectations with noise and aggression. Beauty, having

lost its validity, cedes its place to a deliberate quest to create ugliness. According to Applewhite, ugliness lurks in 'chaos' (427, 430) or 'chaotic material' (423) that only a determined enforcement of technique, something like Eliot's mythic method, keeps in check. In a similar vein, Lucius Garvin grumbles that 'formlessness, failure to achieve expression,' or the failure of elements to combine in a 'unified, expressive whole' amounts to ugliness (405).

The ugly defies boundaries. As frames establish the perimeters of the beautiful, the lack of frames heralds the ugly. Frames, which include laws of perspective and mimesis, contain representation and therefore alert spectators to aesthetic qualities within representation. Boundarylessness or the failure to provide a frame leaves the significance of an object in doubt. Without the conventions imposed by a frame, the artwork remains susceptible to the charge of ugliness. The interminable has an ugliness of its own. Unendingness itself can convert a bounded and finite artwork into something nerve-wracking and dreadful. *Eine kleine Nachtmusik* repeated endlessly and loudly for twenty-four hours loses its charm. What might be pleasurable becomes intolerable because it does not end and because it ceases to please. Representation neutralizes the effect of ugliness by imposing form and finitude and keeping chaotic material in check.

Misapprehended, the ugly disappears within representation: 'in almost all aesthetic theories, at least from ancient Greece to modern times, it has been recognized that any form of ugliness can be redeemed by a faithful and efficacious artistic portrayal' (Eco 19). Fineness of representation effaces ugly details. A piece of rotting fruit or a human face covered with sores is acquitted of ugliness when represented expertly. One ceases to feel disturbed by pus suppurating from a sore when that sore appears in a composition that beatifies suffering. Containment can also be thought of as a relation between dimensions. Mark Cousins, in a two-part article that sets a standard for discussion of ugliness, argues that the ugly defies distinctions between interior and exterior spaces. When the inside of an object breaks through the exterior, the ugly can be said to occur. A face gashed open or a fracture so severe that bone pierces through the skin – 'the sight of subcutaneous reality' (2:4) – recalls that surfaces mask invisible depths. An object is integral insofar as it has a distinct edge that separates it from the world. When concealed depths exceed the surface of the object and disturb its formal boundaries, the illusion of containment shatters. Viscera or bones breaking out of skin violate containment: 'The moment of ugliness, then, is the shat-

tering of the subject's *phantasy* for what makes up the object, in which the object is permeated by its surface just as a face is, and not that there is a non-signifying interior whose pressure to appear is concealed only by the temporary and mendacious skin of a mask' (2:4). Eruption or breakage characterizes the ugly because the unimagined depthlessness of the object forces itself into visibility and contradicts cherished illusions of integrity and unity.

In the case of *Pascali's Island*, the damage inflicted on the statue provides a moral about the nature of representation. Deformity and breakage attest to ugliness – the ugliness of human intervention rather than a defect in the object itself – that otherwise has no expressive power within representational structures. To deform an object is to break its form. Deformity presupposes some kind of correct form. As a discourse about physicality, deformity is said to deviate from correct proportion or harmony. Yet deformity may exist principally in the minds of beholders of objects or other representations. In 'Of the Standard of Taste,' David Hume argues: 'A great inferiority of beauty gives pain to a person conversant in the highest excellence of the kind, and is for that reason pronounced a deformity' (312). While trying to establish a universal standard of taste, Hume upholds an undefined opposition between 'beauty and deformity' (314). Defective taste may arise, as Hume claims, 'from prejudice, from want of practice, or want of delicacy' (314). Hume's appeal to 'delicacy' recalls Alexander Gottlieb Baumgarten's definition of aesthetics as 'the science of sensitive cognition' or 'the science of sensory knowledge or appreciation,' depending on how the Latin phrase is translated: 'Aesthetica [...] est scientia cognitionis sensitivae' (1).[11] As Hume recognizes, a group of people who possess delicacy, have familiarized themselves with diverse examples, and have not allowed their prejudices to intrude on their judgment of the beauty of a work of art will still not hold identical opinions about beauty. Taste, in the end, has no universal standard. If several connoisseurs are asked to evaluate the same object, nothing guarantees that all of them will perceive the object as beautiful. For this reason, Hume allows latitude in the appreciation of beauty. Despite his disclaimer that beauty exists not in material objects but only in the mind of the person who apprehends them, Hume ascribes moral 'deformity' (315) to some artworks. Indecency and immorality, unless censured, mar the work of art. Throughout 'Of the Standard of Taste,' Hume resists the term *ugliness* in favour of deformity, with its intimations of formal qualities.

Aesthetics, as defined by Baumgarten and elaborated by Hume,

leaves certain questions unanswered. If aesthetics exclusively concerns the science of sensitive cognition or appreciation, is it possible to apprehend beauty if one lacks sensitivity? Sensitivity should be understood, in part, to refer to sensory stimulation. Nevertheless, an insensitive brute may be unable to judge an artwork because he remains unmoved by its qualities, or because he lacks expertise in assessing its fineness, craftsmanship, finish, or scarcity. Does sensitive appreciation always require schooling, or can it spontaneously occur without training? Is there an interplay between beauty and ugliness, in which ugliness throws certain characteristics of an artwork into relief? In *Utz*, a warty art dealer sells flawless pieces of porcelain. 'The ugliest men loved the most beautiful things,' the narrator remarks (91). It is possible that ugly men are disqualified from adjudicating the beautiful on the grounds that they have no personal knowledge of the criteria of the beautiful. On the other hand, fineness and flawlessness, as two aspects of the beautiful, compensate for the ugliness of porcelain collectors. The beauty of objects obviates the deficiencies of the 'the ugliest men,' or so it would seem. Collectors' love of porcelain, if love it be, arises from the discrepancy between ugliness and beauty. The art object, revered for its smoothness, freedom from blemish, perfection of glaze, and delicacy, corrects the physical imperfections – the 'warted epidermis' (91) and 'sweaty hands' (93) of the porcelain dealer – that bedevil the human world.

The object world exceeds the human world as the beautiful exceeds the ugly. In other words, the human world is a realm of deformity and defects, a zone of ugliness redeemed by the invented perfections of art. To make such a claim is to associate physical reality with the ugly. Ugliness has a close acquaintance with reality, at least according to Oscar Wilde: 'Ugliness that had once been hateful to him because it made things real, became dear to him now for that very reason. Ugliness was the one reality' (135). In *The Picture of Dorian Gray*, a modernist parable about a hidden painting, art inhabits a zone of possibility rather than reality, a representational perfection at odds with human imperfection. In their considerations of aesthetics, neither Baumgarten nor Hume raises the possibility that one can sensitively appreciate the finer points of ugliness. By comparison, Dorian Gray finds that a nuanced appreciation of vice ushers him into a reality that manifold representations of beauty conceal.

In effect, the ugly is unappreciated because it defies the very idea of representation. By whatever degradations or distortions, the ugly

refutes the hypothetical and longed-for perfections of art. The ugly is interpretable through instances of iconoclasm, as a breaking free from representation and its constraints. The conundrum of ugliness hinges on its materialization and the will not to see it as ugly as soon as it enters representation: 'The most squalid slum scene, the most nauseous affront or revolting act may be subjects for art, but they are represented, not merely exhibited. In a representation, they are relieved by artistry, if only in the composition' (Carmichael 496–7). Composition mediates instances of ugliness, yet ugliness seeks the non-mediation that lies outside representation. One temporary means of access to the realm outside representation is breakage. Almost any object, whether it is made of porcelain or steel, can be broken by human agents. Representation ends when the object is broken and the illusion of wholeness breaks along with it.

On the other hand, aesthetics posits no end to representation. Confined within representation, the ugly manifests itself in roughened surfaces or defacement. Edmund Burke claims that smoothness in an object is an effect of beauty: 'take any beautiful object, and give it a broken and rugged surface [...] however well formed it may be in other respects, it pleases no longer' (114). A painter can smear blobs of paint onto the surface of a finished canvas to prove non-compliance with beauty, as when Noémie Nioche in Henry James's *The American* cancels a painting with a pair of crossed, red lines. A manufacturer of pixies can leave the ridges and deformities on his pixies instead of filing them off. In the same vein, breakage compromises the value of an object or reduces value to nil. Breakage proves that representation is not durable. If art hypothesizes an alternative to human transience by staking claims on immutability, universality, and permanence, ugliness reclaims opportunities for transience, ordinariness, and the *sui generis*. To break or roughen the surface of an object reveals its illusoriness: 'The shock of ugliness occurs when the surface is actually cut, opened up, so that the direct insight into the actual depth of the skinless flesh dispels the spiritual, immaterial pseudodepth' (Žižek 22). As Wilde points out in *The Picture of Dorian Gray*, representation has no depth; to cut, roughen, or break the surface of the representational object scatters the illusion of unity. During the Renaissance, several artists received commissions to restore the Laocoön by fitting it with a prosthetic limb to replace its missing right arm. Michelangelo refused a commission to sculpt such a replacement. Other sculptors were less timid. Around 1540 'the statue's original shoulder was severely sliced back' to accommodate an arm

(Barkan 11). Mutilation of the original sculpture, intended to complete the fragmentary form of the sculpture and enhance its value, conflicts with reverence for antique fragments. Slicing back the shoulder proves that the sculpture is, after all, just a piece of stone.

The will to conserve objects, like the will to smash idols, derives from the perception of some excess in the object. Because the object appears to exceed its physical dimensions in order to express some metaphysical property, whether the sublime or the beautiful, it is said to be aesthetically satisfying. On the other hand, because an object appears to concentrate on physicality – the human image, the body – it is deemed ugly and falls outside the aesthetic. The statue in *Pascali's Island*, excessively beautiful in Pascali's mind and excessively desirable as an archeological treasure in Bowles's mind, is thought to be an object of beauty. Pascali's eroticized description of the statue concentrates on its physical attributes: maleness, youth, squareness of the shoulders, flawlessness of surface. Breaking the statue, which creates a whiff of iconoclasm, disrupts the spell cast by the idol. No longer unique or intact, the broken statue confounds attempts to own it. The loss of the arm literalizes the loss of other qualities, such as integrity and perfection. The aura of the unbroken object falls away in the act of vandalism. Breakage renders the statue imperfect, and therefore, in some degree, ugly.

In his unfinished statements about ugliness in *Aesthetic Theory*, Theodor Adorno claims, 'In art there is nothing ugly *per se*. All that is ugly has its function in some specific work of art' (70). Adorno means that beauty relies on an unspecified cluster of prohibitions that, in a formal consideration of a work of art, is prophylactically labelled ugly. In Adorno's view, the artwork is not functional, but critical. It opposes prevailing ideology; its value resides in its freedom from the commonplace or conventional. Consequently, modern art should ally itself with ugliness in order to protest against orthodoxy and oppression. Commitment to ugliness redeems modern art. Autonomous, the artwork resists the culture industry: 'The subversive force of the advanced work of art violates conventional aesthetic norms by foregrounding the ugly and rejects the false reconciliation of the beautiful' (Hohendahl 186). In Adorno's view, ugliness opposes the ideology of beauty.

More specifically, Adorno argues that beauty ignores suffering: 'The condemnation of ugliness in conservative aesthetics finds support in a subjective inclination that has been verified by social psychology, namely the inclination to equate – justly – ugliness with the expression of suffering in order then to berate it projectively' (73). Adorno means

that aesthetic theory has dismissed ugliness because it traditionally has associations with disease, death, torture, and other kinds of pain. At the same time, an adherence to beauty pardons crimes of monumental vileness. Adorno offers the example of Nazi henchmen who tortured people in basements while 'the roof above rested on neoclassical columns' (73). The Nazis denigrated some kinds of art as degenerate, whether immoral or ugly, as an alibi for criminalizing artists and their works. The nefarious Nazi belief in neoclassical proportion and beauty did not prevent officials from ransacking art collections in a quest for statues and paintings that would glorify the Reich or adorn the walls of private apartments. Art, however degenerate, remains a commodity. If ugliness cannot escape its association with beauty, it should not invariably be the scapegoat for offences committed in the name of beauty. The pursuit of beauty is not an excuse, although it has often legitimated acts of murder, plunder, war, and degradation.

According to Adorno, the ugly revitalizes art. In the hopes of delivering aesthetics from its narrow preoccupation with the beautiful, a preoccupation that prohibits aesthetic theorists from investigating the 'bountiful content of the aesthetical' (75), he constructs a historical account of the ugly. This historical story dwells on the primitive and magical aspects of artworks. Over time, the cult of the beautiful subdues the primitive and magical aspects of objects. The triumph – or tyranny – of the beautiful dates from the eighteenth-century articulation of aesthetics as the sensitive appreciation of objects or the universal standard of taste. This historical narrative allows Adorno to claim that the ugly, associated with the primitive and magical, precedes the beautiful: 'If one originated in the other, it is beauty that originated in the ugly, and not the reverse' (50). The modernist revitalization of the primitive, as demonstrated by modernists' fondness for totems and masks, re-enacts the historical opposition between ugliness and beauty while loosening the grasp that beauty has on culture and the imagination.

Beauty is not so easy to defeat as Adorno reckons. 'Perhaps accepting ugliness is the beginning of beauty,' Jane Rule writes in *This is Not for You* (20). Although Rule is not citing Adorno or even thinking about his aesthetic principles of ugliness, the sentiment creates a historical narrative for the ugly and the beautiful rehearsed at the level of individual apprehension. Having accepted ugliness, one allows beauty to expand incrementally. On the other hand, ugliness may constantly hold a full endorsement of beauty in check: accepting ugliness keeps an appreciation of beauty at a perpetual beginning. While this formulation braves

ugliness as an imprecise encounter and acceptance – ugliness must be faced in all of its hideousness before beauty emerges – that ugliness, in the moment of being accepted as ugliness, yields to beauty. In this formulation, ugliness exists apart from beauty, but only as a step that evolves toward beauty through the apprehension of a perceiver. Nevertheless, Jane Rule, like Adorno, does not admit that beauty is superior in degree or accomplishment to ugliness.

No matter how committed anyone is to the vitality of ugliness, the ugly causes those who perceive it to turn away. We are in the vicinity of the ugly when we shut our eyes to its hideousness or close our ears to its raucousness or pull our fingers back from its gelatinous, oozy surface. In Adorno's view, the rejection of the ugly signifies its critical force. When Ruskin in *The Stones of Venice* categorizes the mascaron on the bell tower of Santa Maria Formosa as ugly – 'inhuman,' 'monstrous,' 'bestial,' 'evil' (3:120) – he also enjoins the viewer to tarry and take in the supreme ugliness of the head. Ruskin commands, 'let it be endured for that instant' (3:120) that the spectator can allot to the ugly. He implies that ugliness cannot be endured for long; downcast eyes scarcely peek at the misshapen head on the wall. Disgust or revulsion drives the spectator away. While decrying the repulsiveness of the head, Ruskin ignores the fact that the head admonishes sinners and evil spirits to be gone. Its ugliness is intentional and therefore, in Adorno's formula for such properties, magical.

Ugly by design, the mascaron on Santa Maria Formosa has monitory powers. It inspires dread or fear, or at least it is meant to. The English 'ugly' descends from the Old Norse 'ugglig,' to be feared or dreaded. Ugliness inoculates one against dread. It fortifies. Ruskin's imperative to endure the lumpy visage on Santa Maria Formosa for a moment and study its features derives from an ideology that dictates all objects to be of aesthetic interest. Not to possess a sense of the ugly means that we are morally lost. Signalled by a turning away, the ugly defies the Kantian category of disinterested contemplation of an object that yields pleasure for the perceiver. If the act of looking or perceiving does not take place, no pleasure can ensue. The ugly pre-empts pleasure even before it begins. Ugliness thus challenges aesthetics as a discipline and field of inquiry, which is what Adorno means by pointing out that the narrow focus on beauty within aesthetics pre-empts 'the bountiful content of the aesthetical.' Ruskin doubts that the beautiful, which, in his opinion, conduces to civic virtue and morality, can accommodate countervailing forces, such as the grotesque, the sublime, and the ugly: 'What happens

to the sense that endorses these [effects]? Is it, like the sense of beauty, a principle of human nature? Or an aberration?' (Donoghue 158). If humankind is born with a sense of ugliness that leads away from virtue or morality, beauty has no convincing monopoly over aesthetics. The problem does not lie with beauty per se; the problem lies with the narrowness of aesthetics as a discipline obsessed with beauty.

Without apprehension or contemplation, the ugly prevails. Alexander Nehamas implies that the ugly remains outside the scope of the visible: 'Perhaps the dogged insistence that something was ugly, the insistent refusal to examine it carefully, once I come to see it as beautiful, can seem in retrospect a mistake' (395). Having determined that an object is ugly, one refuses to look at it further. Nehamas does not specify by what alchemy the ugly converts to the beautiful. Nor does he account for the retrospective disqualification of the ugly 'once' the beauty of the object can be seen. Nonetheless, he repeats this formula of conversion: 'works that do not *look* beautiful may turn out to be beautiful once we pay closer attention to them' (400). If ugliness makes us avert our eyes, a minute inspection of the ugly object, which is to say a prolonged and attentive scrutiny, reveals its beauty. Overmastered by such careful regard, the ugly retreats once again into invisibility.

As a visual sign, ugliness survives in details and ornaments. Indeed, superfluous ornament or abundance of detail, anathema to modernist artists and architects who prefer unadorned lines and severe geometry, brings ugliness back into visibility. Mark Cousins argues, 'An ugly attribute of an object is one that is excessively individual' (1:61). Robert Martin Adams similarly links the ugly to 'the particular, the expressive, and the material' (59). The unique, overworked, individual object acquires ugliness when it refuses norms and forms. The 'excessively individual' could include excess detail or ornament. Aesthetics relies on details insofar as they provide justification for the cognition of beauty or ugliness. As details coalesce, they ornament the object. Ornamentation, as superfluity and excess, can crowd the visual field and thus induct ugliness into apprehension of the object. It is equally true that an absence of detail and ornamentation can be perceived as ugly. While ornamentation has spiritual meaning and calls attention to the complexity of materiality, multiple details that comprise ornamentation can baffle the perceiving mind and provoke a verdict of ugliness. Such a verdict might liberate an altered understanding of the object. Indeed, through the imposed obstacles of detail and ornament, ugliness challenges settled convictions about the nature of materiality itself, specifically how objects are apprehended and evaluated.

Ugliness is everywhere. It lurks amid commonplace events. It stares forth from ordinary objects. Georges Perec, one of the great connoisseurs of the object world in the twentieth century – he returns again and again in his novels to the nature of objects as if they could fix him permanently to the world – kept a box of fetishistic objects with him in the hospital when he was dying (Bellos 714). In *Species of Space*, Perec ranges ugly objects alongside commonplace and improbable objects:

> Ou bien, plutôt, voir, très loin de son lieu supposé d'origine, un objet parfaitement laid, par exemple une boîte en coquillages portant 'Souvenir de Dinard' dans un chalet de la Forêt-Noire, ou parfaitement commun, tel un cintre marqué 'Hôtel Saint-Vincent, Commercy' dans un bed and breakfast d'Inverness, ou parfaitement improbable, comme le *Répertoire archéologique de Département du Tarn*, rédigé par Mr. H. Crozes, Paris, 1865, in-4, 123 p., dans le salon d'une pension de famille à Regensburg (plus connue en France sous le nom de Rattisbone).[12]

The sentence could continue indefinitely as objects fall within the narrator's line of vision. Selected at random, the objects resolutely do not group into a collection; they remain a mishmash. In this collocation of ugly, commonplace, and improbable objects, each is out of place. A box made of seashells has no business migrating from the seashore to the Black Forest, just as a coat hanger has no business migrating from France to Scotland. The whole passage meditates on the aleatory relation of objects to places. Objects, concatenated by the coordinate conjunction *or* have no end; they could pile up interminably. Inside each clause, the narrative provides an encyclopaedia of useless and forgettable information. These details lend an aura of authenticity and uniqueness to the objects. The box made of seashells, perfect in its ugliness, has details that have to be construed as ugly because of their incongruity. The details emit conflicting information or incompatibilities: seashells have no natural link to the Black Forest. Perec's narrative presentation of the object intimates that ugliness emerges from just such a welter of details.

While tracking the provenance of each object, Perec's narrator is disgusted by the accumulation of detail that renders the dislocated objects unacceptable. The ugliness of the seashell box depends on its display. As a souvenir, it harks back to its origins at Dinar. The sentimentality of the souvenir, as a reification of time spent on vacation by the seaside, is visibly displayed. The object might be less ugly were it hidden, or not stamped with 'Souvenir of Dinar,' or not decked out with seashells,

or not dislocated to the Black Forest. Ugliness, in this account, inheres in the features that detract from the object as an object. The lexical feature, 'Souvenir of Dinar,' limits the meaning of the object. The slogan diminishes the mystery of the objects, makes it commonplace rather than artistic. In this brief catalogue of three kinds of objects, all housed inside a single sentence as if in a display case, the commonplace and improbable objects contribute a measure of meaning to the ugly object. The object qualifies as ugly because it has similarities to the commonplace and the improbable, including but not limited to the banality of its details. By contrast, the beautiful object possesses unusual qualities displayed in a probable way.

A certain danger underlies the claim that ugliness could be alleviated if only the conditions of display, manufacture, or intention were corrected. Ugliness lies not only in the perception of difference, but in the display of that difference. In its material forms, ugliness has display value that validates narratives of ownership and cultural heritage. Even though museums neutralize the ugliness of some art objects by putting them on display, ugliness as a physical property manifests itself in too much or too little detail, too much or too little ornament. Ugliness might improve with relocation, but that means that the museums change the meaning of ugliness by displaying ugly objects.

Conservation

Many scenes in Barry Unsworth's novels are staged inside museums. In *After Hannibal*, Monti, an Italian historian living in Umbria, imagines various military campaigns conducted by Hannibal, Gaius Flamminius, and sixteenth-century factions. Monti, trying to access history in its immediacy, visits the Rocca Paolina in Perugia, where he can breathe the atmosphere of the past. Once a papal fortress and prison, the Rocca Paolina has been transformed into a tourist site. Monti deliberately turns into 'the twisting, high-vaulted passages, where the poor remains of the Baglioni houses had lain buried since Paul's conquest of the city in 1540. There were not many people down here; some few occasional wanderers like himself had passed in the gloom of the place. From somewhere not far he could hear the droning voice of a tourist guide' (*After* 197). Tourism mitigates the historical significance of the fortress as 'one of the greatest monuments to tyranny and terror' (197). Visitors wander in the gloom like souls in the underworld. The museum may not be an ideal place to encounter the past in all its complexity, but sometimes it is the only place.

The museum is a temple devoted to representations. More exactly, the museum is a temple devoted to the material remains deposited by history, which are converted into representations through display. In this regard, the museum valorizes representations that speak for historical epochs and cultures. Within the museological view of history, material objects, as traces of past cultures, communicate with the present, albeit in coded and not fully intelligible languages. In their insistent museum scenes, Unsworth's narratives meditate on the ambiguities of history and its representations. In *Crete*, Unsworth inspects frescoes and statues with professional intensity. In *The Greeks Have a Word for It*, Stavros Mitsos takes a guided tour of the Acropolis. In Unsworth's museums, past and present fuse. A place of learning and edification, the museum confronts the visitor with a curated jumble of artefacts and text and stories. Docents, who figure in *After Hannibal*, *Losing Nelson*, and *The Greeks Have a Word for It*, recite dates and names. Instead of seriously questioning the meaning of objects as historical, the museum severs them from their original contexts. While such decontextualization restitutes the past, it also deprives the object of its connection to other kinds of significance than the aesthetic. The Rocca Paolina is not just a place of history but a place of suffering. The Acropolis is not just a tourist destination but a place of debate, lawgiving, and action.

In *Stone Virgin*, all the world is a museum, and most of the people within that museum world navigate between subject and object status. '"We are only interested in *things*"' (*Stone* 48), Simon Raikes complains to his colleagues, a group of British conservators who have descended on Venice to repair damaged Tintoretto paintings. By 'things,' he means material objects or, more precisely, art objects. The art dealer and collector Richard Lattimer, 'supposed to have a fantastic eye' (82), reinforces Simon's insight into the fascination that material things exercise over people: 'It is objects that we really care about' (151). *Stone Virgin* speculates on the meanings attached to art, with particular emphasis on the twists and turns that befall the Madonna Annunciata that Raikes, an employee of the Victoria and Albert Museum in London, painstakingly restores by blasting it with water, before polishing the whole surface with a quartz-cutter. Venice, 'the greatest storehouse of artefacts in the world' (151), is a museum without walls. Its cultural patrimony belongs to the world, as Sir Hugo Templar, head of the mission to rescue Venice from itself, reminds the conservators.

The narrative of *Stone Virgin* unfolds in three historical moments. In the fall of 1432 the sculptor Girolamo Stetto, falsely accused of killing the prostitute Bianca Pellegrino, who served as his model for the statue

of the Madonna Annunciata, writes impassioned letters to his protector Matteo di Rovereto. Girolamo's gaoler never delivers the letters. In the spring of 1793 the libertine Sigismondo Ziani, writing his memoirs, recounts an amorous adventure that occurred in the summer of 1743. A rich Venetian merchant named Boccadoro hires Ziani, still a young man in the mid-eighteenth century, to tidy up the books in his house. At the end of his life, Ziani lives among furniture already owned by creditors; the room in which he writes his memoirs is a 'museum of sheeted exhibits' (213). Ziani's servant appropriates the pages of his memoirs and sells them to concerned Venetians named in the pages; the memoirs, as a result of this petty theft and dispersal, are never published. In the third panel of the narrative triptych, which unfolds between March and June 1972, Simon Raikes, a failed sculptor, meets and falls in love with Chiara Litsov, married to the successful sculptor Paul Litsov. Raikes likes the 'safe hierarchy of the museum' where he works (188). Having failed to become a sculptor in his own right, he takes refuge among the masterworks by other hands from other eras. In a journal, he records his progress on polishing the Madonna statue and his archival research to find out information about the sculpture.

If any single geometry dominates *Stone Virgin*, it is the triangle. Raikes's passion for Chiara, with Lattimer lurking in the background, duplicates, with variations, Girolamo's passion for Bianca, with the wicked Federico Fornarini lurking in the background. Passionate Francesca and deceitful Ziani fornicate within earshot of the cuckold Boccadoro, who subsequently catches the pair *in flagrante delicto*. In each of these situations, the male character feels himself in some measure duped, while the female character is accused, either justly or unjustly, of deceiving her lover. The triangle governs the larger structure of the book as well. Three men write down their troubles in letters, memoirs, and journals that are destined never to see the light of day. Without being conscious that they do so, the three men replicate each others' lives.

Historical repetition prevails in the museum world of Venice. Events in the past worm their way, by fugitive glimpses or re-enactment, into later developments. *Stone Virgin* therefore asks to what degree artworks, as artefacts that survive, retain their imaginative force over time. The Madonna Annunciata is sculpted for display, but display has no limitation, especially when it comes to artworks. Girolamo promises Bianca immortality: '"You will live for ever in the stone"' (18). Although a certain literalness attaches to this prediction – Raikes has visions of Bianca when he crouches next to the statue – Girolamo means that the statue

will be displayed, but not merely as 'a monumental detail for the deco-
ration of a church façade' (20). After cleaning the statue, Raikes vows
that she will have an '"unveiling: she would be restored to the world"'
(268). Diminished because displayed, the statue has a peculiar periplus.
Initially commissioned by the Supplicanti monks in the fifteenth cen-
tury, the statue migrates to the garden of their monastery, then into the
hands of Boccadoro, and from his garden to an 'exposed position' (33)
on the façade of a church. Although many people see the statue, few
understand its meaning as an image of the Virgin Mary. As the statue
moves from site to site, observers interpret it variously as 'a garden de-
ity, a spirit of the seasons' (115), Venus (132), the spirit of Bianca trapped
in stone (293), and an avatar of Chiara Litsov whose 'vivid flesh' resem-
bles the 'immaculate stone' of the fully cleaned statue (302). The statue
moves away from its intended purpose as an object of veneration, a
Madonna Annunciata, into the precincts of the church-as-museum,
where conservation further desacralizes it.

Stone Virgin lingers on the rhetoric of disease and decay to empha-
size that enchantment consists in recovery of the unique object through
conservation. Raikes calls the damaged stone of the Madonna the '"en-
crusted sores of her disease"' (168). The 'infected stone' (68) crumbles in-
stantly under the bit on his quartz-cutter. The stone, however diseased,
has the metaphorical vitality of human flesh. Whereas an Italian official
in charge of monuments calls the sooty effect on the statue a '"patina,"'
Raikes calls it a '"disfigurement,"' the details of which are '"quite hor-
rendous in close-up"' (36). The possibility that dirt and decay create a
patina is dismissed without discussion. The conservators' concept of
art stops at the softening of finish. Raikes smooths out the surface of the
statue by removing its encrustations. Litsov makes bronze sculptures
with highly polished surfaces. Despite their finishes, neither stone nor
bronze is infinitely resilient. As a museum without walls, Venice is full
of art treasures in various states of disrepair. Slingsby, the American
specialist in stone and its decay, seconds Raikes's opinion about the ad-
vanced state of disintegration of statues in Venice: '"The place is stuck
all over with images in the human form, doges and dignitaries, angels,
saints, madonnas – all riddled with bacteria"' (183).

In a word that resonates with *Pascali's Island*, the grime and decay are
described as 'bemonstering' (*Stone* 31) the statue. The Madonna's face
is 'bemonstered' with dirt and discolouration (36), just as the Hellenic
youth was 'bemonstered' with daubs of clay in *Pascali's Island* (144).
Monstrosity approaches ugliness in its potency. But monstrosity and

ugliness are not quite coterminous: the monstrous is ugly, but the ugly need not be monstrous. A neologism, 'bemonstered' appears in several of Unsworth's novels, always in a context of hideous disfigurement. In *The Big Day*, a wounded man is 'bemonstered by bandages' (72). In *The Rage of the Vulture*, a leper 'deliberately bemonster[s]' (193) his face with white makeup to disguise his disfigurement. In *Sugar and Rum*, Benson sees 'bemonstered versions' (55) of novelistic characters in a nightmare. Monsters, seldom beautiful, have an overblown physicality. Unsworth uses the term in *Stone Virgin* and *Pascali's Island* to refer to a perfect statue fouled with earth or grime. In *Stone Virgin*, Raikes's efforts to deliver the object from its layer of encrustation and disease repeats Girolamo's labour 'to release the form contained in the block' (26). Like the excavation of statuary in the Renaissance and Bowles's excavation of the Hellenic bronze in *Pascali's Island*, the restoration of the late Gothic Madonna in *Stone Virgin* is cast as a narrative about the deliverance of beauty out of shapeless ugliness.

Miracles abound in *Stone Virgin*, not least of which is Raikes's reclaiming of pristine whiteness for the dirty Madonna:

> All his doubts, and the discomfort of his crouching position, were forgotten in his delight at seeing the polluted crust thin out and disappear centimetre by centimetre as the microscopic grains of glass with which the cutter was loaded delicately blasted away the efflorescence of disease, leaving the uninfected stone intact. There was something in the nature of a continuous miracle about this transmutation; one moment there was the corroded stain, the next, as by the warm breath of a god, it fanned away, leaving the pale and pristine stone beneath. (69)

Instead of smashing idols as happens in *The Partnership*, the idols in *Stone Virgin* – Tintoretto paintings and Christian statues – recover their 'uninfected' quality through restoration. Not technically a miracle, restoration relies on a language of rescue in *Stone Virgin*; the 'Save Venice Fund' (82), 'Venezia Nostra' (170), 'the American Committee to Rescue Italian Art' (172), and 'Rescue Venice' (43) variously contribute money and expertise to the cause of restoration. If conservation is not a miracle in and of itself, the Annunciation, subject of the statue, forecasts a miracle: Gabriel announces to Mary her role in the virgin birth. For his part, Ziani mockingly calls the statue, which glows in the moonlight with a luminescence that appears to emanate from the stone, '"a miracle"' (224). Not immune to the miraculous effects of the statue, Raikes expe-

riences a swooning sensation, 'a sense of space' (291), as light radiates from the statue. Faced with these inexplicable rays of light, he loses his balance and falls to his knees. He calls this unaccountable event a '"terrible radiance"' (292), but he could just as easily call it a miracle.

Revelation happens through the concealment and disclosure of objects. *Stone Virgin* investigates the power that objects exert over observers. Although that power requires some degree of display, another set of objects in the novel remains hidden. The Madonna Annunciata remains screened off from view as Raikes polishes the stone. Few see her unless they climb the scaffolding for a look. Lattimer, the art-dealer, collects various objects that he displays in recessive spaces, not accessible to all eyes. Visiting Lattimer's house, Raikes appraises individual objects with curatorial finesse while Lattimer narrates tales of their provenance and purchase. In a locked shed in his garden, Lattimer reveals his secret 'museum' (156), filled with souvenirs of his travels, duels, sexual conquests, adventures, and military service. Lattimer allows almost no one to see this collection. Its value depends on its secretness. Knowing that objects fascinate Raikes, Lattimer allows him a brief glimpse of some of his trophies. Lattimer plays on Raikes's expertise of the eye, as well as his curiosity.

Enchantment occurs through careful disclosure. Just as the filthy Madonna is seen afresh once the layer of dirt that cakes her from crown to draperies is removed, other objects come to light and circulate through the novel. When the archives of the church have to be moved, the sacristan heaps them in no particular order on the floor. Raikes roots through 'the litter of objects' (56) to find an eighteenth-century ledger that provides him with a vital clue in tracing the provenance of the Madonna. The disorder of the objects implies their valuelessness. As Raikes's discovery proves, however, objects in disarray have a value magnified by virtue of their being unclassified. Similarly, the merchant Boccadora hires Sigismondo Ziani to 'restore to order' (104) the collection of books that fill nooks and crannies of his house. Among this jumble, Ziani finds a book containing information about the mysterious statue in the garden. By coincidence, Raikes notices a Litsov bronze cast among a group of '*objets trouvés*' in a gallery window; the bronze has no discernible connection to the 'expensive-looking clutter' (237) among which it is displayed.

When Raikes collects Litsov's personal effects from the police station after the inquest into his death has concluded, he initially pays no attention to the various objects in the paper bag: folded clothes, shoes with

white water-lines on them, 'loose change, banknotes, a wallet, a photograph, a little silver pillbox,' and a single cufflink (275). At first, the profusion of clothes and objects obscures the significance of the single cufflink. Cufflinks come in pairs. Knowing that Lattimer collects trophies of his victories and battles, Raikes concludes that Lattimer killed Litsov and removed one cufflink as a souvenir of the murder to add to his secret museum. Far from being innocuous, the object functions as a clue in an unproven homicide. Raikes ultimately hides the second cufflink in the drapery of the Madonna and seals it over with wax. Thus a material clue from 1972 intersects with the haphazard history of the statue. By being attached to the statue, the story of the cufflink becomes integrated into its history as an artwork.

Objects move from valuelessness and neglect to value and exhibition by virtue of the narratives in which they are situated. Lattimer narrates the successful acquisition of objects as a triumph over human ignorance; his stories about outsmarting owners of valuable artefacts add lustre to his trophies. At the same time, Lattimer curbs the value of other objects by restricting their circulation. He makes multiple copies of Litsov's bronzes in order to wring as much money as he can from their sale. As copies proliferate, Lattimer gets rich, but the uniqueness of the artworks is compromised. *Stone Virgin* speculates on uniqueness as a criterion for evaluating artworks. The Madonna attests to uniqueness through narrative meaning: having survived for 540 years, the statue increases in value through its disposition in narrative. By contrast, only the first three to five casts of Litsov's bronze sculptures qualify as original. All the rest are consigned to the limbo of being copies.

The Madonna Annunciata has specific details that differentiate it from other objects. Like the cufflink, the statue provides a clue to two deaths: the drowning of Bianca and the execution of Girolamo. The object contains and releases narrative information. It provokes Raikes to find answers to a historical puzzle. The answers that the statue gives are unique in that they pertain to no other sculpture, no other artwork. Lattimer perversely values the uniqueness of objects above human life. '"For a true concept of uniqueness you have to go to the artefacts of the past,"' he claims (151). He means that certain works escalate in value because no comparable object de-authenticates them or troubles their originality. Raikes endorses this perspective. Having listened to a lecture on the devastation of objects by humidity, he wonders whether conservators should lavish attention on Tintoretto paintings, of which there is no shortage, when, to take a counter-example of scarcity, only

a few '"fourteenth-century decorated saddle cloth[s]"' from Japan remain in existence (162). On one hand, the rarity of a saddlecloth rivals the perceived rarity of Tintoretto's paintings. On the other hand, objects not being comparable in value or scarcity, the rarity of saddlecloths cannot be compared to the rarity of Tintoretto's paintings. The preservation of both saddlecloths and paintings addresses the perception of value in each, as well as the degree to which different cultures make efforts to conserve artefacts based on the perception of relative value.

The museum, as a repository for the broken, the excavated, the plundered, the fragmented, the rescued, the incomplete, the imperfect, and the ugly, assigns new values to objects through display. Humidity unpicks the stitches of a saddlecloth. Sulphuric acid in the atmosphere disintegrates stone. The 1966 floods in Venice damaged churches and paintings. In the long run, time the destroyer pulverizes unique man-made objects. The museum, meanwhile, cannot ward off such depredations, it can only slow them down. Art, as a set of material objects, is implicated in deterioration. Even in cases of intervention to restore a statue, '"something is always lost,"' as Raikes acknowledges (191). He even lectures on the natural, inevitable disintegration of stone through '"a long process of recrystallization, impaired density, increased solution rate"' (169). This process of disintegration contradicts the aesthetic claims of stable, unchanging permanence in artworks.

The parable of disinterred art in *Stone Virgin* counters the parable of destroyed art in *Pascali's Island*. At several junctures, *Stone Virgin* advances an argument for the corruption of all material forms. In neo-Platonic theories of essence and flesh, pure being exists only prior to its incarnation in material form. As Girolamo states, '"The pagans believed that evil comes with the descent of spirit into material bodies but we believe that spirit comes as radiance from the face of God that first enlightens the angels then illumines the human soul and finally the world of corporeal matter"' (318). *Stone Virgin* sides with the pagans. All material manifestation is a form of evil. In other words, all material manifestation is a form of ugliness that can be crafted and perfected and restored and preserved. Yet it will still be a material incarnation subject to the vicissitudes of time and human scheming. Within 'the world of the museum' (202) that englobes the conservators' activities in *Stone Virgin*, decay and ugliness can be put off for a while. It might be advisable, on the other hand, to admit that not all broken objects are beautiful and that not all displayed objects are immune to time.

6 Conclusion: On Display

The presence of artworks in contemporary fiction marks a return to aesthetics, but an aesthetics revitalized by questions about detail, ornament, fragility, ugliness, and other attributes of objects. In defiance of Kantian formulations, artworks in contemporary narratives draw attention to the materiality of objects. The textual representation of artworks contradicts the tendency, following Kant, to relegate objects to a secondary status after their appreciation by human subjects who apprehend them. Objects, whether a portrait by Vermeer or a painted Dutch tile, have a provenance that has nothing to do with the tradition of beholders and their proverbial eye for beauty. Objects exist irrespective of perception or human appreciation. Objects have ornaments and details that are not strictly necessary to the value of the object, yet those details and ornaments contribute to the definition of the object as a work of art. For this reason, counterfeit paintings or sculptures may duplicate, in every detail, an original artwork, yet, without knowing that a work is forged, someone gazing at that object may experience the tingle of delight that goes by the name of aesthetic pleasure to the same extent that an authentic, or an authenticated, work elicits. Defying commodity culture and conventional aesthetics, objects exert enchantment because of their physicality.

Enchanted objects appear in contemporary fiction for at least six reasons.

First, novelists represent paintings, sculptures, porcelains, *sui generis* books, and tapestries in order to redefine the term *object* and, more specifically, *art object*. No comprehensive scheme of classification covers all of the objects that exist in the world. Objects, constantly invented and reinvented, have few common denominators. They take up space and

have dimensions, but almost all similarity ends there. Fictional narratives depict objects in terms of their social meaning, as well as their physical attributes. Objects can be personal or public property, cultural patrimony, or museum pieces. A surprising number of narratives focus on broken and lost objects, while others represent excavated and restored objects. Breakage changes objects, but aesthetics and art history have not accounted adequately for the changes in value and meaning that broken objects incur. If a broken object still qualifies as an object, what kind of object is it? Cultural factors such as scarcity, uniqueness, and desirability heighten the status of artworks and further inflect the meaning of the term *object*.

Second, as representations, artworks are so much fakery, a visual magic designed to beguile the eye. In novels as in paintings, representation is always *trompe l'oeil*. While acknowledging that their efforts are illusory, in the sense that characters and their actions do not exist, novelists represent artworks in order to reinvest the world with enchantment – effects of the infinite, miraculous, redemptive, inexhaustible, and purposeful. Of course, contemporary novelists are not alone in rethinking objects in terms of art. In the 1910s and 1920s, to name just one significant era in which the object assumed primacy, Alfred Stieglitz, Marcel Duchamp, William Carlos Williams, Man Ray, and others made poems and artworks from the foundational object as an object, set apart from human thinking. Contemporary novelists, by comparison, do not think of the object as an isolated element, but as a hieroglyph of social meaning. If the motto of modernism is Williams's 'no ideas but in things,' the motto of contemporary writers is probably closer to 'no stories but in objects.' In particular, objects tell the story of the sensual side of aesthetics, while downplaying abstraction. Not only do contemporary novels about artworks repudiate abstraction by turning to mimesis, they also delight in the pleasures of imitation, while bearing in mind that pleasures equally arise from cunning deceptions perpetrated by representation. In A.S. Byatt's 'Art Work,' Mrs Brown's mythic dragon's lair, for those who care to look at it, does not turn on issues of accuracy or verisimilitude. Dragons, after all, are fictive. Nevertheless, her textile art, in all of its blazing colours and fancifulness, gives pleasure. Representation implies a selection and arrangement of detail, whether in visual or textual form. Representation causes distortions, and those distortions may be the point of departure for the introduction of ugliness into artworks.

Third, the representation of artworks in narrative fiction enlarges

aesthetic inquiry. Instead of asking traditional questions about beauty and form, contemporary novelists dwell on the aesthetic signification of details, ornament, fragility, and ugliness. Details and ornaments are inevitable within narrative. No narrative exists without details, yet some details appear as meretricious ornaments, not essential to formal pattern. According to some theorists, detail and ornament lessen the quality of an artwork, on the grounds that artists should aim for universal truths rather than petty details, or that ornament disguises and detracts from structural or formal essence. Detail and ornament distance spectators from artworks: details are supererogatory; ornaments, so many gewgaws. On the other hand, an object may reveal its details only when a spectator is close enough to examine the object carefully. An ugly object may simply be too far away to give up its details or so intrusively close as to make details crowd out the overall pattern. Yet detail and ornament, as Ruskin acknowledges in *Seven Lamps of Architecture*, create beauty, more even than large structural design does.

Hence, fourth, narratives about artworks concern distance in time and space. Detail, ornament, and ugliness can only be perceived at a certain distance. Distance is both a temporal and an aesthetic issue in contemporary fiction about artworks. Narrative defamiliarizes objects by displaying them; they are kept at a distance as if placed under glass. Unlike objects in lyric poetry or drama – Yeats's 'Lapis Lazuli' or Oscar Wilde's *Lady Windermere's Fan*, for example – objects in narrative represent the material circumstances in which objects are fabricated. Narrative goes beyond ekphrasis to demonstrate the historical consequences of labour. In its ability to show multiple sides of a story and the vested interests of more than one character, fictional narrative makes visible the largely unseen labour relations that are inevitable in the production of objects. Labour, in this regard, becomes an aspect of enchantment, even when it concerns inequities of gender and class. Contemporary narratives present artworks within spatial form as a way to trace the interaction of commodities, including artworks, with aesthetics. 'Spatial form' does not refer to the modernist tendency to systematize heterogeneous material into patterns, of the sort that James Joyce creates in *Ulysses*. Rather, space regulates narrative so that form contains action and the movement of objects. Objects circulate within that frame, sometimes appearing, sometimes disappearing. The vitrine or box is the most common analogue for narrative in contemporary fiction about artworks.

Fifth, artworks in fiction, whether placed in vitrines or dug out of the ground, exist within a culture of display. Novels by Susan Sontag,

Tracy Chevalier, Allen Kurzweil, Thomas Wharton, Bruce Chatwin, and Barry Unsworth pay attention to display value, over and against use, labour, or exchange value. To make such an observation about contemporary fiction is not to nullify other historical epochs in which display matters – for instance, the luxuries of neo-Augustan society or the pomp of imperial England. Contemporary authors critique display as in itself a justification of commodity culture. This critique happens through instances of museal and private exhibition of objects. Collectors who amass and sequester objects challenge established categories of value. An object acquires value by virtue of its being displayed. If an object becomes an object when it is displayed, hidden objects confound the implications of display. The meaning of a display object alters when it is displayed alongside other objects. A group of scythes and dibbles displayed as an ensemble evokes a vanished agricultural past in England, as happens in Penelope Lively's *The Road to Lichfield*. Together they tell a story that a single displayed item cannot articulate. Contemporary fiction about artworks exuberantly indulges in display culture, but not to the extent that critique of display, especially in the precincts of museums, is disallowed.

Sixth, narratives about fine objects concern the social and symbolic significance of art. As a critique of the culture of display, these novels doubt the efficacy of museums and other repositories of objects. Whereas modernity consecrated commodities through the building of museums and the exhibition of fine art, postmodernity deconsecrates museum pieces and releases them back as commodities into systems of exchange. In Kurzweil's *The Grand Complication*, a librarian steals a unique book from the library where he works; a collector hides the book in his private collection until it is repossessed and returned to the library. Vermeer's *Girl with a Pearl Earring* hangs in the Mauritshuis in The Hague, yet it is a portrait in the making, not a museum piece, in Tracy Chevalier's novel of the same name. Art is integral to lived reality in these novels; art insinuates its way into social relations of love, patronage, and servitude. In these fictional narratives, the pleasure derived from making objects trumps the museal or display value of objects. The critical capacity to look at and understand an artwork, the cultural capital that viewers and connoisseurs anxiously quarrel over, takes second place to the social and political integration of art – its lived reality.

Artworks exist not only as objects in their own right, but as objects in narrative patterns. As they circulate among owners and locations, their meanings shift. An artwork that is privately owned and displayed in a

personal collection takes on quite a different meaning when it is ware-
housed with other objects in a museum created for the public good. Art-
works can exist in several interpretive paradigms at the same time. An
owner may lay claim to a Gainsborough painting as private property,
even while that painting belongs to a national heritage. The owner may
hang the Gainsborough on his walls, but its value derives in part from
its place within a cultural patrimony broadly construed. Contemporary
narratives about artworks concern the various meanings of property:
private, national, cultural, intellectual. By the same token, ownership
is not a guarantee of longevity. One prerogative of ownership is de-
struction or alteration of objects, as happens in Peter Carey's *Theft* and
Michael Frayn's *Headlong*. Objects may survive indefinitely, but they
do not, by any stretch of the imagination, survive forever. As coveted
property, they risk damage or destruction some time in the future.

Objects underground and objects in museums have ambiguous rela-
tions to time and ownership. Although in many jurisdictions, excavat-
ed objects belong a priori to the state, an amateur archeologist who digs
up a treasure and does not report it treats the object as private property.
If the state does not know that an object exists – it may have lain under-
ground for centuries or millennia before being excavated – officials are
unlikely to claim it as national patrimony, even though laws designate
the object as such. The object in the ground and the artwork in a muse-
um vault have virtually the same status. Objects in museums belong to
the general public but the general public has access to displayed works
only, not the vaults where paintings and vases are kept. Hiding objects
or displaying them points to the prerogatives of ownership. A collector
may hide his treasures from prying eyes, or stolen treasures may be
hidden from their owners. In either case, hiddenness increases the per-
ceived value of objects. As objects move through artists' studios, mu-
seums, auction houses, and bank vaults, they contribute to the making
and remaking of the limits of value. Enchantment should be understood
as the multiple values, often vexed and contradictory, that overlay ma-
terial objects. Having survived catastrophes and owners, some objects
seem imperishable. Others have a compromised existence, such as the
Portland Vase, smashed and repaired, then taken apart again and put
back together fragment by fragment until its putative integrity has been
recovered. Fragile or durable, all objects have a fate, which is to say a
vexed history and an uncertain future. Objects indicate what human
beings value and how long they value it for.

Objects, freed from religious or functional purposes by being placed

in museums, then, in some instances, deaccessioned, enter into new systems of value established by culture and economics. As Martin Jay writes, objects displayed in museums lose 'their integrity as self-sufficient entities in the world, definable in intrinsic terms as objective exemplars of universal beauty' (6). Unlike libraries, museums do not usually allow public access to stored works. It is worth asking why museums do not create a service in which people could call up specific catalogued objects – at the Metropolitan Museum of Art in New York, for example, a curious museum-goer might ask to see a sixteenth-century bronze Ming incense burner or a 'beehive' porcelain water coupe from the late Kangxi period, circa 1700–22 – in order to study them and know them better. Museum visitors process through rooms filled with artworks without ever touching or holding individual items. In contemporary fiction, museums are never edifying. In Donald Barthelme's 'At the Tolstoy Museum,' dioramas freeze the past in a series of rigid, faintly ludicrous postures that mock the museum-goer's will to be educated. The museum, as curators frequently tell themselves, safeguards objects from the public in order that posterity will benefit. Genuine familiarity, however, derives from day-to-day living with objects, having them in one's sight, picking them up.

In most novels about artworks, objects circulate from hand to hand. They are tactile. They exert enchantment through their solidity and heft. The representation of visual art in contemporary fiction is partly predicated on the appeal of craftsmanship, set over and against expertise as a specialized, modernist conception of production. Artists in Chevalier's *Girl with a Pearl Earring* and Thomas Wharton's *Salamander* are, first and foremost, craftsmen. Motivated by curiosity, they set challenges for themselves and develop solutions to specific problems. They possess hands-on knowledge. To find workable solutions to the technical problems posed by painting or book-making, painters and printers try different arrangements. They move a drapery. They add an earring for a lustrous point of light. They erase sections of paint altogether because something about the massing or the composition fails. Such adjustments are a form of work. The representation of artworks being created thus forces reflections on the nature of work with regard to cultural production. Enchanted objects, whether Vermeer's paintings, Hellenic statues, Meissen porcelains, or medieval tapestries, recuperate the virtues of artisanal production. The making of objects in workshops or artists' studios reveals, conversely, aspects of industrial commodities that cannot be broached within an explanatory framework of disenchantment.

In many accounts of modernity, most notably those offered by Max Weber and Siegfried Kracauer, the adherence to reason causes the disenchantment of the world. From the Enlightenment onward, reason defeats superstition and guesswork. By contrast, as Zygmunt Bauman claims, 'postmodernity can be seen as restoring to the world what modernity, presumptuously, had taken away; as a *re-enchantment* of the world that modernity tried hard to *dis-enchant*' (x). In such a historical account, modernity, associated with industrial capitalism, appropriates scientific knowledge and technology for the production of commodities, whereas postmodernity, associated with global economies and the dematerialization of capital, abandons belief in progress whose hallmarks are scientific inquiry and technology. Contemporary writers recognize that the commitment to reason and technology has its limitations. Commitment to rationality does not make the world a more reasonable place, nor does it make the world less contradictory. The segmentation of tasks in a factory and the invention of machines for the sake of efficiency lead to an alienation of workers from the objects that they produce. Recognizing the limits of reason, contemporary writers dwell on the enchanting qualities of handmade objects, including their imperfections.

Whereas the mechanization of labour throughout the Industrial Revolution creates a separation of workers from artisans and artisans from artists, contemporary novelists investigate the making of unique artefacts, objects designed by hand and executed with practical skill, as a form of material thinking. As a corollary, slowness and stillness emerge as viable aesthetic features within the making of artworks. As everyone after Horace and Chaucer knows, art takes time. Contemporary novels about art objects do not endorse the romantic conception of artists as geniuses and artworks as the spontaneous products of the fertile imagination. In *Girl with a Pearl Earring*, Vermeer figures out how to represent effects of stillness. The inventor, like the painter and the writer, works by trial and error. In *Salamander*, Nicholas Flood develops several solutions for making an infinite book before he alights on one that he deems suitable. Handmade objects, whether books or paintings, enchant because they embody labour value. The enchantment of work performed by hand is of a different order than the enchantment of mass-produced commodities, the difference between, say, the Portland Vase and the multiple reproductions that Josiah Wedgwood's pottery factories produced of the Portland Vase.

In *Utz*, *A Case of Curiosities*, and *Girl with a Pearl Earring*, characters keep workshops or display objects in their homes. Arguing for the tactile knowledge of artisans, Richard Sennett claims that 'craftsmanship is based on slow learning and on habit' (265). The craftsman drafts and sketches, alters his plans as required by the conditions of his project, makes do with what is skilfully done rather than with what is perfect. Faced with ongoing difficulties, the craftsman adapts his tools to the task at hand. A painting, like a novel, is always provisional because not all the technical problems set by the task of making a work of art are answered in the work of art. Unlike the perfectionist, the craftsman knows when to lay down his chisel or paintbrush. In the nineteenth century, 'against the rigorous perfection of the machine, the craftsman became an emblem of human individuality, this emblem composed concretely by the positive value placed on variations, flaws, and irregularities in handwork' (Sennett 84). The artisan does not seek perfection in the sense of uniformity or flawlessness; he values objects in themselves as they take shape in the hand or under the hand. Contemporary fiction about art objects documents the hands-on learning that happens in an artist's studio or collector's apartment. In *Utz*, *Stone Virgin*, *The Volcano Lover*, and other novels, objects exist in relation to human bodies as utensils or adornments. Utz uses his priceless porcelain as everyday dishware. In *Stone Virgin*, Simon Raikes learns the surfaces and gestures of the Madonna statue through the tips of his fingers. In *The Volcano Lover*, Sir William Hamilton, inspecting the Portland Vase, 'brush[es] the tips of his fingers over the low-reliefed figures incised in the creamy white glass' (Sontag 121). Touching glass, he touches history.

Reintroduced into social relations, moved out of the display case in the museum, the art object re-enchants everyday life. In its obduracy and solidity, the object resists explanation. It enchants because it eludes human attempts to own or define it. In novels about enchanted objects, the artwork is evoked as an ocular event – described but not literally visible – within textual representation. A painting or Hellenic sculpture that emblematically conjures up the beautiful as an aesthetic category cannot be situated within narrative, for it remains a sequence of expository details, tantalizingly imagined but never actually produced as a physical entity. As material objects that survive the depredations of time, artworks in narrative fiction parallel the aesthetic ambitions of novels themselves. They cast a particular spell for those who pay attention to their aesthetic properties. The statue of the

Madonna in *Stone Virgin* has 'the stillness of arrested motion,' which Unsworth praises as 'the achievement of art' (163). The artwork sums up its moment in time and generates further meanings thereafter, unless, or until, it ceases to be.

Notes

1. Introduction: Art and Objects in Contemporary Fiction

1 'On one hand, objects in pre-industrial society have more homogeneity because they are, in their mode of production, handmade, because they have less specialized functions, and because the panoply of cultural forms is narrower (speaking of pre-industrial Occidental culture, without reference to external or precedent cultures); on the other hand, there is more segregation between a group of objects that pride themselves on their "style" and local production that valorizes only a strict use value' (my translation).

2 Because *ekphrasis is the verbal representation of visual representation* (Heffernan 3), it homes in on details and ornaments as visual elements. While the rendering of visual objects in language is undeniably an aspect of contemporary novels about art, narrative complicates this definition. Narrative moves through time, whereas ekphrasis moves toward stillness or stoppage of narrative. Ekphrasis is a guise for display culture.

3 Critics often interpret novels set in the eighteenth century in terms of Enlightenment rationality. For instance, Julie Hayes reads four novels, *Perfume*, *Lemprière's Dictionary*, *A Case of Curiosities*, and *The Volcano Lover*, as attempts to unsettle misconceptions about Enlightenment 'ideas and passions, machines and organisms, philosophy and desire' (25). In a review essay, Donna Heiland interprets ten novels about the Enlightenment as explorations of 'how eighteenth-century thinkers understood mind, body, and "self"' (109). Similarly, Amy J. Elias contends that such historical novels express 'postmodern anxieties about [the] Enlightenment optimism offered by heroic science' (535). While bearing in mind these useful rejoinders, I think that certain novels set in the eighteenth century are interven-

tions in the discourse of aesthetics, rather than the discourses of science or reason.

2. Details: Vermeer and Specificity

1 'The *notion* [of the detail] appears when the *object* as such becomes problematic' (my translation).
2 'In practice, two accepted notions of the detail are confused with each other: first, the traditional, non-specialist usage, that insists on the detail as a secondary component [in an artwork]; second, what could be called the "modern" sense, in which the detail acts as a heuristic concept, contributing to reflection on the artwork and its semantic economy' (my translation).
3 Jonathan Crary argues that technological inventions, such as the camera obscura, the kaleidoscope, the magic lantern, and the stereoscope, increase scientific understanding of optics. Change accelerates in the nineteenth century: 'Thus knowledge was accumulated about the constitutive role of the body in the apprehension of a visible world, and it rapidly became obvious that efficiency and rationalization in many areas of human activity depended on information about the capacities of the human eye' (16). W.J.T. Mitchell summarizes and rebuts Crary's arguments in *Picture Theory* (19–24).
4 'What leads away from the whole, but also what condenses in this tiny swerve the significance of the whole' (my translation).
5 Susan Vreeland has made a novelistic career out of women in visual art. In *The Passion of Artemisia* (about Artemisia Gentileschi), *Cedar Spirit* (about Emily Carr), and the short stories about painters in *Life Stories*, Vreeland emphasizes gender politics in visual art. In *The Passion of Artemisia*, one of Artemisia's male patrons asks her to paint a female figure because she will be able to 'see deeply into the life' of a woman (197). According to this formulation, a woman painting another woman sees the essence of gender. In contrast to Vreeland, Tracy Chevalier's fiction debates the relation between materiality and representation. In Chevalier's *Burning Bright*, Thomas Kellaway, an artisan, is troubled by the contrast between function and illusion in made objects: 'The only function of what he now made was to resemble something else rather than to be it, and to create an effect' (151–2).
6 Susanna Kaysen's memoir, *Girl, Interrupted*, draws its title from the Vermeer painting *Girl Interrupted at Her Music*, which hangs in the Frick Gallery in New York. Kaysen plays on the tropes of interruption and capture present in Vermeer novels: 'Interrupted at her music: as my life had been, interrupted in the music of being seventeen, as her life had been, one mo-

ment made to stand still and to stand for all the other moments, whatever they would be or might have been' (167). In *L'Élégance du hérisson*, Muriel Barbery mentions Vermeer several times. In this novel about movement, the stillness of Vermeer's paintings sometimes displeases characters as being sublime but deathly: 'Même pour Vermeer, je ne tiens pas à la vie. C'est sublime mais c'est mort' (35).

7 'The detail does not coordinate with the whole' (my translation).

8 Chevalier dramatizes Vermeer's use of the camera obscura, but the historical proof that he availed himself of this contraption remains controversial. Steadman sets out to prove that Vermeer 'used the camera obscura as an aid to painting' (1). More modulated, Montias considers the possibility that 'Vermeer used optical devices, perhaps a double concave lens mounted in a camera obscura to achieve his truer-than-life effects. The small globules of light with their faint iridescence tend to confirm the use of such lenses' (153).

9 'The detail […] might it therefore not be an idea so much as a moment isolated in the process of perception, of understanding? Something is there, emergent, catching our attention. But we do not know what it is. So we say: a detail' (my translation).

10 'In the age of slippage and of emptying out of the historic sense, the detail henceforth signifies in and of itself, as a sign of the existence and the diversity of the world; it is apt to produce meaning beyond anything having to do with the Great and Prestigious traditions' (my translation).

11 Hal Foster notes that *pronk* paintings feature 'lavish displays of fine objects and extravagant food (in Dutch *pronken* means "to show off")' (253). Foster examines the fetishistic shine or sheen that characterizes these paintings. These perfect and impervious images of things seem to be 'coated with a special shellac before our very eyes, as if the painter were compelled to endow them with a pictorial value to match the commercial value they had already acquired in the marketplace' (257).

3. Ornament: Books in *A Case of Curiosities* and *Salamander*

1 'A surface broken up into ornaments gives a look of daintiness and delicacy to a shoe buckle or a button on a garment, and connects these objects to the idea of the fragile, which stands in pleasant contrast to their hard material' (translation by Christina Oltmann).

2 The ornamentation that Jones rendered at the Universal Exposition in London in 1851 did not suit everyone's taste. John Ruskin notably did not fancy the supposed enchantment that ornamentation brought to dis-

played objects. Agamben refers to the 'hypertrophy of ornament' and the 'elephantiasis of ornament' (39) that appears to confound the object with arbitrary ornamental substitutions, a reminder that, under the auspices of the Universal Exposition, the exchange value of commodities eclipses use value.

3 Trilling discusses Ruskin's theories of ornamentation in the context of universal symbolism ('Meaning' 57–9). Penny helpfully relates Ruskin's theories of ornament to romanticism and its pantheistic impulses, while providing an overview of organicism within Ruskin's theories (276–86). Beginning from the proposition that 'ornament has an ordering function' (87), Soulillou offers an illuminating argument about the relation of orna-ment to hierarchies, especially the persistence of 'excess' in theories of ornament (98).

4 Several translations of the sentence are possible, such as William Duncan's: 'these studies give strength in youth, and joy in old age; adorn prosperity, and are the support and consolation in old age' (297).

5 'These two functions are the opposite of each other. Ultimately the object that is strictly functional assumes a social status: the machine. Reciprocally, the pure object, deprived of function and removed from any practical use, assumes a strictly subjective status: a collectible' (my translation).

6 In a sidebar that accompanied Malcolm Bradbury's *New York Times* review, Kurzweil is quoted to this effect: 'Mr. Kurzweil, of course, divided his novel into 12 sections, but was thwarted in his desire to have it number precisely 360 pages. "It proved technically impossible"' (Graeber 25).

7 *A Case of Curiosities* showcases the connection between names and desti-nies. Lucien Livre gives a lecture on names. Claude Page's surname should be understood in two senses: a sheet of folded paper in a book; a servant in livery working for a master. Some names are red herrings. Plumeaux may evoke 'plume' or 'pen,' but a *plumeau* is actually a feather-duster. In hom-age to the French writer Georges Perec, one of the great object fetishists of the twentieth century, as his novels *Les choses* and *Un cabinet d'un amateur* demonstrate, Kurzweil includes a cameo of 'Perec' (287), a bearded dealer in mechanical games.

8 'The image represents something complete in itself; the frame in turn encloses that which is already complete. The frame expands outward so that, as it were, we peer gradually into the inner sanctum that glimmers through this enclosure' (translation by Christina Oltmann).

9 *A Case of Curiosities* likewise draws upon *Arabian Nights*. The Abbé and Claude play at the roles of caliph and vizier (39), in imitation of *Arabian Nights* characters. Claude's father voyages in the East, and Claude's long-

ing to go there is in part motivated by a desire to understand the enchant-
ment exerted by his dead father.

10 Wharton quotes *Coming Through Slaughter* in the epigraph to *Icefields*: 'As if
everything in the world is the history of ice' (vii). The stylistic tendency to
fragment sentences and create luminescent images that concentrate on sin-
gle objects further demonstrates Ondaatje's influence on Wharton's prose.

4. Fragility: The Case of *Utz*

1 Susan Sontag heard the whole story of *Utz* aloud and 'non-stop' before
Chatwin actually wrote the book (Shakespeare 444). Sebald picks up on
the oral element in Chatwin's fiction: 'Like every true storyteller who
still has links with the oral tradition, he could conjure up a setting with
his voice alone and populate that state with characters partly real and
partly invented, moving among them just as his china collector Utz moves
among his Meissen figurines' (181–2).

2 Chatwin published a version of 'An Eye and Some Body' under the title
'Body Building Beautiful' in the *Sunday Times Magazine*. The essays are
nearly identical, although an editor appears to have trimmed commentary
about Mapplethorpe in order to concentrate on Lisa Lyon in the *Sunday
Times* version. 'Body Building Beautiful' begins with this sentence: 'About
10 years ago New York photographer Robert Mapplethorpe made a name
for himself with his haunting portraits of women' (31). 'An Eye and Some
Body' shifts this focus to more daring content: 'Robert Mapplethorpe is
a New York photographer with an amused grin and coaxing amber eyes
who, about ten years ago, made a name for himself with his haunting por-
traits of women and a series of "sex pictures" that froze – in more or less
liturgical poses – the intimate activities of the so-called leather scene' (9).
In general, 'An Eye and Some Body' is more sexually explicit than 'Body
Building Beautiful.' In it, Lyon wonders about a 'terrible problem: What is
she going to do at the 1982 Dokumenta in Kassel? Something sexual per-
haps? But what? And with whom?' (12).

3 The psychoanalyst Herbert Muensterberger, who knew Chatwin from the
early 1960s onward, thought him a consummate voyeur: 'He was a looker,
an observer, more than a participant [...] For him, homosexuality was
mainly a curiosity. It had the element of being adventurous. His travelling
was another form of voyeurism' (qtd in Shakespeare 126).

4 Chatwin claims, somewhat disingenuously, that the line between fiction
and fact does not exist in his work (Ignatieff, 'An Interview' 24). Working
within a tradition of eighteenth-century philosophical dialogues, Chatwin

uses a fictional persona to filter ideas and anecdotes. Yet Bruce always remains Bruce, as in *The Songlines*, slightly invisible within the 'I' persona and sometimes named outright.

5 Chatwin alludes to classical music with casual authority. A music box plays Schubert's *Trout Quintet* and court functionaries swan around in costumes from Rossini's *Semiramide* in *The Viceroy of Ouidah* (18, 81). In *In Patagonia*, the piano prodigy contemplates Liszt and Wagner (32), 'the Sundance Kid was a keen Wagnerian' (61), Darwin thinks about *Der Freischütz* (165), and Beethoven's Fifth Symphony plays on a tape deck (70). *The Songlines* patently invokes musical comparisons, but none is more startling than 'a featureless stretch of gravel' that resembles Beethoven's piano sonata, opus 111 (14). A similarly surprising musical comparison appears in his essay about Melnikov, whose house is as 'sombre as Prokofiev's 1942 Sonata,' by which he means the seventh piano sonata (*What* 113). Such references attest to the encyclopaedism of Chatwin's style. He exploits the intertextual possibilities of opera fully in *Utz*. The Baron Utz allegedly has an obsession with opera singers, including his downstairs neighbour, who 'had sung Mimi, Manon, Carmen, Aida, Ortrud and Lisa in "The Queen of Spades." One photograph showed her as an adorable Jenůfa in a lace peasant blouse' (122). Utz plays Strauss's *Ariadne auf Naxos* on the gramophone (112–13). The operatic intertext in *Utz* helps to explicate the last line of the novel; Marta, having moved to the country after her husband's death, declares in German, '"Ja! Ich bin die Baronin von Utz"' (154), which resembles, albeit with a gender transformation, the naming of characters during the police inquest in the third act of *Der Rosenkavalier*. In Strauss's opera, the oafish Baron Ochs does not name himself, but Ochs and Utz sound suspiciously alike, and Marta's speaking in German suggests that she has displaced all the other operatic rivals for the title of Baronin.

6 Of course, Chatwin did not read Muensterberger's *Collecting: An Unruly Passion*, which was not published until 1994. Chatwin died in January 1989.

7 'In the Imaginary Museum, the vast department that brings together pictures and statues transforms real museums through an intellectual process without precedent in art itself, and through the destruction of their appurtenances' (my translation). Malraux refers to the disappearance of contextual appurtenances, such as the church for which Christian icons or altars were designed. According to Malraux, the migration of objects into museums nullifies the original contexts in which so-called works of art came into existence. African tribal masks or Roman utensils or Tanagra burial figurines had no aesthetic value per se.

8 Criticism on the museum as a modern and postmodern institution has a
compelling, and very long, literature. Douglas Crimp declares that 'the
museum is an institution whose time is up' (282), in part because of its
idealist history and formalist modernist ideology. Crimp despises 'the ef-
fective removal of art from its direct engagement in social life, the creation
of an "autonomous realm for art"' (303). Other thinkers express more
ambivalence about the value of museums as temples for education and
enlightenment. After an anguished discussion of the sacral qualities of
museums – white spaces, ritual obeisance before artworks – Carol Duncan
cheerfully affirms, 'In the museum's liminal space, the modern soul can
know itself as above, outside of, and even against the values that shape its
existence' (132). Soul-making seems a very long way from Chatwin's ex-
perience of the commercial art market at Sotheby's. In *Irony's Edge*, Linda
Hutcheon offers a gripping account of the politics of museum display
(176–204). At the Royal Ontario Museum in Toronto in 1989–90, a show of
colonial artefacts, supposedly curated with an ironic view of colonialism
in Africa, outraged the black community in the city as a perpetuation of a
colonizing mentality and purpose. Protesters were accused of missing the
irony of the exhibit.

9 Hunting fascinated Chatwin. In *The Viceroy of Ouidah*, Kankpé stalks ani-
mals with uncanny intuition (69). In *The Songlines*, Chatwin participates in
a grotesque kangaroo hunt (210–11), which is a far cry from Ortega y Gas-
set's point that 'hunting (unlike violence) is never reciprocal: the hunter
hunts and the hunted tries to escape' (*Songlines* 206). Utz triumphs as a
hunter by tracking down and haggling over porcelains. As in the case of
Costakis, Chatwin draws a parallel between hunting and collecting.

10 Like J.M. Coetzee, Chatwin thinks conscientiously about animals through-
out his writings. In *Utz*, Orlík studies mastodons and house flies. As a
young girl, Marta falls in love with a gander, an animal fable that reson-
ates with Czech narratives such as Kafka's novella *The Metamorphosis*
and Janáček's opera *The Cunning Little Vixen* in its blending of human
and animal worlds. Utz subscribes to some version of animalitarianism,
described in *The Anatomy of Restlessness* as 'the assumption that animals
are endowed with superior moral qualities to human beings' (80–1). *The
Songlines* echoes this sentiment, with a paraphrase of Democritus: 'it was
absurd for men to vaunt their superiority over the animals' (262). Among
the many references to animals in *Utz*, one in particular deserves annota-
tion. After Utz's funeral, Marta salutes a stuffed grizzly bear with a toast:
'"To the Bear! … To the Bear!"' (12). The gesture mocks Soviet Russia,
whose national symbol was a bear. The meaning of the toast widens, how-

ever, when the narrator learns that Marta is remembering her wedding breakfast (144).

11 'The collection is, first and foremost, a "pastime," in the fullest sense of the word. Collecting simply abolishes time' (my translation).

12 Chatwin read Ovid's *Metamorphoses* carefully and cites Ovid specifically in *The Songlines* (75, 117). Many of the Aboriginal tales in that novel concern the transformation of landscape into anthropomorphized forms. Speaking of Chatwin's own alchemical talent, W.G. Sebald states that 'the art of transformation [...] came naturally to him' (182). *Utz* fundamentally concerns the transformation of commodity into art, and of art into garbage. Utz's story about Böttger's turning clay into ceramic sculpture is only one of many tales of transformation in the novel.

13 In a eulogy for the author, Michael Ignatieff quotes Chatwin on the disappointments of art apropos of *Utz*: '"Art is never enough. Art always lets you down"' (190). Ignatieff reports that, close to death, Chatwin was rehearsing ideas for a new novel about 'a bizarre Russian painter' who has an all-black apartment ('Bruce Chatwin' 191).

5. Looking at Ugliness: *Pascali's Island* and *Stone Virgin*

1 'After all, why would there not be just as much art made from ugliness as from beauty? In short, it is a genre to cultivate' (my translation).

2 'The ancients said that the inspired artist is a visionary who sees into the beyond, a priest or a prophet' (my translation).

3 By discussing Unsworth's fiction in terms of ugliness, I of course do not mean that he consciously theorizes the phenomenon. On the contrary, he uses 'ugly' and 'ugliness' sparingly. In his lexicon, the adjective *ugly* is sometimes solely physical: 'He was bald and very ugly' (*Morality Play* 46). That physicality shades into moral judgment: 'she is ugly, perhaps she is a witch' (*Morality* 62). Ugliness often remains a human trait. In *The Ruby in Her Navel*, a face is 'made ugly by contempt' (37). In *Sacred Hunger*, the narrator associates 'ugly' with states of being, such as an ugly 'mood' (79, 139) or 'ugly temper' (516). In *Pascali's Island*, Pascali tells a tale, 'in all its ugliness and absurdity,' about the collapse of an effigy of Saint Alexei, whose head snaps off its neck and rolls among a horrified congregation (98). No systematic application of the terms *ugly* and *ugliness* occurs in Unsworth's fiction.

4 Patches of Italian, Latin, Greek, Turkish, French, and German fleck Unsworth's prose. By introducing foreign words into his narratives, he draws attention to the limitations of language as a medium for communication.

Operating between languages, translators figure in many of Unsworth's novels. Pascali offers his services to Bowles as a professional translator. Kennedy gives private English lessons in *The Greeks Have a Word for It*, but he is far from being the only 'translation teacher' (50) in Athens. Ritter in *After Hannibal* translates between German and Italian. Polyglot Thurstan in *The Ruby in Her Navel* considers himself 'a model of races and creeds living in harmony' (*Ruby* 151), just as Pascali feels that 'the whole race of men had gone into the making of me' (*Pascali's* 32).

5 *Pascali's Island* was published in the United States under the title *The Idol Hunter*. Whereas the U.K. title articulates a domain that Pascali watches over, the U.S. title shifts the attention to Bowles and his archeological activities. The U.S. title has another disadvantage: it ignores Unsworth's interest in islands, which figure in *The Songs of the King*, *Crete*, and other works.

6 'The ugly is not a mere non-being of the beautiful, but a positive negation of it. Whatever does not fall conceptually under the category of the beautiful cannot be subsumed under the category of the ugly either. An arithmetical problem is not beautiful, but neither is it ugly' (translation by Christina Oltmann).

7 'Ugliness impinges on humankind so closely as to be as agonizing as it is insurmountable' (my translation).

8 'Ugliness – it is the hidden life of mankind, with passions, instincts, and vices caught in their burgeoning state, stripped of all disguise, detached by the artist from its hideous truth, without any trace whatsoever of sublimation' (my translation).

9 'Between household furnishings in good taste but without market value and expensive knickknacks in bad taste, between a two-hundred-year-old piece of clothing without style and a two-year-old piece of clothing that has already lost its style' (my translation).

10 'Ugliness is a refusal even to ask unresolvable problems about harmony, or to resolve other problems, or to live in harmony with all conflict ended' (my translation).

11 Baumgarten defines 'sensory knowledge' in this fashion: 'Cognitio sensitiva est a potiori desumta denominatione complexus repraesentationum infra distinctionem subsistentium. Huius exsistentis si vel solam pulcritudinem ac elegantiam, deformitatemue solam, simul vellemus intelligendo nunc circumspicere, sicut intuetur aliquando saporis eruditi spectator [...] Hinc primum lustremus PVLCRTVDINEM, omni paene sensitiuae cognitioni pulcrae quatenus communis est, VNIVERSALEM et catholicam cum eius oppositione' (7). 'Sensory knowledge, for want of a

better term, is a complex of existing impressions that remain indistinct. On the one hand, it is possible to separate elegance and beauty from ugliness within this emerging complex of sensations. On the other hand, connoisseurs might wish to consider UNIVERSAL and catholic BEAUTY, insofar as it is common to nearly every sensory apprehension, along with its opposite' (translation by Patrick Moran and Meredith Donaldson).

12 'Or rather to see, far from its presumed place of origin, a perfectly ugly object, for example a box made out of seashells bearing the words 'Souvenir of Dinar' in a chalet in the Black Forest, or a perfectly commonplace one, such as a coathanger stamped 'Hotel Saint-Vincent, Commercy' in a bed-and-breakfast in Inverness, or a perfectly improbable one, like the Repertoire archéologique du Département du Tarn, compiled by Mr. H. Crozes, Paris, 1865, quarto, 123 pp., in a sitting-room of a family pension in Regensburg (better known in France under the name of Ratisbonne)' (Sturrock's translation; 104).

Works Cited

Adams, Robert Martin. 'Ideas of Ugly.' *Hudson Review* 27.1 (1974): 55–68.

Adorno, Theodor. *Aesthetic Theory*. Trans. C. Lenhardt. Ed. Gretel Adorno and Rolf Tiedemann. 1970. London and New York: Routledge, 1984.

Agamben, Giorgio. *Stanzas: Word and Phantasm in Western Culture*. Trans. Ronald L. Martinez. 1977. Minneapolis and London: U of Minnesota P, 1993.

Alpers, Svetlana. *The Art of Describing: Dutch Art in the Seventeenth Century*. Chicago: U of Chicago P, 1983.

– 'The Museum as a Way of Seeing.' Karp and Lavine 25–32.

Applewhite, James. 'Modernism and the Imagination of Ugliness.' *Sewanee Review* 94 (1984): 418–39.

Arasse, Daniel. *Le Détail: pour une histoire rapprochée de la peinture*. 1992. Malesherbes, France: Flammarion, 1996.

– *Histoires de peintures*. 2004. Paris: Folio, 2006.

Aristotle. *Poetics. Critical Theory Since Plato*. Ed. Hazard Adams. Rev. ed. New York: Harcourt, 1992. 49–74.

Bailey, Anthony. *Vermeer: A View of Delft*. New York: Henry Holt, 2001.

Bal, Mieke. 'Telling Objects.' Elsner and Cardinal 97–115.

Banville, John. *Athena*. New York: Knopf, 1995.

– *The Untouchable*. 1997. New York: Vintage, 1998.

Barbery, Muriel. *L'Élégance du hérisson*. Paris: Gallimard, 2006.

Barkan, Leonard. *Unearthing the Past: Archaeology and Aesthetics in the Making of Renaissance Culture*. New Haven and London: Yale UP, 1999.

Barthes, Roland. *The Pleasure of the Text*. Trans. Richard Miller. 1973. New York: Hill & Wang, 1975.

– 'The Reality Effect.' *The Rustle of Language*. Trans. Richard Howard. 1968. New York: Farrar, 1986. 141–8.

Barthelme, Donald. *Forty Stories*. New York: Putnam's, 1987.

Basbanes, Nicholas A. *A Splendor of Letters: The Permanence of Books in an Impermanent World*. New York: HarperCollins, 2003.

Baudrillard, Jean. *Le Système des objets*. 1968. Paris: Gallimard, 2003.

Bauman, Zygmunt. *Intimations of Postmodernity*. London and New York: Routledge, 1992.

Baumgarten, Alexander Gottlieb. *Aesthetica*. 1750. Hildesheim: Georg Olms, 1961.

Baxandall, Michael. 'Exhibiting Intention: Some Preconditions of the Visual Display of Culturally Purposeful Objects.' Karp and Lavine 33–41.

Bellos, David. *Georges Perec: A Life in Words*. Boston: Godine, 1993.

Benjamin, Walter. *Illuminations*. Ed. and introd. Hannah Arendt. Trans. Harry Zohn. New York: Schocken, 1969.

Bensmaïa, Réda. 'Du fragment au détail.' *Poétique* 47 (1981): 355–70.

Berger, John. *G*. 1972. London: Bloomsbury, 1996.

Boë, Alf. 'Victorian Theory of Ornament.' *British Journal of Aesthetics* 3 (1963): 317–29.

Bourdieu, Pierre. *Distinction: A Social Critique of the Judgement of Taste*. Trans. Richard Nice. 1979. Cambridge, MA: Harvard UP, 1984.

– *The Field of Cultural Production*. Ed. and introd. Randal Johnson. New York: Columbia UP, 1993.

Bradbury, Malcolm. 'In the Time of the Watchmaker God.' Rev. of *A Case of Curiosities* by Allen Kurzweil. *New York Times Book Review* 26 Jan. 1992, northeast ed.: sec. 7: 1, 25.

Brolin, Brent C. *Architectural Ornament: Banishment and Return*. Rev. ed. New York and London: Norton, 2005.

Brown, Bill. Introduction. Brown 1–16.

– ed. *Things*. Chicago and London: U of Chicago P, 2004.

Buck-Morss, Susan. *The Dialectics of Seeing: Walter Benjamin and the Arcades Project*. Cambridge: MIT P, 1989.

Bunn, James H. 'The Aesthetics of British Mercantilism.' *New Literary History* 11 (1980): 303–21.

Burke, Edmund. *A Philosophical Enquiry into the Sublime and Beautiful*. Ed. and introd. James T. Boulton. 1757. London and New York: Routledge, 1958, 2008.

Byatt, A.S. *The Matisse Stories*. London: Chatto & Windus, 1993.

Cannadine, David. *Ornamentalism: How the British Saw Their Empire*. Oxford: Oxford UP, 2001.

Carey, Peter. *Theft*. Toronto: Random House, 2006.

Carmichael, Peter A. 'The Sense of Ugliness.' *Journal of Aesthetics and Art Criticism* 30 (1972): 495–8.

Carrier, David. *Museum Skepticism: A History of the Display of Art in Public Galleries*. Durham and London: Duke UP, 2006.

Carritt, E.F. *The Theory of Beauty*. London: Methuen, 1914.

Carter, Angela. *Nights at the Circus*. London: Hogarth, 1984.

A Catalogue of the Portland Museum, Lately the Property of The Duchess Dowager of Portland, Deceased: Which Will Be Sold by Auction, By Mr. Skinner and Co. On Monday the 24th of April, 1786, and the Thirty-Seven Following Days at Twelve O'Clock, Sundays, and the 5th of June, (the Day his Majesty's Birth-day is kept) excepted; At her late Dwelling-House, In Privy-Garden Whitehall; By Order of the Acting Executrix. London: privately printed, 1786.

Céline [Louis Destouches]. *Voyage au bout de la nuit*. Ed. Henri Godard. 1932. Paris: Gallimard, 1952.

Chapman, William Ryan. 'Arranging Ethnology: A.H.L.F. Pitt Rivers and the Typological Tradition.' *Objects and Others: Essays on Museums and Material Culture*. Ed. George W. Stocking. Madison: U of Wisconsin P, 1985.

Charles, Ron. 'This Dutch master appears in print more than in paint.' Rev. of *Girl with a Pearl Earring*, by Tracy Chevalier. *Christian Science Monitor* 92 (1999): 21.

Chatwin, Bruce. *Anatomy of Restlessness*. New York: Viking, 1996.

– 'Body Building Beautiful.' *Sunday Times Magazine* 17 Apr. 1983: 30–4.

– 'An Eye and Some Body.' Introduction. *Lady: Lisa Lyon*. By Robert Mapplethorpe. New York: Viking, 1983. 9–14.

– *Far Journeys: Photographs and Notebooks*. Introd. Francis Wyndham. Ed. David King and Francis Wyndham. New York: Viking, 1993.

– *In Patagonia*. 1977. London: Vintage, 1998

– 'Museums.' *The London Spy: A Discreet Guide to the City's Pleasures*. Ed. Robert Allen and Quentin Guirham. London: Anthony Blond, 1971. 95–109.

– 'One Million Years of Art.' *Sunday Times Magazine* 24 June – 26 Aug. 1973. Ten instalments.

– *The Songlines*. New York: Penguin, 1987.

– *Utz*. New York: Penguin, 1988.

– *The Viceroy of Ouidah*. 1980. London: Vintage, 1998.

– *What Am I Doing Here*. New York: Penguin, 1989.

Chevalier, Tracy. *Burning Bright*. New York: Dutton, 2007.

– *Falling Angels*. New York: Dutton, 2001.

– *Girl with a Pearl Earring*. New York: Dutton, 1999.

– *The Lady and the Unicorn*. New York: Dutton, 2004.

– *Virgin Blue*. 1997. New York: Plume, 2003.

Cicero, Marcus Tullius. *Defence Speeches*. Ed. and trans. D.H. Berry. Oxford: Oxford UP, 2000.

– *Select Orations*. Ed. William Duncan and George Mason. Edinburgh: John Brewster, 1825.

Clapp, Susannah. *With Chatwin: Portrait of a Writer*. New York: Knopf, 1997.

Clifford, James. 'On Collecting Art and Culture.' *Visual Culture Reader*. Ed. Nicholas Mirzoeff. New York: Routledge, 1998. 94–107.

Coldstream, Nicola. *The Decorated Style: Architecture and Ornament, 1240–1360*. Toronto and Buffalo: U of Toronto P, 1994.

Connell, Evan S., Jr. *The Connoisseur*. New York: Knopf, 1974.

'Conservation History of the Portland Vase.' www.thebritishmuseum.ac.uk. Visited 13 Feb. 2004.

Coomaraswamy, Ananda. 'Ornament.' *Selected Papers: Traditional Art and Symbolism*. Vol. 1. Ed. Roger Lipsey. Princeton: Princeton UP, 1977.

Cousins, Mark. 'The Ugly.' Part 1. *AA Files* 28 (1994): 61–4.

– 'The Ugly.' Part 2. *AA Files* 29 (1994): 3–6.

Crary, Jonathan. *Techniques of the Observer: On Vision and Modernity in the Nineteenth Century*. Cambridge: MIT, 1992.

Crimp, Douglas. *On the Museum's Ruins*. Photographs Louise Lawler. Cambridge: MIT P, 1993.

Daemmrich, Horst S. 'The Aesthetic Function of Detail and Silhouette in Literary Genres.' *Theories of Literary Genre*. Ed. Joseph P. Strelka. University Park and London: Pennsylvania State UP, 1978. 112–22.

Danto, Arthur C. *After the End of Art: Contemporary Art and the Pale of History*. Princeton: Princeton UP, 1995.

Davidson, Marshall. 'An Early American Silver Spoon and a Pair of Buckles.' *Metropolitan Museum of Art Bulletin* 33 (1938): 146–7.

Defoe, Daniel. *Robinson Crusoe*. Ed. J. Donald Crowley. 1719. Oxford: Oxford UP, 1983.

Dessons, Gérard. 'La stratégie du détail dans la critique d'art et la critique littéraire.' Rasson and Schuerewegen 53–69.

Dickie, George. *The Art Circle: A Theory of Art*. New York: Haven, 1984.

– *Art and Value*. Malden, MA: Blackwell, 2001.

Donoghue, Denis. *Speaking of Beauty*. New Haven and London: Yale UP, 2003.

Duncan, Carol. *Civilizing Rituals: Inside Public Art Museums*. London and New York: Routledge, 1995.

During, Simon. *Modern Enchantments: The Cultural Power of Secular Magic*. Cambridge: Harvard UP, 2002.

Eco, Umberto, ed. *On Ugliness*. Trans. Alastair McEwen. New York: Rizzoli, 2007.

Elias, Amy J. 'The Postmodern Turn on(:) the Enlightenment.' *Contemporary Literature* 37 (1996): 533–58.

Eliot, T.S. *Selected Essays*. London: Faber, 1964.

Elsner, John, and Roger Cardinal, eds. *The Cultures of Collecting*. Cambridge: Harvard UP, 1994.

Flanner, Janet. *Men and Monuments: Profiles of Picasso, Matisse, Braque and Malraux*. Introd. by Rosamund Bernier. 1957. New York: Da Capo, 1990.

Forty, Adrian. *Objects of Desire: Design and Society Since 1750*. 1986. New York: Thames, 1992.

Foster, Hal. 'The Art of Fetishism: Notes on Dutch Still Life.' *Fetishism as Cultural Discourse*. Ed. Emily Apter and William Pietz. Ithaca and London: Cornell UP, 1993. 251–65.

Frayn, Michael. *Headlong*. New York: Holt, 1999.

Freud, Sigmund. 'Fetishism.' *Standard Edition of the Complete Psychological Works*. Vol. 21. London: Hogarth, 1961. 149–57.

Gagnebin, Murielle. *Fascination de la laideur*. Lausanne: Éditions l'Âge d'Homme, 1974.

Garvin, Lucius. 'The Problem of Ugliness in Art.' *Philosophical Review* 57 (1948): 404–9.

Gaskell, Ivan. *Vermeer's Wager: Speculations on Art History, Theory and Art Museums*. London: Reaktion, 2000.

Gigante, Denise. 'Facing the Ugly: The Case of *Frankenstein*.' *ELH* 67 (2000): 565–87.

Gladstone, W.E. 'On Books and the Housing of Them.' *The Nineteenth Century* 27 (Mar. 1890): 384–96.

Gombrich, E.H. *The Sense of Order: A Study in the Psychology of Decorative Art*. Ithaca: Cornell UP, 1979.

Graeber, Lauree. 'The Writer as Horologist.' *New York Times Book Review* 26 Jan. 1992, northeast ed. sec. 7: 25.

Grunenberg, Christoph. 'The Modern Art Museum.' *Contemporary Cultures of Display*. Ed. Emma Barker. New Haven and London: Yale UP, 1999. 26–49.

Harkin, Maureen. 'Theorizing Popular Practice in Eighteenth-Century Aesthetics: Lord Kames and Alexander Gerard.' Matthews and McWhirter 171–89.

Hayes, Julie C. 'Fictions of Enlightenment: Sontag, Süskind, Norfolk, Kurzweil.' *Bucknell Review* 41.2 (1998): 21–36.

Heffernan, James A.W. *Museum of Words: The Poetics of Ekphrasis from Homer to Ashbery*. Chicago: U of Chicago P, 1993.

Heiland, Donna. 'Historical Subjects: Recent Fiction about the Eighteenth Century.' *Eighteenth-Century Life* 21.1 (1997): 108–22.

Hohendahl, Peter Uwe. 'Aesthetic Violence: The Concept of the Ugly in Adorno's *Aesthetic Theory*.' *Cultural Critique* 60 (2005): 170–96.

Hume, David. 'Of the Standard of Taste.' *Critical Theory since Plato*. Ed. Hazard Adams. Rev. ed. New York: Harcourt, 1992. 308–15.

Hutcheon, Linda. *Irony's Edge*. London and New York: Routledge, 1994.

– *A Poetics of Postmodernism*. London and New York: Routledge, 1988.

– *The Politics of Postmodernism*. London and New York: Routledge, 1989.

Ignatieff, Michael. 'An Interview with Bruce Chatwin.' *Granta* 21 (1987): 23–37.

– 'Michael Ignatieff on Bruce Chatwin.' *The Company They Kept: Writers on Unforgettable Friendships*. Ed. Robert B. Silvers and Barbara Epstein. New York: New York Review of Books, 2006. 198–91.

– 'An Interview with Tracy Chevalier.' www.fireandwater.com/authors/interview. Accessed 22 Mar. 2007.

Jackson, H.J. *Marginalia: Readers Writing in Books*. New Haven and London: Yale UP, 2001.

James, Henry. *Roderick Hudson*. New York ed. 1874. New York: Scribner's, 1907.

Jameson, Fredric. 'Capitalism and Finance Capital.' *The Cultural Turn: Selected Writings on the Postmodern, 1983–1998*. London: Verso, 1998. 131–61.

Jay, Martin. 'Drifting into Dangerous Waters: The Separation of Aesthetic Experience from the Work of Art.' Matthews and McWhirter 3–27.

Jensen, Robert, and Patricia Conway. *Ornamentalism: The New Decorativeness in Architecture & Design*. New York: Clarkson, 1982.

Jones, Owen. *The Grammar of Ornament*. 1856. London: Dorling Kindersley, 2001.

Kant, Immanuel. *Critique of the Power of Judgment*. Ed. Paul Guyer. Trans. Paul Guyer and Eric Matthews. 1790. Cambridge: Cambridge UP, 2000.

Karp, Ivan, and Steven D. Lavine, ed. *Exhibiting Cultures: The Poetics and Politics of Museum Display*. Washington and London: Smithsonian Institution P, 1991.

Kaysen, Susanna. *Girl, Interrupted*. New York: Vintage, 1993.

Keates, Jonathan. 'Contriving to be Curious.' Rev. of *A Case of Curiosities* by Allen Kurzweil. *Times Literary Supplement* 20 Mar. 1992: 21.

Keats, John. *Poetical Works*. Ed. H.W. Garrod. Oxford: Oxford UP, 1956.

Keen, Suzanne. *Romances of the Archive in Contemporary British Fiction*. Toronto: U of Toronto P, 2001.

King, Ross. *Ex-Libris*. London: Chatto, 1998.

Klíma, Ivan. *Love and Garbage*. Trans. Ewald Osers. 1986. London: Vintage, 2002.

Kracauer, Siegfried. *The Mass Ornament: Weimar Essays*. Trans., ed., and introd. Thomas Y. Levin. Cambridge: Harvard UP, 1995.

Krestovsky, Lydie. *La Laideur dans l'art à travers les âges*. Paris: Seuil, 1947.

Kurzweil, Allen. *A Case of Curiosities*. San Diego: Harvest, 1992.

– *The Grand Complication*. New York: Hyperion, 2001.

Lalo, Charles. *Notions d'esthétique*. 5th ed. Paris: Presses Universitaires de Paris, 1960.

Lanchester, John. 'A Pom by the Name of Bruce.' *London Review of Books* 29 Sept. 1988: 10–11.

Landy, Joshua, and Michael Saler, eds. *The Re-Enchantment of the World: Secular Magic in a Rational Age*. Stanford: Stanford UP, 2009.

Lee, Vernon, and C. Anstruther-Thomson. *Beauty and Ugliness and Other Studies in Psychological Aesthetics*. London: Lane, 1912.

Liu, Alan. 'Local Transcendence: Cultural Criticism, Postmodernism, and the Romanticism of Detail.' *Representations* 32 (1990): 75–113.

Lodge, David. 'Analysis and Interpretation of the Realist Text: A Pluralistic Approach to Ernest Hemingway's "Cat in the Rain."' *Poetics Today* 1.4 (1980): 5–22.

Loos, Adolf. 'Ornament and Crime.' Miller and Ward 29–36.

Malraux, André. *Le Musée Imaginaire*. 1947. Paris: Gallimard, 1965.

Manley, David, and Ryan Wasserman. 'A Gradable Approach to Dispositions.' *Philosophical Quarterly* 57 (2007): 68–75.

Mantel, Hilary. *The Giant, O'Brien*. 1998. Toronto: Doubleday, 1999.

Márai, Sándor. *Embers*. Trans. Carol Brown Janeway. 1942. New York: Knopf, 2001.

Mars-Jones, Adam. 'Taking the Cure.' Rev. of *Utz*, by Bruce Chatwin. *Times Literary Supplement* 23–29 Sept. 1988: 1041.

Marx, Karl. *Capital: A Critique of Political Economy*. 1867. New York: Modern Library, 1963.

Marx, Karl, and Friedrich Engels. *The German Ideology*. 1845. Amherst, NY: Prometheus, 1998.

Matthews, Pamela R., and David McWhirter, eds. *Aesthetic Subjects*. Minneapolis: U of Minnesota P, 2003.

Matton, Sylvie. *Rembrandt's Whore*. Trans. Tamsin Black. 1988. Edinburgh: Canongate, 2002.

McEwan, Ian. *Atonement*. Toronto: Knopf, 2001.

– *Saturday*. Toronto: Knopf, 2005.

McNeil, Donald G., Jr. 'A Town Rich in Stolen Art, But Not Nosy Questions.' *New York Times* 22 May 2002, arts section: E1.

Meanor, Patrick. *Bruce Chatwin*. New York: Twayne, 1997.

Miller, Bernie, and Melony Ward, eds. *Crime and Ornament: The Arts and Popular Culture in the Shadow of Adolf Loos*. Toronto: YYZ, 2002.

Milton, John. *Areopagitica. Complete Poems and Major Prose*. Ed. Merritt Y. Hughes. Indianapolis: Odyssey, 1957. 716–49.

Mitchell, W.J.T. *Iconology: Image, Text, Ideology*. Chicago and London: Chicago UP, 1987.

- *Picture Theory: Essays on Verbal and Visual Representation*. Chicago and London: U of Chicago P, 1994.
- 'Representation.' *Critical Terms for Literary Study*. 2nd ed. Ed. Frank Lentricchia and Thomas McLaughlin. Chicago: U of Chicago P, 1995. 11–22.

Moggach, Deborah. *Tulip Fever*. London: Heinemann, 1999.

Montias, John Michael. *Vermeer and His Milieu: A Web of Social History*. Princeton: Princeton UP, 1989.

Moritz, Karl Philipp. *Schriften zur Ästhetik und Poetik*. Ed. Hans Joachim Schrimpf. Tübingen: Max Niemeyer, 1962.

- *Werke*. Ed. Horst Günther. Vol. 2. Frankfurt: Insel, 1981.

Muensterberger, Werner. *Collecting: An Unruly Passion*. Princeton: Princeton UP, 1994.

Muschamp, Herbert. 'Broadway's Real Hits Are Its Antique Theaters.' *New York Times* 30 July 1995, northeast ed., sec. 2: 1, 32.

Nabokov, Vladimir. *Lectures on Literature*. Ed. Fredson Bowers. Introd. John Updike. New York: Harcourt, 1980.

Nehamas, Alexander. 'The Return of the Beautiful: Morality, Pleasure, and the Value of Uncertainty.' Rev. of *On Beauty and Being Just by* Elaine Scarry, *Air Guitar* by Dave Hickey, and *The Invisible Dragon: Four Essays on Beauty* by Dave Hickey. *Journal of Aesthetics and Art Criticism* 58 (2000): 393–403.

Nicholas, Lynn H. *The Rape of Europa: The Fate of Europe's Treasures in the Third Reich and the Second World War*. New York: Vintage, 1995.

Noel-Tod, Jeremy. 'Don't Move.' Rev. of *Girl with a Pearl Earring, Girl in Hyacinth Blue, A View of Delft: Vermeer Then and Now, Vermeer's Camera*. *London Review of Books* 23.15 (2001): 17–18.

Norman, Howard. *The Museum Guard*. Toronto: Knopf, 1988.

North, Michael. *Art and Commerce in the Dutch Golden Age*. Trans. Catherine Hill. New Haven and London: Yale UP, 1997.

Ondaatje, Michael. *The English Patient*. Toronto: McClelland, 1992.

Parrinder, Patrick. 'Heads and Hearts.' Rev. of *Underworld* by Peter Conrad, *A Case of Curiosities* by Allen Kurzweil, *Rotten Times* by Paul Micou, and *The Republic of Love* by Carol Shields. *London Review of Books* 28 May 1992: 22–3.

Pater, Walter. *The Renaissance: Studies in Art and Poetry*. Ed. Donald L. Hill. 1873, rev. 1893. Berkeley: U of California P, 1980.

Penny, Nicholas. 'Ruskin's Ideas on Growth in Architecture and Ornament.' *British Journal of Aesthetics* 13 (1973): 276–86.

Perec, Georges. *Espèces d'espaces*. Paris: Galilée, 1974.

- *Species of Space and Other Pieces*. Trans. John Sturrock. London: Penguin, 1997.

Phillips, Adam. *On Kissing, Tickling, and Being Bored: Psychoanalytic Essays on the Unexamined Life*. Cambridge: Harvard UP, 1993.

Plante, David. 'Tales of Chatwin.' *Esquire* Oct. 1990: 182–90.

Plato. *Republic. Critical Theory Since Plato*. Ed. Hazard Adams. Rev. ed. New York: Harcourt, 1992. 18–38.

Price, Martin. 'The Irrelevant Detail and the Emergence of Form.' *Aspects of Narrative*, ed. J. Hillis Miller. New York: Columbia UP, 1971. 69–91.

Pritchett, V.S. *Lasting Impressions: Essays, 1961–1987*. New York: Random, 1990.

Purcell, Rosamond Wolff, and Stephen Jay Gould. *Finders, Keepers: Treasures of Natural History*. New York: Norton, 1992.

Rasson, Luc, and Franc Schuerewegen. 'Le Peu d'existence.' Rasson and Schuerewegen 7–14.

– eds. *Pouvoir de l'infime: variations sur le détail*. Saint-Denis: Presses Universitaires de Vincennes, 1997.

Reynolds, Joshua. *Discourses on Art*. Ed. Robert R. Wark. 1797. New Haven and London: Yale UP, 1997.

Riding, Alan. 'Stranger Than Chatwin's Fiction.' *New York Times* 17 Oct. 2001: E1–2.

Riskin, Jessica. 'The Defecating Duck, or, the Ambiguous Origins of Artificial Life.' Brown 99–133.

Rosenkranz, Karl. *Aesthetik des Häßlichen*. Königsberg: Gebrüder Bornträger, 1853.

Rossetti, Dante Gabriel. *Selected Writings*. Ed. Jan Marsh. London: Dent, 1999.

Rule, Jane. *This Is Not for You*. 1970. Toronto: Insomniac, 2005.

Ruskin, John. *Modern Painters*. 3 vols. New York: Wiley, 1858.

– *The Stones of Venice*. 3 vols. 1851. London: Allen, 1898.

Scarry, Elaine. *On Beauty and Being Just*. Princeton: Princeton UP, 1999.

Schama, Simon. *The Embarrassment of Riches: An Interpretation of Dutch Culture in the Golden Age*. 1987. London: Fontana, 1991.

Schoemperlen, Diane. *Forms of Devotion*. Toronto: HarperCollins, 1998.

Schor, Naomi. *Reading in Detail: Aesthetics and the Feminine*. New York: Methuen, 1987.

Schwarz, Gary. 'Here's Not Looking at You, Kid: Some Literary Uses of Vermeer.' *Art in America* 89 (2001): 104–7, 143.

Sebald, W.G. *Campo Santo*. Ed. Sven Meyer. Trans. Anthea Bell. London: Hamilton, 2005.

Sennett, Richard. *The Craftsman*. New Haven and London: Yale UP, 2008.

Shakespeare, Nicholas. *Bruce Chatwin*. London: Vintage, 1999.

Snodin, Michael, and Maurice Howard. *Ornament: A Social History since 1450*. New Haven and London: Yale UP, 1996.

Sontag, Susan. *The Volcano Lover: A Romance*. New York: Farrar, 1992.

Soulillou, Jacques. 'Ornament and Order.' Miller and Ward 87–99.

Steadman, Philip. *Vermeer's Camera: Uncovering the Truth Behind the Master-pieces*. Oxford: Oxford UP, 2001.

Steiner, Wendy. 'Postmodernism and the Ornament.' *Word & Image* 4 (1988): 60–6.

Stewart, Susan. *On Longing: Narratives of the Miniature, the Gigantic, the Souvenir, the Collection*. Durham: Duke UP, 1993.

Stone, Irving. *Lust for Life*. 1934. Harmondsworth: Penguin, 1984.

Thomson, Michael. *Rubbish Theory: The Creation and Destruction of Value*. Fwd E.C. Zeeman. Oxford: Oxford UP, 1979.

Towers, Robert. 'Secret Histories.' Rev. of *Vox* by Nicholson Baker and *A Case of Curiosities* by Allen Kurzweil. *New York Review of Books* 9 Apr. 1992: 35.

Trilling, James. *The Language of Ornament*. London: Thames, 2001.

– '"Meaning" and Meanings in Ornament: In Search of Universals.' *Raritan* 12.4 (1993): 52–69.

Unsworth, Barry. *After Hannibal*. 1996. New York: Norton, 1998.

– *The Big Day*. 1976. New York: Norton, 2002.

– *Crete*. Washington, DC: National Geographic, 2004.

– *The Greeks Have a Word for It*. 1967. New York: Norton, 2002.

– *The Hide*. 1970. New York: Norton, 1970.

– *Land of Marvels*. New York: Doubleday, 2009.

– *Losing Nelson*. New York: Doubleday, 1999.

– *Morality Play*. 1995. New York: Norton, 1996.

– 'Naples is Closed.' *Granta* 64 (1998): 247–55.

– *The Partnership*. 1966. New York: Norton, 2001.

– *Pascali's Island*. London: Penguin, 1980.

– *The Rage of the Vulture*. 1982. London: Penguin, 1991.

– *The Ruby in Her Navel*. New York: Doubleday, 2006.

– *Sacred Hunger*. London: Penguin, 1992.

– *The Songs of the Kings*. 2003. New York: Norton, 2004.

– *Stone Virgin*. 1985. London: Penguin, 1986.

– *Sugar and Rum*. 1988. London: Penguin, 1990.

Updike, John. *Seek My Face*. New York: Knopf, 2002.

Venturi, Robert, Denise Scott Brown, and Steven Izenour. *Learning from Las Vegas*. Rev. ed. Cambridge: MIT P, 1977.

Vreeland, Susan. *Girl in Hyacinth Blue*. New York: Penguin, 1999.

– *The Passion of Artemisia*. New York: Penguin, 2002.

Wall, Cynthia. 'The Rhetoric of Description and the Spaces of Things.' *Eighteenth-Century Genre and Culture: Serious Reflections on Occasional Forms*. Newark: U of Delaware P, 2001. 261–79.

Walker, Susan. *The Portland Vase*. London: British Museum P, 2004.

Weber, Katharine. *The Music Lesson*. New York: Crown, 1998.

Weber, Max. 'Science as a Vocation.' *From Max Weber: Essays in Sociology*. Trans., ed., and introd. H.H. Gerth and C. Wright Mills. 1919. New York: Oxford UP, 1946. 129–56.

Weil, Stephen E. *A Cabinet of Curiosities: Inquiries into Museums and Their Prospects*. Washington and London: Smithsonian Institution P, 1995.

– *Rethinking the Museum and Other Meditations*. Washington and London: Smithsonian Institution P, 1990.

Weschler, Lawrence. *Mr. Wilson's Cabinet of Wonder*. New York: Pantheon, 1995.

Wharton, Thomas. *Icefields*. Edmonton: NeWest, 1995.

– *The Logogryph*. Kentville, NS: Gaspereau, 2004.

– *Salamander*. 2001. Toronto: McClelland, 2002.

Wilde, Oscar. *The Picture of Dorian Gray*. 1891. Oxford: Oxford UP, 1994.

Wing, Nathaniel. 'Detail and Narrative Dalliance in Flaubert's *Bouvard et Pécuchet*.' *French Forum* 13 (1988): 47–56.

Woolf, Virginia. 'Mr Bennett and Mrs Brown.' *The Essays of Virginia Woolf, 1919–1924*. Vol. 3. Ed. Andrew McNeillie. New York: Harcourt, 1988. 384–9.

Wyile, Herb. 'The Iceman Cometh Across: An Interview with Thomas Wharton.' *Studies in Canadian Literature* 27 (2002): 157–82.

Žižek, Slavoj. *The Abyss of Freedom / Ages of the World*. Ann Arbor: U of Michigan P, 1997.

Index